Negotiating Heritage through Education and Archaeology

Cultural Heritage Studies

UNIVERSITY PRESS OF FLORIDA

Florida A&M University, Tallahassee

Florida Atlantic University, Boca Raton

Florida Gulf Coast University, Ft. Myers

Florida International University, Miami

Florida State University, Tallahassee

New College of Florida, Sarasota

University of Central Florida, Orlando

University of Florida, Gainesville

University of North Florida, Jacksonville

University of South Florida, Tampa

University of West Florida, Pensacola

NEGOTIATING HERITAGE
through Education and Archaeology

Colonialism, National Identity, and Resistance in Belize

Alicia Ebbitt McGill

Foreword by Paul A. Shackel

UNIVERSITY PRESS OF FLORIDA

Gainesville / Tallahassee / Tampa / Boca Raton
Pensacola / Orlando / Miami / Jacksonville / Ft. Myers / Sarasota

26 25 24 23 22 21 6 5 4 3 2 1

Library of Congress Cataloging-in-Publication Data
Names: McGill, Alicia Beth Ebbitt, author. | Shackel, Paul A., author of foreword.
Title: Negotiating heritage through education and archaeology colonialism, national
 identity, and resistance in Belize / Alicia Ebbitt McGill ; foreword by Paul A. Shackel.
Other titles: Cultural heritage studies.
Description: Gainesville : University Press of Florida, [2021] | Series:
 Cultural heritage studies | Includes bibliographical references and index.
Identifiers: LCCN 2020056311 (print) | LCCN 2020056312 (ebook) | ISBN
 9780813066974 (hardback) | ISBN 9780813057873 (pdf)
Subjects: LCSH: Nationalism—Belize. | World politics. | Belize—Social life and
 customs. | Belize—History.
Classification: LCC F1443.8 .M34 2021 (print) | LCC F1443.8 (ebook) | DDC
 972.82—dc23
LC record available at https://lccn.loc.gov/2020056311
LC ebook record available at https://lccn.loc.gov/2020056312

The University Press of Florida is the scholarly publishing agency for the State
University System of Florida, comprising Florida A&M University, Florida Atlantic
University, Florida Gulf Coast University, Florida International University, Florida
State University, New College of Florida, University of Central Florida, University of
Florida, University of North Florida, University of South Florida, and University of
West Florida.

University Press of Florida
2046 NE Waldo Road
Suite 2100
Gainesville, FL 32609
http://upress.ufl.edu

For the Kriol elders and ancestors of Crooked Tree and Biscayne, whose wisdom and strength permeate this book. And for the youth of Crooked Tree and Biscayne, who live and share in their heritage.

Contents

Figures

Foreword

Alicia Ebbitt McGill's *Negotiating Heritage through Education and Archaeology: Colonialism, National Identity, and Resistance in Belize* is a significant contribution to the growing literature of heritage studies. Her work in Belize focuses on analyzing historical and contemporary educational policies within the context of the region's archaeology. Her work delves into the dynamic relationship between local and national heritage and changing relations of power. Key to McGill's work is her exploration of how the official culture is communicated through education, and she shows the ways in which dominant narratives are resisted, co-opted, consumed, and reframed by local people. Much of the emphasis on Belize's heritage focuses on a Maya past, however, most recently there is new focus on teaching about Belize's cultural diversity. Her research skillfully provides a review of historical and archaeological sources, which is enhanced by her ethnography in communities.

State messages about Belize's rich cultural diversity are promoted through archaeological research, tourism, and the educational system. Michel Foucault's work on education provides some context for this study. Schooling, according to Foucault, is a disciplinary response in order to manage a growing population, and in the case of Belize, it was the British government that used the educational system to subvert and dominate local and indigenous populations and supported a history that created social hierarchies. The simple transfer of knowledge cannot be separated from those authoritative processes which seek to instill discipline into the moral fibers of its subjects. The schooling process allows individuals and diverse populations to accept and tolerate steadily increasing degrees of subjection (Deacon 2006).

McGill's examination of the history of Belize's educational system from the late nineteenth century demonstrates how it impacted the way Belizean heritage was created and how it is presented today. Educational systems that developed under colonial rule promoted a glorified Maya past while the heritage of the indigenous and local peoples was oppressed and tolerated by some. Kriol culture

and history were particularly marginalized by the colonial British. They characterized the people in Central America as "inferior," "degenerate," and "primitive," and therefore they needed to be managed, controlled, and tamed.

After World War II, Great Britain slowly became more culturally sensitive to the diversity in the region, although the educational efforts continued to reinforce racial and cultural inequalities, which supported colonial and imperial development agendas. However, more recently, individual actors have played a significant role to add topics like enslavement, ethnic diversity, and precolonial heritage to the educational curriculum, as well as making these issues part of the country's heritage.

Today in Belize there is a demand for more inclusive histories and educational approaches that support diverse histories. McGill's research examines the meaning of place and the heritage in two Belizean Kriol African-descendant villages (Crooked Tree and Biscayne). Surrounded by Ancient Maya sites these villages and community residents have mixed feelings about the meanings and uses of Maya archaeological heritage. For instance, the people of Crooked Tree have actively preserved and promoted the Ancient Maya Chau Hiix site for over a century. Although most Crooked Tree residents do not ethnically identify with Chau Hiix, they have long considered the site a community resource. McGill's work highlights how these Kriol heritage practices connect with other heritage work in the Afro-Caribbean context, and she brings attention to the voices of Kriol teachers and youth as important cultural actors in Belize.

Despite the push to diversify Belize's history and culture, McGill explains that Maya heritage is still considered the primary symbol of Belizean's shared historical past. Ancient Maya history and culture and Maya sites remain the most important tourist revenue producers. Through heritage practices like tourism, museum interpretation, and preservation, heritage actors continue to emphasize the physical characteristics of Ancient Maya heritage; its buildings and objects over more intangible forms of heritage. *Negotiating Heritage* provides an important example of the impact and influence of a national educational system and draws attention to the ways in which local people have engaged the official national memory. It is clear that while everyone may have a past, not all pasts are treated nor understood equally. It is important that we work toward developing a more inclusive past, because this work can help us develop a more inclusive present and future.

Paul A. Shackel
Series Editor

Reference Cited

Deacon, Roger. 2006. Michel Foucault on education: a preliminary theoretical overview. *South African Journal of Education.* 26(2):177–187.

Acknowledgments

Community-based heritage and public history projects are inherently collaborative, interdisciplinary, and social acts. This work would not have been possible without tremendous logistical, intellectual, and personal support from a range of people and institutions, all of whom inspired me, and helped make this a worthwhile project.

Many Belizeans assisted with this work and the friendships I have forged enhanced the research and motivated me to keep returning to Belize. Without the communities of Crooked Tree and Biscayne, this book would never have happened. The Crooked Tree Government School (CTGS) and Biscayne Government School (BGS) opened their doors to me and taught me about local history, Kriol culture, and the power and politics of education. Thank you especially to principals Winnie Gillett, Verla Jex, and Dorla Wade, and teachers Eugene Contreras, Golda Mejia, George Tillett, Kathie Gillett, Recia Wade, and Sherolyn Webster. Thank you to these individuals for their candid conversation at school and during long walks (and boat rides!) to and from school, but also for inviting me into their classrooms and lives, teaching me to cook Belizean delicacies, and watching after me in the village. Since 2005, I have worked with hundreds of CTGS and BGS students and watched them learn and grow into young adults. Their energy, intellect, hard work, and curiosity made my research more enjoyable and successful. I hope this text inspires some of them (including my god-daughter, Caina) to pursue higher education and careers related to history and culture.

Belizeans often remind me that Belize is my second home. In Crooked Tree and Biscayne, people have welcomed me into their homes, adopted me as kin, and entertained and fed me and my family. I am thankful to so many people for their unending hospitality, wit, wisdom, companionship, and for sharing their knowledge, memories, and cultural heritage. I wish that I could have incorporated even more from the meals, weddings, church services, dances, cricket matches, political jokes, gossip, graduations, festivals, and other expe-

riences I have shared with Crooked Tree and Biscayne villagers into the pages of this book. Thank you especially to the following people and their extended families: Horace and Verna Adolphus, Laurence and Ivy Bonner, Roy Bradley, Rudy and Gloria Crawford, Winnie and Clarence Gillett, Evangeline Gillett, Wilhelm Gillett, Reni Jones, Bertie and Anne Kerr, Judy Kay Perriott, Verna Samuels, Arlene Tillett, Ava Tillett, Clifford Tillett and Gloria Cruz Tillett, Hugh Tillett, Steve Tillett, Terese Tillett, Dorla Wade, Landis Wade, Emilia Westby, and Henry and Bernadine Westby. Given the nature of long-term community work, many people who first taught me about Belize passed on before the completion of this book. I am privileged to have met so many Crooked Tree and Biscayne elders and I hope I have accurately represented the words and thoughts of all those with whom I have worked and respectfully honored them with this text.

Many Belizean institutions supported my work by granting and administering research permits, providing me access to resources and financial and in-kind support, and expanding my networks. These institutions include the Belize Archives and Records Service, Belize Audubon Society, Biscayne Village Council, Crooked Tree Village Council, Galen University, Institute for Social and Cultural Research, Institute of Archaeology, Ministry of Education, Youth and Sports, Museum of Belize, National Kriol Council, and the University of Belize. Additionally, Belizean colleagues supported community-based heritage initiatives which were part of this work, enhanced my analysis, and gave me insight into official and vernacular heritage practices, cultural politics, and Belizean history. I am especially grateful to Mary Alpuche, Jaime Awe, Teresa Batty, Sylvia Batty, Herman Byrd, Angel Cal, Olivia Carballo-Avilez, Dareece Chuc, Rolando Cocom, Nigel Encalada, Derick Hendy, Sherilyne Jones, Lita Krohn, Dominique Lizama, Myrna Manzanares, Irene Mckoy, John Morris, Phylicia Pelayo, Giovanni Pinelo, Linette Sabido, Selene Solis, Froyla Tzalam, and Silvaana Udz.

Numerous colleagues in the United States have offered intellectual feedback, supported my scholarly development, taught me about community-based research methods and ethical practice, and collaborated with me on heritage initiatives in Belize. For their continued collegiality and support, I thank Sonya Atalay, Kristina Baines, Katherine Mellen Charron, Craig Friend, Tammy Gordon, Ellie Harrison-Buck, Eric Koenig, Susanna Lee, Bradley Levinson, Patricia McAnany, Kathryn Lafrenz Samuels, Paul Shackel, Richard Wilk, Becky Zarger, David Zonderman, and my colleagues and friends from the Indiana University (IU) Archaeology and Social Context Program. I am thankful to Melissa Johnson for her invaluable and insightful scholarship on Belizean

Kriol culture and history, race, and environmental heritage, and the stories and thoughts we have been able to share about our connections with Crooked Tree. I am especially indebted to Richard (Rick) Wilk and Anne Pyburn for their mentorship, expertise about Belize, and the foundation they built in public archaeology and heritage studies. Rick Wilk's research on Belizean food, popular culture, and history provided me with an incredible knowledge base. Rick and Anne's commitments to social justice issues in Belize motivate me to continue to explore heritage politics in the region. Anne Pyburn has been a colleague, mentor, friend, and inspiration since we first met in 2003. Through her scholarship and our conversations, Anne constantly reminds me to be reflexive and honest in my research. Her public archaeology work with the Chau Hiix Archaeological Project (CHAP) provided the foundation for the research I conducted for this book. Her feedback has strengthened my analysis and her tough love and motivation made me want to see this project through.

Through the CHAP, I learned a great deal about what community engagement looks like in heritage work. CHAP staff and students assisted me with numerous outreach and community activities. As with any field experience, I bonded with my CHAP colleagues and am indebted to them for their emotional and intellectual support, entertainment, and sharing coastal, jungle, and village adventures. Thank you especially to Kip Andres, Caroline Beebe, David Carter, Isaac Cole, Jonathan Dankenbring, Jason Farris, Emily Gage, Allison Foley, Luke Funk, Jimmy Hennes, Polly Husmann, Jacqueline Lipski, Nati Orbach, Genevieve Pritchard, Meghan Rubenstein, Eric Stockdell, Mark Strother, Anne Lise Sullivan, and Sarah Wille. As anyone who has conducted interviews knows, transcription work can seem almost endless. Thank you to Indiana University (IU) students Kayla Hassett, Kaeleigh Herstad, and Jennifer Studebaker, who transcribed many interviews and scanned research materials. North Carolina State University (NC State) public history graduate students Hannah Scruggs and Lisa Withers were the first students I had the opportunity to take to Belize for my own fieldwork. As part of a community-based public history field program in Crooked Tree and Biscayne, Hannah and Lisa developed educational materials and an exhibit about local history and Kriol heritage, conducted interviews, and documented cultural practices. It was exciting and enlightening to experience Belize through them as Hannah and Lisa helped me think differently about cultural politics and race issues and unpack my positionality as a scholar and a teacher, and an outsider and an insider on a variety of levels.

I am privileged to have been surrounded by brilliant mentors early in my educational development from middle school to university. These women have

sparked my intellectual curiosity and supported my academic journey and I strive to model their practices. Thank you to Ellen Bedell, Beverly Chiarulli, Phyllis Friend, and Ceil Sturdevant, who taught me about science, anthropology, public archaeology, and human creativity and ingenuity.

I am thankful to the scholars and editors who assisted in the production of this book. Thank you to the initial anonymous readers whose commentary and suggestions helped me contextualize this research in the Caribbean region and the heritage and public history literature, to Heath Sledge and Molly Mullin whose editing work helped me tighten the text, and to the University Press of Florida team, especially Meredith Babb, Mary Puckett, and Marthe Walters who kept me on task and moved things along so smoothly.

I received financial support throughout this project that funded ethnographic and archival research, dissemination of my work, and the implementation of community-based heritage initiatives. I am particularly grateful to the Wenner-Gren Foundation for their support to conduct ethnographic research, write-up and share the results of my work, and develop community engagement activities. Other sources of funding include travel, fieldwork, and writing fellowships from IU, the IU Department of Anthropology, the IU Center for Latin American and Caribbean Studies, NC State's College of Humanities and Social Sciences, the NC State Department of History, InHerit and the Alliance for Heritage Conservation, and a University of New Hampshire Public Humanities Grant and Student International Service Initiative grant.

As an anthropologist I am well aware of the contributions kinship makes to identity, the formation of community, and the accomplishment of tasks. This project would not have been possible without the ongoing support from my immediate and extended biological family (the Ebbitts and Emerys) and relatives by marriage (the McGills and Findens) who have supported this project by offering words of encouragement, sharing interest in Belizean history and culture, and recognizing the values of education and knowledge. My parents, Lorrie and Jack Ebbitt, have always encouraged me to pursue my dreams of archaeological adventure, world travel, and higher education. Their appreciation for unfamiliar places, people, and experiences helped me navigate discomfort and relish in cultural exchange, which has been invaluable in my heritage work. My in-laws, Sue and Larry McGill shared in my joys of international travel and the numerous "play dates" they engaged in with their grandson gave me much needed time during the final stages of writing and editing. One of the great things about working in a place like Belize with rich Kriol heritage, impressive Maya sites, and beautiful beaches is that many people want to visit you during your research trips. Thank you to the many friends and family who

provided much needed respite during long field seasons but who also whole-heartedly embraced Kriol culture, visiting the schools and homes of my friends and family in Belize and showed enthusiasm to learn about local language, history, and foodways.

My best friend and husband, Dru McGill, has long been my personal and academic partner. Dru has read through my work more times than anyone, provided new insight into my analysis, and made intellectual and editing suggestions which greatly improved this book. We frequently share our interests in and concerns about public archaeology and community-based heritage work. Dru has assisted in conducting interviews, taking photos, and providing emotional support during several research trips and I am immensely thankful to Dru for sharing my love of Belize and Belizeans. Perhaps our most memorable research adventure was experiencing a community-wide flood in Crooked Tree in 2008, which brought us closer to each other and the community. Finally, and most importantly, I am thankful to Dru for sharing the rewards and challenges of parenting with me. Dru has selflessly committed time and energy to our son without which I could have never finished this book. Our son, Finden, has given me new perspectives on my research and enriched my relationships with Belizeans. I look forward to watching him grow up learning about the richness of Kriol heritage from "old heads," eating cashew (in all its forms!), stewed chicken, and rice and beans and beans and rice, learning "fi talk Kriol" better than his parents, and forming bonds with younger relatives of the many Belizeans who have made this work possible.

Negotiating Heritage

Education and Archaeology in Belize

In May 2013, a more than two-thousand-year-old Ancient Maya pyramid at the archaeological site of Nohmul was bulldozed almost to the ground by developers seeking limestone to build roads. Nohmul is located near the predominantly Mestizo and Yucatec Maya village of San Pablo, in the Central American and Caribbean country of Belize. Historically, Belize (formerly British Honduras)[1] was considered the "periphery of the periphery" of the British Empire—an inaccessible territory of limited social and economic interest.[2] Despite Belize's small profile (8,867 square miles with a population of fewer than three hundred ninety thousand people), the destruction at Nohmul quickly made international news and was the subject of a range of responses and concerns. International news sites and historical and scientific organizations like *National Geographic* decried the damage and emphasized the development threats to such a significant example of humanity's shared cultural heritage. Foreign archaeologists referenced Nohmul in discussions of endemic archaeological site destruction and the corresponding need for better national oversight and management of heritage, as well as an example of how Belizeans are "distanced from heritage." Belizean news media quoted politicians and state heritage actors who stressed the criminality of the act, called for harsh penalties, and noted a perceived "insensitivity" of citizens who failed to do their duty of protecting the nation's heritage. Belizean citizens used the damage at Nohmul to lament social and economic inequalities, bemoan the ineffectiveness of politicians and government institutions, discuss ethnic and racial tensions, and make claims for resources for archaeological and tourism development.[3]

The Nohmul story represents fundamental questions about history, culture, and public memory that resonate on a global scale. What are appropriate and inappropriate ways of connecting with, managing, and using the past? Consider the multiple stakeholders and complex stories surrounding debates about Confederate monuments in the United States, the benefits and negative

impacts of tourism development at Machu Picchu, the histories of museum collecting practices and efforts to repatriate Indigenous objects throughout the world, or the Taliban's dynamited destruction of the Bamiyan Buddhas in Afghanistan. Efforts to define, preserve, research, and teach about culture and history connect the past to the present; these efforts and connections are what many scholars call *heritage.*

People previously conceived of heritage exclusively as those aspects of the past that are valued and passed down (that is, inherited), and/or the tangible objects and places associated with the past. By asking difficult questions about how and why the past is valued, scholars have revealed that heritage is constructed, and it is not universal, natural, static, or objective, nor does it consist simply of things and places. Rather, as noted by Laurajane Smith, "heritage [is] a process of engagement, an act of communication and *an act of making meaning in and for the present.*"[4] Understood in this way, heritage is deeply connected to identity and includes the myriad ways individuals, groups, institutions, and states understand, value, and engage with manifestations of culture and history.[5] These manifestations include tangible and intangible forms of the past, such as cultural and historical sites, objects, landscapes, memories, and narratives. People engage with heritage manifestations through a range of practices including visits to culturally significant sites, education programs, scholarly research, management and preservation, tourism, daily practices, and cultural traditions. Heritage engagements are dynamic as cultural identities and the meanings and uses of the past change over time.

Heritage scholarship has shown that heritage constructs and practices occur in multiple intersecting and often contested forms. One form is what Smith refers to as "authorized heritage discourse"[6] and Rodney Harrison refers to as "official heritage"[7]—the latter is the term I employ. These heritage forms are typically thought of as authorized because they are crafted and employed by people with recognized power, like government agents, scholars (for example, archaeologists, historians, anthropologists), and dominant cultural groups. They are structural and ideological in nature because they include institutionalized and legislated forms of control over the past, such as state-sponsored or regulated research, management practices (for example, site development, preservation, and cultural property laws), museum displays, tourism promotion and programming, and education related to culture and history, as well as heritage forms and places (for example, historic sites and objects, historical narratives, and traditions) those in power deem significant. Official heritage discourses are also typically dominant, in that they seek to control and limit how people think about and use culture and history "to make meaning in and

for the present" and often emphasize certain cultural identities and historical narratives over others.[8]

Another form of heritage constructs and practices are those that are more localized, personal, and shared by cultural groups, including storytelling, foodways, traditions, and daily practices, as well as the cultural forms, places, and narratives tied to these (for example, cultural landscapes, sacred spaces, objects of cultural patrimony, and family and group histories). Harrison defines "unofficial heritage" as "a broad range of practices that are represented using the language of heritage, but are not recognized by official forms of legislation," such as "buildings or objects that have significance to individuals or communities, but are not recognized by the state as heritage" or social practices surrounding these tangible and intangible heritage forms. I refer to the ways individuals and communities identify, value, and engage with historic and cultural places and objects on their own terms and negotiate official heritage discourses as "vernacular heritage practices." I also refer to shared cultural components that are embodied aspects of group identity as "vernacular heritage."

Negotiating Heritage employs a combination of ethnographic and historical approaches to demonstrate the processes through which cultural actors have crafted and navigated official and vernacular heritage meanings, practices, and narratives in Belize, including the ways different Belizeans employ the concept of heritage to define culture, history, and identity in multiscalar, intersecting, and often conflicting contexts. We cannot truly understand the Nohmul destruction and similar examples of heritage engagements except within a complicated set of dynamics that influence how the past is constructed, preserved, and used by governments, academics, and local people. In Belize, these factors include colonial history and British imperial policies, constructs of governmentality and citizenship, racial and ethnic politics, social and economic development, the interests and agency of descendant and local communities, and the power of international heritage movements.

Official heritage discourses and practices examined in this book include government-supported and sponsored education policies and school curricula related to culture and history, institutionally sanctioned festivals and events, archaeological exploration and research, and the institutions and policies developed to professionalize archaeology and to manage historic and cultural sites, objects, and practices. Vernacular heritage practices examined include the ways local communities react to, reinforce, and complicate official heritage discourses, for example, by manipulating state agendas to advocate for community recognition and resisting curricula and school practices. I also provide examples of vernacular heritage practices in the ways Belizean citizens value,

preserve, and connect with historic places and maintain cultural traditions, by protecting cultural knowledge, continuing marginalized practices like language and foodways, and identifying connections between themselves and past peoples. Thus, in this book, I use the term heritage to mean both the processual definition given by Smith above and the more traditional sense of what people define as historic sites, material culture, and cultural practices.[9] Drawing from archival sources, interviews, and observations I explore etic and emic perspectives on heritage in Belize from the late nineteenth to the early twenty-first century, revealing the complex intersections between official heritage and vernacular heritage engagements.

The communities at the core of this work are two rural Kriol[10] African-descendant villages in north-central Belize, Crooked Tree and Biscayne. Crooked Tree Village is an inland island surrounded by seasonal lagoons. With connecting tributaries in the Belize River valley, the lagoons form a wetlands environment designated the Crooked Tree Wildlife Sanctuary (CTWS) by the Government of Belize in 1984, which is a protected area and tourist attraction comanaged by the Belizean Forestry Department and the Belize Audubon Society. Indigenous Maya people lived in this region from as early as 1100 BCE until Spanish contact in the sixteenth century. In the early eighteenth century, British loggers forcibly brought enslaved African people to the region to increase productivity in timber extraction. Small logwood cutting outposts inhabited originally by loggers and enslaved people grew into larger formal settlements in the Crooked Tree area, with the establishment of a Baptist church and school in 1843.[11] Anthropologist Melissa Johnson suggests that seminal development of Kriol culture and language occurred in Crooked Tree and similar riverine villages as freed and enslaved African peoples and their descendants mixed biologically and culturally with European colonists (through force and agency), adapted to wetland conditions, and developed ways to communicate.[12] Biscayne Village, located one mile south of Crooked Tree on Belize's Northern Highway, was founded in the late 1970s primarily by residents from Crooked Tree interested in living in an area that was more connected to vehicular transportation channels and more accessible to Belize City.

Ancient Maya sites surround Crooked Tree and Biscayne, and community residents have mixed feelings about the meanings and uses of archaeology. This book's research began with a focus on the relationships between Crooked Tree and a community-based archaeology project (the Chau Hiix Archaeological Project [CHAP], which was directed by K. Anne Pyburn [Indiana University] from 1989 to 2007). Although most Crooked Tree residents do not ethnically identify with the nearby Ancient Maya Chau Hiix site, they have long consid-

ered the site a community resource and part of the community's local history and culture—their engagements with the site and archaeological project reveal Kriol cultural practices of adaptation, negotiation, and resistance.

I participated in archaeological research with the CHAP and directed outreach efforts, much of which took place in local schools. I sought to understand how archaeological sites are connected with living people, who both alter the meanings of sites with their cultural practices and are themselves affected by the ideologies and temporalities such sites represent.[13] I observed practices and discourses that left me with questions. How was it that the Kriol children I worked with seemed to know so much about the Ancient Maya but did not easily articulate the same information about their own histories? Why did teachers on the one hand lament the loss of Kriol culture while on the other perpetuate stereotypes about ethnic groups? How did Crooked Tree and Biscayne residents learn about national and local culture and history, and what roles did these constructs play in their lives?

Negotiating Heritage argues that archaeology and formal education are particularly significant, interconnected social institutions through which official and vernacular heritage forms and practices are constructed, controlled, and contested. The fields of history, public history, archaeology, and historic preservation share goals to understand the past through scholarly investigation, to protect and preserve remains and records of the past, and to share knowledge with people about the significance of the past through education. While scholars often discuss best practices for accomplishing these goals,[14] there are fewer discussions about the intersections between historic scholarship and primary education. This book fills this intersectional lacuna by combining analysis of schooling and curricula with analysis of archaeological research and site management, enabling me to examine heritage in practice as well as in discourse and theory.

Education and archaeology function as official heritage practices defining culture and history for individuals, local communities, and states. Formal education (for example, curricula, school programs and practices, and education policies), affect how people construct a sense of their place in society, for example by reinforcing and legitimizing official cultural categories and historical narratives. Similarly, archaeology is a formal mechanism by which people become temporally and spatially oriented. Archaeologists add social, political, and economic value to the places and groups they investigate by determining the "significance" of sites and cultural histories and making choices about appropriate ways to engage with past material culture (for example, scientific research and preservation).

Education and archaeology are both government-sponsored and managed heritage institutions that are directly connected to, and implicit in, the imposition of colonial authority and the interests of the state. As such, they are powerful, incontrovertibly intertwined forces in the creation of official knowledge about culture, difference, and history. As people engage with formal education and archaeology, they are influenced by such official heritage constructs, but the institutions of education and archaeology are also spaces for agency and cultural production. Within descendant and local communities, both adults and young people negotiate and sometimes actively resist official heritage messages. Their acts of resistance and meaning-making serve as a responding vernacular discourse about cultural identity and public memory.

The fact that education and archaeology were particularly important social institutions in Belize was immediately apparent to me on my arrival in the country. With more than half of its population under the age of twenty-five, education is a major concern. Archaeological "ruins" dot the landscape. Located in the heart of the Maya world, Belize's archaeological resources have been the subject of intellectual fascination, exploration, and study since the nineteenth century, and today are a lucrative resource due to the heritage tourism industry. Historically, the British established formalized colonial education with the creation of an Education Department in 1891. Three years later, they implemented Belize's earliest antiquities law, the Ancient Monuments Protection Ordinance. Information about culture and history derived from archaeology is included in national curricula. Belizean citizens frequently engage with archaeological sites and artifacts, examining them through a framework of history and culture they learn in schools.

A primary goal of this book is to demonstrate how in the context of Belize, education and archaeology are interconnected, powerful heritage practices that worked together to create an official heritage discourse. Colonial powers and independent state actors constructed official heritage discourse and ideologies through education and archaeology to manage difference, govern subjects and citizens, reinforce economic and social development agendas, and create problematic racial and ethnic categories that persist today. But, complicating the hegemony of these heritage ideologies, I also detail the agency of Belizean children, teachers, and others as they interpret, negotiate, and respond to legacies of official colonial and national heritage practices.

Research in this book draws from historic primary sources, participant observation, and interviews to discuss education and archaeology as heritage practices. Some historians are critical of the concept of heritage, as it is often tied to identity politics, a culture of nostalgia, and economic agendas and

can perpetuate misrepresentations of history. Historian and geographer David Lowenthal famously highlighted in his monograph *Possessed by the Past* the ways history has been manipulated as "heritage" to legitimize claims to resources and malign and dispossess groups of their land, rights, and cultural representations, justifying intellectual wariness about heritage.[15]

I address such wariness directly by unpacking the historical, political, and social factors related to how and why different heritage constructions conflict in Belize. In doing so, I contribute to critical turns and decolonization processes that have occurred in public history, archaeology, anthropology, and heritage studies. Scholars engaged in these processes strive to diversify understandings of the ways people define and utilize the past, and reveal the roles academic disciplines have historically played in controlling and legitimizing historic resources and narratives, and privileging certain stakeholders over others.

While this critical turn has shown the value of heritage studies to history, heritage scholar David Harvey argues that despite an examination of how official and vernacular forms of heritage are constructed and employed, scholars have not adequately historicized heritage practices. Public memory scholarship, which involves historicized examinations of heritage, can serve as models for outlining the "heritage pasts" that Harvey advocates scholars should explore.[16] In historian Pierre Nora's "Between Memory and History," he identifies ways memory is embedded in historical landscapes and notes connections between modernity and nostalgia, memory engagements, and heritage practices.[17] Public historians engage public memory by focusing on how state entities as well as marginalized groups construct and promote collective narratives about the past through national civic myths, monuments, memorialization and other practices.[18] Anthropologist and public historian Mary Hancock's work on public memory in Chennai, India (formerly Madras), combines public history and heritage studies and demonstrates the value of historically informed ethnographic work.[19] In Hancock's monograph, she reveals how official and vernacular concepts of heritage were constructed and shifted over time in Chennai, India through colonial archaeology practices and regulations, the development of modern political memorials, and government, private, and community manipulations of the tourism industry in the late twentieth and early twenty-first centuries.

Following Hancock, *Negotiating Heritage* utilizes careful examination of primary sources from the late nineteenth to the early twenty-first century to provide a historicized analysis of Belize's "heritage pasts." I examine education and archaeology policies, reports, and curricula that reveal state-level prac-

tices, along with colonial minute papers and community petitions that show local responses to state practices. Regional and international education and archaeology reports and policies situate Belize in broader geopolitical cultural and historical contexts and I make comparisons with practices in other British colonies (for example, Jamaica and India) and Latin American and Caribbean countries.

Emma Waterton and Steve Watson suggest that scholars have not adequately conceptualized methodologies to unpack heritage practices—to "formulate clear impressions of what [heritage] *does*—what it circulates, what it produces."[20] In addition to the historic research described, I employ an ethnographic methodology to address such concerns and include the voices and actions of living people in my work. Ethnography is a principal method in anthropology and an immersive process, used to systematically study, interpret, and describe cultural practices and ideas through observations of and participation in the cultural actions of groups of people. As such, ethnographic perspectives contribute additional analytical angles to public history research, because they enable deep, contextual examinations of structural and agency-based cultural practices involved in engagements with the past. I gathered ethnographic data through a multiscalar approach that included participant observation of schools and archaeological research, interviews with state and community actors, visits with people in their homes, and participation in traditions and community events.

In their edited volume, *Ethnographies and Archaeologies: Iterations of the Past,* Lena Mortensen and Julie Hollowell suggest that "contextualized and particularistic ethnographic approaches" to the study of archaeology may reveal "a deeper understanding of how concepts such as 'heritage' or 'the past' acquire meaning and of how people experience, interpret, and benefit from them."[21] Ethnographic studies have shown how archaeology, as a scientific endeavor situated in specific historical and cultural contexts, is neither neutral nor apolitical and has long been tied to imperialism, colonialism, and state interests.[22] But critical heritage studies have also revealed how archaeology is not completely dominant, showing how local actors respond to, reinterpret, and manipulate archaeological discourse based on their own connections with material and intangible manifestations of the past as well as their own needs and interests.[23]

In my ethnographic research, I examined the ways Crooked Tree stakeholders engaged with archaeology by participating in and observing two seasons of research and education at Chau Hiix, and by interviewing community members associated with or aware of the local archaeology project (for example,

elders, tour guides, youth, local politicians). Through this ethnographic work, I came to understand the dynamics between the CHAP, Crooked Tree Village, and surrounding communities, revealing vernacular knowledge production and culturally determined negotiation tools that resulted from interactions between community actors and heritage professionals like archaeologists. Widening my scope to the national level, I analyzed interpretive materials at museums and nationally managed archaeological sites. I also conducted interviews with state officials who have authority over archaeological sites and materials. The resulting data enabled me to examine the global and national dynamics of official heritage constructions and practices through archaeological research, tourism, and site management, and explore cultural strategies by which institutions and individuals make claims to the past.

Social scientists and humanists have long examined formal education to understand societies and cultural practices. Schools have been shown to be spaces of social surveillance and sites of cultural transmission where government authorities can normalize and reinforce social control by defining and managing differences within and between cultural groups (that is, in ethnicity, language, and history).[24] Echoing Althusser's view of education as an "ideological state apparatus,"[25] education policy scholar Joel Spring argues that "schooling supports the political needs of the nation-state through education and disciplining a loyal, patriotic citizenry imbued with nationalism and acceptant of the legitimacy of the state."[26] Heritage curricula related to culture, history, and ethnic diversity in the past and present have the potential to be especially politicized. For example, in her study of Ghanaian education, anthropologist Cati Coe explores how the state appropriated and integrated local cultural traditions such as drumming and dancing into curricula, thus institutionalizing ethnic practices as part of an official, nationalized cultural package.[27] However, studies of education and schooling have also shown the ways teachers and students challenge states and engage in vernacular heritage practices of cultural production, transformation, and resistance.[28] Schools are also sites of local advocacy, where teachers may act as intermediaries between the state and their communities. And young people are active cultural agents who interpret what they learn in schools within their own cultural contexts and develop significant ideas about the world.[29]

To analyze official and vernacular heritage practices in Belizean education, I examined historical and contemporary education acts and policies, curricula, and administrative reports, and interviewed national education officers and curriculum designers. I spent over a year observing educational practices and cultural interactions in classrooms, as well as at museums, archaeological sites,

cultural festivals, and sporting events. I interviewed young people and teachers at the government-run primary schools in Crooked Tree and Biscayne to understand youth learning processes. By considering how teachers and students consume and produce heritage knowledge and negotiate education practices, I highlight dynamics between the Belizean government and local communities, demonstrating, as Coe argues, that schools are "places where the relationship between a state and its citizens is negotiated, with each side seeking to influence the other."[30]

Historicizing Heritage in Belize

In the chapters that follow, I demonstrate the value of an interdisciplinary approach to studying heritage that draws from public history, anthropology, and heritage studies. Combining an ethnographic and cultural history lens in my examination of education and archaeology, I address the historical processes through which official heritage discourse has been imparted by colonial, international, and national actors. I demonstrate how modern Belizeans inherited many official heritage constructs from colonialism. And, following common practice in cultural history, I bring attention to the voices and agency of marginalized rural Kriol peoples who received and responded to official heritage discourse with their own vernacular heritage knowledge and practices.

The conclusions of *Negotiating Heritage* contribute to historical and cultural analyses of Belize and the surrounding region, and as noted to scholarly examinations of education and archaeology as heritage institutions. The book also contributes to literature in history, public history, anthropology, and critical heritage studies through the themes of development discourse, the influence of racial ideologies on heritage practices, and research on nationalism, citizenship, and globalization.

Development

Historiographic scholarship on British colonialism in Belize has often focused on the underdevelopment of the former colony.[31] Limited British interest in establishing infrastructure (for example, roads, education, agriculture) led to an underdeveloped economy and a dependency on other countries for food and daily goods, and human capital (for example, teachers). Belize's early economy was built on extractive and exploitative labor and the export of forest products, most notably logwood and later mahogany. These industries were controlled by a small "forestocracy" who owned most of the land and invested little in the local infrastructure.[32]

As colonial power waned in the early to middle twentieth century, Belizean dependencies shifted to the United States, non-governmental organizations (NGOs), and international and private development agencies, leading to increasing difficulties for Belize to compete economically with surrounding Caribbean and Central American states. This long lasting situation of underdevelopment and dependency shapes Belizean society today as the state government continues to struggle with the development and management of agricultural and technological industries.[33]

I complicate and contribute to a historiography of the colonial (under) development of Belize by adding historic and ethnographic examinations of education and archaeology. Working through colonial administrative records, I found that although limited imperial financial support for education left lasting impacts on social and economic development, both education and archaeology structures and policies were quite robust. Colonial education and archaeology practices worked collaboratively to instigate British influence over official cultural and historical narratives about colonial subjects, including how the British felt colonial subjects should and could contribute to the colony and the British Empire.

I also contribute to analyses of development explicitly related to culture and history by unpacking the historical and political roots of development-related heritage practices.[34] Heritage scholar Lynn Meskell's research on heritage tourism and archaeology in South Africa effectively revealed how, while heritage (in the forms of cultural traditions and archaeological sites) can be employed as a tool for social uplift, for example through tourism contexts, the types of heritage practices often promoted by international agencies can also reinforce neocolonial, nationalist, and capitalist ideologies.[35]

In Belize, cultural programming for social and economic development began in the early twentieth century with small-scale handicraft industries. Today, such development takes place on a much larger scale, involves a more diverse range of players, entails competition for cultural recognition and resources on a global stage, and integrates with global trends like UNESCO World Heritage and Intangible Cultural Heritage initiatives. An unfortunate reality is that over time such development efforts have also led to the marginalization of certain aspects of Belizean heritage from official narratives (for example, non-Ancient Maya historic sites, Kriol culture and history, and the history of enslavement).

Drawing from Meskell, I also reveal how recent official heritage programming in Belize utilizes the rhetoric of social uplift. These programs emphasize cultural pride and the potential for communities to empower themselves by

commoditizing heritage through tourism and preservation. However, they also place unfair and unreasonable expectations on communities to utilize and manipulate vernacular heritage.

Racial and Ethnic Dynamics: The Colonial Race Concept

Scholars also examine the ways colonial ethnic and racial dynamics have influenced modern Belizean society and politics, and the ways race and ethnicity shape and define Belizean citizenship, indigeneity, and national heritage. Similarly, race and ethnicity have been central to analyses of colonial history, identity, public memory, and national consciousness throughout the Caribbean.[36]

Located geopolitically in Central America and the Caribbean, Belize has long been a crossroads of the racial, cultural, political, and economic exchanges that exemplify the Atlantic World. Ancient Maya peoples populated the region as early as 2500 BCE, and there were still Maya people living in villages and cities when the Spanish arrived in the sixteenth century. In the mid-seventeenth century, British sailors, also known as the "Baymen," began to settle the lagoon systems in northern Belize to extract logwood.[37] Additional historical migrations included the arrival of the Garifuna (people of African and Arawak Indigenous descent) in the early 1800s, Yucatec Maya people during and following the Caste War in Mexico (1847–1901), and the eventual influx of Mestizo people from surrounding Central American countries. Throughout the first 350 years of European occupation in the region, colonizers clashed with these diverse communities over land, labor, autonomy, and environmental resources.[38]

The history of Kriol peoples is similarly complex and influenced by division and constructs of difference. In the early eighteenth century, British loggers began forcefully bringing enslaved African people to the area to increase productivity in timber extraction. By the 1740s, Africans in Belize significantly outnumbered British settlers.[39] The eventual mixture of enslaved people and the Baymen (often through forced relationships between enslaved women of African descent and European men) became known as the Kriol "race," or ethnicity, which today is considered the early foundation of Belizean society in many state and vernacular historical narratives. Although a Kriol identity features prominently in the historical public memory of Belizean heritage, the majority of Kriol people were discriminated against by British colonists and had limited rights for much of Belizean history. For example, British colonial elites established political structures that limited Kriol peoples' rights to vote and acquire land based on their economic resources and prior land ownership.

By the early 1800s, people of African descent and Europeans fell into many different racialized social categories, including enslaved African people, manumitted enslaved people, free "Blacks," people of mixed race, and poor and rich whites. These categories were fluid and somewhat flexible as people often changed the ways they identified to improve their status and access to resources.

As the colony of British Honduras grew and developed, a Kriol elite formed in Belize Town (the primary port town in Belize, now Belize City). The Kriol elite population consisted of middle class and upper-middle class Belizeans of British and African descent who sought political and cultural representation in the colonial infrastructure in Belize. Anthropologist Laurie Kroshus Medina suggests that on a cultural level, Kriol elites embraced an ethnic identity predicated on a Belizean ethnogenesis and emphasized a "native" status in the hopes that this would legitimize their political interests and power.[40]

The Kriol elite and colonial actors established Kriol as the de facto and primary ethnic category of Belizean identity. An 1888–1889 *Handbook of British Honduras* suggested that Kriols "together with the whites, are, in fact, the backbone of the colony."[41] However, paradoxically the category of Kriol was also deracialized and marginalized through the denigration and exclusion of certain Kriol cultural practices (for example, Kriol language practices were discouraged in school) and historical narratives. Indeed, sociologist Elisabeth Cunin and geographer Odile Hoffmann summarize the complexities of Kriol identity in Belize by noting that Kriol people have long had "ambiguous status," both as "other" and as "founders of this society."[42]

Historian Nigel Bolland contends that in spite of legacies of cultural discrimination and exclusion, Belize did not develop "discrete cultural and social segments." Instead, he argues a kind of cultural pluralism developed in Belize that "did not result in corresponding political divisions and conflicts."[43] Bolland suggests that diverse ethnic groups function as one nation in Belize, without persistent social, economic, or political tensions and disputes based on race and ethnicity. Contrary to Bolland, anthropologist Michael Garfield (M. G.) Smith argues that social and political divisions and conflicts characterize "plural societies," such as Guyana, Suriname, Trinidad, and Belize.[44] And anthropologist Melissa Johnson notes that a complex race/color/ethnicity/class matrix[45] developed in Belize as a result of centuries of European-led exploitation of people (including enslavement), resource extraction, racialized divisions of labor, marginalization of non-European heritage, and British colonial administration over Maya, Mestizo, Garifuna, and Kriol peoples.

A major contribution of this book to these scholarly debates is demon-

strating how colonial officials sought to manage cultural differences and control historical narratives in Belize, primarily through the institutions of education and archaeology. Through reports surveilling schools and communities, policies, curricular materials, and expeditions, colonial education officials and archaeologists detailed the cultural activities of contemporary peoples, reinforced and legitimized racial divisions and stereotypes, and outlined the history of Belize in ways that promoted British values, identity, and history.

Evidence I examined showing the ways colonial authorities described the people of Belize (that is, their "nature," language, histories) indicates that colonial education and archaeology actions rested on scientific and political ideologies about race that existed throughout Europe, the British Empire, and the much of the Atlantic World. I refer to these beliefs as the "colonial race concept." I demonstrate how this concept influenced the structure and content of British colonial education, especially education for African and Afro-Caribbean populations, as well as archaeological science in the British Empire and specifically in Belize.[46] The colonial race concept was based on the following assumptions: that people belonged to bounded categories called "races"; that members of races shared inherent and immutable biological characteristics that could be observed in physical traits as well as cultural practices including mental capacities; and that European races, especially those belonging to Western Christian civilizations, were superior to or more "advanced" on an imagined evolutionary scale than colonized races.

British colonial education materials displayed the colonial race concept in overt ways, speaking openly about British racial superiority. In a 1905 report titled "On the Education of Native Races," R. Maconachie (an English naturalist and civil servant in India),[47] referred to colonial subjects as "non-civilized races," "feeble," and "savages" who needed education for "uplift" beyond their "grossness and barbarity and superstition."[48] In other cases, colonial officials implicitly reinforced racial ideologies and the perceived connections between culture and biology, by making references to peoples' blood, purity, nature, stock, aptitude, instinct, or breed. Although the colonial race concept was applied to subject populations throughout the British Empire by colonial officials and education and archaeology experts, of particular interest to the Belizean context are the ways that people of African descent were racialized. Believing that African and African diaspora populations were culturally and biologically similar in their deficits and practices, the British often lumped together the many cultures and histories of African-descendant peoples in theory and practice.[49] As I demonstrate in chapter 2, a result of such racialization was that

similar education policies and practices were implemented by colonial officers for Afro-Caribbean populations throughout the British Empire.

Influenced by the colonial race concept, Belizean colonial education officials established and reinforced racial constructs through descriptions of different groups (usually their origins and cultural practices) as well as discussions about perceived deficits in morals, intellect, and abilities. Archaeology also played a role in legitimizing racial ideologies. In their popular and scientific accounts, colonial archaeologists as scientific authorities, often disparagingly described the traditions, beliefs, and phenotypic characteristics of the living peoples they encountered.

My historic and ethnographic research examines the ways colonial powers in Belize explicitly defined and manipulated the concepts of culture and history in educational and archaeological practice, through the frame of the colonial race concept, in the service of colonial goals to manage colonial subjects, and emphasize certain historical narratives over others. I demonstrate that, although Belize is a culturally plural society, racial ideologies and divisions were central to colonial education and archaeology. And official heritage constructs based on ideas about cultural difference continue to influence twenty-first century cultural politics, education, and archaeology. As such, my arguments complement the work of other historians, anthropologists, and cultural geographers who have examined the colonial formation and contemporary persistence of racial, ethnic, and class hierarchies and stereotypes, particularly through labor industries and land disputes.[50]

Nationalism, Globalization, and Heritage

Scholars have repeatedly demonstrated that heritage is a fundamental concern of nations and states, which use tangible and intangible heritage manifestations to develop "solidarity and common cultural life"[51] and construct "imagined communities" with unified national identities and historical narratives that promote shared origins, objects, struggles, and places of national interest.[52] For example, anthropologist Richard Handler demonstrates how efforts to define and preserve tangible forms of culture in Québec (for example, houses and monuments) frame heritage as collective property that is essential to Québécois nationalism, conveying the message "we are a nation because we have a culture" and we are a nation because we have tangible remains of the past.[53] Numerous studies have shown connections between state interests and policies, nationalism, and archaeology and the ways states promote archaeological sites as integral components of national identity and invaluable national resources.[54]

Similarly, historians and archaeologists have documented processes in the mid-twentieth century that led to international and global heritage efforts like the development of the United Nations, Educational, Scientific and Cultural Organization (UNESCO) in 1946. Following critiques of colonialism and the destruction of material culture heritage and racialized violence that took place during World War II, world leaders and academics used the rhetoric of democracy, universal humanitarian responsibility, and development to legitimize internationalizing heritage ideologies and practices. Increased cultural globalization from the 1960s to the 2000s, as well as civil rights and human rights movements, also led to growing recognition of the need to highlight diversity within state contexts. In response, international groups have developed policies focused on diverse forms of heritage, and many nation-states have implemented multicultural programming. For example, in 1994 the World Heritage Committee launched the "Global Strategy for a Representative, Balanced and Credible World Heritage List." These global and state heritage practices had strong influences over how archaeological sites came to be managed, developed, and interpreted.[55]

The research in this book contributes to heritage scholarship on nationalism and globalization (and related themes such as heritage tourism) by providing a detailed case study of how official colonial, national, international, and vernacular heritage interests and actions have long intersected through the contexts of education and archaeology.

In the mid-twentieth century, throughout the British Empire and in the Caribbean specifically, there were growing anxieties within extant colonial territories about social and economic development and political control, as unrest among subject populations led to political organizing.[56] Following World War II, many British colonies implemented adaptive and vocational education focused on developing cultural industries to help prepare colonial societies for economic, cultural, and political transitions to modern democracies. In Belize, the 1940s and 50s were characterized by increased interests among colonial administrators, international development agencies, and nationalist actors in managing culture and history, including through culturally relevant education and increased control over archaeology.

My analysis of primary sources from this time shows how, in cultural policies, political speeches, and education, official heritage practices involved many efforts focused on political and cultural decolonization and the cultivation of a national identity centered on a proud and productive citizenry. Independence leaders saw Belize's rich culture and history as integral to these agendas. For example, George Cadle Price, a central figure in the Belizean independence

movement and Belize's first prime minister, emphasized Belize's Mayan antiquity to promote a unique national heritage, physically anchor the nation-state, and reinforce claims to land.

In the late-twentieth and early twenty-first centuries, Belizean nationalist interests in culture and history influenced the development of official heritage efforts that paralleled global movements. Anthropologist Richard Wilk has highlighted an international trend of efforts to manage national cultural difference in globally common forms of programming, which he calls global structures of "common difference."[57] I interpret Belizean state practices to promote national culture and history through education and archaeology as Belizean practices of negotiating "common difference." Belizean politicians, curriculum designers, state heritage actors, and cultural activists have recently worked to bring attention to Belize's rich heritage by emphasizing "safe" (seemingly neutral and apolitical) and commodifiable forms of culture (for example, food, dance, dress, ancient cities and objects) in education, tourism, archaeological site development, and cultural events. I analyze several of these practices and demonstrate that, although contemporary official heritage programming in Belize acknowledges aspects of history and culture that were marginalized throughout colonial history, several of these programs also essentialize cultural differences, continue to marginalize vernacular forms of heritage like Kriol culture and history, and obscure deep histories of social inequality and contemporary cultural politics, often under the guise of national unity.

Afro-Caribbean Heritages

Through the intertwined lenses of education and archaeology, *Negotiating Heritage* examines the entanglements of historical and contemporary official and vernacular heritage processes in relation to the Belizean state and rural Kriol peoples. My focus on Kriol culture and history contributes to a rich body of scholarship on what I refer to as "Afro-Caribbean heritages." Michel-Rolph Trouillot noted how disciplines that study the past have long been implicated in the marginalization and exclusion of certain forms of culture and history and how "silences enter(ed) the process of historical production."[58] Such "silences" have especially affected the history and culture of African-descendant and Afro-Caribbean peoples. This book integrates with scholarly examinations of Afro-Caribbean heritages that have documented the histories and politics of the construction of historical silences, and highlighted the rich histories, cultures, and agency of Afro-Caribbean peoples.

Kimberly Simmons discusses how, under the Trujillo dictatorship (1930–1961), educational practices and racial policies obscured African history, cul-

ture, and identity in the Dominican Republic. In addition to eliminating aspects of African history from national historical narratives and the consciousness of citizens, the Trujillo administration relegated African history and enslavement to Haitian history.[59] Similarly, drawing from archival and ethnographic research, Deborah Thomas has shown how at various points in Jamaican history, colonial and independent state actors selectively promoted certain forms of "folk" African practices (for example, rural foodways, folk-tales, and songs) in efforts to construct a unified identity, while marginalizing other complex racial histories, inequalities, and lived experiences.[60]

Such official heritage practices led by governments to establish national culture and historical narratives were common in post-independence Afro-Caribbean contexts and were often driven by nationalist agendas to spark collective pride and position heritage as a development tool. Thomas notes that in 1996, P. J. Patterson, the Jamaican prime minister, began UNESCO-sponsored "public consultations on Jamaica's cultural policy in order to reconsider the role of culture in national development, education, industry, and tourism." The goal of the new cultural policy was to move away from simply preserving "cultural patrimony" and "toward that of repositioning culture 'as a motivational and development tool to take Jamaicans into the 21st century.'"[61] In the same year, the prime minister also initiated a Committee on National Symbols and National Observances to reconsider the ways the nation's history and culture were promoted and honored.[62] Around the same time, Belizean officials initiated a National Culture Policy Council, whose recommendations included heritage-related reforms and the establishment of a National Syllabus.

Scholarship like that of Simmons and Thomas demonstrates the value of questioning what messages about history, culture, race, and citizenship official heritage discourse include, as well as how these discourses are interpreted and acted on by local communities. In my historical and anthropological examinations of education and archaeology as heritage institutions and contexts in Belize, I similarly unpack the ways that racial ideologies, colonial history, nationalist agendas, and cultural politics influenced the marginalization of African, and specifically Kriol, history and culture. I also bring attention to the paradoxical embrace of an anglicized Kriol identity as a foundational ethnic population in Belize's national narrative. Like Thomas, my research focuses on the intersections between official and vernacular heritage discourses in the ways people (particularly rural Kriol communities) navigate and complicate official racial ideologies and ethnic stereotypes, and construct complex multiscalar individual, local, and national identities.

I also emphasize persistent forms of vernacular Kriol heritage, particularly

in language and connections with ecological resources. I reveal how rural Kriol peoples since early colonial occupation have utilized language as an important identity marker. As such, I connect with scholarship on the continuum and performance of Creole languages in Afro-Caribbean contexts.[63] I also demonstrate how vernacular Kriol heritage is tied to the natural environment through foodways, socialization practices, and historical narratives. These findings parallel with research on socionatural heritage among Belizean Kriol people[64] and examinations of environmental heritage and modifications to natural landscapes in other African-descendant contexts.[65]

Finally, my focus on the CHAP and its community components contributes to scholarship on African-descendant communities' agency and dexterity in negotiating official heritage discourse. Recent work has brought attention to the diverse ways African-descendant people in different contexts connect with archaeological research and historical sites.[66] As I reveal, rural Belizean Kriol peoples engage with historic sites in ways that demonstrate Kriol practices of negotiating power dynamics and protecting cultural knowledge. I also demonstrate how an archaeological consciousness about the political and cultural significance of archaeological research influences when and how Afro-Caribbean people choose to engage with archaeology.[67]

Chapter Summaries

Negotiating Heritage is organized chronologically within examinations of education (chapters 2 and 3), and archaeology (chapters 4 and 5).

I identify three temporal distinctions to unpack the history of education and archaeology as heritage institutions in Belize: The Colonial Period, the Independence Period, and the Globalization Period. The Colonial Period starts in the late nineteenth century when the colonial government carried out the first formal education efforts and enacted the earliest antiquities laws that structured official archaeological practice. Informal and formal archaeological expeditions began in the Colonial Period primarily as a foreign endeavor. At the end of the Colonial Period in the mid-1950s, nationalist activists began voicing perspectives about Belizean education and foreign archaeologists and colonial officials engaged in some of the earliest efforts to formalize archaeology through state institutions.

The Independence Period refers to the late 1950s until the mid-1980s when rising anti-colonial sentiments and nationalist movements eventually resulted in Belize's independence from Britain in 1981. During this period, colonial, nationalist, and internationalist actors advocated for more Belize-specific con-

tent in curricula and educational programming. At this time, archaeology was increasingly professionalized and managed by the Belizean state.

Finally, the Globalization Period refers to the late 1980s until the early twenty-first century, when Belizean intellectuals and politicians developed explicit education programs on Belizean heritage, politicians incorporated archaeology and other forms of heritage into national cultural policies, international heritage agencies became increasingly influential in Belize, and state heritage actors and foreign archaeologists began engaging more extensively with local communities.

This chronological organization is meant to allow each heritage institution to be examined separately, to draw attention to particular heritage trends over time, and to explain why the landscape of education and archaeology looks the way it does in the twenty-first century. Though I separate education and archaeology, I examine interconnected themes throughout the text, such as social and economic development, race, nationalism, globalization, and marginalized history and culture. The chronological organization also allows me to place official heritage discourse in dialogue with the vernacular heritage practices of descendant and local communities. This reveals the practices of Belizean education and archaeology as dialogic processes wherein ideas about culture and history were shaped by government and academic actors and by Belizean citizens.

In chapter 2, I examine the Colonial and Independence Periods of Belizean education. I reveal that during the Colonial Period education served as a form of colonial statecraft used to enforce British colonial rule, manage cultural difference amongst subject-citizens, and promote development and modernization agendas. Imperial policies, colonial education reports, and programming in Belize were replete with racial ideologies, suggestions for ways to overcome the perceived cultural deficits of different groups, and denigrations and exclusions of Kriol history and culture. With examinations of education reports, colonial minute papers, and community petitions, I also reveal that Belizean citizens in rural Kriol communities resisted colonial education by choosing not to attend school, manipulating colonial development rhetoric in requests for community resources, and maintaining linguistic and subsistence patterns among other cultural practices.

In the second half of chapter 2, I discuss how the Independence Period was shaped by a growing national independence movement, efforts to decolonize and "Belizeanize" education, and emphases on education for social and economic development purposes. Imperialist and internationalist actors considered ways education might smooth the transition to independence. On a nationalist level, calls for social and economic autonomy, constructs of national

identity and citizenship, and arguments about the need for culturally relevant programming dominated many aspects of Belizean education. As such, the Independence Period is a time of increased Belizean voices about the purposes and values of education.

Chapter 3 is focused on the Globalization Period of Belizean education when national actors in the newly independent state advocated for educational content on Belizean culture and history to help citizens overcome colonial legacies, embrace a national identity, and better understand Belizean diversity. In chapter 3, I also outline the structure of contemporary education in Belize and analyze early twenty-first century social studies curricula and interviews with state actors. I discuss ways education related to culture and history connects with nationalist goals, global trends, and social and economic development rhetoric, as well as how education programs continue to essentialize and stereotype cultural differences. In the second half of chapter 3, drawing from ethnographic observations and interviews with teachers, other community leaders, and young people from the villages of Crooked Tree and Biscayne, I reveal local negotiations of official constructions of heritage in educational contexts. Though Crooked Tree and Biscayne citizens replicate ethnic divisions, cultural stereotypes, and social hierarchies, they also challenge them, resist state institutions and foreigners, advocate for their communities, and engage in vernacular heritage practices.

In chapter 4, I discuss the Colonial Period of archaeology in Belize. I focus on official archaeological heritage discourses drawing from the voices and actions of colonial officials, archaeological explorers and scholars, and state heritage actors in popular travelogues, newspapers, and archaeology reports and articles. Archaeologists during the Colonial Period played powerful roles in constructing the deep "history" of the colonial territory and marginalized the histories of subject-populations by focusing on Ancient Maya history and culture. Additionally, Colonial Period archaeology authorized archaeological expertise and legitimized colonial and later state power to manage archaeological heritage by emphasizing the scientific knowledge that could be gained from studying the tangible aspects of Ancient Maya culture and history. I also draw attention to agentive aspects of archaeological heritage, revealing that even with the earliest archaeological expeditions in Belize, descendant and local communities were well aware of archaeological interests in tangible Ancient Maya heritage and responded to such interests, but also maintained their own cultural connections with ancient cities and objects.

In the second half of chapter 4, I shift to the Independence Period of archaeology, when foreign archaeologists and state actors formed the first na-

tional archaeology institution and promoted professional heritage training efforts for Belizeans to ensure national control over archaeological practices and resources. During this time, government entities and foreign archaeologists emphasized the political and economic potential of archaeology, and independence leaders promoted Ancient Maya sites as central to national history and identity. Though the rise in Belizean voices about Belizean control over aspects of the country's culture and history is significant, in this chapter I also demonstrate that an official heritage discourse driven by state interests continued to privilege scientific interests in Ancient Maya cities and objects over the interests and needs of local communities.

In chapter 5, I shift to an analysis of the Globalization Period of archaeology in Belize. During this time, archaeological practice continued to be controlled by the state and politicians created new institutions and policies to promote a Belizean heritage on national and global scales, for example through tourism. During the Globalization Period, national heritage actors also developed programming to promote forms of Belizean history and culture beyond tangible aspects of Ancient Maya heritage. Additionally, since the 1990s, national and foreign archaeologists have increasingly engaged in public archaeology programming and community-based initiatives. The remainder of chapter 5 is based on ethnographic research in Crooked Tree and Biscayne and with the Chau Hiix Archaeological Project. I demonstrate the ways heritage processes and places are embedded in the daily reality of many Belizeans through archaeology, tourism, and education and discuss how this has influenced the ways Crooked Tree and Biscayne residents conceptualize, interact with, and utilize archaeological heritage. Many of the same themes emerge as in the earlier chapters on education, including marginalization of Kriol culture and history. My ethnographic work also shows, however, how Kriol adults advocate for community resources for tourism development and resist official archaeological practices when frustrated by perceived broken promises and youth identify connections between themselves and Ancient Maya people they learn about in creative ways.

Chapter 6, the concluding chapter, discusses lessons I learned about key aspects of vernacular Kriol heritage, the centrality of youth in contemporary Kriol culture, and how Kriol people connect with archaeology. Additionally, I emphasize the importance of community-based heritage scholars understanding the historical and cultural contexts in which they work.

As I reflect on my experiences working with a long-term public archaeology project, situated in a Kriol village (Crooked Tree) located next to an Ancient

Maya city (Chau Hiix), I am often reminded of the importance of examining the heritage institutions of education and archaeology in tandem. When I first started working in Belize, I was struck by what I perceived as disconnects between archaeology and the Crooked Tree community despite decades of public outreach and education; historical apathy despite extensive national curricular initiatives focused on Belizean culture and history; and limited knowledge among young people about local history in spite of the fact that Crooked Tree is one of the oldest Kriol villages in the country. Only after conducting over a decade of ethnographic research and examining the histories and contemporary practices of education and archaeology could I understand why these disconnects existed. But only then was I also able to identify my own blind spots with regards to Kriol heritage and the goals and impacts of public archaeology on local communities. Unpacking these blind spots has also enabled me to reflect on my positionality as a white, female, upper-middle class heritage scholar working in a predominantly African-descendant community and the ways I and my scholarship are entangled in race/color/ethnicity/class dynamics and history of Belize.

Historically, educational outreach efforts in archaeology have focused on helping lay people understand archaeological practices and appreciate the value of the cultural and historical knowledge produced by archaeologists.[68] However, such a "deficit model" does not adequately appreciate the knowledge local communities already have, nor seek to understand the historical and cultural frames through which people interpret archaeological knowledge. The field of public archaeology has changed in important ways since the late twentieth century to be more reflexive, inclusive, collaborative, critical, and post-colonial. The findings in my research suggest that to more successfully engage with communities and understand the kinds of disconnects I found in my own work, heritage scholars must understand the historical ways that the institutions of education and archaeology have functioned to create official heritage discourses which often marginalize vernacular heritage constructions and obscure historical processes of inequality.

As I demonstrate, there are many means through which people construct values, meanings, and practices related to heritage. These heritage constructions have wide-ranging influences in people's lives—on cultural identity, daily practices, historical narratives, and engagements with tangible and intangible culture. In Belize, given the extent of Ancient Maya cultural resources; diverse cultural history; a deep legacy of archaeology; and early British efforts in resource extraction, exploitation of people and the environment, and socialization of subject-citizens as a productive citizenry, education and archaeology

have long been driving dominant official heritage forces. Education and archaeology in Belize have worked and still work together to define and manage cultural difference, legitimize specific historical narratives, and naturalize but also obscure aspects of Kriol history and culture. It is also through education and archaeology that local peoples have manipulated, resisted, and transformed colonial and state agendas and rhetoric for over a century. By examining the institutions of education and archaeology and their discursive and praxis-based components, one can understand how they have functioned through Belizean history to create "heritage."

2

Education as Heritage Practice in Belize's Colonial and Independence Periods

Since the late nineteenth century, education has been a powerful heritage process through which colonial officials and educators established and reinforced constructs of race, culture, language, and history in efforts to manage Belizean subject-citizens. During the Colonial Period of education (late nineteenth century to the mid-1950s), these individuals employed characterizations of cultural difference to explain and address perceived cultural deficits in subject populations and augment imperial development agendas. These education practices also established historical narratives that obscured complex aspects of Belizean history (for example, the history of enslavement) and marginalized the culture and history of many ethnic groups, especially Kriol peoples, in favor of British heritage. Belizean citizens, concerned about their individual and community needs and determined to continue cultural practices, found ways to navigate colonial education systems. They manipulated social and economic development rhetoric to advocate for community resources, responded to discrimination by maintaining cultural practices and resisting school, and utilized school programs and buildings for local uses.

Early colonial constructs of race, culture, and history had continuing ramifications for education and cultural politics from the middle to late twentieth century. From the 1920s to the 1940s, colonial actors began to consider the relevance of education to the lives and employment opportunities of Belizeans and advocated for more relevant materials and programming. However, these adaptive and mass education efforts continued to reinforce racial ideologies and cultural inequalities, and support colonial and imperial development agendas. Beginning in the mid-twentieth century, imperialist fears and global concerns about burgeoning nationalist efforts influenced ongoing efforts to develop education that would assist in the country's social and economic transitions to independence. During the Independence Period (the 1950s through the 1980s) politicians and educators, knowingly or not, continued some colonial heritage themes, such as attempting to manage

cultural difference in classroom practices and curricular materials. However, during the mid-twentieth century Belizean actors also became increasingly vocal about the societal implications and values of education and for the first time, Belizeans integrated their own voices into the formal contexts of education.

Colonial Structures and Agendas in Belizean Education

Many historians characterize early British Honduras as a frontier society, dominated by entrepreneurial explorers who were "preoccupied with exploiting the economic potential of the forests."[1] The unsettled, impermanent nature of early foreign occupation in the region meant that for centuries the British took little interest in creating social welfare programs, building roads, or providing healthcare. Hesitant to spend public funds on social services, early settlers were disinterested in developing an education system for colonized Belizeans who were considered an important labor force.[2]

Christian institutions established the earliest schools in Belize.[3] A church-state education system also developed in other Caribbean territories including Barbados, Bermuda, Trinidad and Tobago, many of the British African colonies, and India. These church-run schools were designed to serve proselytizing and "civilizing" goals through the education of non-European colonial subjects.[4] A church-based education system seemed appropriate to many British citizens and colonial actors, as noted in this 1885 editorial in an early Belizean newspaper: "Education is the training of the moral and intellectual faculties so as to render a person apt for whatever particular end he may have in view, while disposing the whole being towards the great end for which it is made [. . .] [Religion is] the soul of education [. . .] without it all efforts to educate will prove futile [. . .] Thank God in this Colony [British Honduras] the denominational system which practically represents the view we propound, is stroung [sic] and vigorous, and long may it remain so."[5]

The first Belizean school, the Honduras Free School (also called the Honduras Grammar School), was founded by Anglicans in 1816 and was likely only attended by the children of free persons despite the fact that in 1816, 72 percent of the Belizean population consisted of enslaved peoples.[6] As settlements grew at the mouth of the Belize River in and around Belize Town (now Belize City) in the 1840s and 1850s, competing Christian institutions formed schools. By the 1840s, there were Wesleyan and Baptist mission schools, a Roman Catholic school, and private schools.

Colonial government involvement in education in Belize increased in the

mid-nineteenth century. In 1850, the colonial government situated in Belize Town passed an Education Act "to provide for additional schools for the benefit of every Denomination of Christians in the settlement of British Honduras and to make certain regulations for the government of such schools."[7] This act also established a Board of Education to manage schools. In 1868, the Board of Education was dismantled, control over school administration and public moneys used for education were transferred to the colony's governor and executive council, and all of Belize's Free Schools were abolished. The colonial government established an Education Department in 1891, and re-created a Board of Education in 1892 under a new Ordinance of Education. Education Ordinances in Belize from 1892 and 1926 stipulated how the British colonial administration was to be involved in schooling—by evaluating schools, distributing funds and other resources, overseeing teacher training, and making and enforcing rules and regulations for various districts and schools. During the period 1879–1926, an inspector of schools (most of which were elite British civil servants) was responsible for publicly examining schools, evaluating teachers and students, and assigning teacher bonuses based on the students' passing of "standards."[8]

Reports from inspectors frequently expressed concerns about the poor conditions of Belizean schools, especially rural ones. In the 1899 report, A. Barrow Dillon, inspector of schools, wrote that "schools are not sufficiently staffed or properly equipped in the matter of furniture and apparatus to enable the Educational training of every young child conducted upon such methods and would ensure an intelligent system, personal comfort and due attention to hygiene."[9] Dillon's 1916 Education Report, which included the church-schools in Grace Bank, Burrell Boom, and Crooked Tree (all rural Kriol villages in the northern Belize River valley), described the poor status of the Crooked Tree school. He noted "too much crowding . . . for efficient organization," decay in walls and sills, and even rotten floor boards and pillars.[10]

Thus, limited government financial and administrative support for education continued in the Colonial Period, though this did not stop English commentators from blaming a lack of educational "progress" on the colonized populations. In an 1873 note in *The Times,* an author discussing the state of the British Honduras colony reported "the progress of education is very slow, on account of the little store set by it on the part of Creole parents, and also on account of the money to be made by children almost as soon as they can walk."[11] Such language is indicative of cultural and racial biases and foreshadows the context within which colonial authorities used education as an official heritage process to manage colonial populations.

Colonial Education as a Heritage Process: Constructing and Manipulating Race, Culture, Language, and History

> All colonising nations are sooner or later faced with the problem of the education of the natives. It is a grave, a difficult, one may say a distressing, problem, which cannot be evaded, and which involved a conflict between interest and conscience.
>
> —*Joseph Chailley-Bert and Sir William Stevenson Meyer, writing about administrative problems in the British colonies, 1910*[12]

As Chailley-Bert and Meyer's quote indicates, the education of subject-citizens was a central concern for colonial territories and was a difficult task, which colonial authorities often characterized as a problem. During the Colonial Period in Belize, educational structures, content, and actors were driven by civilizing and moral missions. Educational efforts and agendas were reinforced by a close managerial and financial relationship between Christian institutions and the colonial government. With increased British control over social services and infrastructural development in the late nineteenth and early twentieth centuries, Belizean education began to function as an official heritage apparatus of the colonial government. The British designed Belizean schools to cultivate obedient, loyal subject-citizens and surveil and maintain control over Belizeans and their communities. Colonial schools, education policies and programs, and curricula established the foundations of an official heritage discourse in Belize by constructing and reinforcing racial ideologies, ethnic categories, linguistic practices, and historical narratives.

Belizean schools functioned as tools of governmentality, imparting British values and expectations about conduct and work ethic through daily practice, curricula, and oversight and discipline of students. In the 1892 Annual Report on Primary Education in British Honduras, W. J. McKinney, acting colonial secretary, noted that in schools, "Methods should be adopted to promote and foster habits of thrift industry, economy, and purity of life."[13] The Belizean colonial administration managed education through school reporting and inspections. Schools were one of the few arms of the British colonial government in rural communities. Thus, the British could use colonial education to ensure subject-citizens were participating in colonial social institutions and that British civilizing and development goals were being met.

In order to ensure "the vitality and efficiency of the educational system,"[14]

the British established supervision systems and advisory boards for colonial education. Similar practices of surveillance, supervision, and discipline were carried out in British colonies throughout the Caribbean. For example, a series of reports about education in the Bahamas, Barbados, Bermuda, Trinidad and Tobago, and British Honduras expressed concerns about student behavior, described ways school attendance and the payment of school fees were enforced, and included extensive details about disciplinary techniques (for example, contacting parents, confinement after school hours, public rebuke, moderate corporal punishment, fines, and even expulsion).[15] In Belize (as was the case throughout the British Empire), schools worked together with other colonial social welfare institutions (for example, the Agricultural, and Medical, and Police Departments) to manage the population, demonstrating multifaceted aspects of colonial control.[16]

A series of letters that addressed school attendance in Crooked Tree demonstrate colonial surveillance tactics. In 1920, Reverend Robert Cleghorn (Baptist missionary and later head pastor and manager of Baptist schools) wrote to A. Barrow Dillon (inspector of schools) describing the "very irregular way many of the children at Crooked Tree have of attending school." Cleghorn referenced the "ill consequences" of poor attendance on school examinations and inquired about the possibility of making Crooked Tree a "compulsory attendance area." Cleghorn's requests were granted by the Board of Education a few months later. And as there were no police in Crooked Tree village to monitor truancy, one of the villagers, Mr. Alpheus Gillett, was appointed "School Officer" and charged with this task in 1920.[17] Indeed, school attendance was a concern throughout the Caribbean and was often described as a cultural issue.[18] In 1938, colonial education official Arthur Mayhew remarked that the fact that only 69 percent of the population of school-aged children in the West Indies was enrolled in school was "not creditable to a region most of which has been under British rule for more than one hundred years."[19]

School reports and memos from inspectors documented details about how successfully colonial schools followed British models in ideology, form, and content.[20] Basic classroom practices paralleled those in British society. Inspectors evaluated classrooms based on their organization and tidiness. Rote learning and memorization were standard pedagogical practices. Colonial schools generally adhered to a British grade level and curricular system and Belizean students read British textbooks, learned British history, and took British exams which determined their future educational opportunities. For much of Belize's educational history the only secondary and tertiary

institutions available to students were located in the United Kingdom. The primary language of instruction was English and most teachers were foreign.

Additionally, because the colonial government could not deny the cultural diversity within the colonies, instead, British colonial education established and reinforced official racial and cultural heritage ideologies and historical narratives. Indeed, as Deborah Thomas suggests in the context of Jamaica, "British imperialism was not merely a system of economic exploitation and political domination but also one of cultural control that attempted to socialize colonial populations into accepting the moral and cultural superiority of Englishness."[21] Official heritage practices in cultural control and socialization were particularly powerful in the Caribbean.

Believing that all Afro-Caribbean populations were culturally and biologically similar in their deficits and practices, similar education policies and practices were implemented by colonial administrations throughout the British Empire in the West Indies. Education scholar Udo Bude suggests that in British colonial contexts, "The same education was prescribed for all populations of Black Africa, irrespective of their differences and without attention being paid to their divergent historical contexts and their divergent aspirations."[22] British education in the West Indies was both influenced by the colonial race concept and actively contributed to it.

The racialization of Afro-Caribbean populations in British colonies was deeply tied to efforts to define and control culture and history. In Belize, as well as other West Indian contexts, this meant that education reports, policies, and programming constructed and reinforced race and racial histories; described cultural practices as innate and deficient; emphasized British values, norms, and practices as superior; obscured, denigrated, and delegitimized African cultural practices and histories; and emphasized the importance of social and economic development through education.

Official discourses on culture and history were constructed and manipulated in Belizean colonial education reports in explicit and implicit ways. Education officers categorized ethnic groups and described their cultural practices (for example, traditions, language, subsistence practices) but also their places of origin and histories. Education reports also characterized the "nature" of various groups. At times, education officials discussed culture as a "problem" and something to be controlled; they portrayed culture as something that needed to be understood to facilitate learning and make the British-centered education relevant to students. The official narratives education officers developed about race, culture, and history in Belize were used by colonial educators

to manage cultural difference, and implement political projects to assimilate cultural groups and cultivate subject-citizens.[23]

As noted in the first chapter, the descriptions of culture in Belizean colonial education materials reflected and reinforced a colonial race concept, which had wide-ranging implications in colonial rule including reinforcing social hierarchies and assumptions of European superiority. Descriptions of groups presented culture, ethnicity, and race as related (and sometimes equated) constructs of difference and community. Descriptions authored by colonial authorities frequently compartmentalized ethnic groups into bound and static categories, describing culture as if it was innate, biologically determined, and immutable.

In colonial documents, what one might refer to today as the "ethnic groups" or "cultures" of Belize were often categorized as "races" and cultural differences were often referred to as "racial characteristics." *The Handbook of British Honduras, 1888–1889*, outlined four racial categories for the country: the "natives," the "Ladinos" (also referred to as "Spaniards" or "the Spanish element"), the "Caribs," and the "colored" (also referred to as "Creole"). The colonial authors of the *Handbook* described these groups based on geographic location and characteristics believed to be innate such as labor and subsistence practices. The "natives" were said to "live in villages industriously and inoffensively scattered over the [Northern and North-Western] district, cultivating their patches of maize and pulse." The "Ladinos" were described as having Spanish and Indigenous descent and a "freedom of thought and manners, as well as information and enterprise." In their descriptions of the "Caribs," Bristowe and Wright said, "the usual division of labour among savage nations is observed by them. The daily drudgery of the household belongs to the women, who also cultivate the small fields [. . .] The men pursue their hunting and fishing, and undertake the more severe labour attendant upon the building of their huts." Bristowe and Wright described "Creoles" as being "of European and African descent," and being "a hardy, strong, and vigorous race of people, who are the woodcutters of the interior, and the main instrument in keeping up the commerce of the colony."[24] Texts like *The Handbook of British Honduras* served as models for educators and education policymakers.

Belizean education reports typically began with a "General Historical Introduction" that listed and described the "races" in the colony with information about history and origins, geographic location, skin color, and language. Consider this typical excerpt from the 1938 education report by B. E. Carman, superintendent of education to the colonial secretary:

2 British Honduras is perhaps unique among British Colonies in view of the diversity of races represented. No fewer than six languages are spoken viz. [namely] English, Spanish, Carib, North Maya, Southern Maya, and Keckchi; English and Spanish being predominant.

3 The aboriginal inhabitants are the Maya Indians who achieved a very high degree of civilization, the remains of which have been a great source of interest to archaeologists. They are found in the Northern and Western Districts and in the Southern District of Toledo where they live in small self-contained communities more or less remote from the towns. They speak the Maya language. A branch of the Maya family called the Keckchi Indians are to be found in certain villages in the Southern District. These also speak their own language—Keckchi.

4 The majority of the inhabitants of the Northern District are descendants of colonists of Yucatan ("Yucatecans") who fled from that province during the Indian rebellions of 1847–49. In the Western District there are immigrants from the province of Peten in Guatemala ("Peteneros"). These people are chiefly of mixed Spanish and Indian blood and speak Spanish.

5 The Caribs are found in settlements along the coast to the south of Belize. They are not pure-blooded, being descended from the Yellow (West Indian) Caribs and the Negroes. They hailed originally from the island of St. Vincent whence they were deported in 1796 to the island of Ruatan near the coast of Spanish Honduras. From Ruatan they crossed to the mainland. Their language contains elements from English and French as well as African dialects.

6 English is spoken chiefly by people of European descent. The Creoles who are mostly descended from the white and negro races speak very largely a corruption of English called "Creole."

7 Religious divisions follow roughly racial lines. The majority of people, some sixty percent, are Roman Catholics; next follow the Anglicans comprising twenty-one percent and the Methodists fourteen percent. The Indians, Caribs and Spanish-speaking people are generally Roman Catholics. The majority of Creoles are Protestants.[25]

Such racialized ethnic descriptions were included in Belizean education reports for decades. These essentialized categorizations reinforced divisions between groups, and perpetuated incomplete and inaccurate views of culture as a series of geographically bounded, isolated wholes, with little connectedness between them. Further, by equating culture and race and making refer-

ences to "blood," education reports further naturalized racial and cultural constructs.

On occasion, education reports alluded to perceived problems related to certain groups in references to and discussion of the "ways" or "nature" of people. Such descriptions were usually tied to racial ideologies and premised on assumptions of cultural deficiency and inferiority. I use the phrase "cultural deficit" to characterize British colonial perspectives that the culture of non-European communities was deficient in comparison to English culture. The concept of a cultural deficit is based on a theory that minority groups are "culturally disadvantaged"[26] and "their culture is deficient [. . .] from the dominant majority group"[27] in ways that affects their educational performance. Although the concept of a cultural deficit was not formalized or utilized extensively in psychology and education studies until the 1960s, educational approaches and rhetoric driven by this ideology have existed in Belizean education since at least the early twentieth century. In Belizean colonial education, such approaches privileged Anglo (primarily British and American) cultural knowledge, learning practices, and value systems and blamed non-Anglo groups for social disparities and inequalities as they were seen as the result of cultural deficits.[28]

Pertinent to this research, I found specific examples of cultural deficit rhetoric in primary sources from this period, where education officials describe perceived behavior or skill deficits as innate Kriol attributes. As noted above, in 1920 Reverend Robert Cleghorn wrote of the "very irregular way" Kriol Crooked Tree children attended school, which he blamed on familial and cultural practices: "Although there are over 80 children of school age at [Crooked Tree], only 50 have put in an appearance since the holidays and of these some have already gone camping out at Blackburn with their parents. It is this irregular way that makes it so difficult to advance the children."[29]

Cleghorn's use of the term "camping" is, while seemingly innocuous, noteworthy. Colonial officials may have considered camping a leisure activity, however, "camping" at Blackburn in the 1920s was likely an important way Crooked Tree people learned Kriol cultural knowledge through bush[30] activities like: hunting, fishing, small-scale farming (what past and current residents refer to as "plantation" farming), and clearing land. Cleghorn's reference to "camping" delegitimized these cultural practices, equating Kriol subsistence and enculturation practices with a pastime. In the twenty-first century, "camping" and related practices continue to be noted cultural traditions in Kriol communities like Crooked Tree.[31] Cleghorn's references to "irregular" school attendance and camping trips are indications of cultural

resistance and resilience of rural Kriol peoples in the 1920s, which I examine in detail later in this chapter.

Another example of cultural deficit rhetoric in British colonial education are the ways education reports, newspapers, and other colonial documents expressed concerns about family structures (for example, families with an absent parent) and settlement patterns (for example, fluidity due to seasonal employment) that did not fit British norms. Concerns about family practices were one of the ways the British racialized Afro-Caribbean peoples throughout West Indian colonies.[32] Education programs and schools were seen as powerful structures for modernizing West Indian populations. British colonial actors considered social and economic development integral to modernization and considered "loose" family organization and "careless" upbringing of children causes of poverty and underdevelopment.[33] Social welfare programming that combined concerns about education, public health, and social and economic development was implemented by colonial administrations throughout the West Indies in the 1930s-1950s. An important part of this programming was domestic education which focused on family planning, nuclear family construction, self-help, child-rearing, homemaking, and European gender norms (for example, male breadwinner and female housewife).

In a 1946 article about "Education in the British West Indies," S. A. Hammond, a colonial education adviser, referred to the "prolific" nature of West Indian populations and "looseness of family ties" and wrote, "In a great part of the population again, family life is weak, illegitimacy rates running as high as 70 percent of the live births in some territories."[34] Hammond advocated for an approach common in domestic education at the time: teaching young women British-prescribed child-rearing and homemaking habits and emphasizing health education.[35] Anthropologist Deborah Thomas discusses such domestic education in Jamaica in the 1940s and 1950s as well as sociological studies from the mid-twentieth century which sought to understand Jamaican family structures and values, socio-economic dynamics, and the impacts of the history of enslavement on social and economic development.[36]

Colonial education reports in Belize defined Kriol families as a "problem" linked with truancy and juvenile delinquency. For example, in the 1947 and 1949 education reports, the director of education in Belize, Jack Forrest[37] raised concerns about the "nature" of children and their attendance. He described a "large part of the population" as having a "fluid nature," noting "many families live part of the year, during the mahogany and chicle seasons, in the bush and part in the villages and towns; there is constant movement between the places

with and those without schools, and many children find themselves within reach of a school for the first time in their lives at age 9 or 10." Forrest also characterized juvenile delinquency as a "cultural problem" tied to family dynamics. He suggested that truancy was caused by "lack of normal family life," "parental negligence," and "psychological upsets in the children." Forrest went on to mention poverty, the lack of a father figure at home, and "irresponsibility and carelessness about a child's schooling"[38] among both parents. In the same year, the Prison Department attributed "the perceived rise in youth crime to 'illegitimacy [. . .] and the carefree way so many fathers regard the offspring of these casual unions as well as to the 'calamitous upbringing' offered by unwed mothers."[39]

When officials like Forrest and Hammond referred to a fictional "normal family life," they ignored the diversity of families that existed within Belizean and British society. The cultural deficit arguments of Forrest and Hammond also made no recognition of the broader social and economic conditions and inequalities in Belize that contributed to the "home problems" they identified. The noted lack of a father figure at home was in reality very likely due to the lack of jobs in the colony for Kriol and other non-white populations other than in field or timber labor, which often required extensive travel. Impoverished conditions were related not to an inability or lack of desire among Kriol people to work, but rather to racism that denied Kriol people access to sufficient employment, or affordable, culturally relevant, and effective education.

Another powerful and persistent example of cultural deficit rhetoric is the ways colonial education reinforced racial and ethnic stereotypes regarding labor, agricultural practices, and work ethic. For example, in a 1933 letter to the colonial secretary from the principal medical officer (PMO) following a visit to Crooked Tree, the PMO took the opportunity to express concern about what he perceived as unreasonable dependence on outside sources and a lack of self-sufficiency among Crooked Tree residents: "There is no starvation in Crooked Tree and there should be none. If people would only plant enough ground provisions . . . sweet potatoes, yams, plantains, and corn to feed them[selves] instead of depending on imported foodstuffs, this village like others in the Colony would be alright." He then went on to suggest that "giving away food or oodles of money will not help the people" to break away from their dependency.[40] Such expectations for the self-sufficiency of colonial citizen-subjects were common at the time and were tied to heritage ideologies that Kriol people were not particularly self-sufficient nor good farmers, and were overly dependent on handouts.

Agricultural education was a persistent concern within the British colonies and agricultural education programming was implemented throughout the West Indies. Reports on Jamaica, the Bahamas, Barbados, Trinidad and Tobago, and British Honduras in the British Board of Education's 1905, *Special Reports on Educational Subjects Volumes 12–14* all referenced agricultural education. Influenced by the colonial race concept, discussions among colonial officers and education specialists about agricultural education often referenced what they perceived as deficiencies in Afro-Caribbean populations' agricultural knowledge and practice. Some officers even shamelessly referenced a kind of nostalgia for the "skills" and "training" that people of African descent received during slavery. The 1905 report about handicraft and agricultural education in Jamaica acknowledged that Jamaicans knew how to grow root vegetables, but claimed they "had no reliable knowledge and experience" about farming for efficiency, industry, surplus, or profit. The report stated that the Black Jamaicans had learned about cultivation of cane and coffee from their masters and teachers "in the days of slavery."[41]

In Belize, the colonial government and colonial schools developed agricultural education programs primarily focused on rural communities in the 1940s and 1950s to train students in Western agricultural skills and knowledge. According to education reports, many of these programs were unsuccessful due to unsuitable soil, adverse weather conditions, inadequate teaching training, and difficulties in maintaining gardens over holidays. Education officer Forrest, however, also noted a "distaste of the young workers" for the hard labor of agriculture—a euphemism for laziness—and what he thought were "slip-shod methods of cultivation" "introduced by pupils"[42] indicating his disdain for native farming practices. These comments deny the food-heritage of Belize's diverse cultural groups, who after arriving in Belize adapted to unfamiliar crops and natural landscapes in often highly marginalized environments.

Language is a significant heritage practice that the British attempted to control. English language instruction became an ideological tool of socialization and governmentality, reinforcing colonial authority throughout the British Empire.[43] Connecting language with colonial rule, comparative education scholar Mohammed Kazim Bacchus writes that during early British colonization in the Caribbean, "school was English and English was school."[44] The official language of instruction in Belize has always been Standard English. The 1894 "Education Rules," outlined that students should be taught to speak English and "every examination [. . .] shall, as far as possible, be conducted in the English Language."[45]

Like with race, official heritage discourses in colonial education reinforced British values about language and delegitimized the linguistic practices of certain groups. Languages within African diaspora groups in many Caribbean colonies were often particularly marginalized in a form of linguistic heritage violence. Scholar of comparative and international education Norrel London discusses the "ruthless" and "conscious oppression" of the Creole linguistic practices of people in Trinidad and Tobago through colonial education. He suggests that the intent of language education was to produce a class of colonial subjects "who would appreciate, respect, and put the highest value on the English language and British culture."[46] Colonial education officers in Afro-Caribbean contexts often worked to obliterate Creole linguistic practices because they were not considered legitimate languages. Such attempts took passive and active forms in the West Indies. Colonial actors frequently characterized Afro-Caribbean languages as simply "bad English," but students were also punished for using their native Creole languages in the classroom, a colonial legacy that lasted well into the twenty-first century. Crooked Tree and Biscayne residents recounted stories to young people and me about being beaten for speaking Kriol at school.

In discussions of reading and writing in Belizean colonial education reports, students' linguistic backgrounds were often characterized as a "problem" or "difficulty." A 1905 report, identified language issues as a "hindrance to the satisfactory progress of education in the Colony" due to the fact that "if the majority of the children happen to be ignorant of [the English] language, learning is to them a very great difficulty."[47]

Belizean educational reports were replete with references to "Creole" as "poor" or "bad" and concerns about "too much Creolism." In 1913, Inspector Dillon noted "the use of the present tense when the past tense was needed and of the singular when the plural was required."[48] Today, linguistic scholars recognize that such syntax issues were not due to students' carelessness as implied, but resulted from students using the rules of their native language(s) rather than English. Indeed, Kriol verb tenses work quite differently than British English tenses, using helping verbs rather than past and present tenses, and rarely using plural forms of words.

In the 1933–1934 education report by B. H. Easter,[49] he acknowledged Spanish, Garifuna, and Maya as languages in Belize, but implied Creole was simply an impure form of English, as he referenced "the Creoles speaking their own peculiar form of [English]."[50] Reports from the 1930s to 1940s sometimes did not even list Creole as a language spoken in Belize, or the officers wrote that Creole was a "corruption of English."[51] Despite decades

of Kriol linguistic practices being challenged and denigrated in official heritage discourse, this vernacular heritage practice persisted among teachers, students, and other Kriol people. This demonstrates the complex interplay between colonial education structures and cultural agency in Kriol communities in Belize.

Language was not the only oral tradition denied cultural legitimacy by colonial officials in Belize. In his 1948 report, Forrest wrote: "There are peculiar difficulties about the choice of songs in British Honduras; the Creole population has not a folk-song tradition, as in Jamaica and Trinidad; the Maya Indians have few songs; and so practically all school music has to be imported." He went on to suggest the use of the "Oxford Song Book" for music instruction.[52] It is not true that Kriol people lacked music traditions. Caribbean linguist, Stanley Reginald Richard Allsopp discussed connections between Belizean Kriol and Caribbean languages as well as the persistence of linguistic folk traditions well into the 1960s: "the total vocabulary, structuring and the whole character of British Honduras Creole, the survival of similar Africanisms, an identity of proverbs, the introduction and termination signals and the content and linguistic character of Anancy stories all demonstrate overwhelmingly the immediate kinship of British Honduras Creole with all other English Caribbean Creoles."[53]

Another way British colonial actors controlled and delegitimized Belizean vernacular heritage practices was by constructing an official heritage discourse that limited content about Belizean history in favor of British and biblical history, provided skewed historical narratives in educational contexts, and discriminated against native Belizean forms of transmitting histories (for example, language, folklore). Colonial education reports rarely mentioned histories of the various "races" in Belize. When they did, they appeared only in brief "historical introductions" that discussed British perspectives of groups' origins. Such histories reinforced racial and cultural stereotypes, and omitted details about British involvement in actions like labor exploitation and enslavement. Easter's 1933–1934 report described the Caribs as being descended from "war-like Black Caribs," and the "Negro and Coloured" races as "originating from the ancient baymen—the white settlers who first came to these regions for the purpose of cutting logwood and mahogany—and their slaves" with no mention of either group's African history.[54]

Whereas education officers sometimes offered brief histories of Maya, Carib, and Mestizo groups in their reports, they wrote almost nothing about Kriol history. In his previously discussed 1938 report, Carman characterized the Maya as the "aboriginal inhabitants" who speak their own languages,

"live in small self-contained communities more or less remote from the towns," and "achieved a very high degree of civilization, the remains of which have been a great source of interest to archaeologists." Here Carman lumps together modern and Ancient Maya people in similar ways to archaeologists and colonial and independent state actors as I discuss in chapters four and five. Carman described Mestizos as "descendants of colonists of Yucatan ('Yucatecans') who fled from that province during the Indian rebellions of 1847–49." He noted that the Caribs "hailed originally from the island of St. Vincent whence they were deported in 1796 to the island of Ruatan."[55] Thus, the origins of several major ethnic communities in Belize were acknowledged by British education leaders like Carman. Though Carman mentioned Kriol people, he did so in such a way as to imply that their origin was primarily European, noting before describing them that "English is spoken chiefly by people of European descent." Carman made no mention of the African aspects of Kriol cultural identity or history except to say that they "are mostly descended from the white and negro races."[56]

When Kriol history was addressed in official colonial education documents, it was under the purview of British colonial authorities and a group of Kriol elites. As the Kriol elite gained power and influence with political titles and roles in the colonial government, they along with British colonial authorities heightened class aspects of racial/cultural divisions and rural/urban divides. They carefully curated an official mythologized historical narrative about Belizean identity that privileged them and obscured the history of enslavement and the African roots of Kriol culture.[57] A principle example is a mythic narrative about the Battle of St. George's Caye, which occurred on September 10, 1798. According to the myth, which was constructed by British colonial figures and Kriol elites, enslaved people fought alongside their British masters against the Spanish, who were asserting claims to the region. This narrative emphasized British justice and liberty in the history of the colony and promoted the idea that the loyalty of Kriol people to the British was foundational in Belizean history. The reality of the situation was more complicated, with enslaved people fighting on both sides.[58]

The official historical myth of the Battle of St. George's Caye and connected ideologies about Belizean identity were reinforced in history texts, curricular materials, educational reports, newspaper stories about the history and significance of the battle, and public programming like parades and events designed to commemorate the battle.[59] For example, in 1921 the British Honduras Taxpayers Association (BHTA), comprised of many Kriol elites, promoted reviving a Battle of St. George's Caye celebration (also called

the 10th) to "encourage historical research on 1798, to educate the public 'in the facts of the glorious history of their forebears' and in the 'fitting and proper observance of Public Holidays [. . .] connected with the history of the Colony.'"[60] Kriol and British elites considered the 10th a "premier holiday in the colony," and the efforts to celebrate were supported financially and politically by British colonial officials. The BHTA organized Battle of St. George's Caye festivities from 1922 to 1925.[61]

The 10th celebrations of the 1920s included two components related to education, a children's essay contest, and a march featuring thousands of schoolchildren. Children learned about the battle through school lessons using texts like Colonial Governor Burdon's *A Brief Sketch of British Honduras Past, Present, and Future* and *The Archives of British Honduras* and Metzgen and Cain's *The Handbook of British Honduras*[62] in the classroom. In his 1927 *A Brief Sketch,* Burdon described September 10, 1798, as "the birthday of the colony, in as much as it freed itself that day from foreign domination and interference."[63] Historian Anne Macpherson suggests that the members of the popular masses who actually participated in official 10th celebrations in the early twentieth century may have been limited.[64] This made the educational tools particularly important in reinforcing the myth of the Battle of St. George's Caye.

The history of slavery in Belize was almost never mentioned in education reports except in reference to the mythologized Baymen and Battle of St. George's Caye, though such references were not realistic or honest descriptions.[65] Carman's 1938 education report emphasized the "loyalty" of Belizean slaves and the power of the British Baymen in fighting off the Spanish. Carman noted, "The right of settlement was repeatedly challenged by Spain but eventually on September 10, 1798, the 'Baymen' as the settlers were called, gallantly assisted by their slaves who had rejected an offer of freedom made to them by the Spaniards, finally defeated the enemy at the Battle of St. George's Cay—a very glorious episode and worthy of a place in 'Deeds that Won the Empire.'"[66] In Carman's descriptions, there is no indication of the African origins, history, or culture of the enslaved peoples. By the time of Carman's report, Kriol people had existed within Belize for centuries, yet they were denied a complete history.[67]

The myth of the Battle of St. George's Caye had several consequences for heritage ideologies and practices in the colony and later independent state. The myth was designed to emphasize the population's Britishness. It deemphasized African aspects of Belizean history and culture. And the myth and the related celebrations were used by colonial officials and Kriol elites, as Macpherson

argues, to "lull race and class animosities."[68] The myth solidified a narrative of Kriol people being both loyal slaves and the central, legitimate, and "native" population of Belize (by excluding Garifuna and Maya people from the narrative).

Comparison with other British colonies with African and African diaspora populations and histories of slavery reveals the extremes to which aspects of Belizean Kriol history were marginalized by colonial actors in the construction of Belizean heritage. Consider a 1905 multivolume publication that included reports on education in various British colonies. The Barbados report began with a brief "Introduction" with details about the ethnic makeup of the colony, noting people of African origin and "blacks making up about three-fourths of all of the inhabitants."[69] The report goes on to describe the arrival of the first British colonists in 1625, the importation of the first enslaved peoples with numerical estimates and the kinds of labor they engaged in, and outlines the early history of education including the instruction of enslaved peoples and their children. The Bermuda report has similar details about the earliest colonists, ethnic makeup of the colony, enslaved peoples, and early education.[70] The report on education in British Honduras simply began with an "Early History" of education in the year of 1816, when the Honduras Free School was established, and did not describe ethnic groups, Kriol history, or the colony's history of slavery.[71]

It is not surprising that the history of slavery and African aspects of Kriol heritage would be minimized in Belizean colonial education materials and history texts: British colonial authorities had no interest in bringing attention to their roles in the exploitative and violent institution of slavery. Moreover, Kriol elites had worked hard to deracialize the identity they constructed for themselves. Their version of Belizean history legitimized their positions of relative power and authority by emphasizing their Britishness, the contributions they made to the stability of the colony, and their endurance through trials such as the Battle of St. George's Caye.

Adaptive Education and Mass Education during the Late Colonial Period

Beginning in the 1920s, there were increasing concerns about the responsibilities of the British Empire to its colonies. Responding to widespread concerns in education reports about the learning difficulties certain groups faced in schools, British colonial authorities started to acknowledge that an exclusively British model of education was inappropriate in many cases for colonial subjects. Colonial administrators sought expertise from linguists, anthropologists, educators, and others on how to diversify education. These

experts noted that cultural backgrounds likely influenced the learning of subject-citizens, and proposed adapting educational content to the backgrounds and experiences of subject-citizens. This movement was known as "adaptive" education.

Historian of British colonial education Clive Whitehead notes that during the period between the First and Second World Wars, the British Empire faced challenging questions about the futures of the colonies: "Should Britain promote the transformation of colonial society into a modern western type of civilization [. . .]? Or should traditional society be preserved, purged of its grosser abuses such as cannibalism or slavery, so that it might survive until the native people were able to rule themselves?"[72] These kinds of questions were further influenced by threats to the sustainability of the empire as independence and nationalist fervor grew, and critiques about British agendas for the social and economic development of colonial and post-colonial territories.[73]

In 1923, the British took a major step towards adaptive education when they founded the Advisory Committee on Native Education in British Tropical Africa (ACNE). ACNE first focused on British colonies in Africa and later expanded to include territories throughout the empire. Based on a philosophy that the British had responsibility for the education and advancement of colonial populations, ACNE was formed to address concerns related to "native education" such as language of instruction, whether and how to incorporate practical and industrial education, and the most appropriate ways to cultivate productive British subject-citizens. One of ACNE's primary goals was to adapt education to native life.

In a 1923 memorandum from ACNE, secretary of state for the Colonies and ACNE leader William Ormsby-Gore stated:

> Education should be adapted to the mentality, *aptitudes, occupations and traditions* of the various peoples, conserving as far as possible all sound and healthy elements in *the fabric of their social life;* adapting them where necessary to changed circumstances and progressive ideas [. . .] Its aim should be to render the individual more efficient in his or her condition of life, [. . .] and to promote the advancement of the community as a whole through the improvement of agriculture, *the development of native industries,* the improvement of health, the training of the people in the management of their own affairs, and the inculcation of true ideals of citizenship and service [. . .]. Such teaching must be *related to the conditions of life and to the daily experience of the pupils.*[74]

Recommendations of how to achieve such goals included the various forms of "adaptive" education, and use of local teachers for village schools who were "familiar with [the tribe's] language, traditions, and customs" in the hopes of avoiding "the children losing much that the old traditions might have given them."[75]

Adaptive education included efforts to implement vernacular language education into colonial classrooms, and industrial arts and practical education programs focused on post-education labor opportunities. Curricular foci included hygiene lessons, handiwork and crafts lessons that used local resources and sometimes drew from local traditions, agricultural education, and the organization of community projects like village clean-ups and tree planting. In some cases, adaptive education specialists explicitly acknowledged values of native culture. In his 1938 book on colonial education, Arthur Mayhew (Joint Secretary of ACNE)[76] noted that: "Culturally, the negro races in the West Indies may have an important contribution to make to the world. On the artistic side, particularly in music, dancing, poetry, and the plastic arts there is good reason to hope that the West Indian temperament and its gift for self-expression, more particularly on the emotional side, will produce something quite distinctive."[77]

Although adaptive education programs appear to acknowledge more forms of vernacular heritage practices, adaptive education was still influenced by the colonial race concept and preexisting official heritage discourse. References to "mentality," "stock," and "condition of life" were tied to assumptions about innate differences between the British and colonial populations. Indeed, in a 1937 discussion of educational problems in the colonial empire, Ormsby-Gore stated that "the hereditary make-up and the local traditions as well as the background and environment of the children to be educated are almost all wholly different from both the heredity and environment of children in this country [England] [. . .] consequently the mere imposition of our systems and ideas, without adaptation, is not likely to prove successful."[78]

Comparative education scholars suggest that adaptive education largely served as a form of colonial governance to control non-European populations. Racial ideologies featured prominently in adaptive education targeted at African and Afro-Caribbean groups, who were often lumped together as "Black" populations. According to Udo Bude, "white settlers had supported the introduction of adapted education with the argument that the Africans were less intelligent than the whites and had contended that the practical components of this education represented the only means of bringing the blacks up to a higher development level."[79] And actual inclusion of diverse cultural practices

in education was limited. These issues, combined with continued limited investments in colonial education and a limited pool of local trained teachers, meant that adaptive education was largely unsustainable and local populations rarely benefited.[80]

Colonial authorities and education officials in Belize engaged in the discourse about adaptive education, but created few adaptive and cultural programs. Starting in the 1930s, general education reports in Belize, as well as reports focused on education reform increasingly referenced concerns about the need for local teachers and teachers prepared for encountering the experiences and cultural background of different groups. They also occasionally mentioned education materials and programs relevant to the backgrounds and experiences of Belizean subject-citizens.[81] B. H. Easter's 1933–1934 report was a particularly important education assessment. It was widely read in the realm of Belizean education and referenced in many later education reports. In the report, Easter expressed concerns about the lack of Belizean education infrastructure, highlighted concerns about resources, criticized what he considered inadequate financial support for education, and advocated for major programmatic and curricular reforms.

For example, in a description of geography education, Easter expressed concern about students' limited knowledge about their country [Belize] and argued for including more regionally focused resources, particularly related to the West Indies:

> Few children, I fear, leave with any clear idea of their own country [. . .] "[. . .] it is surely obvious that any system of education must at least include an intelligent study of the environment; that we may know something of the meaning of all those little happenings which make up our daily lives; that we may learn to know and respect the forces of nature which dictate our every action, and at the same time learn to know how far we may overcome the barriers which nature frequently sets up." The book from which this quotation is taken—"Far Away from the West Indies" by Stamp and Newman (Longman) is specially written for the West Indies and I strongly recommend its adoption as a basis of Geography teaching after the child has gained some idea of its own country.[82]

Concerns about educators and curriculum disconnected from the lives and experiences of students continued well into the mid-twentieth century. In the 1949 report, Forrest noted: "[. . .] there are no teachers of the Indian race, and Carib and Indian tongues have not only no text books and no one to produce them but practically nothing of any kind in writing."[83]

Vernacular language education (which was heavily debated by colonial officials and education scholars throughout the British Empire) was a particular concern in Belize. Easter's report reveals an open attitude about the use of vernaculars in Belizean classrooms stating, "Until English becomes thoroughly familiar, the use of the vernacular—Spanish, Carib, Maya—appears inevitable. Nor do I see any reason why those native languages should be discouraged. Spanish, more particularly, is valuable not only because of its utility in dealing with neighboring Republics but because of its own culture-value. In those schools where there is a large Spanish-speaking population, I should be inclined to advocate its encouragement in every possible way, and there need be no suggestion of inferiority to English."[84] Although Easter was supportive of vernacular language instruction, there was never an official, colony-wide effort to develop vernacular language programming. This was due in large part to the limited infrastructure and curricular and human resources for education. Additionally, in Easter's discussion of vernacular languages, he did not acknowledge the Kriol language.

Beginning in the 1930s and 1940s adaptive education programming included efforts among education specialists, citizens' groups, and charitable and remedial organizations to develop handicraft programs, promote "cottage industries," and encourage artistic and linguistic cultural practices throughout the West Indies. Deborah Thomas discusses attempts in Jamaica in from the 1940s to the 1960s "to encourage and develop elements of the plastic arts, music, and folktales of the Jamaican peasantry in order to provide the foundation for an emerging Jamaican national culture."[85] Educational cultural programming in Jamaica also included national and local cultural festivals and accompanying syllabi; the exhibition of art and craft work; school workshops in music, drama, dance, literature, and art; and performing arts events.[86]

In Belizean education, such cultural programming was not extensive, but some schools developed handicraft initiatives. These programs acknowledged the potential economic values of cultural products drawn from extant cultural practices. In his 1944 education report, Forrest noted success in Mayan villages where "Indian instructresses were engaged to teach weaving, spinning and pottery."[87] In 1949, he discussed educational programming which explicitly considered traditional Maya cultural practices: "the teachers in the Indian villages [. . .] discussed the traditional economic ways of life, and culture of the Maya Indians, and the type of curriculum that would be suitable for the Indian community."[88]

Handicraft programs tied to goals of economic development were also likely linked to efforts following the end of the Second World War to mod-

ernize education in the British colonies with an emphasis on mass education, literacy, adult education, and development and welfare programs. The British passed the Colonial Development and Welfare Acts in 1940 and 1945 and concomitantly established a Colonial Development and Welfare Office, which focused on social and economic development initiatives throughout the colonies, including mass education and vocational programming. The rhetoric and goals of mass education overlapped with adaptive education as both were overtly pursued by colonial actors as paths to social and economic development.[89]

The modernization of colonial education through mass education was driven by postwar imperial concerns about integrating colonies into an international political economy, as well as colonies' transitions to self-determination.[90] Throughout the West Indies educational programming focused on modernizing Afro-Caribbean populations culturally, politically, and economically. In 1946, colonial education official and expert on education in the West Indies S. A. Hammond advocated for showing colonial subject-citizens "how to help themselves economically *e.g.* by the development of small industries, [and] how to help themselves socially in the development of club work, occupational and recreational."[91] Hammond and other supporters of mass education thought that educational programming related to, for example, vocational training, agriculture, tourism, and local trades would increase self-sufficiency and lessen dependency on the Mother Country, contributing to development and progress.[92] As Deborah Thomas discusses in the context of Jamaica, community development, cultural education, and welfare programs focused on cultivating values in individuality, self-responsibility, and self-sufficiency.[93] A 1953 UNESCO report on Jamaica Welfare's[94] community programs explicitly states such agendas: "responsibility for social betterment must be left with the people themselves, but they must nevertheless be given both the desire and the means of self-improvement."[95] Thomas also notes that cultural education was closely aligned with community development and social welfare. The community development model and other educational programming utilized by Jamaica Welfare was adopted for social welfare programming by many British West Indian territories.[96]

In Belize, mass education efforts were carried out by the Development Planning Commission, which was established by the colonial governor in 1945 to develop social, economic, and welfare programming and policies for the colony, including educational policies and programming. From the 1930s to the 1950s colonial authorities increased programming in agricultural, practical, and vocational education. The shifts to adaptive, practical, and mass educa-

tion in Belize from the 1920s to the 1950s were inspired by a range of social, economic, and political factors. For example, the global economic decline of the Great Depression and the 1931 Hurricane (the deadliest natural disaster in Belize's history) resulted in extensive financial losses and infrastructural and human devastation. Economic loss combined with political and racial tensions between colonial elites, the Belizean middle class, and Belizean popular masses led to unrest throughout Belize and fueled the growth of labor movements, riots, and other forms of resistance.[97]

Though the development of adaptive and mass education programs in Belize suggests colonial recognition of the value of non-European vernacular heritage, descriptions of these programs frequently included terms like "practical," "useful," "development," and "remunerative." These terms demonstrate that the focus of these efforts was less on preserving and celebrating local communities' cultural traditions, and more on training students to be "productive" members of society and colony. Adaptive and mass education was really about education being relevant to the labor opportunities the British thought were realistically available to certain racial groups.

Adaptive education also largely excluded programming focused on Kriol people, perpetuating a stereotype that some groups had rich cultural practices to incorporate into education while others did not. This is an interesting difference from adaptive education programming in Jamaica, where Deborah Thomas demonstrates that from the 1940s-1960s, adaptive education and cultural programs (for example, festivals and performing arts) legitimized Jamaica's "African heritage" by promoting "selected elements of previously disparaged Afro-Jamaican cultural practices in order to foster a sense of national belonging."[98] As I noted previously, colonial education officials did not seem to believe Kriol peoples had folk traditions like those of other ethnic groups in Belize. The "cottage industries" programs in Belize were "based mainly in Garifuna and Mayan villages, where the [education] staff viewed women as having 'a natural aptitude' for craft work."[99] In all of the colonial education reports and other discussions of adaptive education from the late nineteenth to the mid-twentieth century that I examined, I never came across education officials advocating for the preservation of Kriol cultural practices in Belize. Even during the adaptive turn, schools acted as institutions of structural violence, controlling culture, playing powerful roles in reproducing social positions, hierarchies, and inequalities.[100] Thus, these programs maintained colonial government control over populations by reinforcing official heritage discourse and ideologies in education, and supported colonial goals for modernization and social and economic development.

Belizean Citizens Responding to Colonial Education

> Any idea that education makes people nice and amenable and grateful to
> those who provide its benefits is a childish illusion. Education, in its first
> impact, is a disruptive social force [. . .] Teach people to think for themselves
> and to use their minds freely and there is little chance they will think on lines
> agreeable to established authority.
>
> —*Violet Rosa Markham, British social reformer, 1953*[101]

Since the earliest colonial schools in Belize, education officials and other pow-
erful actors used education as a social service to surveil and control citizens,
and as a heritage institution to craft official heritage discourses that defined the
traits, abilities, and histories of ethnic groups in Belize. However, these official
heritage discourses and practices were not all-powerful. As Markham's quote
indicates, education is a "disruptive" force. It is thus not surprising that colo-
nial subject-citizens would respond to educational institutions and content in
a variety of ways including in ways that conflict with colonial authority and
expectations. Examining the experiences and actions of Belizean citizens in ru-
ral north-central Kriol communities through Colonial Period primary sources
reveals how they responded to official heritage discourses and practices in edu-
cational contexts by manipulating development rhetoric to advocate for their
communities, resisting school, continuing their own cultural practices, and
utilizing school programs and structures for community needs.[102]

Anne Macpherson has unpacked numerous examples in Belizean history
of popular masses resisting the middle class and colonial elite in urban con-
texts, demonstrating the tensions between colonial subject-citizens and the
British Empire.[103] Macpherson describes a post-World War I riot in 1919 when
"war veterans of the British Honduras Contingent, recently returned from the
Middle East, had marched through downtown [Belize Town], methodically
smashing the plate glass of the ten largest merchant stores."[104] She argues that
the riot was not just carried out by frustrated ex-servicemen, but that Kriol and
Garifuna women and other civilians participated in this and other protests,
demonstrating persistent colony-wide popular unrest and rising challenges to
colonial power.[105]

While there are limited primary sources documenting protests and revolts
in rural villages like Crooked Tree, there are sources that offer insight into
the relationship between rural communities and the colonial government. In

particular, colonial minute papers (collections of administrative documents and correspondence) provide information about how the colonial government wielded power and knowledge, and how marginalized and disenfranchised subject-citizens tried to address power imbalances by manipulating colonial and imperial agendas for their own interests. The minute papers I examined included community letters and petitions, descriptions of community actions, and discussions of concerns about communities.[106]

Requests for Community Development

Letters and petitions addressed to colonial officials were common ways rural villagers, including those in Crooked Tree, expressed frustration with infrastructure (for example, limited roads) and made requests of the colonial government. In these documents, villagers invoked themes of official heritage discourse, including the British Empire's "responsibilities" to the colony, their own loyalty to the Empire, and British interests in modernization and citizens' productivity.

Multiple petitions from Crooked Tree residents in the 1920s requested dredging of the Black and Spanish Creeks to improve passage. Local waterways were a primary source of transportation for Crooked Tree residents until the late 1970s. Additionally, these waterways are central to Crooked Tree and Kriol culture and feature prominently in village oral histories and in the cultural education of youth. It was through local waterways, that villagers maintained connections with Belize Town (now Belize City), the central British port in the colony. Historically, Crooked Tree residents traveled the over twenty-mile distance to the city on dories and rafts. On some occasions, residents would only travel as far as one of the intermediary Kriol Belize River valley villages, connecting with other Kriol peoples. Through connections with Belize Town, Crooked Tree residents acquired food and supplies and engaged in the local and regional economy by transporting and selling timber and eventually cattle and other agricultural products. When the local waterways were blocked by debris (which happened often), this symbolically and physically isolated Crooked Tree from the rest of the colony.

An August 1924 letter from Robert Cleghorn, Baptist minister and superintendent of the Baptist Mission in Belize, stated "I have the honour to forward herewith a petition addressed to His Excellency the Governor, and signed by most of the leading inhabitants of the Crooked Tree and Spanish Creek Districts of the Belize River requesting the Government to have the Creeks referred to cleared so as to make them navigable by doreys and small motorboats."[107] The next year, another petition was filed by local mahogany cutter E.

H. Bradley, this time suggesting the economic consequences of not maintaining the creeks. Bradley wrote to the Department of Public Works:

> On my own behalf and on behalf of the other Mahogany Cutters and Planters, operating at Spanish Creek, and Crooked Tree, I beg to ask your kind assistance in remedying a condition namely: the clearing of the Creek, which has been giving us much inconvenience through not being properly cleared last year [. . .] The Cutter's season is now on and unless something can be done to help us between now and June, serious consequencies [*sic*] may result to us in getting out our wood and other produce.[108]

A letter submitted that same year by a group of solicitors on behalf of Crooked Tree villagers to the colonial secretary further implored the colonial government:

> The reason of our expression of urgency in this matter is the fact that the floods are now on, and that there is a quantity of mahogany and logwood ready for transportation to Belize through the only means which the Imperial Government have thought fit to provide for this little Colony, namely, its natural waterways.[109]

These letters reveal that Crooked Tree citizens and those advocating for them were clearly aware of the colonial government's agendas for economic and social development and modernizing reforms, and attempted to manipulate these to their favor.

Beginning in the 1950s, letters and petitions also signaled growing internal threats to British colonial power as Belizean nationalism and political power grew. Village residents were aware of both modernist reform efforts and rising political tensions. In an August 1951 letter from Crooked Tree resident Randolph Gillett ("on behalf of the People of Crooked Tree") to Ronald Garvey, governor of British Honduras, Gillett thanked the government for the newly constructed police station and school building, and then proceeded to detail several requests for community development projects including a road, well, and street lighting in addition to land for cultivation and work opportunities for residents.[110] Gillett both emphasized residents' commitments to the British Empire and acknowledged imperial responsibilities for economic and social development in rural communities. Gillett wrote:

> May it please your Excellency that we, the people of Crooked Tree, wish to give you a hearty welcome to our village, this being the first time we

have the honored privilege of meeting you [. . .] Although we are living in a very little isolated place, yet we hope that our little island seen with its population of over 600 people may be an attraction for Your Excellency's attention [. . .]

We are glad today that we can lay our needs to you in person and trust that you may take us into consideration.

We are proud to know that we are British and that we are under the British flag. As British subjects we will ever be loyal to our king and Queen and also to you.

We do appreciate your visit. May God bless you and keep you in the great task you are responsible for in this colony.[111]

On the same day as Gillett's petition, a letter was written by Crooked Tree Government School (CTGS) pupils to Governor Garvey and his wife. This letter also appeals to colonial agendas to cultivate obedient, knowledgeable, and productive citizens, while at the same time requesting resources. In the letter, the students thanked the Garveys for their recent visit, which they note was "an outstanding historical event as it is the first time that a governor—the King's Representative has ever touched the shores of Crooked Tree." The identification of the governor's visit as an "outstanding historical event" suggests a perception among the CTGS students (and likely staff) that Crooked Tree had previously been relegated to the periphery and ignored. The students continued by expressing their "appreciation for all you [Garvey] have done and are doing to improve the standard of education of the boys and girls of British Honduras. We offer you very sincere thanks for the new school in this village which when completed will provide us with better facilities for study, thus making us useful citizens of British Honduras and of the Empire to which we belong." Finally, the students proceeded to plea for a radio to better connect them with the outside world:

Owing to the fact that we are so far removed from any other town or village, caused by the difficulties of transportation during many months of the year, we are at a disadvantage. To associate with pupils of other schools is an impossibility. Our knowledge is therefore limited, as we are confined only to our own environment. There is the need of a radio for our school, when at fixed periods we may listen to the local and foreign broadcasts.[112]

Though several community requests for resources were not fulfilled for years and others never fulfilled, the letters and petitions were also not outright ignored. Consideration of the requests in Gillett's 1951 letters lasted at least three years. In more than fifteen letters dated between August 2, 1951, and May 3, 1954, village residents, the colonial secretary and governor, and officials in the Department of Public Works, Department of Surveys, and Colonial Development office negotiated various requests point by point, including requests for school resources.

These petitions reveal the role of schools as both colonial and community institutions with students and teachers acting as clever social intermediaries, calling for more from their government within the appropriate boundaries of a dutiful subject. Through petitions like these, young people, teachers and other adult community leaders acted together as cultural agents, defining the characteristics of their village (isolated, proud) and working to gain some control over future development. The radio request demonstrated savviness to the outward facing social and economic development concerns about the British colonies in the 1950s.

Petitions and requests for resources highlight villagers' political savvy and vernacular heritage practices. Indeed, in a 1954 petition from Crooked Tree villagers for better road access the authors congratulate the colonial secretary for his recent "success at the Polls" and pledge their "unswerving loyalty [. . .] to the well-being of British Honduras." Additionally, they note the productivity of Crooked Tree in cattle and crops and conclude by asking for help because "over 700 persons of *respectability and industry* are, as it were, cut off from most of the privileges that *modern civilizations offer.*"[113] Such requests demonstrate a Kriol heritage practice of negotiating power structures and constructs of identity and community. Petitions from Crooked Tree youth and community leaders reveal efforts to claim a British connection, while at the same time trying to maintain local identity through autonomy. Indeed, the balancing and blending of multiple race/class/culture identities is one of the vernacular heritage practices that define rural Belizean Kriolness and Crooked Treeness.[114]

Another act of heritage negotiation in community petitions was the usage of language. Crooked Tree actors authoring letters and petitions to colonial officers wrote eloquently in British English. Nevertheless, the previously noted references by colonial officials to "too much Creolism" in the classroom demonstrate that Kriol linguistic practices persisted. Drawing from ethnographic, folklore, and sociolinguistic research, scholars have discussed the abilities of Afro-Caribbean peoples to adapt their language practices in efforts to manip-

ulate power dynamics and assert identities from colonial times to the early twenty-first century. The languages that Afro-Caribbean peoples developed combined African styles and traditions with European forms and norms. Creole languages in Belize and other countries with British colonial history are English-based Creoles, and many have roots in West African languages. In Belize and elsewhere, people of Afro-Caribbean descent have long been selective about when to assert more official English linguistic practices or more vernacular African ones.[115]

Resistance to Schooling and the Persistence of Kriol Culture

Several colonial minute papers and education reports also invoke vernacular heritage practices in their discussions about school attendance in Crooked Tree and nearby communities. As noted above, Reverend Cleghorn's 1920 letter to inspector of schools A. Barrow Dillon discussed concerns about the "very irregular way many of the children at Crooked Tree have of attending school" and the "ill consequences" of poor attendance on school examinations.[116] The 1937 education report referred to "irregular and unpunctual attendance," due to accessibility issues in wet weather, but also due to parents making excuses "for keeping their children home from school" and teachers using weather as an excuse "for not opening their schools."[117] The 1947 and 1949 education reports lamented children missing classes, living for periods of time in places without schools, and switching schools during the year.

Incidents of irregular attendance raise questions about why children were not going to school. A combination of economic, cultural, and political factors likely influenced school attendance. As noted, Reverend Cleghorn connected "irregular" school attendance among Crooked Tree children with family camping practices. The 1947 report blames parents' "irresponsibility and carelessness about a child's schooling," while the 1949 report notes "seasonal employment, changes of residence, denominational pressure," as the main reasons for students switching schools.[118] In the 1949 report, education director Jack Forrest states: "It is difficult to assess how far dissatisfaction with school standards, or petty differences between parents and teachers, are responsible for changes of enrollment, but apparently they are factors of some importance."[119]

Forrest's comments inspire deeper speculation about the tools of agency utilized by Kriol people, and suggest that irregular school attendance can be examined through a lens of "everyday resistance."[120] Families were likely frustrated with poor school conditions, limited resources, and accessibility issues—all responsibilities of the colonial government. And, as the colonial education system was not relevant to the life experiences and modes of learning of

rural and Kriol students, families and students may have considered schooling unnecessary and chosen other means to educate youth.

"Camping" and related activities like hunting, fishing, small-scale farming, and clearing land have long been important ways through which Kriol people learn Kriol cultural knowledge. In these ways, the "camping" Cleghorn observed represented people choosing one form of education (a Kriol one) over another (a British one). Camping and its accompanying activities reveal much about Kriol peoples' vernacular heritage practices, their ties to the land, and ecological politics in the past and the present. The camping area mentioned by Cleghorn ("Blackburn") has long been a politicized landscape and a site of resistance.[121] By the late twentieth century, most land in Belize was part of the Belize Estate Company, a superpower in Belize's forestocracy. However, for several decades, Crooked Tree residents farmed plantations in Blackburn, which they considered part of the village. Today, much of Blackburn falls within the Crooked Tree Wildlife Sanctuary and the Chau Hiix Archaeological Site. Crooked Tree residents continue to clear and utilize Blackburn land for their cattle farms and to hunt and fish, sometimes in response and resistance to official conservation protocols.

I have learned from ethnographic interviews, observations, and others' scholarship that, even after more than a century of discrimination and racialization of "bush practices,"[122] "camping" and other outdoor activities continue to be cultural practices that involve socialization between peers, enculturation of young people into Kriol hunting and fishing practices, and exchanges of ecological heritage. People talk about camping and fishing with enthusiasm and nostalgia. Families celebrate milestones like elementary school graduations with camping trips. Similarly, when I asked Teacher Donna[123] from CTGS about her retirement plans, she said simply, "fishing" and her fellow teachers gifted her a tackle box and fishing rod at her retirement party.

Another example showing colonial concerns about education and the persistence of vernacular heritage practices is the usage of Kriol language. As noted, Kriol language persisted despite repeated colonial attempts to make Kriol children learn to speak and write "correct English." During the Colonial Period, residents in Crooked Tree and other riverine communities used Kriol to transmit information and engage in cultural practices in ways that were also discriminated against and misunderstood by colonial education officers. Discussions in education reports about the need for reading matter that was interesting and "useful" hint at colonial schooling's lack of relevance to the lives of Belizean children.[124] Additionally, the heavy emphasis on reading in general implies a lack of recognition of Kriol folk traditions, which have long been

passed down orally. Crooked Tree residents continue to tell allegorical folk stories with African cultural and linguistic influences such as anthropomorphized animals like Anansi the Spider. The tradition of Bram, which began in Belize Town and Kriol villages like those in the Belize River valley and Gales Point Manatee, is a music and dancing practice done during the Christmas season and has existed since at least colonial times. Bram involves singing, dancing, and musical instrument playing (for example, drums and guitars) in the street and visiting neighbors' homes.[125] Bram traditionally involved Kriol Brokdong music, but in Crooked Tree Village, Western country music was also a popular musical genre embraced during Bram.

Rural Kriol communities have also historically been known for particularly rich linguistic practices. As Melissa Johnson argues, Belizean "Kriol is spoken along a continuum of more English/less African to less English/more African"[126] and credits rural Belize River valley communities like Crooked Tree with the development of Kriol language and cultural practices with particularly strong African heritage.[127] William Salmon and Jennifer Gómez Menjívar also bring attention to a Kriol continuum and the fact that many Belizeans today place significant prestige on the Kriol spoken in rural communities suggesting it is more closely tied to Belizean and Kriol identity.[128] People I interviewed within and outside of Crooked Tree referred to the Kriol dialect spoken in villages like Crooked Tree as particularly *braad* (broad) and *tik* (thick). What they implied is that rural Kriol is more authentic—as in "*Dehn di taak braad Kriol*" (they speak broad Kriol).[129]

Schools and Communities

In colonial education reports, education officers emphasized the importance of community support and discussed ways to connect families and schools. In the 1937 education report, director of education B. E. Carman suggested that interesting "parents in their children's educational welfare," enlists "their cooperation in all aspects of the work of the school" and leads to "marked improvement in attendance."[130] Beginning in that same decade, the colonial administration implemented programs to increase school-community cooperation. In the 1938 report Carman notes efforts "made to emphasize the importance of the 'school in the community,' through the organisation of Parent-Teachers' Association and Parents or Open Days," where programs included the development of school clubs, agricultural competitions and fairs, publicity, and "the exhibition of handwork [. . .] done by the children, entertainments by the school and the giving of addresses to parents." These programs were designed by colonial educational officers to "arouse greater interest in education among

the parents and the entire community" and to indirectly "accomplish the aims of the Compulsory Education Law."[131]

Colonial minute papers indicate Belizeans often used government school buildings as community organizing spaces. Crooked Tree villagers pushed the limits of such community uses of schools showing their agency in manipulating colonial infrastructure. For example, a 1954 letter from a Baptist minister requested use of the Crooked Tree schoolroom for religious meetings until it was possible to repair the local Baptist Church.[132] The colonial secretary approved the request, referencing precedent in which the colonial government allowed churches to use schools in nearby communities.[133] However, political uses for school buildings were discouraged. A March 1954 letter from director of education E. Brown, to Mr. C. A. Engleton, the CTGS head teacher, stated that the government was informed that "the Crooked Tree Government School has for some time been used for the purposes of political meetings. As this is contrary to the conditions governing the use of government schools, I am to request that the practice should cease immediately."[134] Even today, in both Crooked Tree and Biscayne, school buildings serve many purposes. I have witnessed them being used for village political meetings, elections, and educational outreach sponsored by institutions like NGOs and foreign churches.

Independence Period Education: Imperialist Forces, Internationalist Interventions, and Nationalist Voices

The community petitions I described above exemplify an interplay between official colonial heritage discourses and practices and vernacular heritage in the form of community agency. This interplay was situated in broader historic geopolitical debates about governmentality, citizenship, and social and economic development. Persistent and growing unrest with colonial agendas within Kriol and other communities inspired conversations and actions about Belize's eventual transition to democracy.[135]

Following roughly a century of colonial education heritage practices that aimed to govern subject-citizens and manage cultural differences, beginning in the late 1950s, the Independence Period of Belizean education includes a final thrust of imperialist attempts to control education and development-focused international discourse. However, this period can also be characterized by burgeoning nationalist efforts and post-independence educational programming designed by Belizeans to decolonize and democratize the educational system and to "Belizeanize" education in form, purpose, and content.

During the Independence Period, Belize underwent extensive economic

and political changes in ways that influenced and affected Belizean education as a heritage institution. Economically, the Belizean economy transitioned from dependence on the exploitation and exportation of forest products to the establishment of agricultural industries, specifically, sugar and citrus, which were supported by foreign investments and marketing arrangements. However, there was limited agricultural land, no trained labor force, and limited infrastructure for industrial agriculture so Belize continued to be dependent on imports from other countries for the majority of its basic goods. Belize was also dependent on financial and institutional assistance from the United Kingdom, United States, and development aid agencies such as UNESCO, The World Bank, and the United Nations Children's Fund (UNICEF).

The shifting economic infrastructure also influenced politics. Civil unrest that emerged in the 1930s continued into the 1950s, fueling political nationalist movements. In 1949, the British government devalued the pound to improve the British economy, which led to a devaluation of the Belize dollar and severe economic strife as the cost of British imports increased. Frustrated by the lack of representation in British politics, and the impact of British decisions on Belizeans, political activists formed the People's Committee which eventually became the People's United Party (PUP) in 1950. This party, backed by labor activists and organizations, promoted a multiethnic vision of Belizean identity and an anti-colonialist agenda.

As the result of activism led by nationalist actors, the first general assembly elections were held in April 1954, the same year Belize acquired universal adult suffrage for all literate adults. The new Constitution of 1964 established internal self-government, though the British continued to be in charge of foreign affairs, national defense, public services, and internal security. Symbolic and infrastructural changes of the 1970s indicated Belize's growing transition toward independence, including the city of Belmopan replacing Belize City as the capital in 1970, and changing the name of the colony from British Honduras to Belize in 1973. In 1981, Belize finally achieved independence.

Although the Independence Period was a time of rising political and cultural nationalism, the road to independence for Belizeans was not easy, nor was there consensus among citizens about the proper path to, or benefits of independence. Historians and anthropologists also note that there has also never been a truly collective construct of national identity or history within Belize.[136] As a result, numerous political parties emerged during the 1950s through the 1970s with varying agendas and concerns. The PUP formed as an anti-colonial party (founded by activists including Philip Goldson and George Cadle Price—eventually, Belize's first prime minister). The National Party (NP)

formed by W. H. Courtenay, Herbert Fuller and others in 1951 was a colonialist response to the PUP. This party stoked fears about the country's lack of economic, political, and cultural readiness for independence. The NP was largely comprised of those who stood to benefit from an extended connection with the British Empire—for example, members of the Kriol elite and middle class, especially merchants, colonial administrators, and those tied to the forestocracy. Following the dissolution of the NP in 1958, the National Independence Party (NIP) formed in 1958 and became the main opposition to PUP during the Independence Period. NIP advocated for a gradual transition to Belizean independence. In 1973, the NIP merged with the People's Development Movement, and a significant portion of the United Black Association for Development (UBAD)[137] to form the United Democratic Party (UDP). Since its founding, the UDP has been the primary opposition to the PUP. In the late 1960s, political activists Said Musa and Assad Shoman[138] formed the People's Action Committee (PAC) based on economic and political concerns about the PUP. They feared that economic development efforts in Belize that relied too heavily on United States aid, investments, and trade would result in new structures of economic dependency and cultural domination from the United States and a kind of neocolonialism. Musa and Shoman eventually played integral roles in Belizean education programming and advocacy, establishing the Society for the Promotion of Education and Research in 1969.

In 1981, Belize gained independence during a time of turmoil. Ongoing disputes flared between politicians and political parties. Politicians and average citizens alike had concerns about the possibility of military conflict with Guatemala over a long-disputed border. Belizean independence had significant economic impacts. It took several decades for the Belizean government to develop more autonomous and sustainable national industries, so Belize continued to depend on foreign products, investors, and infrastructure developed by foreigners.

Because of this history, education in general and programming related to culture and history during the Independence Period was influenced by multiple agendas and ideologies: imperialist, internationalist, and nationalist. The British Empire, international development aid agencies, and Belizean nationalists shared interests in outlining the future of the country, defining the country's identity, and advancing the country's social and economic development through education. All of these groups also emphasized the importance of a smooth transition from colonial occupation to independence. However, official heritage ideologies and practices from the Colonial Period continued to affect education.

Imperialist education agendas were driven by British desires to maintain a good image of the British Empire and its history, and to ensure a political transition that served British interests. Internationalist education agendas spearheaded primarily by development aid agencies such as UNESCO focused on education as a human right, transition to a self-sufficient democracy, and the cultivation of a Belizean identity through education. Implicit in the philosophies and programming of aid agencies was the idea that countries with a strong sense of heritage have productive citizens. Nationalist agendas for education focused on a Belizean future that was democratic, self-sufficient, and decolonized, as well as the formation of an "imagined community" of a Belizean state that embraced its rich and diverse cultures and addressed colonial history. Nationalist approaches to education during the Independence Period are forms of Belizean agency in response to colonial official heritage discourses. Nationalist approaches demonstrate Belizeans perspectives about the agendas, values, and appropriate structures and content for education. However, these also represent the voices of state powers.[139]

Imperialist Approaches to Education

In the mid-twentieth century, British politicians displayed significant angst about the future of the empire. This angst was fueled by concerns about the empire's sustainability, responsibilities to the colonies, and the role of colonial territories in an international market and political economy. Political and intellectual critiques of colonialism at the time focused on empires' failures to serve the social, economic, and political needs of their colonies and subjects. In response, the British initiated reforms in the late 1940s, such as the adaptive and mass education efforts noted previously. Nevertheless, concerns within the British Empire intensified in the 1950s following what imperial leaders identified as several "failed" political transitions in former colonies, most notably in India where following independence there continued to be significant animosity toward the British and ongoing conflicts between upper and intellectual classes and lower classes.

During the Independence Period, calls for adaptive and mass education efforts continued. British imperial officials concerned about the education of native populations increasingly consulted social scientists. In colonial education scholar Margaret Read's 1955 book *Education and Social Change in Tropical Areas,* Read advocated for research about and programming for "the relation of the local school to local native administrations" and "the relation of youth organisations to schools and to tribal society and the methods of collecting and teaching tribal history."[140] Her book was read by colonial administrators and

consulted by those making decisions about education policies, content, and the training of educators working in the colonies.

British colonial education officer W.E.F. Ward expressed concerns similar to Read's in a 1959 summary of "Education in the Colonies."[141] Noting problems stemming from poor funding, Ward delved into cultural issues, such as local resistance to educational institutions, and debates about the most appropriate content and language of instruction.[142] In a departure from many earlier reports, Ward noted local populaces eager for education and presented their thought processes as complex, particularly during times when new national identities were emerging. He predicted: "there is likely to be a reaction in favour of national culture, the undiscriminating eagerness for everything British will be replaced by a more deliberate selection, and an attempt will be made to construct a new national culture from a combination of indigenous elements with British technology, parliamentary procedure, and other British ideas."[143]

Some British education specialists continued to advocate for the goals of adaptive education. Colonial education officers like Ward recognized that history needed to be taught differently in colonies than it had been during the previous century. For example, Ward suggested that "a good history syllabus for Central Africa, [. . .] shall begin with the pupils' own history, [and] shall give them some understanding of the relations of Africa with Europe, the rest of the Commonwealth and the world as a whole."[144] However, different from the goal of adaptive education to manage subject-citizens, Ward was particularly concerned about colonies transitioning to independence and saw culturally and historically relevant materials as important for this process.

Political leaders in the metropole and the regional colonial administration struggled with the meanings and implications of increased Belizean political representation, how to manage a restless and diverse population, and how Belizeans might navigate an evolving international market and political economy. Many colonial actors considered education to be a key means of addressing imperial sustainability. In the mid-twentieth century, imperial education efforts were assisted by colonial leaders and Belizean members of the political elite and middle class, many of whom were members of the NP (eventually the NIP) and whose interests were tied to the existing Belizean economy and the colonial powers—thus, they strove to maintain British financial and social support. Through welfare, educational, and cultural organizations such as the Black Cross Nurses, Infant Welfare League, Loyal and Patriotic Order of the Baymen (LPOB), British Honduras Social Services Council, and the British Hondu-

ras Taxpayers Association (BHTA), elite and middle class Belizeans supported colonial efforts in health, domestic, and vocational education. These efforts reinforced dependence on British resources and bolstered a Belizean economy that supported British interests.[145] Additionally, these individuals promoted a political philosophy that emphasized a collective identity that combined the concept of a modern Belizean nation and the country's British colonial heritage. For example, organizations like the LPOB and BHTA organized cultural events and educational programming that promoted the mythic narrative of the Battle of St. George's Caye and other British-centric aspects of Belizean heritage.[146]

Despite suggestions for more culturally and historically relevant education programming advocated for by those like W.E.F. Ward, during the Independence Period colonial education officials did little to integrate content related to Belizean culture and history. Occasionally individual educators made their own efforts as noted by some education reports. For example, a principal in Barranco collected Carib folk songs and a group of teachers encouraged "children to collect facts of local history from the oldest inhabitants."[147] Nevertheless, other formal education initiatives focused on culture and history are missing from primary sources.

Internationalist Approaches to Education

The mid-twentieth century saw extensive interest among world leaders in developing nations like Belize, as indicated by the increased presence and power of development aid agencies. These agencies were particularly concerned about countries' transitions from colonial occupation to politically independent democracies. This concern was influenced in part by devastating economic and societal impacts of World War II and Cold War fears about rising socialist and communist regimes throughout the world. Additionally, contentious transitions from colonial control in places like India and Egypt fueled concerns about harsh internal views toward colonizing states and potential social, political, and economic instability in newly independent countries.

Influenced by economists and political scientists, development aid agencies considered democracy, economic development, and productivity—all to be stoked by education—as key to political autonomy.[148] And they considered it their mission to cultivate democratic, modern, and economically self-sufficient societies. As such, from the 1950s to the 1980s aid agencies became increasingly involved in developing and transitioning countries like Belize throughout the Caribbean. Aid agencies conducted research, made policy and programming

recommendations, and provided funding for social services like education and they took an explicit interest in heritage for several reasons. Many aid agencies and the democratic superpowers involved in them considered a sense of identity and history to be integral to democracy, political and economic success, and recognized that heritage manifestations like archaeological sites were marketable assets.

The actions of development aid agencies during Belize's Independence Period both supported and countered British imperial agendas. Like British imperial leaders, these organizations saw education as a critical tool in accomplishing social and economic development goals. However, they differed in the reason for sponsoring development—mainly, to encourage the spread of democratic ideals and to support the development of international capitalism.

Aid agencies emphasized the importance of establishing a productive labor force and developing agriculture, industrial technology, and tourism, but also advocated for culturally relevant educational materials. By offering expert perspectives about Belize's future and citizenry, and explicitly and implicitly addressing culture and race in connection to education, they were also indirectly controlling Belizean heritage.

In 1964, UNESCO sent a team of scholars to Belize for an Educational Planning Mission. The team consisted of a specialist in general education and educational planning from the United Kingdom, an economist from the United Kingdom, and a specialist in technical education and vocational training from Cyprus. A primary goal of the planning mission was to bring the Belizean education system "more into line with the changes and developments in the political, social and economic life of the country."[149] International education officials thought the existing British colonial school system was not set up properly to achieve this goal and identified cultural disconnects in educational contexts as one barrier to the country's self-sufficiency.

Noting the failure of the British to successfully achieve goals of the adaptive and mass education movements, the 1964 *Report of the UNESCO Educational Planning Mission to British Honduras* critiqued Belizean primary schools and their:

> rigid application of syllabuses which give insufficient emphasis [. . .] relating content and teaching approach to *the world that the child knows* [. . .] On the whole, the *educational experiences* offered children [. . .] are hardly commensurate with the *needs* of children at this age [. . .] The facilities except in a few cases are not available for the introduction of practical work to give substance and meaning to the blackboard learning.[150]

The authors of the 1964 UNESCO report continued by suggesting that the "overwhelmingly academic and, indeed, literary bias of education in British Honduras" interfered with economic development. They stated a need for making use of the land, seeking assistance and cooperation of the community, and programming in natural sciences, handicraft, and agricultural education to prepare Belizeans for their futures and enable them to make contributions to the "economic development of the country."[151] The 1964 UNESCO report also advocated for the implementation of teacher and student training in cultural activities and skills such as bookbinding, pottery, woodwork, and weaving as such "articles of *local character*" could serve as "an additional source of income for the rural population."[152] The context of these suggestions indicates they were less about respect for cultural traditions and more about teaching young people in rural communities marketable skills.

In a 1975 UNESCO report on educational change and growth in Belize, Sylvain Lourié, UNESCO Education Regional Adviser for Central America and Panama, stated that Belizean education remained "foreign-inspired, elitist and remotely linked to the lives of Belizeans today or their likely future." He argued that more appropriate and relevant curriculum was "one of the most important—still unresolved—problems affecting Belize's school system."[153] Although Lourié suggested that some progress was being made in relevant education with repeated references to Belize's history and geography in social studies materials, he was gravely concerned that the structure and content of Belizean education were disconnected from the lives, communities, and experiences of young Belizeans. He stated: "school programmes [. . .] are essentially divorced from the *local background* and are hardly founded on the natural—or spontaneous—motivations, curiosity, sensitivity or interest of the children and the youth [. . .]. Rote learning, repetition of words conveying an abstract world foreign to the *every-day life* of children and their parents continue to survive in the curriculum. Hence [. . .] education [does not] reflect the reality of Belize today or the hopes its leaders have for tomorrow."[154]

Lourié encouraged curricular changes to incorporate: "elements of Belize *everyday life*. [. . .] teachers [should] be expected to "translate" these elements into terms even more closely associated to *local life* and having even more concrete significance at the community level. 'Quality' would then be felt as that essence of an activity, or of the relation between object and subject, which finds an 'echo' in the child himself. He would, as it were, recognize it as his, or her, own and not consider it as another set of facts to be added onto others layers of memorized 'foreign matters.'"[155]

Though Lourié never explicitly used the term culture and only referred to

history once in his commentary, he referred to the background, origin, world, every-day life, existence at home, and local life of children, clearly making connections between culture, education, and the production of young citizens.

Lourié expressed enthusiasm for respecting the cultural backgrounds of young Belizeans, but his advocacy for culturally relevant education was still driven by economic and social development concerns. In the 1975 report, Lourié recommended that UNESCO provide consultative and training services, including in archaeology.[156] This recognition of Belize's archaeological potential was, not an acknowledgement of the cultural and historical significance of Belizean pre-European history or archaeology as part of Belizean identity as much as a recognition of its economic potential, particularly for tourism. Additionally, the models Lourié outlined for primary school curriculum included programming in "rural life" (agriculture, forestry, fisheries production), repair and maintenance activity (small scale technology), servicing home and community (cooking, sawing, management of cooperatives), and health and nutrition, among other more traditional subject areas, and were all tied to interests in economic and social development. To his credit, Lourié identified a need for a balance between social and economic development. He suggested that the Belize Vocational Training Centre "must not limit itself to making of its students specialized 'robots' without concern for, or interest in general education or culture."[157]

Intersections between native languages and education continued to be a concern during the Independence Period and were explicitly addressed by international aid agencies. The 1964 UNESCO education report identified language as a "problem" and concerns about the use of languages other than English at home persisted, indicating that native languages like Kriol continued to be seen as barriers and a cultural deficit. However, international aid agencies also advocated for language education that was relevant to students, including oral expression and active learning.[158] Some international education efforts noted the inevitability of multilingualism in diverse Caribbean states like Belize and acknowledged connections between linguistic practices and other forms of vernacular heritage like folklore. International aid agency reports also often acknowledged cultural similarities and historical parallels between many Afro-Caribbean populations in the West Indies. In 1978, the Economic Commission for Latin America within UNESCO partnered with the Caribbean Development and Co-operation Committee to organize a "Meeting on Removal of Language Barriers" held in Belize City. The resulting report described cultural issues for Caribbean populations such as educational challenges in multilingual countries and persistent prejudice against

vernacular languages and emphasized the need for educational materials in students' mother tongues.[159] Ultimate goals for language education identified in the report were for citizens to fully participate in society and communicate across the Caribbean region.[160] This meeting resulted in several recommendations for culturally relevant materials including curricula about: "regional languages, [. . .] literature and folklore, [. . .] the history of the cultures and civilizations of the Caribbean peoples, with the aim of removing cultural barriers to comprehension; [. . .] [and] a view to preparing a "History of the Culture of the Caribbean peoples" and related school texts."[161]

Thus, in a stark difference from the British imperialist rhetoric about culture and education that focused almost exclusively on the economic development aspects of culturally relevant education, the internationalist approach did in some instances acknowledge the rich and shared cultures and histories of Caribbean groups. Nationalist approaches to education inspired by Belize's burgeoning independence movement also addressed these issues.

Nationalist Approaches to Education

During the Independence Period of education, Belizeans first started advocating for the incorporation of expressly Belizean culture and history into educational contexts on Belizean terms. Nationalist approaches to education acknowledged the complex history of the country and emphasized the impacts and legacies of colonialism on cultural practices and institutions. In 1977, I. E. Sanchez, a former chief education officer in Belize, described aspects of colonial history: "To be colonized means to be dehumanized, to be depersonalized and to be pitted one against the other. But colonization does more: it imposes an inferiority and dependency complex on the colonized; it severs the colonized from their history, tradition and culture, in its place the colonizer forcibly substitutes his history, tradition and culture."[162]

Belizean nationalist politicians and public intellectuals who considered cultural autonomy, the decolonization of Belizean society, and economic sustainability central to the country's transition to independence saw education as an integral tool in meeting these objectives. The structural reforms they advocated for in education included increased teacher training, curriculum development, and culturally relevant education and programming specific to the needs of Belize.[163] Given that cultural discrimination and historical erasure were powerful colonizing tools often implemented through education, nationalist leaders also noted the necessity to define, legitimize, and promote Belizean culture and history through education to cultivate a national "community."[164]

The shift in Belizean education toward cultural, political, and economic decolonization began in the 1960s.[165] Shortly before achieving internal self-government in the new Constitution of 1964, Belize passed The Education Ordinance of 1962. This ordinance maintained the church-state partnership in education and ensured that the colonial governor retained significant authority through the ability to appoint the chief education officer and make other appointments in the Department of Education. However, the ordinance also granted substantial powers to the minister of education and chief education officer. In the 1960s, Belizean-born individuals held these roles for the first time.

In 1963 the Belize minister of education appointed a "Planning Committee on Education" to examine the country's education system, recommend changes to the structures and programing, "study and analyse the present educational system and to seek and suggest ways in which it could be made to play a more purposeful role in the country's striving for economic progress." The resulting report discussed the need to "focus attention on education as an instrument of economic growth" and urged the government "to spend more on education," suggesting that such attention to economic progress is particularly important for "an underdeveloped country [. . .] standing on the threshold of political independence."[166] Further, the report stated that "If an effective primary education provides children with the minimum tools for taking part in the life of the modern economy as producers and consumers and for receiving vocational training [. . .] much remains to be done for primary education in the country."[167]

In the early 1960s, nationalist leader George Cadle Price requested an evaluation of the Belizean infrastructure, specifically pertaining to the economy and education. The Belizean Legislative Assembly and ministers of education and chief education officers requested multiple surveys and support from organizations such as the United Nations to assist in creating and implementing a Belizean development plan. The result was the Government's Development Plan 1964–1970, which advocated for increased government autonomy in education supervision and development, increased Belizean financial support for education, and educational improvement through child-centered education, relevant curricula, facilities for practical work, leadership and initiative opportunities for adolescents, and a flexible promotion system. Cynthia Thompson, Belizean scholar of education, refers to this plan as Belize's "first bid towards nationalizing the education system." [168]

Many Belizean nationalists were particularly concerned about the influence of foreign goods on Belize's culture and economy as well as the impacts of

international aid. As such, during the Independence Period, national education actors emphasized the roles education could play in social and economic development.

The 1969–1970/1971–1972 education report by Belizean-born chief education officer William Fonseca exemplifies nationalist education interests in development and citizenship noting that the aim for primary education was to: "provide necessary foundation on which [children] can develop their individual interests and abilities and so that they may function meaningfully as citizens."[169] Similarly, Joseph Alexander Bennett,[170] noted Belizean educator and historian of Belizean education, made connections between education and national development, stating that the decolonization process, "must enable us [Belizeans] to develop our own national philosophy of education and give us confidence that working together we can equip our youth to play constructive roles in Belizean development."[171]

Perhaps inspired by international development rhetoric, many national education actors during the Independence Period thought that technical, industrial, agricultural, and commercial training in education would be particularly useful for economic development. These actors advocated for training colleges to teach subjects such as, machine-shop practice, mechanical drawing, auto and diesel mechanics, carpentry, masonry, electrical installation, woodworking, plumbing and pipe-fitting.[172] In the 1960s and 1970s, new programs in technical and agricultural education flourished. Between 1969 and 1972, two junior secondary schools that emphasized technical education were established. The Belizean government appointed a Belizean agriculture education officer in the mid-1970s and in 1976 the Rural Education and Agriculture Program (REAP) started, integrating academic subjects with agricultural education into the primary school curriculum.[173]

Nationalist education actors during the Independence Period also discussed needs for more relevant education in Belize. In some instances, they reinforced development rhetoric. In the Belizean Planning Committee on Education's 1963 report concerns about education's relevance were particularly strong with regards to rural education; rural communities—where "the majority [of children] will be farmers when they grow up"—were seen as most in need of social development and economic assistance.[174] This development-focused national education approach as well as the emphasis on technical and vocational education was driven by a labor-based rhetoric popular during the late Colonial Period as well as within imperialist and internationalist education approaches during the Independence Period.

However, nationalist education actors also acknowledged the importance of

culturally relevant education to Belizean identity and decolonization efforts. A particularly impactful nationalist organization was the Society for the Promotion of Education and Research (SPEAR), established by Said Musa, Assad Shoman, and other political activists in 1969. Though not a government or partisan institution, SPEAR has always unequivocally been a political organization. When SPEAR was founded its general objectives were focused on: "rais[ing] awareness and political consciousness, providing educational opportunities for the disadvantaged, promoting discussion about national and international issues and generally working for a more just and democratic society."[175]

SPEAR's mission was to move beyond colonialism, empower people, and address social and economic development issues specific to Belize.[176] To meet their objectives and mission, SPEAR developed educational initiatives and advocated for culturally relevant educational programming.

Nationalist actors also promoted programs for training Belizean teachers. They considered competent local teachers who were familiar with Belizeans' needs a precondition of national autonomy in education. In a 1979 message to the Belize Teachers College, education minister Elizio Briceño stated that the fact that formalized teacher education was established in 1954, the same year as universal adult suffrage was evidence of "a people's awakening and a definite step towards their *taking control and directing their future.*"[177]

The decolonization of education also happened through textbook projects and the development of culturally relevant education materials. In the 1969–1970/1971–1972 education report William Fonseca highlighted "the great need [. . .] for more suitable textbooks relevant to the experiences and interests of the country's children and to the culture and aspirations of the Belizean people."[178] Nationalist actors recognized shared cultural and historical connections throughout the West Indies and in addition to advocating for Belize-specific materials, they also promoted materials focused on Caribbean and Afro-Caribbean culture and history. In his discussion of textbooks, Fonseca referenced Sir Philip Manderson Sherlock's book *Belize: A Junior History* published by Collins in 1969. Sherlock was born in Jamaica and educated at London University and he eventually became a prominent scholar of Caribbean education, culture, and history.[179] During his career, he wrote several books about Caribbean heritage including texts for young people about Caribbean folklore and history. Fonseca's focus on culturally relevant pedagogy is distinguishable from similar pursuits by imperialist actors and international aid agencies in that he noted the importance of programming that respected the cultural backgrounds of children, and their place in society, for the benefit of Belizean people. Fonseca wrote: "The solution is not to denigrate Creole or

Carib or Maya but rather to appreciate the place of these in the community and in the social relationships of the child."[180]

Scholars like Caribbean linguistics professor Stanley Reginald Richard Allsopp emphasized connections between language, identity, and culturally relevant education. In a 1965 article, Allsopp expressed concern about the marginalization of the Kriol language in Belize and called for more research on Belize's linguistic history and its connections to the rest of the Caribbean. He emphasized the centrality of Kriol to Belizean national culture and identity and advocated for the development and promotion of publications like a glossary and "collections of 'Nancy stories and Folklore and Belizean Proverbs."[181] And, in a 1971 article on educational planning in Belize, Norman Ashcraft critiqued the prejudice against Kriol in educational contexts stating that: "Foreigners, [. . .] regard the Creole language spoken by the majority of the inhabitants as merely a corrupt and bad form of English. Most indigenous teachers tend to emulate their "educated" counterparts and "Creole" is forbidden in the classrooms."[182]

Ashcraft supported the implementation of "a mixture of liberal arts and practical education based on cultural values, local needs, kept in pace with economic growth" and "humanistic courses with local cultural content."[183]

Many nationalist politicians and public intellectuals in Belize considered appreciation and pride for culture and history integral to the development of a shared sense of national history, which they considered key to the nation's future. They saw education as an important avenue for achieving these goals. SPEAR activists were some of the first Belizeans to acknowledge the legacy of British-centric education materials and advocate for more education content related to Belizean culture and history. Importantly, in 1975, a National Curriculum Unit was established advancing Belizean control over educational content and the development of Belize-specific curricula.

Decolonization and Belizean history and culture were addressed in many curriculum products following independence. The first major curricular attempt to incorporate Belizean heritage into the education system was political activist Robert Leslie's *A History of Belize: Nation in the Making*.[184] The first edition of this text was published in 1983, just two years after independence, and its appearance represented a powerful political statement of Belizean self-determination. *A History of Belize* is now in its 15th edition (2016) and is one of the most popular textbooks for upper level primary school history education. In the 1983 text, Leslie describes Belize's diverse heritage, the importance of unity within difference, and concerns about how colonialism influenced cultural dynamics:

Belize has its own rich culture which includes the heritage of the different ethnic groups of Belize [. . .] For much of our history, the natural interaction of cultures which co-exist within one community was inhibited by the colonial policy of divide and rule, which ensured that our various cultures remained largely isolated from, and suspicious of each other, and that the colonizer's culture remained dominant. An essential part of the decolonization process must therefore be the elimination of all colonially inherited prejudices about each other's cultures.

The historical origins of our people and the more recent influences upon our culture have produced diversity. Out of this diversity we must seek unity, while recognizing the value of our different customs and traditions.[185]

Leslie's text exemplifies another important way the nationalist approaches to education differed from imperialist and internationalist ones. Though imperialist, internationalist, and nationalist education approaches all advocated for teacher training, curricular change, and education for a democratic society, the nationalist approaches were developed and promoted by Belizeans, for Belizeans. Additionally, they addressed the history of colonialism head-on and in many instances represented cultural diversity as a benefit.

Conclusion

Education is a heritage structure whereby those in power construct dominant, official narratives about race, culture, language, and history. Through the development of a British education structure, British colonial descriptions of the people and history of Belize in education reports, promotion of mythical public memory like the Battle at St. George's Caye, and denigration of non-English vernacular heritage like language, colonial officials established foundational official heritage ideologies for Belizeans. Though local communities searching for resources from the colonial government challenged colonial education practices, it was not until the Independence Period when Belizeans began to gain control over their educational structures and advocated for the Belizeanization of education.

Nationalist actors made strides during the Independence Period to highlight the importance of culturally relevant education, but it was in the late 1990s and early twenty-first century when Belizeans really began incorporating more extensive content on Belizean culture and history into national curricula

and programming. In the next chapter, I outline how, during the Globalization Period of education, politicians and state heritage actors have become more invested in how they define and represent national heritage internally and on a global stage. In the late twentieth and early twenty-first centuries, Belizean education initiatives are even more firmly situated in state politics and structures. As a result, during the Globalization Period there are explicit messages about culture, history, and diversity in curricula and textbooks. Just as was the case during the Independence Period, some legacies from Colonial Period official heritage discourses and ideologies persist in the ways culture and history are defined and managed, and some forms of vernacular heritage continue to be marginalized in education. For example, as noted in later chapters, much educational material related to Belizean history and archaeological research focuses on Ancient Maya history and culture, with little discussion of Kriol culture or the history of enslavement. However, as the next chapter also shows, teachers and young people in rural Kriol communities practice vernacular heritage by negotiating power dynamics and responding to official heritage discourse that persist in school practices and curricula in many innovative ways.

3

Globalization Period Education

A Culturally Educated Citizenry

Globalization Period education in Belize has followed international trends in what Richard Wilk describes as global structures of "common difference"— efforts to manage national cultural difference in globally common forms of cultural programming in ways that are locally and nationally specific.[1] Belizean politicians, curriculum designers, heritage officials, and other cultural actors have worked since the late 1980s to bring attention to Belizean heritage by emphasizing safe, manageable, and commodifiable forms of culture (for example, food, dance, dress) and national identity in educational programs, tourism, and cultural events. For example, in 2000 Belizean officials created the National Institute of Culture and History (NICH), in 2004 educators published the African and Maya History Project textbooks, and in 2012 Belize implemented a UNESCO-sponsored initiative to safeguard Belize's Intangible Cultural Heritage. These efforts were influenced by internal anxiety about colonial history, national identity, and cultural difference, as well as ongoing social and economic development agendas and competition for cultural recognition and resources on a global stage.

Scholars, politicians, and heritage and education professionals continue to consider culture both a problem and an opportunity. These individuals express concern about Belizean citizens struggling with diverse identities and fears about the loss of cultural knowledge. Many national goals for Belizean education are now structured around the creation and governance of a proud, productive, and "culturally educated citizenry."[2] As stated by a former minister of tourism in a *Belize Times* article: "unprecedented increase in our country's investment in culture [. . .] has allowed us to intensify our efforts in bringing culture and cultural awareness to the forefront our society."[3] Through education, popular culture, tourism, and archaeological research, politicians and heritage actors transmit state messages about the importance of a unified national identity and citizen appreciation for a rich Belizean past and present. Additionally, education programs focused on cultural diversity seek to manage

difference in the hopes of assuaging ethnic conflicts, motivating young people to become more engaged in national development, and sustaining cultural traditions in the face of the perceived homogenizing effects of globalization.

Heritage programming in Belize in the twenty-first century involves a more diverse range of players than ever before. However, colonial culture concepts, racial ideologies, and ethnic stereotypes continue to influence education. Several Globalization Period programs essentialize and reinforce cultural differences, guiding discussions of social divisions into safe forms of culture that continue to marginalize certain groups. As such, these programs limit discussions of cultural fluidity and obscure deep histories of social inequality, often under the guise of national unity.

In the first part of this chapter, I outline state agendas and structures for education related to culture and history as demonstrated in interviews with state heritage actors and detailed in curricula and textbooks. In the second half of the chapter, I provide examples of the ways Kriol residents in two rural communities negotiate heritage discourse in educational contexts. Drawing from participant observations in middle school classrooms and interviews with teachers, local heritage actors, and students, I reveal that educators and young people replicate reified versions of culture like those in educational materials and reinforce cultural hierarchies and stereotypes in their discussions of cultural difference. However, I also highlight the ways they resist educational structures, advocate for their communities, and challenge narrow constructs of culture and identity presented in curricular materials.

National Education in Belize during the Globalization Period

On a state level, after independence, Belizean politicians and activists emphasized the need for new curricula, materials, and programming focused on Belizean history and culture, which they considered a human right and a societal obligation. In his opening speech at the SPEAR Education Symposium in 1990, Assad Shoman argued that: "Belize is a multi-ethnic, multi-lingual, multi-cultural society, and [. . .] we are obliged to respect the child's own cultural identity, language and values. This implies that the child must be taught in his or her own language, and [. . .] that provision must be made for the child to learn about the history and culture of his or her ancestors."[4]

Belize established a National Culture Policy Council in 1993, which promoted a pluralistic and inclusive vision of national identity that incorporated and celebrated multiple ethnic groups. The National Culture Policy Council made recommendations to include more details about different cultural groups in social

studies education. The National Syllabus of Belize, developed by the government in 1999, carried out some of the Council's recommendations, diversifying content on Belizean culture and history.[5] The Culture Policy Council's recommendations and revised 1999 curriculum inspired schools to hold cultural events, which persist today, featuring ethnic costumes, food, and dance.[6] A 1999 Ministry of Education report on textbook standardization urged educators and curriculum designers to utilize texts focused on Caribbean history, multiple ethnic groups, the geography and history of Belize; the report also provided visual materials relevant to students' historical, social, cultural, and economic way of life.[7] As I demonstrate below, one of the driving goals for increased content on Belizean culture and history in education was social and economic development.[8]

While few new state-operated schools were opened post-independence (due to financial strain and continued dependency on the church-state system), national governing institutions in charge of education increased their involvement in education infrastructure and curriculum development. Today, the main governing body of education, the Ministry of Education, Youth, Sports, and Culture (MOE) manages government primary schools and supervises and provides funds to all schools, including church-based institutions. The MOE also collects and maintains countrywide statistical information about schools and students, develops policies, designs and implements the national curriculum, controls the training and certification of teachers, provides materials to schools, and conducts national examinations.

Though there is now more Belizean control over education, cultural disconnects persist in schools. The structure of school in the twenty-first century continues to be modeled after Western institutions and there are many survivals of the British colonial system of education. The general primary, secondary, and tertiary education structure is based on a British system and standardized examinations still follow many British protocols. Until recently, most textbooks were produced outside of Belize in the United Kingdom, the United States, or Jamaica. Education scholar Charles Rutheiser suggests that the modern Belizean education structure reinforces colonial cultural values regarding learning and knowledge.[9] The standard education structure is a banking model that utilizes rote memorization and recitation over more culturally appropriate forms of learning such as observation and trial and error. Teachers lecture to students, using textbooks as resources and writing information on a chalkboard. Students copy information from teachers' lectures in their notebooks and memorize this information. For assignments and tests, students are required to recall the information they learned in class. Belizean students also give recitations at school performances, graduations, and church events

by memorizing poems, quotes, and other written works and reciting them verbatim to their audiences. Additionally, Western-based school knowledge is valued above other non-school forms of knowledge (for example, husbandry practices, bush knowledge, child-rearing).

Language policies also survive from British colonialism. Although for the majority of Belizean students English is a second language, Standard English is the national language and primary language of instruction. Most schools use monolingual instruction and assessments. National standardized examinations focus extensively on Standard English reading and writing. There are only two government-sponsored schools that incorporate Indigenous languages into their curriculum: the Gulisi Community Primary School (Garifuna) and the Tumul K'in Center of Learning (Mopan and Q'eqchi' Maya).

State Agendas for Education Related to Cultural Heritage

State heritage actors in Belize have strong opinions about the values and goals of education and they are often significant players in the construction of national education materials as consultants and textbook writers. At every Belize Archaeology/Anthropology Symposium I have attended, heritage themes have been explicitly invoked by dignitaries (for example, foreign diplomats and Belizean politicians) during the opening ceremonies. These dignitaries regularly draw parallels between cultural programming like academic conferences, archaeology, and education and social and economic development. One year, the director of NICH highlighted education programs focused on culture and history and anthropological research and urged scholars to connect with local communities so citizens could learn more about their work. Echoing the perspectives of dignitaries, every state heritage actor I have met since I first began working in Belize in 2005 has stressed the importance of Belizean youth learning about their culture and history and touted the development potential of these subjects and related cultural resources. Below, I draw from ethnographic interviews with heritage actors to unpack common threads in their discourse about the values of education related to culture and history in overcoming colonial legacies, promoting national identity and unity, managing difference, minimizing social problems, and cultivating economically and socially engaged citizens.

I heard concerns about the impacts of colonialism on Belizeans' perspectives of and misunderstandings about culture and history from state heritage actors as well as teachers, tour guides, business owners, social science and humanities scholars, and in popular media. The mission printed on the back of every African and Maya History project (AMH) textbook, (an early twenty-first century national initiative to incorporate more content on African and Maya civiliza-

tions into Belizean primary schools) states: "The overall purpose of the project is to strengthen pride in Belize's African and Maya heritage to complement the pride we have in western civilization that dominates our worldview today."[10] In an interview with former AMH project member Christina Pop (and former director of the National Social Research Organization in Belize), she talked about the importance of overcoming colonial history and cultivating pride, and cultural awareness through education. Of colonialism, she said it has "left a legacy which we haven't even begun to address."[11]

Given the colonial history of ethnic divisions of labor, racialized stereotypes, and a "divide and conquer" mentality, Belize's contemporary diversity, and the fact that Belizean demographics have shifted significantly in the late twentieth and early twenty-first centuries,[12] it is understandable that there is a nearly universal concern among politicians and heritage actors about the need to define national identity. There is much less agreement about how to do that.

Cultural anthropologist Laurie Medina suggests that three different visions of Belizean identity coexist in the twenty-first century.[13] "Syncretic nationalism" promotes a national identity made up of several ethnic cultures but defined by a shared national culture and identity based on a combination of the practices and values of the various groups. "Cultural pluralism" sees the nation as composed of multiple distinct ethnic groups. Within "hegemonic nationalist" ideologies, groups and individuals link "their own racial ethnic identities preferentially to the nation" and claim a privileged identity as central to national identity.[14] Officially, in many contexts such as education and tourism, Belizean politicians, state heritage actors, and public intellectuals espouse cultural pluralism. However, because diversity is often politicized by citizens and politicians, in educational programming a combination of a culturally pluralist and synthetic nationalist identity is promoted to assuage tensions between groups and domesticate difference. In reality, all three visions of Belizean identity persist in official and vernacular heritage discourse, complicating Belizeans' understandings of who they are.

A common approach in education related to culture and history across the globe that it is used to promote a national identity in a way that minimizes ethnic tensions is a "unity out of difference" approach that draws from a mixture of syncretic nationalism and cultural pluralism.[15] In Belizean national curricula, this approach includes efforts to emphasize specific and safe forms of cultural identities and practices as part of the tapestry of Belizean identity—promoting the idea of many ethnic groups living together as one nation—*Aal a wi da wan* (We are all one). As such, simultaneously, national curricula legitimize the authority of the state to define both Belize's diversity and the existing social order.

Many state heritage actors I interviewed seemed to find a message of syncretic nationalism and "We are all one" appealing. Christina Pop told me the philosophy of AMH was to define what it means to be Belizean, create a unified sense of Belizean-ness, and demonstrate the fact that all Belizeans have diverse backgrounds but also shared pasts. Pop felt this was crucial to moving beyond ethnic "dividedness." She said:

> Eighty percent of Belizeans, have African, European, and Maya, sometimes one will have all three, sometimes one will only have two, but 80 percent of us have that.[16] That means the majority of us have so much in common. So [. . .] why do we have dividedness why do we have the crime that we do? Why is it that we are so quick to say oh that person's a Maya so therefore I have nothing, in common with them?[17]

"Development" has been a concern since the Colonial Period of education. Belizean politicians in the twenty-first century consider a productive and engaged citizenry and a vibrant economy as markers of the strength and legitimacy of the Belizean state, with youth—the future citizenry—seen as important targets. Public speeches by politicians and state education and heritage actors reinforce such development-focused messages. Former Minister of Education Patrick Faber[18] gave the keynote address at a 2009 6th Form graduation ceremony at the Belize Adventist Junior College in northern Belize that I attended. Faber urged the graduates:

> Become productive citizens [. . .] Belize is depending on every one of you to do good things for the country. So many of our young people [. . .] are not making Belize look very good [. . .] You need to lead and provide for your country. Young people are the majority and we are the future and the present of Belize. [. . .] You need to give back to your community unconditionally and don't expect rewards.[19]

I have witnessed teachers, religious figures, politicians, and state heritage actors blaming citizens for a lack of productivity because they consider them too proud, lazy, or disconnected from their Belizean identity. The ideology that citizens who know and appreciate their culture and history will be more socially and economically engaged appeared frequently in discussions I had with Belizeans about education. Former AMH project member Manuel Jimenez (and a former University of Belize administrator) told me a goal of the AMH project was to enhance student pride in their cultural heritage with the hopes that this would inspire young people to become more civically involved in their communities and make economic contributions to the Belizean state. In short,

many national heritage actors I spoke with think that citizens with a rich history should do something with this history.[20]

National Curricula and Education Initiatives Related to Culture and History

Concerns among state actors about managing cultural difference and minimizing ethnic divisions and cultivating pride in a rich unified heritage influence Belizean education in both its structure and content, for example national curricula. The Quality Assurance and Development Services arm of the MOE writes, evaluates, and revises the National Primary School Curriculum (hereafter "the national curriculum/a"), introduces new materials to schools and teachers and assesses curriculum implementation. The MOE generally does not write textbooks, but promotes certain texts by endorsing them and listing them in the national curriculum. The most commonly used textbooks for social studies classes in the twenty-first century in Standard IV, V, and VI primary school classrooms (the highest three grades in Belizean primary education)[21] are: *A History of Belize: Nation in the Making* (Cubola Productions: Benque Viejo del Carmen, Belize); *A Geography of Belize: The Land and its People* (Cubola Productions); *The Environment of Belize: Our Life Support System* (Cubola Productions); and *Atlas of Belize* (Cubola Productions).

In 2000 and 2001 the MOE published a new national curriculum for all subjects and grades, which incorporated more content on Belizean history and cultural groups than ever before. The 2001 social studies curriculum specifically included new content on Belizean cultural heroes, the impacts of slavery, ethnic groups, and precolonial history.[22] The primary school social studies curriculum was revised in 2004 with limited major changes with regards to Belizean culture and history content, other than a noted decrease in information about contemporary Belizean cultural groups and an added focus on the prehistory of continental Africa.[23]

Although Belizean culture and history are included in the national social studies curricula, these topics receive significantly less coverage than other social studies topics like geography, environmental sciences, government, politics, and civics. Like in the Colonial Period, Globalization Period curricular materials categorize and describe the cultural groups of the country with general introductions to groups, details about groups' linguistic, economic, and cultural contributions to society and cultural preservation mechanisms, and sometimes brief histories. However, these materials no longer refer to groups as races and instead identify Belizean cultural groups as ethnic groups or ethnicities.

Much of the historical content in the 2001 and 2004 Belizean social studies curricula focuses on the Ancient Maya. There are a few brief sections in the 2001 curriculum on early relationships between the British and Spanish, and colonial history. Mythologized events and individuals feature prominently in the curriculum, including the Battle of St. George's Caye, Baron Bliss,[24] George Cadle Price, the arrival of Garifuna people, and Belizean independence. There is little in the national social studies curriculum on community histories or vernacular heritage and limited coverage of complex aspects of Belizean history such as slavery.

The 2001 and 2004 national social studies curricula expose students to Belizean ethnic groups in a way that compartmentalizes them into static identities. Ethnic groups are divided into different curricular sections, and each is identified by specific cultural traits and practices (that is, their language, dress, foods, and music, as well as practices identified as "contributions" to Belizean society). Ethnic groups are also portrayed as if they are homogeneous and unchanging over time. For example, in the 2001 and 2004 social studies curricula, the terms "Mayans" or "the Maya(s)" are often used to lump the many chronologically and culturally distinct Maya groups together.[25] There is rarely any indication of the different time period(s) the curricula are referencing, and no explanation of the historical relationships between past and present Maya groups or the changes in Maya cultural groups and practices over time. A couple suggested activities are for youth to visit contemporary Maya communities or interview older Maya people to learn about "how the Mayas lived" or "how they governed themselves." These activities imply that modern Maya people are survivals of the past and that all Maya peoples share the same practices. Such essentialization and homogenization of Maya cultural identities, practices, and history by the state via Belizean education is problematic as it denies cultural fluidity, and perpetuates stereotypes and misunderstandings about Maya people, who live in a political climate where modern Maya groups are exploited and are the victims of cultural prejudices and social and economic inequalities.[26] The reality of Maya migrations, ancestry, and other questions of heritage over the past thousands of years are, of course, extremely complex and difficult to summarize. Given these complexities, it is therefore not surprising that cultural differences are reduced by the state to "safe" forms in education and tourism, while difficult topics of Belizean history such as ethnogenesis, cultural politics, slavery, and colonialism are largely ignored.

In using the 2001 and 2004 national curricula, teachers present culture as a set of essential and immutable characteristics, emphasizing the cloth-

ing, food, and language associated with each Belizean ethnic group. "Ethnic days" are another way school children learn about ethnicities in Belize. These events are common throughout the country. Schools I observed during my ethnographic research both organized and participated in ethnic days, festivals, and competitions where students dress in traditional clothing of specific ethnic groups (often those other than their own), bring foods associated with those groups to class, listen to their music, and perform ethnic dances.

In the 2001 and 2004 Belizean curricula, ethnic groups are essentialized based on colonial-defined labor histories. The "contributions" of ethnic groups are often listed in the national curricula as industries (for example, logging, farming, hunting, and fishing) historically associated with those groups. For example, when Kriol history is discussed in the curriculum, Kriol people are tied to the logging industries. The curriculum, thus, reinforces the concept that the history of extractive and exploitative labor industries defines ethnic identities and cultural histories.

National standardized exams also present data about ethnic groups and their legacies. For example, the primary school examination (PSE), taken in students' final year of primary school (Standard VI) often has questions about which ethnic group is associated with certain languages, achievements, products, practices, or foods. In one 2006 PSE question, students were presented with an image which highlighted the annual cashew festival in Crooked Tree. The question states, "Use the table below to answer question 9." There is a picture with cashew nuts, cashew fruit growing on a tree, and a tub of cashew fruit and a label that says, "Cashew Festival Crooked Tree Village May 3 and 4 2005." The test question that accompanies the image is:

> Which ethnic group is MOSTLY associated with the above?
> a. Chinese,
> b. Creole,
> c. Garifuna,
> d. Mestizo.

The following test question was very similar:

> In which of the following areas has the *Chinese* contributed *greatly* in Belize?
> a. cattle ranching,
> b. forest conservation,
> c. poultry farming,
> d. retail business.

Such questions highlight and reinforce perceived differences and contributions of ethnic groups in Belize and a "culturally pluralistic" national narrative. However, syncretism in Belizean is also highlighted. The "Society and Culture" unit of the 2004 national curriculum for Standard IV states the importance of "portraying all the cultures which have been blended to create the multicultural Society of Belize."[27] Thus, students receive mixed messages in the classroom. They learn about ethnic identities as particularly distinct, compartmentalized entities, but that Belize is also a "blended" society.

The examples above demonstrate an often limited and unequal inclusion of contemporary ethnic groups in the national curriculum. The topics of history and tourism are similarly noteworthy. Although Globalization Period social studies education incorporates more information about Belizean history than curricula in the Colonial and Independence Periods, coverage by group is not equal. Kriol history continues to be marginalized despite being one of the largest ethnic populations in the country. While the 2001 and 2004 curricula include some topics ostensibly connected with aspects of Kriol history (for example, slavery, life on a slave ship, continental Africa, the logwood/mahogany industries), there are almost no explicit references to Kriol history, early Kriol peoples, connections between Kriol and African heritage, or past or contemporary Kriol cultural practices. I spent over a year conducting participant observation in Belizean primary school classrooms in predominately Kriol communities. In that time, I never witnessed teachers covering material related to slavery, colonialism, Kriol history and culture, or local community history in the broader context of Belizean history.

What I did observe was many teaching lessons focused on tourism, which is also a central aspect of Belizean society. The 2001 and 2004 national curricula focus on several aspects of tourism (for example, tourism resources, the importance of tourism to Belizean society, different types of tourism, preservation and conservation, and tourism careers). I observed Crooked Tree Government School (CTGS) and Biscayne Government School (BGS) students researching tourism jobs, designing tourism brochures, and giving presentations about cultural practices and festivals that attract tourists. Connections between Maya heritage (especially Ancient Maya history and culture) and tourism are particularly highlighted. For example, in the 2001 national curriculum for Standard IV, tourism is incorporated into several units and Maya ruins, artifacts, and clothing are listed as "Mayan contribution[s] to tourism." The 2001 Standard IV social studies curriculum outlines the ways tourism in Belize benefits from "Mayan achievements," but no other ethnic groups are identified as making explicit contributions to tourism. Ad-

ditionally, ancient Maya ruins are the only historical sites identified as tourist attractions in the 2001 and 2004 curricula.

The African and Maya History project (AMH), which included primary school textbooks and teachers' handbooks about Ancient African and Maya civilizations and modern African and Maya cultural practices, was designed in the early twenty-first century by history scholars, NICH institution directors, and NICH research officers with academic backgrounds in sociology, history, cultural anthropology, and archaeology. AMH texts were written and distributed to schools throughout Belize. There was an African Civilizations and a Maya Civilizations student's "handbook" and a teacher's "handbook" for the lower, middle, and upper divisions in Belizean primary school (for some examples see figure 1).[28] Additionally AMH project members created supplemental materials (for example, CDs of contemporary music and resource lists) and ran teacher training workshops. AMH was endorsed by the People's United Party (PUP), the political party in power when the texts were written.

More than half of the content of the lower division AMH books is on pre-twentieth century people. The texts on African heritage primarily highlight continental Africa with emphases on the geographic regions in the continent, ancient kingdoms and civilizations, and contemporary ethnic groups and communities in Africa and their history. Despite being an African diaspora ethnicity, Kriol history and culture are not covered much in the AMH texts, giving an impression that what is most important about Belize's African heritage is the history of continental African groups.

The AMH texts do focus on dispelling stereotypes about African and Maya people and highlight diversity within these groups (for example, there are a vast variety of African ethnic groups mentioned). Differing from the national curricula, the AMH texts also emphasize that although ethnic groups maintain many cultural practices and ideas, cultural practices also change over time. Both the African and Maya AMH texts discuss Belizean colonial history, including how colonialism and modern development issues have affected African and Maya peoples. To my knowledge, the AMH upper division African student handbook is the first primary school textbook to explicitly address the history of the African slave trade and some of the details of slavery in Belize (for example, the lives and work of enslaved peoples, slave revolts, life after slavery).

The AMH project addresses some disparities in Belizean social studies education and incorporates histories of groups who had long been excluded from British-centric education. But there is limited material in the AMH texts relevant to the lives of contemporary Belizean ethnic groups. Instead,

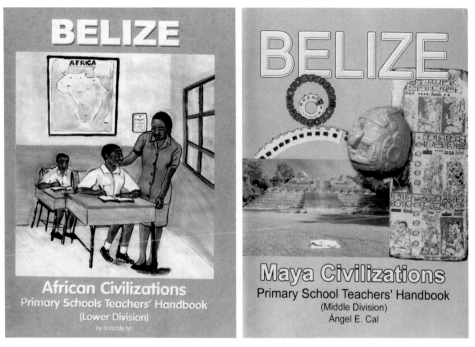

Figure 1. (*A*) and (*B*) are examples of African and Maya History Project texts. Published by the Ministry of Education, Culture and Sports, Belmopan, Belize.

the AMH texts center largely on ancient and historic populations or non-Belizean populations. Roughly 60 percent of the Maya textbook content is focused on ancient and pre-twentieth century Maya history and culture. And, although about 55 percent of the African texts focus on contemporary peoples, more than 95 percent of that content is on groups in continental Africa. The history and culture of African diaspora groups in Belize (for example, Kriol and Garifuna peoples) is particularly insufficient in the AMH texts. There are only a few references to Garifuna peoples and seven pages total out of 240 on Kriol culture and history.

Impacts and Implications of Education on Culture and History

While during the Globalization Period Belizean education has moved beyond British-centric models of the Colonial Period education, curricula, and programming continue to essentialize and compartmentalize ethnic groups, and marginalize Kriol culture and history in particular. Laurie Medina argues that the ways ethnic and racial categories are naturalized and essentialized in

political discourse "obscure the human agency, historical contingency, and power involved in their making and remaking."[29] As I demonstrate, these issues clearly extend to the essentialism of culture in educational contexts. Additionally, although some aspects of Belize's diverse and vibrant local cultures are promoted in education, not all cultural groups are equally represented. Citizens learn through school curricula, visits to archaeological sites and museums, and national symbols, that certain forms and themes of culture and history are especially significant to Belizean heritage. Repeatedly seeing the culture and history of other communities highlighted over their own, many Kriol people I interviewed remarked that Maya and Garifuna groups do a better job maintaining their cultures. These sorts of ethnic comparisons, tensions, and concerns were what state heritage and education actors were hoping to avoid when designing education materials focused on culture and history.

Limited representations of Garifuna and Kriol culture and history in Belizean curricula have also been shown to negatively influence youths' ideas about themselves. Research by social scientists Karla Lewis and Nancy Lundgren suggests that limited representations of African descendant history in educational materials perpetuates ideas that the culture of other groups is more important than their own and encourages young Garifuna and Kriol people to internalize racial hierarchies.[30] Additionally, the syncretic and culturally pluralistic visions of Belizean national identity represented in educational contexts that celebrate unity and diversity do not make space for the ways that colonial history, racial ideologies, cultural exchanges, and globalization have influenced specific cultural identities in the country.

A result of this situation in Belize is a kind of no-win story of cultural dynamics. Groups whose cultural practices were discouraged and discriminated against for centuries found ways to adapt to the colonial model by learning Standard English, assimilating to British practices, and integrating cultural practices from the many groups who make up Belize's cultural fabric. But the complexities of their resulting rich vernacular heritage practices (for example, the ways they combine African, Caribbean, Mestizo, and American language, music, foodways, and even fashion) were not integrated into the 2001 or 2004 national curricula or the AMH educational materials. Ironically, these groups are then blamed for not maintaining their cultural identities and practices in the present, as essentialized cultures and histories have become valuable assets.

The Belizean situation is similar to issues Deborah Thomas discusses in cul-

tural education and programming in Jamaica in the late twentieth century.[31] She argues that in spite of the goal for educational programming to promote a more holistic and dynamic definition of culture, "two rather static visions of culture emerged as paramount: culture as possession and culture as either positive or negative."[32] As Thomas demonstrates, Jamaican cultural education materials and programming presented culture as either a problem or tool for development. She suggests that Jamaican cultural actors expressed concerns about the "loss of culture" caused in part by a decline in moral values and the influences of globalization.[33] And, instead of highlighting the dynamic nature of Jamaican culture, some forms of culture were promoted as more authentic and positive (for example, folk practices) than others (for example, popular culture).[34] Later, I describe similar characterizations and essentialization of Belizean culture that create a kind of hierarchy of cultural practices and identities in the minds of teachers and youth, and reinforce fear about the "loss of culture."

Essentialization of culture and the expectations of different cultural groups frequently came up in my casual conversations with Belizeans. On one occasion, when I was talking to Miss Evelyn, a prominent community figure and business owner in Crooked Tree about a shop she used to own in the city, she expressed frustration that the Chinese-owned store next to hers was outcompeting her business. She was worried that no one would come to her shop because the Chinese-owned store sold a diversity of products and people could get everything they needed in one place. Miss Evelyn explained to me that the Chinese people were selling fruit and vegetable produce, which she depicted as stepping outside their cultural role. She proceeded to tell me that "everyone knows" that Chinese people sell dry goods and packaged foods and that it is the role of "Spanish" (Mestizo) people to sell fruit and vegetable produce. Such stereotyping has made it difficult for Belizeans to embrace, articulate, and understand cultural fluidity.

In the following section, I expand on some of the impacts and implications of education as a heritage institution and examine the interplay between early twenty-first century formal education and Belizean citizens. I demonstrate the ways Belizean teachers and young people in two Kriol communities have responded to and navigated official heritage discourses revealing that at times they have replicated cultural and racial stereotypes and ethnic divisions. But I also explore how they have resisted education, manipulated the social and economic development rhetoric of heritage, and made sense of constructs of culture and history on their own terms.

Kriol Community Responses and Resistance to Education about Culture and History

When I first started working in Belize, my primary research goals were to understand the ways local citizens internalized and negotiated state heritage agendas that were embedded in the structures of education and archaeology, as well as the impacts of external programs like university-directed archaeological research. As a heritage scholar trained in qualitative research and ethnographic methodologies, I felt that the best way to gather local voices and perspectives was to focus on a specific case study. The implementation of explicit national education initiatives focused on culture and history (for example, the AMH project) in the early twenty-first century as well as the over 20 year history of public archaeology through the Chau Hiix Archaeological Project (CHAP) made the rural Kriol community of Crooked Tree Village an ideal research site. Plus, Crooked Tree had an active Government School (CTGS), where teachers and youth had long been primary audiences for cultural education and public archaeology efforts carried out by national heritage institutions in Belize and the CHAP.

I have been working with educators and school children in the Kriol village of Crooked Tree since 2005, when I joined the 2005 CHAP field season for six weeks. In addition to participating in archaeological excavations at Chau Hiix, I spent several days a week with Standard IV-VI students[35] at the CTGS teaching lessons about Maya archaeology and talking with students about archaeology, culture, and history. I organized an Open House field trip to Chau Hiix for the CTGS students, during which they visited the archaeological site (which they call a ruin).[36] In 2007, I returned to Crooked Tree to continue working with the CHAP and CTGS. I developed after-school arts and crafts activities and organized a field trip for students to the Museum of Belize and Old Belize, a history-themed, privately owned cultural center.

To add a comparative examination of cultural education in school, I started working with the Biscayne Government School (BGS) in 2008. I spent the majority of the 2008–2009 school year conducting participant observation in Standard IV and V classrooms at CTGS and BGS. I focused on educators who are both agents of the state and community leaders and role models for young people. And I worked with young people because they are vessels of cultural transmission and active cultural agents. In total, I conducted interviews with sixteen teachers, interviews with multiple cultural actors involved in local tourism and education initiatives, base-line interviews with sixty-eight students at the beginning of the school year (forty-three from CTGS

and twenty-five from BGS) and follow up interviews with about a third of the students.[37] Throughout the year, I participated in school activities and events and travelled with the Standard IV and V classes to sports events, academic competitions, and festivals. I learned the schools' daily routines, observed a range of subjects being taught, and enjoyed getting to know the teachers and students.

Teachers Interpreting and Negotiating Heritage Discourse

In Belize, the structure and content of the social studies materials encourage teachers to teach state approved lessons about history and culture, but teachers also grapple with how to express the complexities of these topics for themselves and their students. Though many state education and heritage programs promote a message of Belize as a diverse country made up of many distinct ethnic groups—*aal a wi da wan* (we are all one)—teachers recognize that due to colonial histories, racial hierarchies, and the ways that cultural practices and identities are unevenly promoted, the situation is more complex than a harmonious, apolitical syncretic multiculturalism. Teachers struggle to negotiate mixed messages about cultural difference but also thrive in providing their own forms of culture and history to students, demonstrating ways that hegemony is "continually resisted, limited, altered, and challenged by pressures not all its own."[38]

"Each Culture Have Their Own Identity"

As noted above, the Belizean Primary School Social Studies Curricula present a form of liberal multiculturalism that reify and compartmentalize cultural identities and practices. Curricular materials and events like ethnic days and cultural festivals encourage thinking that culture is a possession, that ethnic groups can be divided into mutually exclusive categories, and that each group's identity can be boiled down to a small set of traits, such as their food and dance.

Teachers often conform to this authoritative multiculturalism in the classroom. I observed teachers instructing students about Belizean ethnic groups by presenting them with lists and tables of "typical" traits and overt features such as the clothing, food, and language associated with different Belizean "cultures." Students were meant to memorize and later recite these cultural traits. As an example, teachers encouraged students to learn that Maya peoples (ancient or contemporary) eat tortillas, wear brightly colored clothing and are mostly farmers; Garifuna people were associated with eating "ground food,"[39] wearing brightly colored clothing, and being fishermen. Kriol people were not

always included in these lists, but when they were, they were associated with eating rice and beans and stewed chicken.

When I asked teachers about the value of students learning about different ethnic groups, they reiterated an understanding of culture similar to that found in official state heritage discourse. They suggested it was important for youth to learn to identify "who is who" and "which groups do what" to understand the cultural makeup of their country. Teacher Melecia stated:

> It's important for them [students] to learn about ethnic groups, because, you know we know who is a Mestiza and who is a Maya and what they eat and stuff. We should even be able to say that, we know the Mestizos usually [eat] all those food from corn and stuff [. . .] But I think everybody here really in Belize know about the different culture and what ethnic group they belong to.[40]

Essentializing culture in this way can promote stereotypes, some of which are similar to colonial racial ideologies about work ethic, labor, and class. In several conversations I had, Crooked Tree and Biscayne teachers and community members lamented a perceived loss of self-sufficiency and self-motivation in modern Belizean society, and specifically among Kriol people. The Crooked Tree and Biscayne teachers argued that people discontinuing farming practices and relying on modern conveniences instead of "doing things for themselves" has caused extensive social and economic problems in their communities like apathy and inconsistent employment. Teacher Albert, a senior teacher at CTGS, well-respected member of Crooked Tree, and resident history expert, frequently expressed frustrations that his students were not motivated or acted too *bushi* (bushy).[41] Teachers also referenced their concerns about parents' laziness. In a conversation with Teacher Melecia about Belizean education, I asked her what role she thought parents and family can and should play in a child's education. She said some families have difficulty being involved in their child's education due to their busy work schedules, but then went on to express frustration:

> Some parents just don't put the effort in helping the children [. . .] some of them try to help, but others, really and truly, Miss Alicia, I don't know why [they're not involved]. [. . .] I don't know why some parents don't help, but I think some of them is just lazy.[42]

Often after hearing Kriol people described as lazy, *bushi,* or poor workers, I heard Maya and Mestizo people described as hard-working and self-sufficient.

Business owners in Crooked Tree told me that they preferred to hire Mestizo and Maya people rather than villagers because they worked harder. Teacher Albert utilized such language of blame in his discussions about youth performance in school, suggesting that it was their responsibility to work harder and be more productive citizens in order to better themselves, their ethnic group, and their community.

Essentialist approaches to culture and ethnicity in educational contexts also do not address the multiplicity and fluidities of identities, which can lead to confusion and frustration in a country like Belize that has such a complex cultural history. I observed manifestations of this confusion when speaking to people about their concerns about cultural change, mixing,[43] and the impacts of globalization on culture.

Some teachers I interacted with found it difficult to discuss and teach about Belizean cultural diversity and blending of practices across ethnic groups because of broader structural and ideological constraints. Teacher Ranicia—who is an important community leader and has been the principal at Biscayne Government School for over ten years—expressed to me concern about youth in Belize, and on many occasions talked about how youth were significantly different from when she was a child:

> I think the Kriols lost their sense of identity because they mix with all the other ethnic groups and they don't practice their own culture [. . .] I think the younger generation lost touch completely. They don't know what to do. They don't know what the Kriol culture is all about.

Later in the conversation, Teacher Ranicia continued to discuss concerns about mixing.

Interviewer: Do you think they [students] need to learn about different cultures, different groups?

Teacher Ranicia: Yes, we need to learn about different groups. Although, I think it's _ We need to move away from the groups because right now we don't, I don't see a big division in groups anymore.

Interviewer: So, because there's mixing you think that it [education] needs to be less focused on particular groups.

Teacher Ranicia: Yes. Because how can I tell a child this is a Mestizo, or this child is a Mestizo and that child there is a Mestizo mixed with Kriol? What will that child be? Which ethnic group will she identify with?

Interviewer: But how do you teach about those groups without, you know, separating?

Teacher Ranicia: We try to separate with the_ If you have a mother and a father that are Mestizo then you are Mestizo.

Interviewer: Right. But like it makes it harder, would you say to teach about the mixing?

Teacher Ranicia: Yes. We don't get into the mixing because the mixing will be a problem because one child could have a Garifuna mother, a Mestizo [parents] and they have Kriol grandparents. So, it's, how will I tell that child you are Kriol or you are supposed to be a Garifuna and then the child come out like. Because of the mixing the child comes like an East Indian [. . .]

When they have too much mixing it will be hard for them to figure out who they are. [. . .] sooner or later I think if we don't stop mix we'll have just one big group. No Kriols, no Mestizos no -

Interviewer: And why is that a bad thing?

Teacher Ranicia: To preserve the richness of the country I think we need to keep a certain identity and each group, each culture. Because each culture have their own identity [. . .] we need that.[44]

Teacher Ranicia's comments about mixing demonstrate her struggles and her perceptions of students' struggles with thinking and talking about cultural difference, ethnicity, and identity. She identified several distinct ethnic groups and suggested that different groups have their own identities. However, she also recognized that cultural and personal identities do not fit the format of prescribed ethnicities embedded in education materials and official public discourse. She was limited by official language and models of cultural diversity and ethnicity she encountered in society and curricular content. Additionally, Teacher Ranicia was influenced by problematic racial ideologies as she linked physical appearances with ethnicity in her references to how a child "comes out." And Teacher Ranicia suggested that the mixing of cultures makes it difficult to teach students about culture and difficult for them to make sense of their own identities.

Kimberly Simmons identified similar dynamics in her work on peoples' negotiations of racial identities in the Dominican Republic. Simmons notes that Dominicans acknowledge their blackness and racial and ethnic mixedness, and are aware of their cultural practices with African origins, but find it difficult to articulate the complexities of their African heritage given the state's historical efforts to erase an African past from official constructions of Dominican identity. Like Belizeans, Dominicans frequently racially categorize each other, but also struggle to express complex aspects of culture and history.[45]

Creole, by definition, refers to a combination, hybrid, or mixture. In the case of Belizean Kriols, the term specifically refers to an ethnicity that resulted from the complex history and cultural exchanges between African peoples (free and enslaved) and European colonizers. These exchanges, along with an extensive history of interaction between Kriol people and other Central American groups, has led to a rich mixture of diverse cultural practices. Yet in her commentary, Teacher Ranicia identified "mixing" as at least partly a problem.

The exchanges of people, ideas, and goods that come with globalization further complicate the ways teachers understand and instruct about culture. Commenting on "the international networks of people, ideas and goods" involved in globalization, Melissa Johnson suggests "Belizeans, including residents of Crooked Tree, have a lot to say and express about what the world means to them, about things they want to incorporate into their lives and what they wish to exclude."[46] Many Belizeans recognize that having family in the United States can be useful as they have access to resources like clothing and financial support sent as remittances back to Belize and Belizeans engage with cultural practices and resources from a range of United States contexts in a variety of ways. However, at the same time, Belizeans I spoke with are concerned that young peoples' interests in American music or sports might replace their knowledge of Belizean music and traditions, thus threatening Kriol cultural autonomy and sustainability.

Explicit concerns about globalization appear in teachers' comments about cultural identity and education. In interviews, teachers' discussions about the influences of globalization often implied that Belizeans (especially Kriol people) were more "traditional" in the past when they were more isolated from global forces. Belize is part of the racial, cultural, political, and economic exchanges that exemplify the Atlantic World, through such forces as slavery, colonialism, resource extraction, and tourism. Thus, cultural traditions in Belize are more the result of interaction than isolation.[47]

Nevertheless, acknowledging this history is difficult. To do so would require dealing with the complicated intertwined histories and cultures of the Atlantic World, addressing how and why places and people came into contact, and examining the resulting power imbalances, legacies of exploitation, and inequalities. For example, the people who established Crooked Tree village were people of European descent and free and enslaved people of African descent. The descendants of these founders were engaged in the logwood market or were small-scale landowners. This means that many contemporary residents are the descendants of enslaved people and those who exploited them, a fact that can be difficult to unpack in the classroom.

"They're Fastly Forgetting Their Culture"

Many teachers I spoke with expressed concerns about the future of Kriol identity and referenced cultural loss. These comments echo state heritage discourses, which contain reified versions of culture that promote the idea that heritage is a possession. Teacher Ranicia suggested to me that young Kriol people "lost their sense of identity," "lost touch," and "don't know what the Kriol culture is all about." Teacher Melecia expressed concerns that technology could lead to a loss of knowledge about local cultural practices and history and indicated that many young people in Crooked Tree were unfamiliar with local history because teachers do not cover it in schools. She said,

> at least a history of the village should be taught to children. And all they [children] can say, "Oh, I live in Crooked Tree." [But if someone asks] "What's the population of Crooked Tree?" [children say] "I don't know." [If someone asks] "How did Crooked Tree get its name?" [children say] "I don't know." [If someone asks] "Who were the first people who lived in the Crooked Tree area?" [children say] "I don't know." The only thing they know [is] that they live in Crooked Tree village.[48]

Teacher Melecia argues that if more locally relevant information was taught in school, kids would know where they came from, which she considers necessary on a cultural and individual level for students. In other words, she acknowledges a deficiency in the way heritage is dealt with in the curriculum, and in her own practice as an enculturating agent.

Another unfortunate result of the colonial history of essentialist notions of culture and the marginalization of Kriol heritage, is that teachers blame the loss of Kriol culture on Kriol people or sometimes fail to recognize the richness of vernacular Kriol heritage. Though teachers never suggested to me that Kriol people did not have unique culture of their own, when talking about Kriol language or other practices, some implied that Kriol people are more susceptible to outside influences than people in other groups and even that Kriol culture is less prominent or "authentic" than that of other ethnic groups.

Teacher Albert frequently expressed concerns to me about his students and the future of Belizean youth, together with his perspectives about politics, education, and globalization. In an interview, he argued that young people are "fastly forgetting" and "losing" their culture, and implied that in the past people in Crooked Tree maintained their culture more:

> Back in our days, the only thing we used to listen to were our parents. Nowadays children have television to listen to, they have all this enter-

tainment, um, to listen to and stuff like that, music and stuff like that, that they're fastly forgetting their culture [. . .] Every day they're losing it, and they're more into this { } American thing.[49]

And when asked about differences in cultural sustainability between different ethnic groups, Teacher Albert also suggested that the Maya were better at preserving their heritage,

Mayas tend to keep within their culture, keep within their tradition. [. . .] Quite a few of them have traveled out of their community to be in secondary education. But then, what? They go back and impart their knowledge to their people, and you know try to be humanitarians [. . .] but what have Kriol achieved? Nothing. All of them [young people] want to sing [. . .] Hannah Montana, you know, and stuff like that. [. . .] Secondly, a lot of the Kriol population have migrated to the US, where, um, the family that stays back in Belize depend a lot on them. So, um, the clothes we wear, [. . .] everything is Americanized, you know?[50]

Leena Garbutt, a scholar of Kriol language and culture and a leader in Kriol education, also spoke to me about culture loss. Garbutt described the efforts of certain groups to maintain their culture in the context of "pervasive" American influences:

Leena Garbutt: It's in the Maya culture you're seeing the young people coming out. You're seeing like the little, your young . . . it's not just the older Maya people anymore. Its young Maya people coming out with this {land rights}, and so we have to _ We, the other cultures _ have to find a way to get our youth impassioned the way I think the Maya culture is.

Interviewer: Yeah, why you think that is, too, that? _

Leena Garbutt: I don't know. Maybe, can we say the Maya still somehow are the least influenced by American culture? [. . .] Because American culture is so pervasive. I mean, in both Garifuna and Kriol culture the biggest influence you see is Americanism. And [. . .] families still migrating.[51]

Many Belizeans I spoke with suggested that certain cultural practices were more "legitimate" or "authentic" than others, such as Maya clothing and Garifuna food. In speaking with educators, it became clear that there are mechanisms and practices perceived as particularly significant markers of cultural legitimacy and sustainability. Interviewees told me other groups did things to maintain their identities like "keeping within their own culture," having na-

tionally recognized holidays and festivals, wearing "traditional" dress, making claims to land, and "going back to impart their knowledge to their people." In a discussion about how groups promote their identity through cultural practices, Teacher Melecia told me "you will see little Garifuna's in their little dress and their suit tie." Teachers also expressed frustration that there is a national Garifuna Day holiday, but no Kriol day—a direct critique of national government cultural recognition and preservation efforts.

Who or what is to blame for the perceived loss of Kriol culture? As I noted previously, teachers sometimes blame youth and their families for allowing American media to influence them. They also imply that older Kriol citizens are failing by not making strong enough attempts to pass on and preserve cultural knowledge and practices. Teacher Ranicia told me: "the older generations are not teaching [cultural traditions and practices] to the younger ones. So, I think that's the biggest problem."[52]

Similar to state heritage actors' concerns about the impacts of colonial history on Belizeans, Teacher Albert attributed what he perceived as a "deterioration" of Kriol culture to Belizean Kriol's "colonialized" minds. He said that Kriol people historically were taught to embrace everything British and reject everything Kriol, including language, traditions, music, and dance. In contrast, Maya people, he said, "stick to their culture." To emphasize the importance of education related to culture and history Teacher Albert said, "I like teaching about ethnic groups, especially strong ones" and suggested that texts about Ancient Maya civilization might influence his students to think more about their own culture. He believed that as his students learned about Maya heritage, they would be influenced to preserve their own culture and history and might be more motivated and engaged in school.[53]

Teacher Albert and the other teachers care deeply for their students and work hard to help them succeed in the classroom. However, teachers' ideas about Kriol cultural loss are disconcerting for several reasons. Although Teacher Albert recognizes the ways colonialism has shaped ideas about cultural identity, he and other teachers still place some blame on Kriol citizens for their societal positions and the state of Kriol culture and history today. Teacher Albert's suggestion of the need to promote a "strong" culture is also a value judgment about the nature of culture that reinforces social hierarchies established during colonialism, when Kriol culture was negatively stereotyped, considered somehow less legitimate because it was "mixed," or was not recognized at all.

Interestingly, when Belizeans expressed concerns about young people "forgetting" or "losing" their culture, they never mentioned language. This is in-

dicative of the complicated place Kriol language has held in Belizean society. While it has been discriminated against since colonial times as "broken English," Kriol developed out of the intersections of diverse groups in Belize. For a long time, Kriol has been a kind of de facto lingua franca, and today it could be considered an unofficial national language. Additionally, the perceptions about Kriol language held by Belizeans I worked with reveal ways they navigate between official heritage discourses and practices and vernacular heritage. Teachers discouraged the use of Kriol in the classroom, but they also maintain strong Kriol linguistic practices.[54] Additionally, people in rural Belize River valley villages have reputations for more "authentic," "broad," and "real" Kriol,[55] but also *bushi* (bushy) Kriol or "bocatora language." Such characterizations of Kriol are both derogatory and markers of pride.[56] The continuum of Kriol that exists in Belize is tied to historic factors and racialized identity politics in Belize,[57] but "broader" Kriol in rural contexts is not simply the result of historic isolation; it is also the result of intentional cultural persistence. People in Crooked Tree speak broad Kriol to assert identity, as a socialization tool, to reinforce and maintain social and familial ties, and to navigate power dynamics, all with recognition of the historical politics of language and discrimination of Kriol.[58]

"Many Teachers Rejected the AMH Curriculum"

As much as I witnessed teachers replicating notions of culture and history that were colonial legacies or tied to nationalist discourse, I also witnessed them negotiate and transform official heritage discourse and ideologies. Specifically, teachers expressed frustration with the education system, were selective about the content they cover and educational programming they engage in, and advocated for their communities and students.

Belizean teachers I worked with shared a variety of frustrations with educational programming related to culture and history. Teachers repeatedly told me they are overwhelmed by the amount of information they are expected to cover in their classes and said the current curriculum is already too packed and there is not space for new initiatives. Referencing the African and Maya History project (AMH), and other Belizean social studies initiatives, a school principal from western Belize, Keesha Young, said,

> [The curriculum] is too packed and this is the reason that principals do not push it [the AMH curriculum]. They have been teaching about African and Maya cultures for years and this is a new twist [. . .] But principals are concerned that they have lost a focus on the basics, reading, writing, and arithmetic and there is too much focus on other things.[59]

Other teachers expressed more concern with how to teach about culture and history, rather than fitting those subjects into the curriculum. Though interested in social studies topics, some teachers told me that social studies is their least favorite subject because they felt they did not have the appropriate tools, training, or materials to teach it effectively. For example, I was told Belizean textbooks and curricula did not include enough engaging activities. A few teachers even told me the training workshops designed to prepare them to integrate the AMH materials into their classrooms were "boring." Though teachers never told me explicitly that they found social studies materials irrelevant to their own cultural practices and identities, I think this was another reason why they resisted education content and programming related to culture and history. Deborah Thomas found similar forms of resistance among rural Creole residents in the Jamaican village of Mango Mount. She argues that Mango Mount community members expressed ambivalence about state-sanctioned cultural programming, including efforts to revitalize Emancipation Day in the late 1990s, because the forms of African heritage and identity promoted through state institutions did not resonate with their lived experiences.[60]

Belizean teachers' concerns about a tight curriculum and limited resources are valid, particularly for those in rural, government schools. As there is no single required social studies textbook, teachers are expected to consult a range of texts identified in the curriculum, but they only have consistent access to some of these. Additionally, new materials are often presented to teachers by education administrators without thorough explanation of how they are different from previous ones. Such a lack of explanation and preparation with the AMH materials was acknowledged by Christina Pop:

> And a lot of [the teachers] saw it as a lot of extra work [. . .] a lot of teachers had **no information none** [. . .] teachers said yeah you're givin' us the content but we want to know how to teach it. We need lesson plans [. . .] Teachers aren't really happy with that [lack of training and resources] [. . .] I don't think they [the teachers] were clear on why it was being brought into the system to begin with.[61]

Belizean teachers are understandably selective about what they teach. Some teachers I observed chose to limit social studies education, particularly related to topics like slavery and ethnic tensions. Others chose not to utilize new curricular materials. I only witnessed Crooked Tree and Biscayne teachers using AMH materials a few times in years of observations in schools. In fact, in several classrooms I noticed the AMH textbooks stacked in corners where they remained for months. On one occasion I was at CTGS when it was announced

that AMH curriculum designers would be visiting in the upcoming week to observe the implementation of the AMH project. I witnessed one of the teachers pull together a lesson plan based on AMH materials the day before to make it appear as if he had been using these materials all along.

By choosing not to use materials or participate in various education programs focused on culture and history, teachers express their aggravation with the lack of government support for schools. This resistance is also a way of teachers asserting their power and authority in their schools and communities. Talking freely and frequently about their frustrations and challenges, teachers used a discourse of frustration as subtle forms of everyday ideological resistance to government institutions and cultural, racial, and economic inequalities.[62]

When teachers did use AMH materials, they did so on their terms in ways that were likely unintended by the curriculum creators. For example, I twice observed the AMH resources being used by Teacher Albert. Teacher Albert often asked me questions about archaeology, enthusiastically engaged in class visits I sponsored to the Chau Hiix site, the Museum of Belize, and Old Belize, and was interested in educational materials about Belizean culture and history. Occasionally, if Teacher Albert had extra time at the end of a lesson or a long day, or simply wanted to try out a new activity in class, he used supplemental AMH materials he acquired in one of the implementation training workshops. On one day, he had the students listen to a contemporary Belizean Maya group talking about their language and singing songs in a Maya dialect. This was not intended to be a formal educational lesson; it was simply a fun activity to pass the time. Though the students seemed to enjoy this, and likely learned something, several also giggled when they heard the unfamiliar voices and language on the CD. Teacher Albert did not respond to their amusement.

As noted previously, teachers I worked with struggled to teach about culture, in some cases leading to fear of the loss of Kriol culture. In spite of these concerns, some teachers I spoke with recognized the persistence of Kriol heritage in their communities and advocated for increased knowledge among young people about their own culture and history. Several older teachers mentioned the fact that in the past, village elders used to visit the elementary schools to share narratives about community history and lamented that this no longer happens.

Speaking Kriol in the classroom is another way that teachers negotiate official heritage discourse and ideologies and maintain vernacular Kriol heritage. For most instruction, teachers used Standard English and they chastised students for using Kriol in the classroom. The majority of teachers I asked told

me they did not think Kriol should be taught in schools. However, teachers frequently switched to Kriol in the classroom when they disciplined students, wanted to emphasize a point, or discussed local cultural practices or events. Additionally, teachers freely spoke in Kriol in their interactions with each other as they spoke about family and community concerns or expressed frustration with the local and state government.

The process of switching between languages based on perceptions about the most appropriate language for a context is defined by social scientists as code-switching. But Kriol linguistic practices go beyond simple code-switching. As Melissa Johnson suggests, "Belizean Kriol is replete with double meanings, and talking Kriol is often a self-conscious, performative, and competitive act."[63] The Kriol language is a powerful example of cultural sustainability and agency, and is used by Belizeans as a tool for resistance and negotiating social relationships and power dynamics in ways that are common in many Afro-Caribbean contexts.[64]

Despite decades of colonial attempts to reduce the usage of Kriol in school contexts and deny Kriol as a language, teachers in Crooked Tree and Biscayne continue to see it as more appropriate for certain contexts of education, speak Kriol with their peers, and continue to transmit it to their own younger relatives. William Salmon and Jennifer Gómez Menjívar who studied language opinions amongst Belizeans of diverse ethnic and class backgrounds in Belize City and Punta Gorda, noted that 100 percent of "respondents said that Kriol should be spoken on the streets and with family but that English should be spoken at school, the workplace, and in more formal settings [. . .] [However] Belizeans do speak Kriol at school and in the workplace; they just do so with other speakers of Kriol."[65] Belizeans have become adept at employing language for social and political reasons. Such language negotiations are particularly strong in rural Kriol communities. In Crooked Tree and Biscayne, people have long engaged with outsiders like me. When people choose to speak Kriol is a purposeful choice, which at times rejects social orders while at other times conforms to them. Each choice reinforces Kriol vernacular heritage practices. For example, when frustrated with government institutions like the Ministry of Education, teachers I worked with spoke quickly and loudly in Kriol. Nevertheless, they still taught the standard national curriculum, and emphasized the importance of young people learning proper English. When at school and in formal interviews with me, teachers often spoke in Standard English. But when I visited them in their homes, they gossiped and shared family stories in Kriol. Today, in my interactions with people from Crooked Tree and Biscayne who have known me for years and who I consider friends and family, I often find

people "catching" themselves speaking in Standard English, and then promptly switching to Kriol, in part to reinforce our social ties.

Though few teachers I worked with advocated for Kriol language instruction, some advocated for more Kriol history to be included in the curriculum. Teacher Melecia specifically advocated for the incorporation of more content about local history and even slavery in the classroom. She said,

The most important thing the kids should learn today in school is about our history [. . .] our children need to know who was our first ancestors [. . .] But I think the main thing that we should learn is our history about the slaves, and our Mayas [. . .]

Interviewer: And why do you think that's important for kids to learn about that stuff?

Teacher Melecia: Um, for example, we live right here in Crooked Tree, right? And Chau Hiix is right here, back there. And [. . .] if we don't educate our children about who the Maya was and the stuff that they used, you know, the jades and the () pots and stuff, one of these days, you know, they might put another foundation for a house and they might find stuff [. . .] And then the slavery. We need to know about slavery and about what the peoples have done, do to our ancestors and stuff like that, you know? Because even in slavery a lot of people [. . .] a lot of Americans still treat, you know, dark people like slaves, you know? Even () rich white people will have maids in their home, but they will get dark people to be maids. It's because they still have this mentality that, you know, they can treat those people how they want. And if we're educated about the slavery, you know one of these days you might not have all the education and stuff and you get one of those jobs, at least you know what's right from what's wrong. They can't treat you how they want.

Interviewer: Why do you think that stuff has been limited in the curriculum for so long?

Teacher Melecia: I think what happen is, um, people start living in the future. You know, we don't really live in the past, and the history of the Mayas and the slavery, that's in the past. So, it's like they're trying to, you know, forget it.[66]

Though Teacher Melecia never explicitly made the connection between Kriol history and the history of slavery, she implied these connections and it is clear that she felt strongly that Belizean students should learn more complicated aspects of their history in schools. Although Crooked Tree residents rarely talk about slave history in the classroom and rarely mentioned it in interviews

with me, they are well aware of this history. People mention it in informal discussions about local history and in references to skin color differences in the village. Additionally, slavery is alluded to and explicitly mentioned in popular culture.

Teacher Albert also shared concerns with me that his students did not know enough about Kriol history and said things like "you have to know where you come from," and youth "need to know their history." Teacher Albert relayed stories to his students about what it was like growing up in Crooked Tree several decades earlier. When assigning homework, he talked about doing his own homework by gas lamp and later by generator-powered electricity. When Crooked Tree students visited museums and cultural centers, Teacher Albert made connections with material culture on display, pointing out artifacts like mahogany baking and bathing bowls and cast-iron hand irons that were central features of his childhood. Teacher Albert's stories about "the Olden Days" were familiar lessons about the hardships of the past tantamount to classic "walking uphill both ways to school" stories one might hear in the United States. But Teacher Albert's stories were not solely didactic, grumpy clichés. They also had hints of nostalgia and urgency.

Youth Interpreting and Negotiating Heritage Discourse

Like teachers, young people receive messages about the values of culture and history and what it means to be Belizean through national curricula taught in schools, programming at historic sites, and lessons learned at home from community and family members. Such programming shapes young peoples' concepts of themselves, their fellow citizens, and their history. But like teachers, youth are active agents in these processes. They learn more than the specific curricular content conveyed, and employ this knowledge when making sense of their own cultural experiences. Education scholarship has shown that youth often struggle to integrate school knowledge and other narratives about culture, race, and history with the realities of their own identities and experiences. Young people negotiate the messages about identity and cultural politics they receive from school and other contexts (for example, family, friends, popular culture, religious institutions) to create meaning about themselves and the world around them.[67]

In observations within and outside of school, and in interviews with Crooked Tree and Biscayne youth, I found that youth had little difficulty replicating school versions of cultural identities as they memorized facts about ethnic groups. However, in some cases students found it difficult to process school versions of culture because of their personal experiences, multiethnic

backgrounds, and exposure to other forms of heritage knowledge, such as family histories. As a result, when asked about culture and history, at times youth confused ethnic groups, added personal anecdotes to their interpretations, and described culture and their own identities in creative ways.

"We Have Not Gotten Our Maya Notes Yet"

The state heritage discourse of culture being a set of distinguishable and static traits of a group of people was replicated by many students in our discussions. When asked to define culture, some students referenced specific groups of people (most often Garifuna) by listing the traits they memorized for school, such as their dress, food, music, and dance. When I asked students what they had learned about Belizean history one student (Robert) responded: "How *dehn* (they) dress how they eat, what they eat."[68] Another student, at my first mention of the word culture in an interview, began a seemingly unrelated commentary about Andy Palacio, a famous Garifuna singer who died earlier that year, and then proceeded to define culture as language, singing, and dance.

As noted, rote memorization and recitation are two common school techniques for students to learn about culture. When trying to recall information about cultural groups, several students mentioned this pedagogical approach, which students often referred to as receiving notes.[69] Students mentioned such "notes" when talking about cultural groups, such as the Maya:

Interviewer: Where have you learned about, history and that kinda thing?
Shaleen: In our notes { } *wah* (that) teacher give *wi* (us).
Interviewer: Yeah. Some in school too yeah?
Shaleen: [. . .] *wi no get wi* (we have not gotten our) Maya notes yet.[70]

Just as the teachers did, youth also identified dress as a significant marker of ethnicity. This association makes sense considering government-sponsored education practices like ethnic days and cultural festivals, during which students wear clothing associated with different ethnic groups. Dress also features prominently in representations of culture in Belizean museum exhibits and tourism brochures. When I asked what they knew about different ethnic groups, students often referred to the kinds of clothes they thought these groups wore in the past or currently wear. For example, some students suggested to me that the Maya covered themselves in things made from natural objects including clothing made of animal skins, leaves, and coconuts, as well as body paint. And I heard frequent mention of Maya and Garifuna people wearing brightly colored clothing.

On one occasion when I was talking with a few CTGS students before classes

started, Miss Vanessa, a prominent Crooked Tree resident, arrived to lead daily religious devotions at the beginning-of-the-week assembly. Occasionally, Miss Vanessa wore clothing with bright African prints. One of the students (Linda) saw Miss Vanessa from afar but did not recognize her. On seeing Miss Vanessa's clothing, Linda shouted without hesitation, "*Bwai* (boy) Garifuna suit!" I was struck by the uninhibited way she commented about an elder's dress. In the United States this might have been considered ethnically insensitive (perhaps the equivalent of yelling "Wow! African suit!"), but it was not thought of that way in Crooked Tree.[71]

Students also shared the teachers' feelings that national holidays focused on specific ethnic groups are important symbols of identity and recognition. In commentary about her mixed background, a student of Kriol and Garifuna heritage told me that "Kriols talk a { } good language. And Garifuna [. . .] We have a **day**. Like Garifuna Settlement Day.[72]

Young people certainly picked up on adults' anxieties about cultural loss. One particularly articulate and thoughtful student who is the son of a teacher discussed his concerns that his culture is disappearing and blamed outside influences and modern conveniences for cultural loss:

Dean: Our culture is like disappearing [. . .] Yeah like, everybody likes, they're {turning} to the States. [. . .] we used to didn't have things very good, but now everybody is having things good [. . .] when my Mom were young, they would they, get only one coke a year. Now, we get all the time.

Interviewer: How does that mean that your culture's disappearing?

Dean: It's like, so many say people will stop, talking Kriol or, when my Mom was younger they used to em use old *taims* (times) things, old *taim* (time) things and, *tingz dat* (that), Kriol people does used to use [. . .] like ashes to brush your teeth and, different *tingz* (things) but, now, now they're getting toothpaste and all kinds of things and so what _ I don't really mean it's disappearing but,—*tingz* (things) are getting much better in this village.[73]

In Dean's opinion, limited access to goods in the past was part of Crooked Tree identity, and brushing teeth with ashes was a Kriol tradition. This conversation demonstrates a student's attempts to negotiate his knowledge about the reality of changes in cultural practices over time and what young people have learned about the positive and negative impacts of globalization. Dean also struggles to balance the importance of preserving culture with modern conveniences and seems to equate poverty with tradition and heritage.

"I Forget Their Food That They Eat"

The ways youth conceive of past cultural groups reveals information about how they construct concepts of culture and history in the present. For CTGS and BGS students, these constructions include struggles to negotiate multiple forms of knowledge and experiences related to cultural difference. In our conversations, students frequently lumped together all groups of people who were unfamiliar or different from themselves into one group. They also confused past and contemporary ethnic groups with each other. For example, when asked about what Ancient Maya people used to eat, 33 percent of the responses the students provided were foods generally associated with Garifuna people.[74] One student, Beto, told me Maya people ate cassava and then "corrected" himself and said: "No *dat* (that's) Garifuna who ate, cassava no em, [. . .]—I forget their food *weh dehn eat* (that they eat).[75]

Such corrections were common during interviews. Students would furrow their brows and silently mouth responses during interviews before answering questions about cultural groups, trying to recall and recite the list of cultural "facts" they had memorized in class.

Confusions about cultural complexity were also common in interviews. Students confused Ancient Maya people with contemporary Mestizo people, and even mixed up Maya people with Kriol people. Some talked about Ancient Maya people speaking Spanish and chopping bush (a practice commonly associated with Mestizo people). Others referenced Ancient Maya peoples cutting logwood (an early labor industry primarily carried out by Kriol people). In interviews, I asked students about what they thought "the Mayas"[76] did in the past and some of them confused Maya people with archaeologists and talked about Maya people "digging at ruins," "looking for old things," "finding old things," and "digging up dead bodies." When asked "Who are the Mayas?," one student even suggested that Maya people worked at archaeological sites:

Charla: Like they work in the ruins? [. . .] They live in them. They, they also find, old tingz. They find like dead body and *dende* (those).[77]

When asked to draw archaeologists, several students instead drew objects they associated with contemporary Maya people like grass skirts, brightly colored clothing, and people doing activities like farming, cooking, washing, and cutting brush (see figure 2).

Although some students recognized that there were Maya people who used to live at the ruins and that there are Maya people living in Belize today, many

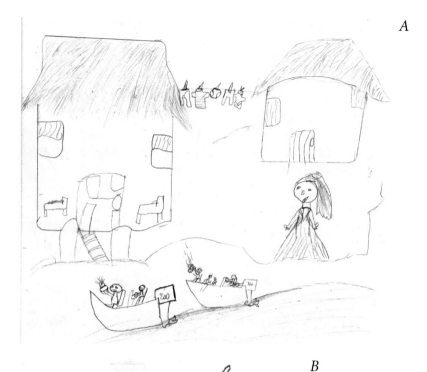

A

B

Figure 2. Representations of
contemporary Maya people
in student drawings of
archaeologists. Drawings done
by: Ethan (*A*), Lorena (*B*),
Raymond (*C*).

of them were unsure about the differences between ancient and contemporary Maya peoples. State heritage practices of lumping all Maya groups together in the curriculum, cultural centers, and public discourse makes it difficult for youth to understand who exactly various Maya groups were and are. Students' confusion was also likely due to their limited contact with people who identify as ethnically Maya (only eight students told me that they actually knew a Maya person).

Confusion about culture and ethnic groups does not only extend to "others," however—Kriol youth also sometimes demonstrated limited knowledge about their own culture and history:

Interviewer: Do you know [. . .] how Kriols, came to live in Belize?

Kadijah: I'm not sure if this is the topic that I remembered, I think they were, two, great-great-grandfathers, that decided to um, to build a generation or something like that {but} I'm not sure.[78]

Interviewer: Do you know where Kriol came from?

Jamal: Kriol, come from the _ from *di* (the) Baymen [. . .] One *dat* (that) win *di* (the) war, with Spanish.

Interviewer: And what about the, Garifuna?

Jamal: Garifuna *dehn* (they) come from, em, Africa. Dehn {paddle *eena* (in)} dory { } they come. *Wehpaa* (where) Africa to, *da* (to) Belize *eena* (in) dory.[79]

Interviewer: Do you know where the Kriols, came from?

Eric: From Africa?[80]

Interviewer: Do you know where Kriols come from?

Eric: Kriol come from Belize.

Interviewer: But do you know how, Kriol, culture started in Belize?

Eric: No sir.[81]

Students clearly remembered having learned details about Belizean history, but they had difficulty recalling these details and situating their own vernacular heritage into official constructs of history and culture. Their confusion about Kriol history was undoubtedly influenced by the limited content on Kriol culture and history in the curriculum as well as mythical narratives about national origins. Some students made comments about Belizean history that replicated the myths about the Battle of St. George's Caye, which were crafted by colonial officials, politicians, and Kriol elites during British colonial occupation. Students referenced stories about Baymen (the ancestors of European colonizers) and Kriols helping to fight off the Spanish. As I discussed in chapter two, the Battle of St. George's Caye, which occurred on September 10, 1798, has become legendary in Belizean public memory. The story solidified a myth of loyal slaves, defined Kriol as the central, legitimate and "native" identity of Belize, and emphasized British heritage in Belize thereby obscuring the African components of Belizean identity.

Students' confusion about ethnic groups and cultural histories is understandable. Learning about culture and history through rote memorization decontextualizes ethnicity. It becomes an abstract, impartial, and naturalized concept, separated from history and identity politics. This also reinforces an idea that culture is a lesson you learn in school rather than a dynamic combination of ideas, processes, and practices constructed and transformed over time.

"The World Was Hard Then. Very Hard"

Colonial heritage discourse created and reinforced a number of stereotypes and racialized ideas about Belizean ethnic groups. Colonial actors often invoked these stereotypes to reference the work ethic and skill sets of certain groups. For example, they described Maya people as well-organized, hardworking, and good with crafting and described Kriol people as, in so many words, lazy, but helpful as a labor force in the timber extraction industries. Such stereotypes persist today, in part because they still come up in societal contexts, including education. In interviews I asked students about the daily lives and activities of people in Belize in the past and present. Because of my interest in examining the relationship between Kriol people and nearby Ancient Maya archaeological sites, these groups were often the focus of my questions. Student responses to questions about what Maya people did every day, what one might see going on at a Maya ruin when people used to live there, and what kinds of skills Ancient Maya people had, reveal prevalent cultural stereotypes.

A majority of students said they thought life was significantly harder in the past than it is today (77 percent). Although contemporary Belizean children often hear accounts about the struggles their parents and grandparents faced growing up, the students seemed particularly struck by the hard work Ancient Maya people did. The two most popular responses about what "the Mayas" used to do every day were "work" (51 percent) and "farm" (41.5 percent).

Students were particularly impressed by the skills they perceived Ancient Maya people as having and what they believed to be evidence of self-sufficiency; echoing Colonial and Independence era discourses. When asked what kinds of skills Ancient Maya people had, many students provided responses about food, saying: "they could find food for themselves and their families," "you didn't have to go and work to make money, you could grow food for yourself," and "they plant and reap their own food." Other students focused on skills associated with tools, building, and self-sufficiency saying: "they could make their own stuff that they need," "they could build ruins without modern tools," "they had to build their own houses," "they could build pots on their own," and "they could make their life on their own." In an interactive response, one student said: "They didn't have tools. These [showed hands], were their tools."

Referencing the difficult lives of Ancient Maya people, some students indicated that in the past people had to work harder than they do today. When asked how the Maya peoples who lived at the ruins were different from people today, one student said,

Karina: *dehn* (they) never lazy *dehn* (they) always {*di*} work (worked) and now *som a wee* (some of us) are lazy.[82]

Interviewer: And what was the world like when the Mayas built the ruins?
Tanisha: *Di werl mi haad den. Veri haad.* (The world was hard then. Very hard.)
Interviewer: And do you think it was harder to live back then than it is today?
Tanisha: It was much harder, to me.
Interviewer: And why? What else? What do we have today?
Tanisha: Today all you have *fi* (to) go and do is [. . .] go buy {bread} *tingz* (things) and so, bring it home. Have people *fi* (to) build your house and so. But now _ *eena dende* (in those) days you never have to pay people. You have to do **it**.

Interviewer: If we could go way back in time and we could fly over top of a ruin and look down when the Mayas were there what would we see going on?
Tanisha: *Unu work. Nobody mi-di* sit down right now *oanli mi-di work.* (You worked. Nobody was sitting down right now, they were only working.)[83]

The high regard students had for the skills of Ancient Maya people and their assumptions about work ethics reveal broader societal concerns prevalent in public discourse. Public archaeologist Marcia Bezerra's discussion of Brazilian students' perceptions of the work conducted by prehistoric peoples provides an interesting comparison.[84] Similar to the Belizean students, Brazilian students implied that life is easier today than it was in the past. They perceived technological advances as a significant marker of contemporary society, and their descriptions suggested they saw change and development over time as occurring through a linear evolutionary model. However, the Brazilian students also used words like primitive, evolved, and domination in their descriptions of prehistoric people and perceived past people as being less advanced.

The Brazilian students' perceptions about the inferiority of prehistoric peoples contrasts starkly with the high regard Belizean students expressed for the skill-set of Ancient Maya people. Class and racial dynamics contribute in part to these differences. Bezerra notes how the Brazilian students she worked with came from middle to upper class backgrounds in which manual labor is associated with lower classes. The Crooked Tree and Biscayne students came from lower to middle class backgrounds, where much of the available work

consists of manual labor. Belizean students' responses about the abilities and work practices of the Ancient Maya are related to societal expectations and colonial rhetoric about productivity, development, and self-sufficiency that have persisted in Belize for centuries. The different perspectives among Belizean and Brazilian students highlights that the ways that young people talk about past populations not only reveals their perspectives about other cultural groups, but also reveals contemporary commentaries about intersections between work, body, race, and class and the ways children "reproduce the stereotypes of the dominant culture."[85]

"My Culture Is Crooked Tree"

Young Belizeans witness cultural diversity, fluidity, and change every day. Many of them have family living in various parts of the United States—family whose gifts of money, cell phones, or other goods exemplify Belizeans' participation in globalization. At least 25 percent of the students I spoke with had a parent, grandparent, aunt, or uncle who lived in the States. A smaller percentage of these students had been to the United States themselves. Some young Belizeans regularly travel to Belize City for high school, where they study with students from many ethnic backgrounds. Youth in Crooked Tree and Biscayne eat a mixture of dishes traditionally associated with Garifuna and Mestizo people in addition to Kriol dishes, and they listen to a range of music including Garifuna Punta, Kriol Brokdong and Soca, Puerto Rican Reggaeton, and American Pop. But in school, through print and television media, and in their daily interactions, young people receive mixed messages with confusing contradictions about the nature of cultural differences.

In 2008, I visited the Museum of Belize with Crooked Tree and Biscayne students where we viewed an exhibit called "Belizean ID." At the beginning of the exhibit, visitors were presented with engaging and complicated questions about Belizean history, culture, and diversity: "Who are we?," "Should knowing about Ancestors both distant and recent mean anything?," "Upon what do we base our identity?," "I'm a Belizean because . . . ?" Through a variety of signs and activities, the exhibit addressed issues about cultural difference, the social constructions of race, Belizean cultural dynamics, and the complexities of Belizean identity. The exhibit design and content showed a recognition by museum staff of the fact that Belizeans young and old struggle with how to define Belizean identity.

After our museum field trip, I talked to one CTGS class about the exhibit and the students were less vocal than they usually were and had a difficult time answering some of my questions. Teacher Albert talked with me about this

experience, and suggested that issues like cultural identity should be a larger component of the curriculum:

> The day after the visit to the House of Culture [*sic*] where you wanted the children to identify themselves, who they are, where they come from, why are they Belizean [. . .] those were very, very tough and challenging questions for them [. . .] if [there was] stuff like those [. . .] in the social studies curriculum, it will bring us more closer to achieving that, to knowing our past, knowing where we come from, and it will probably make our culture even richer.[86]

I agree with Teacher Albert that one of the reasons why the exhibit questions were "very, very tough and challenging" for the students was because of the way culture and history are taught in schools. Some of the students I worked with internalized the popular idea that Kriol people do not have culture. Despite initiatives led by the National Kriol Council and other organizations to promote and celebrate Kriol culture through language, traditions, and history, and despite the rich cultural practices of residents in Kriol communities, concerns persist amongst Kriol teachers and youth about "cultural loss" and disintegration. In an interview one student even mentioned the phrase "Kriols gat no kolcha," perhaps recalling the late Belizean Kriol singer Leela Vernon's well-known song "*Ah Wah Know Who Seh Creole No Gàh No Culture*" (I want to know who says Kriols don't have any culture).[87]

Even though the ways culture and history are defined and discussed in educational and societal discourse provide limited opportunities for students to legitimately assert more diverse identities that cross boundaries and change over time, some students I spoke with self-identified in complex ways. For example, some students told me about their multiethnic lineages, but not in public contexts during school. When asked in interviews whether they had family members who were of Maya descent, almost all of the students said "no." However, a few students told me about their Maya background outside of the interviews. On one day early in my time at CTGS, Donald approached me to express his excitement about learning about "the Mayas" and taking a field trip to a Maya site. He proudly whispered to me that his "grannie" was "part Maya." I believe that Donald divulged this information in secret not because he was embarrassed by it or felt the need to hide his Maya ancestry, but because he was unsure about the most appropriate way to articulate and share this information about his mixed background.

Anthropologist Sarah Woodbury Haug found similar patterns of student confusion about cultural identity in the Belizean community of Punta Gorda.

When educating students about culture and history, teachers forced students to label themselves with a certain ethnicity. However, a significant number of the Punta Gorda students considered themselves mixed because they had parents from two (or more) different ethnic groups. These students struggled to identify with the seemingly mutually exclusive ethnic labels presented in the classroom and did not associate with the traditions and practices outlined for only one specific group in the curriculum. As such, many students became frustrated and perplexed by what teachers were trying to teach them.[88]

In my work with Crooked Tree and Biscayne students, in addition to some of them expressing their mixed heritage, some tried to explain aspects of their Kriol identity, while at the same time addressing the reality of cultural fluidity. For example, Loretta acknowledged the diversity of her own cultural practices and the reality of cultural exchange in Belize when she discussed foods she eats:

> Well my culture is Crooked Tree because people eat the same food they eat fish, they eat beans and rice pigtails, and dumplins. They eat powder bun, Johnny cake, tortilla, bread [. . .] Well, they [Kriols] actually they like to, enjoy different food from other nations.[89]

I found it interesting that Loretta did not use the term Kriol to reference her identity, but instead referred to her culture with the name of her village. Loretta's commentary demonstrates that her community is an important part of her cultural identity, foodways are a particularly significant aspect of Kriol culture, and that vernacular Kriol heritage practices are significant aspects of Crooked Tree identity. For me Loretta's example is a reminder that when thinking about ethnic groups and cultural diversity, we should not assume homogeneity across ethnic groups and should consider diversity across and within communities. Loretta's example also demonstrates that young people can process complex aspects of culture, like that although there are practices common to specific ethnic groups, there is also fluidity and exchange across groups. Foodways can be a particularly effective way to explore the complexities of heritage in the classroom, since it is a topic often on the minds of young people!

Some CTGS and BGS students I spoke with also demonstrated awareness about Kriol history, such as recognizing the role of Kriol people in Belize's extractive industries:

Interviewer: And why did, Europeans come [to Belize]?
Chantal: Because, they found {out} *dat* (that) Belize has, good mahogany [. . .] So like, {build} furnitures [. . .] they went back and, they, find other workers and brought them to, cut mahogany.[90]

And a very limited number of students who responded to questions about what they learned about Belizean history and Kriol history specifically referenced the African origins of Kriol heritage or acknowledged slavery.

Brianna: I've learned that [. . .] we came from African people and they {were} worked hard and we shouldn't work people so hard as they were because, it will hurt us as well as it will them.[91]

Interviewer: Do you know how, Kriols, came about? How the Kriol people started in Belize?

Dean: Slavery. People came _ some people escaped from slavery probably. And, some maybe, just em, have children and stuff and, um, it's African and American I think Kriol is. African and American [. . .] The Americans that probably em, slavery {actually} slaved them, maybe saw a girl that they liked and, probably had a child and that's how Kriol came to be maybe.[92]

There was one particularly insightful young girl who recognized a historical connection to slavery, despite the topic's limited coverage in the curriculum. She also acknowledged that other students may be "shy" to talk about slavery but was unable to elaborate why.

Interviewer: And who are you the descendants of?

Tanisha: Like maybe _ Garifuna _ Oh *di* (the) um slaves.

Interviewer: Nobody's been able to tell Mr. Dru and I that. [. . .] Why [do] you think not?

Tanisha: Maybe *dehn* (they) shy *di* (to) answer *dat* (that) question or something [. . .] Because *dehn* (they) no wanna tell you.[93]

Conclusion

In the late twentieth and early twenty-first centuries, education programs and curricula focused on culture and history bring attention to Belizean diversity but also perpetuate cultural stereotypes and ethnic hierarchies which Belizean citizens often replicate. However, as I demonstrated people in rural Belizean communities have long negotiated educational structures and official heritage discourses to benefit their communities and teachers and young people make sense of educational content and state messages about culture and history in ways that connect with their own lives and concerns.

Belizeans' perceptions about cultural mixing, loss of Kriol culture, and cul-

tural sustainability reveal that people often hold conflicting ideas about heritage. Kriol teachers, activists, and youth acknowledged that specific forms of Kriol culture and history exist and enact Kriol culture on a regular basis, but also talked about Kriol people losing their culture or not doing a good job of preserving it. These individuals identified the unique mixture of cultural practices in Belize as part of national identity, but then suggested cultural mixing was a problem. They acknowledged there have always been outside influences on vernacular heritage practices, but they also blamed globalization for corrupting Belizeans. Such conflicting ideas are evidence of the complexities of cultural identities and demonstrate Belizean citizens actively negotiating official heritage discourse and practices with vernacular ones.

In the following two chapters, I focus on the development of archaeology in Belize and the ways descendant and local communities navigated archaeological knowledge and practices from the late nineteenth century to the early twenty-first century. Parallel to the historical development of education, foreign archaeologists and colonial actors were conducting archaeology throughout Belize. Foreign archaeologists and colonial and state actors involved with archaeology have long contributed to official heritage discourses by providing definitions of culture and historical narratives legitimized by scientific authority. Similar to education, archaeology has also marginalized Kriol culture and history, emphasized Ancient Maya history and culture as central to Belizean identity, and reinforced the social and economic development potential of culture and history. I discuss the ways that official heritage discourses and practices were established and reinforced through archaeology but I also highlight ways Belizean citizens have long connected with Ancient Maya history and culture and manipulated archaeological practices. Additionally, I provide examples of how Crooked Tree and Biscayne residents interpret and interact with Ancient Maya history and culture in the early twenty-first century and promote local archaeological resources for community development like tourism.

4

Archaeology as an Official Heritage Practice and Community Negotiations since Colonialism

For millennia, the remains of ancient cultures in Central America have been the subject of archaeological fascination, exploitation, and control. Like education, the discipline of archaeology is a powerful heritage institution integrally tied to social processes that inform how people come to define, value, and manage cultural and history. In this and the following chapter, I examine the history of archaeological heritage practices in Belize in order to understand how archaeological knowledge and practices are invoked, interpreted, and negotiated in contemporary official and vernacular heritage contexts.

During the Colonial Period of archaeology, Anglo (primarily British and American) archaeologists and explorers constructed an official heritage discourse that justified the exploration, documentation, and surveillance of colonial landscapes. This discourse also established archaeologists as the principal authorized heritage experts over prehistoric and historic sites and artifacts, privileged scientific examinations and extraction of tangible archaeological resources, defined Belize's archaeological heritage as Ancient Maya cities and objects, and reinforced colonial racial ideologies that also appeared in education discourse and practice.

While Colonial Period archaeologists legitimized British and American values for, and control of official archaeological heritage,[1] I also reveal examples of Maya descendant and local community engagements with Ancient Maya sites and objects, and examine the ways people attempted to influence archaeology during the Colonial Period. I then shift my discussion to the Independence Period of archaeology during which colonial actors, foreign archaeologists, and Belizean state actors advocated for increased institutionalization of archaeology in Belize. During the Independence Period, government and intellectual actors continue to privilege scientific control over tangible heritage manifestations. However, as Belizean nationalists did with education, at this time nationalist actors worked to establish Belizean oversight and control of archaeological heritage, and emphasized connections between Ancient Maya

heritage and national identity, and between archaeology and social and economic development. For the first time, during the Independence Period, Belizean voices (albeit official ones) and interests in archaeological resources were incorporated into archaeological heritage practices.

Colonial Period Archaeology in Belize

The first substantial archaeological exploration efforts in Central America were conducted in the 1840s by American author and explorer John Lloyd Stephens and British artist Frederick Catherwood.[2] Stephens and Catherwood traveled to ancient cities throughout the Old and New Worlds and compiled extensive popular accounts of their explorations, but they only stepped foot in Belize on their way to other Central American territories. As Maya archaeologist Norman Hammond argues, until the late nineteenth century, "Little attention was paid to archaeology in the Colony [Belize]."[3] Belize was on the fringe of archaeological interest because of the erroneous belief that it was on the periphery of Classic Ancient Maya culture and settlement. Additionally, unlike education, archaeology was not seen as a moral imperative of the colony—this combined with limited British interest in developing infrastructure in Belize meant that archaeology was not initially supported by the colonial government or other bodies like churches. Distaste among some explorers for the colony's primary port of Belize Town (now Belize City and often referred to simply as Belize), further marginalized the territory in terms of archaeological exploration.[4] Disdain for Belize Town persisted well into the twentieth century. For example, British explorer and writer Frederick Albert Mitchell-Hedges said in 1931:

> Have you ever been to Belize? [. . .] If you haven't, don't go [. . .] into streets are flung much garbage and other filth [. . .] Belize was built on a swamp filled in with mahogany chips and empty gin bottles. [. . .] Belize is a disgrace of the British Empire.[5]

The earliest institutionally organized and supported expeditions describing archaeological sites in Belize were carried out by surveyors and colonial officials mapping the "unexplored" territory and documenting and assessing floral, faunal, and other resources (for example, timber, fruits, spices, minerals) for imperial industry and development prospects. Archaeology was thus connected to imperialist and colonialist agendas from its beginning. The Colonial Secretary Henry Fowler mentioned archaeological ruins in his 1879 report focused primarily on Belize's terrain and climate, lamenting lack of cultural development in the colony: "As the present cannot compare with the immediate past,

so the past fails to compare with the ancient, for the old Indian ruins surpass all others, and will long outlive any relics of more recent ages."[6]

Archaeological explorers inspired largely by curiosity about Central American people and places continued the tradition of Stephens and Catherwood, publishing popular expedition travelogues. These texts were widely read by upper-middle class and elite Europeans and Americans. Early archaeologists and explorers working in Belize gave lectures at premiere cultural institutions like the British Museum and major newspapers like the New York Times covered their work. Early archaeological expeditions in Belize contributed to the establishment of the discipline of archaeology globally, which became situated in universities and museums in Europe and the United States as scholars and explorers amassed material culture collections that donated them to museums like the Smithsonian, Peabody, and British Museum.[7]

Antiquities Management, Colonial Documentation, and Archaeological Adventure

During the Colonial Period of archaeology, the earliest antiquities laws were enacted by the Belizean colonial government, such as the Ancient Monuments Protection Ordinance (1894), which resulted in the preservation of many Ancient Maya cities and objects. Until very recently, and despite the presence of other ethnic-historic sites and objects, archaeologists and other official actors associated archaeology in Belize almost exclusively with the Ancient Maya, as I discuss later in the chapter. The development of ancient monuments and antiquities policies, laws, and preservation efforts was a trend in heritage management reform across the globe.[8] For example, the United States Antiquities Act was established in 1906. Colonial Period antiquities laws in Belize protected past sites and objects for archaeologists' usage and established colonial control over cultural and natural landscapes. As such, these archaeological practices and laws were not neutral or exclusively scientific. The ways early explorers and archaeologists interacted with ancient sites and objects in Belize created certain precedents, practices, and discourse about what heritage is, how it should be managed, and by whom. Combined with educational structures and practices in the colony, education professionals and archaeologists constructed authoritative definitions of culture and history that perpetuated to the present.

One early and prolific archaeologist in Belize was Thomas William Francis Gann, who Norman Hammond suggests was "responsible for the eventual awakening of official archaeological interest in British Honduras."[9] Gann, a physician with expertise in tropical medicine, was first posted to Belize in 1892 and served in district medical positions and eventually as Principal Medical

Officer for the colony. He was also a member of the colony's Legislative Council. Though Gann had no formal training in archaeology, he was fascinated by ancient antiquities and conducted the earliest archaeological excavations in Belize. Archaeologist J. Eric S. Thompson suggests that Gann actually "decided to practise [medicine] in the Colony because of an interest in Maya archaeology [...] and he took up the appointment on the understanding by the Colonial Office that he would serve only in those parts of the country well-endowed with Maya ruins."[10] Gann benefited from his colonial government position gaining support from local and state governments and easily obtaining access to sites, archaeology permits, and documents to extract objects. On one occasion Gann referenced the support he received from the Governor of Yucatan who gave him "an open letter addressed to all Government officials and others throughout the Yucatan, advising them to give us every aid and assistance in their power in the prosecution of our archaeological work [...]"[11]

As an arm of the colonial government, Gann's travels to various communities also served to establish archaeology as a form of social surveillance, similar to the way's schools acted as spaces to monitor the actions of subject-citizens. This happened in explicit and implicit ways. Gann kept tabs on the physical well-being and cultural practices of colonial subjects through medical clinics. And in archaeological reports and popular books, he wrote some of the first descriptions of Ancient Maya cities, burials, and objects, as well as documented information about the accessibility of roads and waterways, natural resources his teams extracted, and politics and conflicts in Belizean villages and the surrounding countries of Mexico and Guatemala. Referring to it as "interference from outside," Gann himself identified ways the colonial government interjected in the lives of local peoples. In his writings, he provided examples of the "Medical Officer coming round to vaccinate his [the Indian's] children; Public Health officials to [...] compel him to buy latrines [...] malaria experts to make blood tests [...]; School Inspectors to worry about the education of his children; Police Officers to interfere with the [...] methods of the village alcalde [...] archaeologists and ethnologists, who of recent years have swarmed like flies over the whole Maya area."[12] It is little wonder that, as described below, local and descendant communities exerted heritage agency in attempts to protect cultural knowledge and traditions and resist archaeologists in their communities during the Colonial Period. Gann hints at this in the passage cited above as he says, "The Indian hates more than anything else any sort of interference from outside."[13]

Gann's first archaeological explorations were at Santa Rita in northern Belize in 1896. In the early twentieth century, he received substantial institutional

support for his work and in the 1920s he joined British Museum excavation expeditions in Belize. Gann wrote numerous popular books and archaeological reports, publishing much of his work with the Smithsonian Institution's Bureau of American Ethnology. He gave public lectures at the Institute of Archaeology at the University of Liverpool and was connected to United Kingdom and United States intellectual societies, universities, and cultural institutions. Gann remained actively involved in archaeology in Belize until his death in 1938 and many of the antiquities Gann collected were eventually donated to the British Museum and Institute of Archaeology.

Gann's work was the beginning of professional archaeology in Belize, however, Gann's role in archaeology was complicated. He recorded extensive and important details (through text, photographs, and drawings) about the ancient built environments and material culture he examined and uncovered, as well as the traditions, daily practices, and belief systems of living people with whom he came into contact. But like many others of his time, Gann was also an adventurer and collector—he amassed private collections of antiquities and romanticized Central American history and culture. Gann's identity epitomizes the multifaceted dynamics of Central American archaeology in the late nineteenth and early twentieth centuries.[14] Though in part driven by scientific pursuits of knowledge, archaeology at this time was also deeply tied to imperialist and colonialist constructs of resource extraction and efforts to claim and control natural and cultural environments. Gann's expeditions demonstrate that archaeology in Belize was dependent on and benefited from colonial power structures and in turn the colonial government benefitted from archaeologists' official exploratory and documentary heritage practices.

Most public accounts of early colonial archaeological expeditions read more like travelogues than scientific reports. Although invaluable in their information and quite detailed, the work of colonial archaeological explorers is viewed by more recent archaeologists as passionate and entertaining but not overtly scientific by modern standards.[15] In their publications, early archaeological explorers frequently recounted their hardships and acts of derring-do. Gann and his contemporaries (such as F. A. Mitchell-Hedges and Lady Mabel Richmond Brown, both English adventurers and writers) romantically described dangerous plants and animals (especially insects and reptiles), diseases, and difficult and uncomfortable treks to ancient cities in the heart of the jungle.

The writings of Mitchell-Hedges and Lady Brown exemplify the archaeology action/adventure genre of the early twentieth century. Mitchell-Hedges, a wealthy British citizen and charismatic character, made a life out of expeditions and adventure, taking many expeditions throughout Central America. Prone

to hyperbole and drawn to "mystery," Mitchell-Hedges was obsessed with the myth of the lost city of Atlantis.[16] Mitchell-Hedges was also connected to the famed and dubious Crystal Skull claimed to have been discovered by his adopted daughter at the Belizean site of Lubaantun (but in fact purchased at a Sotheby's auction in 1943).[17] He wrote accounts of adventure to appeal to public audiences and sell books. Lady Richmond Brown (born Lilian Mabel Alice Roussell) was a British elite who married Sir Melville Richmond-Brown, but later divorced him because he was legally deemed insane. Lady Brown traveled throughout the world and was a member of numerous British naturalist, anthropological, and exploratory societies. She was particularly well-known for her expeditions in the Caribbean and Central America with Mitchell-Hedges (some of which took place in Belize and the Yucatan with Thomas Gann) and her wealth likely supported several of Mitchell-Hedges' explorations. Lady Brown's archaeological pursuits were also driven by a desire to travel, publish, and experience grand adventures. She published magazine and newspaper articles about her exploits, but only one book, her 1924 *Unknown Tribes: Uncharted Seas.*[18]

Early twentieth century archaeological adventure narratives about past and contemporary Central American cultures and history were engaging and accessible for popular audiences. They brought public attention to ancient Central America cities and cultures and inspired wealthy British and American citizens to financially support expeditions and research. However, these narratives also reinforced imperialist views about colonial territories and the people within them as dangerous, mysterious, and underdeveloped, mirroring themes related to the colonial race concept in education. For example, Mitchell-Hedges referred to the "ruthlessness and barbarism of the true wilds" which he and his contemporaries explored and conquered.[19] Archaeological accounts also served to justify colonial control, as archaeological explorers "conquered" territories and civilized them by bringing scientific order and documentation to these seemingly unchartered, untouched, and uninhabited areas. In 1928, Gann characterized the Maya site of Lubaantun in Belize "as [a] virgin site, absolutely unexplored and unexploited."[20] Mitchell-Hedges described his travels as a "gamble with life" in the "unexplored jungles and fastnesses of Central America . . . where what life may be existing is unknown, and one can only speculate on the dangers that are certain to be lurking in these mysterious wilds."[21] The hyperbolic references to "virgin," "unknown," and "unexplored" places were usually outright incorrect, as most Ancient Maya sites documented by early archaeologists and explorers were already known to local people. For example, the site of Lubaantun, which Gann suggested was unknown and "ab-

solutely unexplored," was reported to the colonial government by inhabitants in a nearby community in the late nineteenth century, and Gann himself had previously visited there in the early twentieth century. Indeed, as I discuss later, local and descendant communities knew archaeologists were often reliant on their knowledge of Ancient Maya cities and objects and used this to their advantage.

The practices of colonial archaeology exaggerated differences of past and present peoples in Central America and reinforced assumptions of Anglo and European superiority, similar to the ways Edward Said notes that history and archaeology served as institutions that crafted ideologies of "The Orient."[22] Archaeological accounts by British and American explorers, scholars, and civil servants naturalized the characterizations of "untouched" and "difficult to tame" exotic lands and people. Archaeological expedition teams were also assisted and authorized by a variety of colonial government institutions, including the Surveyor General, Forestry Department, and various District Commissioners. Descriptions of "untouched" spaces full of resources connected archaeology with resource potential for the British Empire, justifying colonial efforts to control, manage, and extract what were considered to be imperial resources. These descriptions also legitimized foreign explorers as the entitled "discoverers" of such resources.

Legitimizing Archaeologists as Heritage Authorities

Colonial archaeological expeditions were driven, in part, by competition for antiquities and recognition. Although the British Museum was the earliest institution to sponsor an expedition to Belize (in 1926), the Carnegie Institution of Washington and other American institutions quickly began to dominate archaeological research in Belize.[23] As the Director of the British Museum, Frederic Kenyon, lamented in a 1928 appeal for archaeological funding, "We ought not to leave a British colony to be explored by others."[24]

Until the late twentieth century, non-Belizeans conducted almost all archaeology in Belize on behalf of foreign institutions, which usually received a substantial amount of the ancient objects found by archaeologists through a partage system.[25] Under early twentieth century ordinances and laws concerning "Ancient Monuments and Relics" in Belize, Ancient Maya sites remained privately owned by landholders. When implemented, these laws and policies generally favored foreign archaeological enthusiasts and scholars with institutional connections.[26] Early twentieth century reports often detail formal and implicit understandings between archaeologists and their institutional sponsors. Thomas A. Joyce stated that the "archaeological explora-

tion of the colony [Belize]" was "a matter of mutual arrangement between the Colonial Government and the British Museum"[27] as the British Museum had been invited by the "Government of the Colony [. . .] to advise upon all archaeological work which takes [took] place within its territory."[28] All of the objects excavated in the British Museum projects in the late 1920s and early 1930s were to go to the institution. In another example of such arrangements, Gann made reference to archaeologist J. Eric S. Thompson working in Belize and being "out for Maya objects of any kind, for the Field Museum."[29] Mitchell-Hedges also mentioned a meeting of the Legislative Council in Belize in which "an exclusive concession was granted" to himself, Lady Richmond Brown, and Thomas Gann, giving them "exclusive right for twenty years to excavate not only the ruined city we had found but also an area of seventy square miles adjoining."[30]

In 1928, the Colonial Government passed the Antiquities Ordinance, which established government control and oversight over the acquisition and treatment of antiquities. Though foreign archaeological experts continued to be privileged consumers of archaeological heritage in Belize, the 1928 Ordinance also identified the British Colonial Government as a particularly privileged stakeholder, making it illegal for antiquities to be exported from Belize without permission from the Governor in Council.

The early archaeological accounts and government ordinances had the effect of legitimizing foreign "scientific" engagements with historic sites and objects, and delegitimizing local engagements as unauthorized. Numerous Colonial Period archaeology accounts noted local peoples' vernacular heritage practices, which involved interactions with Ancient Maya material culture (for example, local people visiting Ancient Maya sites, building altars and burning incense, engaging with ceramic vessels, and telling ghost stories about sites). However, these accounts never implied that Belizean archaeological heritage belonged to Belizeans or that archaeological expeditions should consider or benefit local people or Maya descendants. Instead, the accounts distanced local people from ancient cities and objects, defining them not as local history and culture but as archaeological heritage for the benefit of the colony and science. These actions established the erroneous idea that living peoples have no interest in or connection to archaeology or Ancient Maya history and culture.

Colonial explorers, scholars, and administrators further legitimized the right of archaeologists to study ancient cities and objects by discussing the dangers posed by local people in the form of looting, site disturbances, and development. In a 1912 Colonial Report on the "Preservation of Historic Sites,"

in the West Indies the colonial governor of British Honduras even expressed concern about publishing accounts of the ancient monuments in the colony. Emphasizing the scientific import of ancient sites and reinforcing the authority of archaeological scholars, he stated, "*Bonâ fide* antiquaries alone should visit them [ancient monuments]. The more unscientific people go to see them the more likely it is that mischievous damage will be done."[31] The accounts of archaeological explorers and scholars framed locals as untrained, unauthorized people who might damage archaeological sites, and archaeologists as professional experts who protected sites through scientific excavation—an authorized form of destruction. Archaeologists vehemently opposed damage to historic sites or objects by locals or people they identified as "treasure-hunters." However, in order to remove and transport particularly large ancient objects, stone monuments, and architectural features, archaeologists themselves often split them up. A 1930 British Museum excavation report detailed the removal of stelae from Pusilhá in southern Belize: "By this time the first stela had arrived at Flour Camp, and the tractor had reached our camp for the second. [. . .] one piece was very large and heavy, and there was a great weight of uncarved stone on the base which actually contained only one row of glyphs. After some trouble I managed to split this perfectly, and was then able to reduce the front half right up to the glyphs."[32] The damage here to an historic object was defended by a perceived authority as the product of a careful, methodological decision rather than as destructive.

The perceived rarity and fleeting sustainability of ancient and modern Maya heritage was a particular concern for many early archaeological scholars, who saw it as their duty and right to preserve cultural materials and contemporary practices before they were "lost." In a 1924 presentation about Maya jade objects, Gann hoped that British and American institutions would carry out more excavations soon, "before these priceless records of one of the most interesting civilisations in the world are lost to us for ever [*sic*], through the unauthorized digging of natives and travelers in search of treasure and saleable curios."[33] Similarly, J. Eric S. Thompson reinforced archaeologists' authority to study past and present Maya culture and history by suggesting they were disappearing, "A few embers of the fire of Maya culture still continue to glow dimly. It has been my aim to gather these isolated sparks before all is trampled out by the onward rush of what we, in our insularity, call progress."[34] This "save the lore" attitude, common among cultural anthropologists and archaeologists working across the globe from the mid-nineteenth century to the mid-twentieth century, reinforced colonial power dynamics and Anglo heritage control in Belize.

Object-Centric Archaeology and the Mysterious Maya

As noted, the vast majority of Colonial Period archaeological exploration focused on Ancient Maya culture and history. As such, Ancient Maya heritage—specifically, tangible places and material culture—became equated with archaeology in peoples' minds (and vice versa—archaeology became equated with the Ancient Maya in Belize). The reports and popular accounts of early archaeologists like Gann, Thompson, and Joyce primarily consisted of descriptions of architecture, site layouts, and object finds at Ancient Maya cities. Objects considered especially significant included whole pieces (for example, stelae, preserved architecture, artifacts), and forms with aesthetic decorations or made of rare materials such as jade. In their descriptions of burials, archaeologists often referred excitedly to finding grave goods like jade, polychrome pottery, whole vessels, or eccentric stone tools. Early archaeologists often defined the significance of historic places based on the objects they yielded: for example, Joyce and his coauthors referred to the "exceptional promise" of some sites while suggesting that others had no pottery "of any interest."[35] This object-driven focus of early archaeologists, and their aesthetic preferences for certain kinds of objects, imposed an Anglo and Eurocentric and archaeological-driven classification and value system on Belizean archaeological heritage.

Colonial Period archaeologists also defined significance in terms of sheer size, seeing monumental architecture as a mark of the "highest civilization." Mitchell-Hedges wrote of uncovering a "vast city" and marveled at the labor that moving the massive limestone blocks must have required, saying it "baffle[d] the imagination."[36] Gann often asserted that the Ancient Maya were "the most advanced civilization in the American continent, and in many ways the highest civilization the world has ever known,"[37] evidencing their "exquisite workmanship."[38]

In equating archaeology with monumental and elaborate Ancient Maya cities and objects, Colonial Period archaeologists established heritage tropes that continue to influence the Belizean public today, in particular about Ancient Maya culture. One major trope was the mystery and strangeness of the Ancient Maya, neatly captured in a 1926 New York Times article by American journalist and explorer Gregory Mason, who suggested that "mystery surrounds Mayas" and asserted that "of all of the great races with which archaeology is concerned, none is more shrouded in romance than is the Maya race [. . .] the Mayas have both a mysterious beginning and a mysterious ending."[39] Similarly, a 1929 New York Times article describing an aerial mapping expedition, piloted by Charles Lindbergh and aimed at locating archaeological sites, referred to the

"strangeness and romance" of the expedition and described the team as "delving into the secrets of the Maya."[40] The Ancient Maya's mysterious "disappearance" before the arrival of the Spanish was a favorite trope of archaeologists for decades. Gann and several others referred to the Ancient Maya as having "vanished." In 1928, despite having met Maya people in his work, Gann noted "now nothing remains of this once dense population and flourishing civilisation but broken walls, ruined temples, and bush-covered mounds."[41] Tropes about the mysterious Maya and disappearance of the Ancient Maya persist in Belize in twenty-first century tourism materials. And, as I discussed in chapter three, since twenty-first century educational materials offer little explanation of the historical relationships between past and present Maya groups, there is often much confusion among young people and other citizens about the fate of the people who once inhabited archaeological sites that dot the Belizean landscape.

Another major theme of the "mysterious Maya" trope perpetuated by early archaeologists was the denigration of Indigenous religious practices. Archaeologists exoticized Ancient Maya people by characterizing their religious practices and beliefs as magic, superstition, and sorcery, and by giving graphic descriptions of perceived violence and sacrifice in Ancient Maya culture. Gann provided sanguinary imagined interpretations of Ancient Maya religious traditions: "The procession of wild-looking, half-crazy, unwashed priests, smelling horribly, their gory hair matted, and their white cotton robes smeared with the blood of countless previous sacrifices, marched up the western steps of the dance platform."[42] Gann even went as far as to suggest, with no supporting evidence, that the Ancient Maya practiced ceremonial forms of cannibalism. By emphasizing this imagined exoticism, archaeologists like Gann marginalized other forms of culture, such as subsistence practices, which might have made the Ancient Maya more relatable to readers, but perhaps would have also made colonial goals of subjugation of modern Indigenous and other minority peoples more difficult.

Archaeologists Establishing Tropes about Living People

In addition to establishing themselves as authorities about ancient culture and history, similar to education officials, archaeologists also acted as authorities on contemporary cultural groups by providing detailed and systematic descriptions of the cultural practices and "nature" of the living people with whom they came into contact. Archaeologists were both influenced by and contributed to the colonial race concept that established an official racialized heritage legacy in Belize, distanced ancient and contemporary Maya peoples in the context

of archaeology, and obscured Kriol culture and history by denigrating Kriol culture as inauthentic and mythologizing Belizean history. In their works, archaeologists outlined and reinforced racial constructs in ways very similar to education scholars and colonial officials. Specifically, by characterizing living people in Central America as "inferior," "degenerate," and "primitive" they supported and reified colonialist perspectives that it was morally justifiable for the British to manage and control local people, including their cultural practices and histories.

Archaeology in the late nineteenth and early twentieth centuries was often focused on determining what stages of cultural evolution societies represented by analysis of their architecture, practices, and material culture. These stages were tied to Anglo and Eurocentric and racialized ideas about development and civilization.[43] In accounts from archaeologists working in Belize, cultural evolution also pervaded early descriptions of living people. Gann frequently referred to contemporary Maya people as a degenerate form of their ancient ancestors who built the sites they explored. He called Santa Cruz Indians, "degenerate, traditionless descendants of the ancient Maya."[44] Mitchell-Hedges also perpetuated a view of cultural degeneration among contemporary Maya people, suggesting that the Kekchi Maya were "the direct descendants of the once great Maya race [. . .] [who had] sunk into a state of degeneration and must soon be extinct."[45] Colonial Period archaeologists categorized contemporary Maya people as primitive as well. Mitchell-Hedges suggested that "the native mind is very simple" and that "civilized life belongs to another world when compared with the native customs of the primitive wilds."[46] By emphasizing "degeneration" and "primitiveness," archaeologists established and reinforced distance between ancient and contemporary Maya people and negated connections between living Maya people and their ancestors, hence bolstering colonial and archaeological efforts to control the narratives of ancient and modern Maya culture and history.

Maya people were not the only ethnic group that archaeologists racialized and denigrated. Thomas Gann referred to one group of women of African descent as "burly negresses"[47] and described Garifuna women at a festival as "brawny, black, prognathous jawed, woolly headed Carib maidens."[48] In a narrative about a trek to archaeological sites, he described a Belizean Kriol man steering their ship, singing at night, "Standing—or rather crouching—on top of the wheel, the spokes of which he grasped with his prehensile toes [. . .] he reminded one of a great black ape."[49]

Though the subject of their racial ridicule, African history and culture in Belize was not considered by colonial archaeologists to be archaeologically (or

otherwise) significant like that of the Ancient Maya. As legitimized heritage experts, archaeologists defined the culture and history worthy of study as Ancient Maya, the "most advanced civilization" of the region. Thus, archaeologists contributed to Kriol and Garifuna culture and history being marginalized in Belize. When they did discuss Kriol or Garifuna history, Colonial Period archaeologists emphasized British-centric narratives (for example, the myth of the Battle of St. George's Caye), thereby supporting British colonial endeavors to craft and control history. Thomas Gann even reinforced a popular racial myth in Belize that enslaved people were well treated by their masters, which he said was evidenced by the fact that they fought with them in the Battle of St. George's Caye. Gann suggested that such mutuality was the foundation of the colony: "The descendants of these same black slaves who fought side by side with their owners at St. George's Cay, form to-day the backbone of British Honduras, and probably one of the finest coloured citizenry in the world, black and white respecting each other, and working amicably hand in hand for the advancement of the country."[50]

The marginalization of African and African-descendant history and culture by archaeologists is not unique to Belize. Indeed, early archaeologists and explorers working throughout Central America focused almost exclusively on the Indigenous prehistory of the region until the mid-twentieth century. Even in the West Indies where African-descendant populations have made up a significant percentage of the population since the seventeenth century (primarily due to the forced migration and labor of enslaved peoples), the earliest archaeology focused on Indigenous Amerindian prehistory (for example, the material culture of the Lokono and Kalinago people which Europeans referred to as Arawak, Taíno, and Carib).[51] The earliest formal investigations of the material culture and built environment associated with colonial Caribbean history were carried out by historians and architects in the mid-late nineteenth century interested in the "monuments of the colonial-era" (for example, colonial estates, planter houses, and forts).[52] A 1912 Colonial Report on the "Preservation of Historic Sites" in the West Indies notes some Arawak remains and a few maroon settlements and sites associated with slave rebellions. However, by far the majority of sites identified in the report as worthy of documentation, restoration, and preservation by colonial administrators and archaeological scholars throughout the West Indies were sites associated with early European colonial settlements, skirmishes, and the residences and burials of colonial leaders.[53] As Douglas Armstrong and Mark Hauser note in a discussion of the history of archaeology in the Caribbean, the focus on colonial-era architecture continued during rising independence movements and shifts to local rule as ar-

chaeologists, historians, and national heritage organizations in the Caribbean began promoting the preservation of colonial sites as historic landmarks and public parks to "herald" "the might of past imperial powers."[54] For example, in Jamaica, "the National Heritage Trust was established in 1958 to mark and protect significant forts, estate houses and works, and prehistoric sites."[55] Armstrong and Hauser suggest that archaeological investigations on the African diaspora in the Caribbean did not begin in earnest until the late 1970s and early 1980s, first with studies of the material culture and built environment of plantations and later with examinations of the houses and yards and material culture of enslaved peoples and the adaptive communities they constructed.[56]

Colonial Period archaeological exploration and scientific examination in Belize legitimized the documentation and collection of tangible forms of Ancient Maya heritage, privileged archaeological authority and control, and reinforced racialized stereotypes about living peoples. However, Belizean citizens have long engaged with Ancient Maya history and culture and have been aware of the social, political, and economic significance of archaeological heritage. I provide examples of local and descendant communities' connections with Ancient Maya cities and objects and discuss the ways people manipulated archaeological interests and involvement in Belize for their own needs and interests during the Colonial Period.

Local and Descendant Communities' Engagements with Ancient Maya Heritage and Archaeology

Archaeological reports, expedition logs, and popular accounts of archaeological explorations in the Colonial Period are replete with examples of Belizeans interacting with Ancient Maya heritage in interesting cultural ways that differ from authorized archaeological investigations. Ancient cities and objects were clearly part of religious practices, local economies, political structures and decisions, and cultural preservation efforts at the same time they were documented and collected by colonial actors.

In a 1926 article about an archaeological expedition in the Yucatan, Gregory Mason made it clear that contemporary people still felt connected to ancient sites: "Not once but a hundred times was it made evident to us that the Indians of the Yucatan Peninsula regard these temples of the ancient Mayas with reverence."[57] Indeed, Mason reported that contemporary Maya people objected to archaeologists visiting certain Ancient Maya cities because "their temples were still used for worship."[58] In some accounts, contemporary Maya people connected with Ancient Maya heritage by constructing shrines and leaving offer-

ings near and at Ancient Maya sites. Archaeologists noted that people collected and interacted with pottery incense burners, reliefs of human figures, and effigy pots; they burned incense, said prayers, and broke pots at Ancient Maya sites; and they left decorated offerings for Ancient Maya objects.[59] Thomas Gann described a cave where "great quantities of pom had been burnt [. . .] and fresh flowers and palm branches strewn on the floor; moreover, someone had carved a small cross on the inscription rock to indicate, again, that the place was not sacred to the ancient gods alone."[60] And in a description of Santa Cruz peoples' connections to incense burners and reliefs with human figures Gann said, "The Indians firmly believe that at night these figures come to life, leave the vases to which they are attached, and visit these little houses [shrines constructed for them], the scene of their former life, returning by day to lifeless pottery."[61]

Protecting Heritage and Regulating Archaeologists' Actions

Chronicles of early archaeologists and explorers also show how local people attempted to control the treatment of Ancient Maya sites and objects by outsiders by resisting archaeological excavations, collecting Ancient Maya objects for their own personal collections, selling and faking Ancient Maya objects or refusing to sell them, and protecting knowledge about Ancient Maya history and culture.

A widely shared story in colonial archaeology records about such heritage stewardship efforts[62] involved a response to Gann's "discovery" and documentation of painted stucco murals at Santa Rita in northern Belize. Shortly after Gann came across this Ancient Maya artwork, they were "torn from the wall"[63]—supposedly by local Indians—before Gann could fully document them.[64] Archaeologists proposed various ideas about why this was done, including resistance to archaeologists, cultural connections to Santa Rita, superstitions about past objects, and that contemporary Maya people ground up fresco paint as a form of ethnomedicine.

With regards to Ancient Maya objects, Gann suggested that while local people were often willing to show them to archaeologists and sometimes sell them, they also tried to maintain control over such transactions. For example, Gann recalls that an old man revealed his collection of Ancient Maya artifacts to archaeologists, but would not let them handle more than one object at a time and kept a keen eye on them.[65] In another account, Gann told a story about when his trusted worker, Muddy attempted to purchase a vase from an old woman,

On his visiting the owner, she [. . .] started searching the house for it [. . .] The vase was not to be found, however, and the old lady, [. . .] remarked casually: "Ah, it must have gone out again, but it will be back tomorrow morning." This vase, she explained, often took a walk by itself but always returned to her. The curious belief is general amongst the Indians that chochohuiles [relics] of all kinds are endowed with life and possessed with the power of locomotion [. . .][66]

Perhaps this vase had been misplaced, perhaps the old lady did not want to give it up or wanted to manipulate Gann and his team for a better price, or perhaps the objects did indeed "wander off."[67] Regardless, these examples demonstrate vernacular heritage practices associated with Ancient Maya sites and material culture.

Colonial archaeologists also told of contemporary Maya people setting the terms for excavations, sometimes requiring that archaeologists seek permission from local leaders and other times simply forbidding access. For example, Gregory Mason said that the Mason-Spinden expedition's interests in the ruins of Mayil "precipitated an Indian council of war," "one party had been for ejecting us by force before we should profane Mayil with even a glance. The other party, made up of those whom the new prosperity founded on the trade in chicle has introduced to the ways of the outer world, was for letting us alone, so long as we injured no building and carried away no relic of former piety. Fortunately for us, this party carried the day." According to Mason, local people were generally cautious about allowing explorers and archaeologists to access sites: "Everywhere in the Yucatan, members of the Mason-Spinden expedition encountered reluctance on the part of the natives to let strangers enter the sacred buildings erected by the ancient Maya race [. . .] No sooner would we reach an old Maya ruin than an Indian would appear as if by magic and keep a close eye on us until we had finished our measuring and photographing [. . .] they resent foreign invasion [. . .] they [local Maya people] are also extremely suspicious of foreign interests in their altars and shrines."[68]

Gann also told stories about Maya workers' expressing concerns about excavation. He said one individual informed him he had been cautioned by an Ancient Maya limestone head about the archaeological work they had been doing. Gann wrote: "[The head] warned the worker that he and the other Indians were doing very wrong in interfering with the graves of their remote ancestors, and that [. . .] the Indians themselves could, and would, be punished very severely [for this desecration], unless they left the work immediately, without even turning another spadeful, and never returned to it again." Gann found

the situation frustrating and tried to convince the workers otherwise by telling them they were being tricked by the limestone head, and falsely claiming that they could go to jail for ceasing work they agreed to do.[69]

These cautions by local people were likely attempts to protect Maya cultural knowledge and sites from what they perceived as foreign violations of their emic heritage stewardship values. In a 1927 British Museum report, archaeologist Thomas Athol Joyce described contemporary Maya people in Belize as being "extremely reticent on all questions connected with his religion and customs" and suggested that early efforts "to obtain information were blocked by evasive answers, or straightforward denials."[70] In one of Gann's archaeological texts he said, "The Indians have little objection to strangers witnessing the common ceremonies which are about half Christian and half pagan, but the really important ones, carried out in honour of the old gods exclusively, are never on exhibition."[71] And after the archaeologists had stumbled on a cave with evidence of worship, Gann stated, "We had some difficulty finding the cave again, and a number of Indian labourers working in the fields, of whom we asked the way, denied all knowledge of it, evidently not approving of our visit."[72]

Despite Colonial Period archaeologists' descriptions of the many ways living people interacted with Ancient Maya heritage, foreign archaeologists and explorers also denied such connections, revealing a complicated interplay between colonial constructions of archaeological heritage and local and descendant community's own vernacular heritage constructs. Colonial administrators also discounted local interests in historic sites and objects. In a 1908 extract from the West India Committee Circular included in a 1912 Colonial Report on the "Preservation of Historic Sites" in the West Indies, a colonial secretary noted that, "It is proverbial that inhabitants of places rich in historic associations care far less for them than visitors do. We are afraid that residents in the West Indies form no exception to this rule."[73] At times, Colonial Period archaeologists outright suggested that local residents and contemporary Maya people did not care about Ancient Maya heritage. Gann said of a meeting with the leaders of one Maya village, "These men were undoubtably [sic] descendants of those Indians who had erected the mounds, sculptured the inscriptions [. . .], *yet they took not the slightest interest in the history or traditions of their great ancestors*."[74] Similarly, Maya archaeologist Eric Thompson said in the introduction to his memoir that the book was an "account of incidents of excavation of the Mayas' ancient cities and of contacts with their descendants who, *ignorant of their past,* still live there."[75]

Such colonial accounts purposefully distanced living people from Ancient

Maya heritage in order to legitimize archaeologists' authority over ancient cities and objects. In their accounts, archaeologists repeatedly privileged their own heritage engagements by emphasizing their expertise and delegitimizing living peoples' connections by calling them superstitions or beliefs. Mitchell-Hedges described contemporary Maya ideas about the discovery of Ancient Maya remains disparagingly: "Their beliefs and legends are grotesque. They believe that the specimens we excavated were centuries ago buried deep beneath the earth, and that gradually those still unrecovered are working up to the top until the time arrives when they will appear on the surface."[76]

The legitimization of archaeological expertise paid off. By the 1950s, archaeological science and state control were the established official forms of engagement with ancient and historic sites and objects and archaeologists and state heritage actors were the primary experts with authority over the Ancient Maya past in Belize.

Archaeological Heritage Management during the Independence Period: Belizean Agency and Institutionalizing Archaeology

Colonial Period archaeologists and government officials established the foci of official archaeological heritage in Belize: monumental structures, Ancient Maya history and culture, tangible objects, and foreign archaeological and governmental (rather than local) control over historic cities and objects. During the Independence Period of archaeology, in some ways, the lines between colonialist and nationalist interests in archaeology overlapped. As colonial and nationalist actors recognized the inevitability of Belize's transition to independence, they worked to institutionalize archaeology and establish a national infrastructure for archaeological heritage management. New antiquities legislation reinforced state oversight of Ancient Maya objects and sites, and British colonial officials and foreign academics helped establish the Department of Archaeology (1957), the first governmental institution for managing archaeological heritage in Belize. Nationalist interests in archaeological research and heritage-based professional development as a consideration with impending independence was not unique to Belize. Caribbean archaeologists Armstrong and Hauser refer to the late 1950s and early 1960s as an "era of transition from colonial rule to nationhood" throughout the Caribbean and suggest that at this time "archaeological investigations began to be organized with a decidedly new agenda."[77] Throughout British colonies in the West Indies, colonial governments, archaeologists, and nationalist actors established institutions to manage archaeological resources and historic sites.

Jamaica (which gained independence in 1962) enacted the Jamaica National Trust Commission in 1958 to protect historic resources.[78] In the Bahamas, which gained independence in 1973, the National Trust Act was passed in 1959 to promote and preserve Bahamian natural and historic resources.[79] And, the International Congress of Caribbean Archaeology was founded in 1961.[80]

During Belize's Independence Period, colonial actors, nationalist politicians, and archaeologists (mostly foreign) alike recognized the role archaeological heritage could play in defining Belizean national identity and in contributing to economic and social development. Independence activists and leaders like George Cadle Price (Belize's first Prime Minister) and the People's United Party (PUP) claimed Ancient Maya history and culture as Belizean heritage; they used the Mayan past to emphasize the deep history of Belize and to promote a new collective identity. As such, although archaeological research and development initiatives during the Independence Period were certainly conducted by archaeologists, colonial actors, and nationalist activists in the service of the state, they also represent Belizean agency in archaeological practice. For example, it is during this period that Belizeans first began to direct the management and development of archaeological objects and sites.

State Control, Foreign Influence, and Professional Development

Colonial government interest in Belizean archaeology expanded during the Independence Period. In the 1940s, Colonial Secretary E. D. Hone and Governor Ronald Garvey were both supportive of archaeological research and promoted the development and preservation of ancient cities.[81] During the Independence Period, the colonial government began designating Ancient Maya cities as Crown Site Reserves,[82] a name that explained both who owned archaeological heritage and the preferred management technique—preservation. The colonial government began employing guards at these reserves to prevent "unauthorized" access and established licensure protocols for archaeologists who needed a license from the governor to dig or export ancient objects. Penalties were set for unauthorized excavations, removal of materials, or damage to sites. By 1971, a new Antiquities Law strengthened and reinforced state control and archaeological authority, stating the Crown's ownership of all archaeological material (sites and objects), outlining how people were required to interact with archaeological sites, and explicitly articulating what could be done with finds.[83]

A partage policy of dividing finds between foreign archaeologists and the colonial government persisted into the Independence Period and was used

as an incentive for foreign archaeologists to work in Belize. This policy was justified by an archaeo-centric, paternalistic, and colonialist argument that: without a Belizean national museum or trained personnel, ancient cultural materials would be better cared for abroad. Many materials acquired during the Independence Period are still held today by foreign institutions, including the American Museum of Natural History and British Museum.[84]

The Department of Archaeology (DoA; now the Institute of Archaeology) was founded by the colonial government in 1957 to supervise and implement archaeological research and the management of research, sites, and material culture. British civil servant A. Hamilton Anderson was appointed the first Archaeological Commissioner. Before this appointment, Anderson had served as First Assistant Secretary in the Colonial Government, where he oversaw archaeological excavations and exports of ancient cultural materials. Between 1976 and 1987, the DoA expanded from one staff member to about a dozen (several with advanced degrees).[85] And in 2019, the DoA had more than twenty staff members. Although the DoA was a national institution, it was not until 1971 that a Belizean was named director (a position originally called the Archaeological Commissioner).[86]

During the Independence Period, the DoA's archaeological heritage management efforts were primarily oriented toward preservation: site protection, stewardship of the nation's cultural patrimony, and the regulation of archaeological research. To reinforce preservation efforts, the colonial government worked with the DoA and foreign archaeologists to create programming—displays, lectures, and newspaper articles—aimed at educating members of the public about archaeological resources and the enforcement of antiquities laws.[87] They also began cooperative programs with law enforcement and customs departments in other countries to reduce the illicit trade in antiquities from Belize and surrounding countries.

Several colonial actors strove to develop greater national infrastructure for research, conservation, and site management by training Belizean archaeologists. A. Hamilton Anderson recognized the importance of such developments. In the 1958 and 1963 versions of his *Brief Sketch of British Honduras,* he argued for financial support for excavations and developing archaeological sites, and asserted that sites needed to be made more accessible for both archaeologists and visitors by clearing roads and cutting trails.[88] Anderson also networked with Maya archaeologists from Yale University, Harvard's Peabody Museum of Natural History, the University of Pennsylvania Museum, British Museum, and the Royal Ontario Museum at regional archaeological conferences such as the International Congress of Americanists to

convince them to conduct research in Belize.[89] He developed a particularly important partnership with the Government of Belize, DoA, Royal Ontario Museum (ROM), and Trent University in the mid-1970s. Trent had established a master of arts degree program with a focus in "Art and Archaeology" and human osteology, and archaeologists from Trent and ROM began to conduct numerous archaeological projects in Belize. In the late 1970s, Trent archaeologist Paul Healy received a Canadian International Development Agency grant to develop a university degree program to train Belizeans in archaeology, museum studies, and cultural resource management. In addition to the degree opportunities, this initiative involved creating numerous Trent/Belize Archaeological Field Schools and short-term conservation courses for site caretakers and other Belizean heritage professionals.[90] Such connections between foreign universities and Belizean national heritage institutions persist into the twenty-first century as foreign archaeologists and other social scientists conducting research in Belize are often encouraged by state heritage actors to incorporate Belizean university students and employees from national heritage institutions as volunteers and interns in their research projects.

Archaeologists as Legitimate Heritage Actors

By the 1950s, archaeologists working in Belize were committed to systematic, problem-oriented scientific examinations of the Ancient Maya past, distinguishing themselves from earlier explorers and antiquarians.[91] As such, during the Independence Period, archaeology was almost exclusively conducted by trained academics who strove to answer specific questions about Ancient Maya culture (for example, politics, economics, religion, agriculture, and social structure).[92] In texts from later in his career, J. Eric S. Thompson posed many questions about Ancient Maya history and culture. Rather than imagining in vivid detail an exoticized, violent pagan ceremony (as Gann had), when Thompson envisioned young initiates before a ceremony, he presented questions about their potential mindsets: "I tried to picture those youths of a thousand years ago. [. . .] Did they accept authority, or were they in revolt against their elders? Did they accept the gods without question, or were they skeptical? Surely, they complained to each other about the long periods of fasting and vigil. Or did they? What right have we to suppose that they reacted as modern young men would?"[93] Thompson classified early archaeologists as "Explorers," and he was particularly critical of Mitchell-Hedges who he said:

described his life at Lubaantun, where he sat night after night repelling attacks of prowling jaguars, which invariably bit the dust, and where the climate was so deadly that no white man could survive for more than three weeks. He "discovered" a ruin that had been known to archaeologists since the last century [. . .] Later he and a collaborator wrote a book, *Land of Wonder and Fear;* to me the wonder was how he could write such nonsense and the fear of how much taller the next yarn would be.[94]

An increased focus on methodology, training, and science resulted in extensive knowledge documentation and analysis of the cultural practices of Ancient Maya people. It also further legitimized the authority of archaeological experts and distanced scientific examination of the Ancient Maya from the vernacular heritage practices and interests of living people. In 1981, archaeologist Clemency Coggins reviewed an educational archaeology film, *Maya Lords of the Jungle,* which unpacks the history of Maya archaeology since the nineteenth century. Coggins suggested that this film appropriately highlighted the increased scientific and interdisciplinary foci in archaeology, and the ways archaeologists complicated the concept of the "Maya Collapse"[95] in the late twentieth century. However, she critiqued the film's lack of discussion about ancient and contemporary Maya peoples, saying that the film demonstrated that archaeology was still dominated by privileged foreign archaeological experts. She stated, "[. . .] there is very little mention of the ancient Maya rulers portrayed on monuments and buried in tombs—the 'Lords of the Jungle' turn out to be the archaeologists themselves who are virtually all North American and who speak authoritatively of their work without mentioning the institutions or host countries that made it possible."[96]

Despite shifts in research questions and methods, in the Independence Period, archaeologists continued to grant weight to tangible, aesthetically pleasing objects when defining archaeological significance. For example, Thompson expressed in his 1963 memoir his frustration with finding a burial chamber in western Belize with few objects: "I am usually oversentimental towards the Maya, but I hoped that the priest who had the nerve to place only two miserable bowls and a crude figurine with the cremation fell off one of the stepping-stones as he climbed out of the tomb and broke his neck!"[97] In another passage, Thompson described his discovery of one particular object as career-defining: "a little gem of an ornament of a soft green color in the form of a human head," of which he said, "archaeologists are very lucky in their finds. I am not among them, but there are three or four great finds in my career and that was one of them."[98]

Archaeological Heritage and Living People during the Independence Period

Whereas archaeologists during the Colonial Period frequently (though often disparagingly) discussed descendant and local communities' engagements with Ancient Maya objects and places, archaeologists during the Independence Period rarely described living people in their publications. When they did, they usually framed living Indigenous people as sources of information, making ethnographic analogies between them and the Ancient Maya.[99] For example, Thompson said in his memoir, "modern descendants of the ancient Maya still preserved many ancient customs and religious ideas [. . .] it was clear that archaeological excavations were not the only means of learning about the ancient ways [. . .] pick and shovel would never reveal the many customs that had survived in San Antonio from an earlier age."[100]

Partly because they saw Maya people as living repositories of data about ancient life, during the Independence Period, archaeologists continued to be concerned that Maya culture and history would disappear. Thompson frequently referenced this concern: "Chol and Chorti are dying peoples. The former are reduced to an island around Palenque; the culture of the latter is being rapidly infused with Latin-American elements and survives only in the smaller settlements,"[101] and "many of the past ways and old beliefs have been lost with the opening of the country to 'progress.'"[102]

In addition to characterizing living Maya peoples as potential sources of evidence about Ancient Maya history and culture, archaeologists also expressed concerns about the ways living people interacted with and affected archaeological heritage. Additionally, foreign archaeologists and nationalist actors alike considered the social and economic potential of archaeological heritage for the Belizean state and its citizens. References to living people in archaeologists' work during the Independence Period by and large legitimized archaeologists as official heritage experts and emphasized a need for state control of ancient cities and objects. However, discussions about social and economic development and archaeological heritage as a national resource also indicate a growing recognition among archaeologists and state actors of the intersections between archaeology and modern society and the impacts and implications of archaeological practices on living peoples.

Preservation Concerns and Privileged Stakeholders

Concerned with mitigating the loss of Ancient Maya sites from development, natural disasters, looting, and disturbances from local people, the colonial

government commissioned several reconnaissance and salvage archaeology projects in Belize in the 1960s that were carried out mainly by foreign archaeologists. Archaeological Commissioner Anderson saw both the public and government institutions to blame for site destruction, asserting that "unauthorized operations on Crown land sites" were being carried out, resulting in damage to sites or "unauthorized removal of material therefrom." He noted the difficulty in obtaining evidence of site damage due to "public indifference," and expressed concern about the permission given to the Public Works Department to remove stone materials from Ancient Maya sites like Baking Pot to use for road construction.[103] By chastising the "indifferent public" and the carelessness of a government department, Anderson positioned archaeological experts as the primary stewards of Belize's ancient culture and history.

As the illicit removal of antiquities from ancient cities in Central America increased in the latter half of the twentieth century, such destruction began to receive more attention from archaeologists. Maya archaeologist Clemency Coggins suggested in 1981 that "one of the gravest problems facing Maya archaeology today is the staggering illicit destruction of southern lowland sites."[104] In a 1981 article about looting at Xunantunich, archaeologists David Pendergast and Elizabeth Graham described doing salvage work, going through the "backdirt" left behind by looters:

> While working in looters' leavings is disheartening enough, it is even more so when dealing with what appear to be important remains [...] it appeared that the looters had struck a burial, and that most of the information contained in this burial was irretrievably lost. The loss in such cases is far greater than the vessels or other artifacts alone, for when a looter rips a burial to pieces, data on the critical associations among objects are destroyed forever. Furthermore, information on the position of the burial is lost along with any small or fragile object trampled underfoot.[105]

Pendergast and Graham note that looting is a "matter of grave concern," refer to the loss of information and data and damage to objects, and suggest that as archaeological sites are sacked "to fill museums and collectors' shelves," "all of those concerned with the preservation of past human achievements must count themselves the losers."[106]

In these comments, Coggins, Pendergast, and Graham set themselves apart from looters, emphasizing that they are seekers of knowledge who methodically identify context and associations between objects—an approach that is integral to archaeological science and interpretations. These archaeologists

(like those of the Colonial Period) define items as particularly significant to archaeological heritage when they are rare, whole, and decorated, though they differ in their emphasis on context and information. Independence Period archaeologists' discussions of looting also privilege preservation as the best form of archaeological heritage management. By emphasizing the loss of data to looting and by invoking a scientific approach to archaeology, the authors reinforce a myth of archaeology as politically neutral and universally valuable. I was particularly struck by the fact that Pendergast and Graham did not mention the desecration of the Xunantunich tomb—a human gravesite—as a concern. They also did not identify Belizean people as being specifically affected by the looting problem. Finally, the authors did not contextualize the looting situation by considering who was engaging in this act and why. Such approaches privilege archaeological perspectives and knowledge and obscure the social complexities of non-archaeological engagements with ancient cities and objects.[107]

Archaeology, Economic and Social Development, and Belizean Identity

Colonial authorities have recognized connections between economic development, tourism, and archaeology since some of the earliest archaeological expeditions in Belize. In 1928, the Director of the British Museum, Sir Frederic Kenyon, alluded to this connection, saying that "'Trade follows the flag,' but it is equally true that economic development follows the spade of the archaeologist."[108] The recognition of the development potential of archaeology inspired many of the efforts to make heritage sites accessible to tourists during the Independence Period.

Between the 1950s and the 1980s, Belizean archaeological research was often done with tourism development in mind. Xunantunich and Altun Ha, two monumental sites with large central plaza complexes, were two of the first Ancient Maya cities the DoA restored for tourism. Maya archaeologist Richard Leventhal and colleagues detail the history of tourism development at Xunantunich following the 1949 rediscovery of the site's iconic stucco frieze as archaeologists worked with the DoA to consolidate and reconstruct several buildings on the Castillo complex.[109] A similar process took place at Altun Ha, according to Norman Hammond, who said that during the Independence Period, "substantial attention was paid to the restoration of the site as a national monument and as a contribution to economic development as tourism burgeon[ed]."[110]

By the late 1960s and early 1970s, archaeologically-themed Central American tourism was extensively promoted by news media and tourism agencies. A

1968 New York Times editorial highlighted the tourism potential of the Maya cities in Belize, in ways that continued Colonial Era tropes, emphasizing the "marvel and mystery" of Ancient Maya architecture and suggesting that the Maya sites in Belize were "outstanding" even in comparison with famous ones like Chichén Itzá and Uxmal in Mexico.[111]

But archaeology was not only seen as valuable for tourists and economic growth; research and restoration at sites were also viewed as developing social resources that could be appreciated by all Belizeans. Anderson discussed efforts to form "an Archaeological Society open to all persons in the Colony" to "arouse the public's interest in its Ancient Maya heritage and in the protection of sites on privately owned as well as Crown lands."[112] Anderson also developed exhibits on the natural history and Ancient Maya history and culture of Belize and the 1958 and 1963 versions of Anderson's *Brief Sketch of British Honduras* mention cultural programming at the Baron Bliss Institute, which was managed by the colonial government. This institute developed as a space for educational and cultural programming and housed an auditorium, public library, lecture room, and exhibits of Ancient Maya objects and other Belizean material culture. Anderson noted that "the contribution the Institute is making to the social advancement of the country is great and the level of attendance at events in it is high."[113] Anderson's views about the social values of Belizean culture and history are reminiscent of rhetoric about adaptive education and nationalist development goals for Belizean education during the Colonial and Independence Periods of education.

The notion that Ancient Maya history and culture could unite Belizean people as part of their collective heritage appealed to political actors as well, including nationalist and PUP leader George Cadle Price, who argued Ancient Maya history and culture were a foundation of Belizean national identity as they represent a history prior to European contact and influence. A connection between Belizean people and the Ancient Maya past also physically anchored the nation in Central America, reinforcing its peoples' land claims. The PUP thus used the deep history of the Ancient Maya in Belize and the prevalence of their physical markers to construct an imagined community, recognizing a commonly held belief among political actors worldwide that heritage defines a nation.[114]

During the late Independence Period, national politicians embodied claims to Ancient Mayan heritage in their vision for and eventual construction of the new Belizean capital of Belmopan, where buildings were constructed to emulate the style of Ancient Maya pyramids. Anne Macpherson suggests these efforts supported a racialized construction of Belizean identity "as an histori-

cally Maya nation oriented toward Central America rather than the emerging Commonwealth Caribbean, a construction that the pyramid-like design of Belmopan made literally concrete."[115] Similarly, Laurie Medina argues that in order "to anchor the Belizean nation in antiquity and strengthen its hold on the disputed territory it claimed, the PUP emphasized Belize's Mayan roots" by moving the capital from "the Creole stronghold of Belize City to Belmopan, a new town in the interior named for the Mopan Maya," which was "designed to resemble an ancient Mayan plaza."[116]

Conflation of Ancient Maya culture and history with Belizean national heritage by nationalist actors and archaeological scholars meant that, similar to the case with educational materials and programming, non-Ancient Maya history and culture were often marginalized through omission. There was almost no discussion about Kriol, Mestizo, or Garifuna people in archaeological publications during the Independence Period, and few governmental or academic actors considered Kriol, Mestizo, or Garifuna archaeological heritage appropriate for research or tourism development purposes until very recently. This omission may have been an intentional attempt to unify Belizeans under the myth of a neutral and apolitical Ancient Maya heritage that carried universal value, thus occluding deep ethnic divisions that actually existed within Belizean society.

As I demonstrate in the following chapter, national emphases on the touristic and economic values of archaeological heritage and Maya-centric archaeological practices continue into the late twentieth and early twenty-first centuries in Belize.

Belizeans Engaging with Archaeological Heritage and Community-based Projects

During the Independence Period of archaeology popular accounts of archaeological expeditions and studies were rare, as archaeological practice was shifting towards primarily scientific reporting for scholarly audiences. These reports rarely included details of interactions with living people.

In conversations I have had with archaeologists who have been working in Belize since the Independence Period, they have shared personal accounts of peoples' local engagements with archaeology which demonstrated the general Belizean public's interests in archaeology and Ancient Maya material culture. In the 1980s, archaeologist Cynthia Robin toured Belize with a DoA staff member and the "jade head," a famous archaeological discovery from Altun Ha that serves as a kind of national icon and symbol of Belizean heri-

tage. They lectured about archaeology and Belize's Ancient Maya heritage in villages and towns, bringing the jade head because it was an identifiable and tangible object. According to Robin, Belizean citizens were keen to learn about this part of the country's past and they easily connected with Ancient Maya culture and history through educational programs and renowned artifacts.[117]

Though Independence Period archaeology in Belize can be characterized by a strong emphasis on archaeological scientific authority, it was also during the Independence Period that anthropologists' engagements with descendant communities inspired new developments in archaeological analyses and a subset of archaeologists developed the earliest community-based archaeology initiatives in Belize, sometimes inspired by the interests of local communities.[118] Some anthropologists' research with descendant communities in the late 1970s and early 1980s led archaeologists to consider the lives of everyday people as well as the ways descendant communities' cultural knowledge and practices could contribute to archaeological interpretations. Indeed, Richard Wilk's seminal work with living Maya people documenting spatial organizations within and between Maya sites inspired the development of household archaeology studies (as opposed to large monumental city-focused archaeology) both in Belize and around the world.[119] And in the mid-1980s, Crooked Tree Village residents approached K. Anne Pyburn about the possibility of studying the nearby Chau Hiix Maya Archaeological Site.[120] Archaeologists working at other sites in Belize, like Lamanai and Xunantunich also began to develop engagements with local communities in the 1980s and 1990s. In the context of Crooked Tree, community members were interested in learning more about Chau Hiix and its potential for economic and cultural development. The interactions between Pyburn and Crooked Tree residents resulted in the development of the public archaeology-focused Chau Hiix Archaeological Project (CHAP). As I demonstrate in the following chapters, a kind of consciousness about the value of archaeological research and knowledge empowered Crooked Tree citizens to approach Pyburn and advocate for site development, but this consciousness also highlights vernacular heritage practices in interesting ways.

Through an examination of projects like the CHAP, heritage scholars can learn a great deal about how colonial legacies and nationalist heritage rhetoric in education and archaeology intersect, how official heritage discourses and practices are replicated and transformed by local citizens, and the diverse ways Belizeans engage with and negotiate archaeological heritage in the twenty-first century.

Conclusion

During the Independence Period state control and management over archaeological resources increased through the work of the DoA and tourism development efforts. Nationalist actors highlighted the connections between Belizean heritage, archaeology, and social and economic development and many politicians promoted Ancient Maya culture and history as part of Belize's deep history and central to Belizean identity. It is also during the latter part of the Independence Period (in the 1980s) that archaeologists developed the earliest community-based archaeology projects in Belize. During the Globalization Period of archaeology (early 1990s and the early twenty-first century), the DoA formalized outreach programs focused on Belizean archaeology and community-based heritage projects increased. Additionally, following international trends, Belizean politicians became more invested in how they define and represent national heritage internally and on a global stage. As a result, the Belizean national government developed the National Institute of Culture and History (established by legislation in 2000), which manages national cultural resources, conducts and supervises research focused on Belizean history and culture, and promotes Belizean heritage through educational programs and tourism efforts.

On structural levels, state control of Belizean archaeological heritage persists, and colonial legacies about appropriate ways of interacting with archaeological resources and emphases on tangible forms of Ancient Maya history and culture endure, thus so does the marginalization of non-Maya culture and history. National actors also continue to emphasize connections between archaeology, Belizean identity, and social and economic development. However, the national government and heritage scholars have also diversified their foci on Belizean archaeological heritage and increased community engagement. Additionally, Belizean citizens negotiate nationalist rhetoric about archaeology, tourism, and Belizean heritage for their communities and find ways to promote local history and culture. In the following chapter, I discuss examples of the interplay between official and vernacular archaeological heritage discourses and practices, drawing from research on the CHAP and in the rural Kriol communities of Crooked Tree and Biscayne. I demonstrate the innovative ways teachers and young people negotiate power dynamics and official heritage discourses that persist in archaeological practices and national heritage management initiatives.

Official Archaeological Heritage Management and Community Negotiations in the Globalization Period

In the previous chapter, I explored the historical foundations and manifestations of official archaeological heritage in Belize from the late nineteenth century until independence. In this chapter, I reveal that during the Globalization Period, several of the previously described trends in official archaeological heritage continue: state control of ancient cities and objects, an overt emphasis on Ancient Maya history and culture, and the promotion of archaeology and Ancient Maya history and culture as nationalist and economic resources. I also discuss ways Belizean state initiatives parallel global trends in heritage development with attempts to institutionalize state management of archaeological heritage and, as in education, efforts to diversify cultural representations and programming. During the Globalization Period more archaeologists began to reflect on the impacts of their work, recognize community connections with archaeology, and implement public initiatives. Because of this, I complemented my research on official archaeological heritage management with extensive community-based ethnographic research in Crooked Tree and Biscayne to unpack Belizean citizens' constructions and negotiations of official archaeological heritage during the Globalization Period.

State Management of Archaeology, History, and Culture in Belize

Much of the Globalization Period of archaeology can be characterized by a national approach to manage archaeology, historic sites and objects, and culture that began in the 1980s and flourished in the early twenty-first century.[1] This approach involved increased government control over archaeological practice and resources, the growth of the DoA (which became the Institute of Archaeology in 2003), the creation of new heritage institutions, initiatives, and heritage-based bureaucracy, increased training of Belizean heritage actors, and continued efforts to promote Ancient Maya sites, objects, and history as central to Belizean history and identity. A Belize Times article from 2003 emphasized

what a significant change it was for Belizeans to be in control of archaeology, noting: "For decades the few Archaeologists that were Belizean were confined to supporting roles, while the largely foreign archaeology projects gathered information, excavated and then returned to their Universities abroad with their samples and information. Belizean Archaeologists and archaeology enthusiasts had little access or control over the work done at Belizean sites. This has changed dramatically [. . .] Belizean Archaeologists are [now] leading [. . .] historic restoration effort[s]."[2]

Nationalist and institutionalized approaches to heritage are part of an international trend. It is as if Belize took cues from a kind of global heritage handbook in which a "veritable carnival of acronyms" and "metaculture of modernity"[3] came to structure heritage management organizations, regulations, and policies. Global efforts like the World Heritage movement have promoted varied heritage forms as universal components of human history, but they have also empowered states to define and control "national heritages."[4]

Throughout the Caribbean at this time, governments continued earlier colonial efforts (noted in chapter four) to develop centralized state institutions and policies to promote and control historic sites and objects as national forms of history and culture. In 1998, the Bahamas passed the Antiquities, Monuments and Museums Act, which established a national museum, formalized a permitting process for archaeology, and outlined details for the protection of antiquities, among other practices.[5] Trinidad and Tobago passed The National Trust Act in 2000, which enables a National Trust Council to prepare lists of "buildings and sites of particular national, historic, archaeological, or architectural interest, which should be preserved," and provided the minister of town and county planning the ability to limit development "in areas with significant archaeological remains."[6] In 2000, the Dominican Republic passed the Ministry of Culture Law, which established a Council for National Culture as a central institution for managing cultural and historic resources. Additionally, this law defined National Cultural Patrimony and National Cultural Identity as tangible and intangible forms of heritage that should be promoted and preserved, created a National Network of Museums, and outlined details for the protection of cultural and historic resources.[7]

Today, the Belizean state centers itself as the principal heritage stakeholder as it supervises all research related to culture and history (for example, in disciplines like archaeology, cultural anthropology, sociology, and history), as well as the management, protection, and development of historical objects, monuments and sites, and museums for the appreciation of citizens and tourists. State institutions also promote a vision of Belizean national heritage in the

form of traditions, historic sites, and historic narratives through education and cultural programming. These responsibilities are mandated under the National Institute of Culture and History Act (known as the NICH Act, which replaced the Ancient Monument and Antiquities ordinance), which was passed in 2000 and revised in 2003.

The NICH Act established the National Institute of Culture and History (NICH) as the government institution in charge of managing, protecting, and studying Belize's heritage. According to their website, NICH "seeks to encourage Belizeans and persons interested in Belize to better understand our historic and ethnic roots and instill pride in ourselves about our country's unique heritage and shared national identity."[8] As of 2020, NICH has four departments: the Institute of Creative Arts; the Museum of Belize and the Houses of Culture; the Institute for Social and Cultural Research; and the Institute of Archaeology. I describe the latter three. These departments, along with the Belize Film Commission, are administered by the Belize Ministry of Tourism and Civil Aviation.

The Museum of Belize, the country's national museum, manages the collection, preservation, study, and exhibition of objects significant to Belizean history and culture. The Museum also educates citizens and visitors through education programs, events, and outreach and oversees the seven Houses of Culture located throughout Belize. The Houses of Culture are community centers that feature exhibits and programs and offer space for local cultural activities and events.[9]

The Institute of Social and Cultural Research (ISCR) evaluates, regulates, and supervises all social, cultural, and historical research in Belize. It disseminates the results of this research via educational programs and events like public lectures and conferences. The ISCR also runs programs to document, promote, and safeguard intangible forms of heritage (for example, festivals, foodways, and cultural traditions), administers the writing and publication of books about Belizean history and culture, is involved in community-based heritage initiatives, and partners with the Belize History Association.

The Institute of Archaeology (IA, formerly the DoA) has primary responsibility for Belize's archaeological heritage–for example, sites and objects. The IA facilitates and regulates preservation of and research into Belize's archaeological resources and oversees the development and management of archaeological sites and national reserves. The IA promotes Belize's archaeological resources to citizens and foreign visitors through educational programming, classroom visits, events, and tourism. The IA has the largest budget of all the NICH departments, and brings in the most money, primarily through archaeo-tourism

and research projects. It is thus a particularly powerful NICH institution, reflecting the status of archaeological resources and knowledge as official heritage forms in Belize.

During the Globalization Period, the IA and ISCR updated existing policies for evaluating research proposals, granting permits, and monitoring projects including those involving living people. Detailed guidelines determine who is qualified to conduct archaeological and cultural research and the kinds of excavation and collections work permitted. Researchers are required to contribute to academic understandings of Belizean history and culture by sharing copies of research publications, reports, and presentations with the IA and ISCR. Archaeologists must also give a percentage of their research budgets to the IA to help sustain both the IA and the conservation and restoration of structures disturbed by excavations.[10] In 2003, the IA organized the first national Belize Archaeology Symposium, a now annual national conference at which Belizean and foreign scholars are encouraged to share the results of their work. The IA and ISCR jointly organized a conference from 2012 to 2016 and in 2018, the ISCR held its own independent conference. These conferences hold researchers to certain standards of public accountability, and the conference proceedings are published by NICH every year, ensuring a Belizean-directed heritage publication.

As part of developing national control of and authority over its archaeological resources, Belize has increasingly focused on professionalizing heritage disciplines and training Belizean citizens as scholars.[11] Today, the majority of heritage professionals in Belize, and all of the IA and ISCR staff, are Belizean, a dramatic shift from before independence. The IA and ISCR encourage employees to pursue higher degrees in heritage disciplines and they legitimize these disciplines by supporting collaborative projects with foreign researchers, disseminating research results, and training young scholars. For example, foreign-run research projects are encouraged to take on Belizean interns as volunteers in the field.

NICH has been active in organizing and supporting national preservation initiatives as responses to threats to Ancient Maya sites and objects like the illicit antiquities market, urban development, and resource extraction. In the face of these threats, the NICH Act emphasized the protection of material culture resources, defining "ancient monuments" and "antiquities" as national property, and establishing laws prohibiting the looting, damage, and sale of Belizean cultural resources.

In Belize such rhetoric about "heritage at risk" frames preservation and archaeological management as a universal responsibility that is part of a global

movement.[12] Belizean government offices and heritage officials have increasingly worked to bring their laws and policies in line with international preservation conventions to legitimize their official heritage discourses and practices in the eyes of global superpowers—a relationship Shoshaunna Parks sees as representing the "hierarchy of power that dominates the investigation, interpretation, and management of pre-Hispanic cultural heritage in Belize and throughout the Maya region."[13] The IA enforces cultural property legislation, implements site conservation and development plans, and has developed stewardship-based educational programs. In the early twenty-first century, the IA started a campaign to educate the public about antiquities laws, mass producing posters with the slogans "PROTECT Our Cultural Heritage" and "PROTECT Our Belizean Heritage." And in 2013, Belize entered into a bilateral agreement with the United States to ensure the imposition of import restrictions on historic objects.

National heritage institutions and programs across the globe emphasize site protection, preservation, and state management of historic sites and objects. These official heritage processes privilege Anglo-conservation and management practices and scientific archaeological interests, which frames historic sites and objects as spaces for scientific investigation and interpretation that must be protected from other types of engagements, such as local vernacular heritage practices. This privileging can distance local people from the material past, reinforce boundaries between archaeologists and diverse publics, and borrowing from Garcia's work in Peru segregate "the space of ruins from the broader local dynamics in which they were integrated."[14]

Continued Emphasis on Tangible and Essentialized Ancient Maya Heritage

Despite the diversity of Belize's history and culture, in the twenty-first century the vast majority of archaeological research continues to be focused on Ancient Maya history and culture, and Maya sites are among the most important tourist revenue producers. Additionally, Ancient Maya objects and cities and history continue to be considered primary aspects of Belizean's shared past and this is reinforced through state archaeological management efforts, research, tourism, and public display.

The NICH Act identifies protection as particularly important for "Ancient Monuments" (defined as "any structure or building erected by man or any natural feature transformed or worked by man, or the remains or any part thereof, whether upon any land or in any river, stream or watercourse or under the territorial waters of Belize, that has been in existence for one hundred years or more") and "antiquities" (defined as "any article manufactured or worked

by man, whether of stone, pottery, metal, wood, glass, or any other substance, or any part thereof:—(i) the manufacture or workmanship of which belongs to the Maya civilization, being of an age of one hundred years or more; or (ii) the manufacture or workmanship of which belongs to a civilization other than the Maya civilization, being an article which is of an age of one hundred years or more").[15] Though the NICH Act's definitions of ancient monuments and antiquities do not overtly exclude other cultural groups, "Maya civilization" is the only cultural group explicitly listed. Additionally, the emphasis on "ancient" heritage (defined as 100 years old or older) excludes many historic sites and antiquities of African descendant groups, or other groups who settled in Belize more recently.

Of the fourteen Archaeological Reserves in Belize, twelve are associated with the Ancient Maya. The two non-Maya sites (which were not designated as national reserves until 2009) are the Serpon Sugar Mill in Stann Creek and Yarborough Cemetery in Belize City. Both of these sites are part of Belize's colonial history. There are no explicitly Kriol, Garifuna, or other non-Maya ethnic group archaeological reserves in Belize.

In the twenty-first century, images of Ancient Maya cities and objects are prominently used by the government and private companies to market products and promote tourism. Maya pyramids and famous archaeological objects like the "jade head" found at Altun Ha in 1968 appear on the country's currency, textbooks, phonebooks, stamps, bottles of Belikin beer (the leading domestically produced beer in the country), and tourism brochures.[16]

Heritage actors privilege the "physical authenticity"[17] of Ancient Maya history and culture by promoting Ancient Maya sites and objects as icons of national identity. In an interview with Xavier Choc,[18] at the time director of the IA, he referenced the power of Ancient Maya material culture:

> You look at the Belize dollar, what's one of the main icons on that Belize dollar?—The jade head. You look at Belikin beer [. . .] it's the only beer in Belize and it's got a Maya temple [. . .] [as] its logo. [. . .] [and] when people [say] "oh what's the largest building in Belize?" well it's still a prehistoric structure. It's Cana at Caracol or Xunantunich Castillo—you know, those are the two biggest structures in this country still.[19]

In Belize, archaeology is not only focused on the material, but on the *monumental* material. The physicality of large Ancient Maya cities dominates both the Belizean landscape and the attention of national heritage institutions and tourism, for which they have become a synecdoche for Belizean heritage.

A Maya-centric emphasis for archaeology has several consequences. First,

it equates the Ancient Maya with all of Belizean heritage. This conflation re-
inforces state interests in claiming and managing historic sites and objects.[20]
It also marginalizes contemporary Maya communities by disconnecting them
from their ancestral pasts. Since the Colonial Period, the sites and objects of
importance to archaeologists and the government in Belize have largely been
those connected with ancient civilizations that many authorities described as
disappearing, dead, or dying, and not with living peoples, thus ignoring the
millions of Maya descendants alive today.

Second, the Maya-centric archaeology of Belize has historically focused on
an inaccurate essentialized concept of "the Ancient Maya," which obscures the
diversity of Maya peoples across time and space. This concept includes promo-
tion of Ancient Maya culture and history as mysterious, exotic, elite, and nearly
superhuman. National brochures and popular books represent Ancient Maya
culture with iconic images like those described by Xavier Choc, for example,
temples and rare, elite-associated objects like the "jade head." Stories of Maya
commoners who lived at smaller sites are often excluded from the narrative
presented at museums and to tourists. A Belize Tourism Board–sponsored
website promoting the "Maya Heartland" to tourists states that "Belize is truly
the heart of this once great and mysterious culture."[21]

Such essentializations of Ancient Maya culture and history deny space for
cultural fluidity in the present and perpetuate stereotypes and misunderstand-
ings. This is particularly problematic in the current Belizean political climate,
in which modern Maya groups are victimized by prejudice and inequality. For
example, in early twenty-first century court cases that involved Belizean Maya
communities, resource extraction companies, and the national government,
the communal use and ownership of land by contemporary Maya communities
in southern Belize was contested by state representatives. These representa-
tives employed narrow constructions of Maya culture and history to argue that
modern Maya groups in Belize are all recent immigrants, have no connections
to earlier Maya groups, and have no rights to the land they have been using
for generations.[22] It is ironic that while the Belizean government appropriates
Ancient Maya sites, objects, and history to serve as the bedrock of Belizean na-
tional identity, they have simultaneously denied contemporary Maya peoples
essential human rights.[23]

A Maya-centric focus in archaeology also obscures the history and culture
of other ethnic groups in Belize. Though this is changing, archaeologists, gov-
ernment officials, and state heritage actors have historically overlooked the
historic sites and cultural materials of African descendant groups like Kriol
or Garifuna peoples. Certainly, this was most prevalent during the Colonial

Period. However, the absence of national archaeological reserves of historic places associated with Kriol, Garifuna, or other ethnic groups in the twenty-first century suggests incorrectly that these groups have a lack of deep history to be studied, and limits tourism income for these groups.

Marginalization of African history and culture through official heritage practices has been noted in other Caribbean nations and former British colonies. In a discussion about how tourists rarely engage with Afro-Indigenous culture and history in the Caribbean, Niall Finneran and Christina Welch suggest that "popular tourist understandings tend to focus on the Caribbean islands as beach holiday destinations, with any cultural heritage tourism remaining a minority pursuit."[24] And, in general, European colonial historic sites including the "ubiquitous extant sugar plantations as well as historic urban centers, military forts, and churches" are a common focus for historic tourism in Caribbean contexts.[25] Architectural historian Brent Fortenberry demonstrates how in Bermuda, official heritage programming markets a white, colonial, British heritage that dominates the built environment and under-represents African and enslaved heritage. According to Fortenberry, this elision of Bermuda's African history and culture reflects narrow ideas about what the material culture signatures of African populations would look like, as well as assumptions that tourists will be primarily interested in sanitized, white, Anglo heritage.[26] Fortenberry's research provides interesting comparisons with Belize. In tourism efforts, both Bermuda and Belize largely ignore complex histories related to colonialism, slavery, and the cultural practices of African populations in official heritage practices. However, different from Bermuda, until very recently, very few tangible aspects of British colonialism have even been emphasized in Belizean national or private heritage tourism initiatives.[27] Winston Phulgence reveals that even in Afro-Caribbean contexts in which the history of slavery and the legacies of the trans-Atlantic slave trade are acknowledged, they are often done so in ways that reinforce problematic narratives that celebrate male "revolutionaries" as African warriors and leaders.[28] Through an analysis of monuments to address slave history in Guyana, Barbados, Antigua, Dominica, and Jamaica, Phulgence demonstrates that, influenced by nationalistic agendas to promote strength, forward-looking messages, and a shared Afro-Creole identity, the majority of such monuments are of male figures of African descent who led slave rebellions. Though the monuments emphasize the agency of Afro-Caribbean people, the overarching messages of these monuments are problematic and plantation sites still serve largely as sites of leisure and entertainment and the violent history of slavery is largely "silenced in the wider landscape and historical narratives."[29]

Archaeological Resources and National Identity

Throughout the world, archaeological sites and objects are increasingly considered integral to nation-building and social and economic development.[30] This is no different in Belize, where since the Independence Period, foreign and Belizean archaeologists, politicians, and state heritage actors have identified historic sites and objects as integral to Belizean national identity. When I talked with Xavier Choc about archaeological education, he made explicit connections between archaeology and nationalism: "For us in Belize, archaeology is about national identity. It's about [. . .] symbols of a nationhood." Choc recognized the importance of heritage symbols in constructing national identity, stating that "all nations [. . .] all cultures need icons."[31]

Ancient history and culture are seen by some state heritage actors as important alternatives to colonial history. When I asked Xavier Choc about archaeology's role in society, he said that awareness of ancient history and archaeological sites and objects, especially in developing countries like Belize, can make citizens "feel proud" of who they are. He implied that learning about Belize's Ancient Maya past could help Belizeans move on from the nation's difficult history and colonial legacies:

> We need things that make us feel proud of who we are. [. . .] archaeology lends itself to that because . . . we have the sort of like developing country mentality you know [that] we can't compete with anybody else but if you take archaeology and show them look "the first Belizeans were among **the most** advanced societies in the **world**" it gives them a sense that we can achieve [. . .] one of the most important things [. . .] for archaeology within the school curriculum [. . .] is to give people a sense of who we are, that we are this mixed group of people with a rich heritage and that one of those branches of our heritage you know can still be compared with **all the world's** greatest civilizations and then it will give them a sense of pride and to believe in themselves.[32]

As the state continues to maintain control of archaeological sites and objects, politicians and state heritage actors increasingly use the rhetoric of "heritage for the common good"—a focus on national pride and identity that emphasizes a national collective over individuals' and ethnic groups' engagements with the past. Concurrently, archaeology outreach programs have traditionally approached the public from a deficit model, assuming that people need to be taught about their past (or the national idea of the past) in order to appreciate and protect it. These attitudes discourage and obscure vernacular ways of connecting with the past.

The promotion of archaeology and Ancient Maya culture and history as shared national heritage also glosses over diversity, complex cultural politics, and colonial history. For example, Shoshaunna Parks suggests that Belize's official archaeological heritage practices delegitimize Maya indigeneity and limit contemporary Maya peoples' access to Ancient Maya heritage. According to Parks: "pre-Hispanic Maya sites remain a draw for international tourists and, thus, a major source of revenue for the nation. Permitting Maya people to have greater access to ancient places threatens not only the government's ability to capitalize off of the past of its territory, but compromises deeply entrenched conceptions of national identity and history."[33] Other groups of living people, such as the Kriol, Garifuna, and Mestizo, are doubly marginalized by official archaeological heritage discourse and practices since their culture and history are overshadowed by a national focus on Ancient Maya archaeology.

Archaeo-tourism and Social and Economic Development

Tourism is a global phenomenon, and is particularly significant in Central America and the Caribbean.[34] In Belize tourism has grown steadily since independence and is now one of the country's top industries.[35] Belize's rich cultural (for example, archaeological sites, cultural festivals, museums) and natural (for example, the barrier reef, tropical rainforests, diverse flora and fauna) resources, attract visitors interested in small- and large-scale archaeo-tourism, cultural tourism, ecotourism, and adventure tourism.

The increased development of state heritage policies and institutions in Belize during the Globalization Period is in part linked to national interests in tourism. Archaeological sites are particularly important tourist attractions, following trends in other Central American countries of the "Mundo Maya."[36] Building on the archaeo-tourism developments that began in the Independence Period, national tourism initiatives expanded during the Globalization Period. Various NICH branches and other national organizations including the Belize Tourism Board and the Belize Tourism Industry Association[37] emphasize tourism's economic and social development benefits, regulate tourism, and work to attract international support for tourism initiatives.

In the late 1980s and early 1990s, the Government of Belize acquired funding from the United States Agency for International Development to develop accessible Ancient Maya sites like Xunantunich for tourism and to enable "scientific investigation, archaeological conservation, and architectural consolidating."[38] Between the late twentieth and early twenty-first centuries, the DoA (now IA) partnered with foreign scholars, and conservation and anthropology organizations in the United States and Mexico to conduct devel-

opment projects at Xunantunich including the rehabilitation and reconstruction of the iconic Castillo complex and its stucco frieze and the construction of a visitor center, improved parking and driving facilities, concession stands, restrooms, buildings to house stone monuments, storage facilities, and picnic areas.[39] Similar site development efforts to improve access and strengthen archaeo-tourism infrastructure went on at Lamanai, Altun Ha, Caves Branch, and Caracol—under the umbrella of the Belize Tourism Development Project, a $15 million project funded by the Inter-American Development Bank, the International Cooperation and Development Fund in Taiwan, and the United States.

Belizean state heritage actors I spoke with emphasized the economic and social development potential of archaeo-tourism. Xavier Choc said national efforts to incorporate the Belizean archaeological past into curricular materials was related to economic benefits. Choc argued that awareness of archaeological resources "empowers people about the past and provides them with an avenue for employment. [There are] lots of tour guides and they make a fairly good living by taking tourists out and inform[ing] them about the achievements of the Maya in Belize." Similarly, Belizean historian Manuel Jimenez told me that tourism and tour guide training were inspirations for Belizean education programs focused on culture and history. Jimenez said that before such content was incorporated into national curricula, "tour guides were not in touch with their own culture," in part because of a shortage of Belize-specific educational materials.

Thingification of Belize's Archaeological Heritage

Since the Colonial Period, official heritage discourses and practices in Belize have privileged material aspects of history and culture over the "social life of heritage." To borrow a term used by anthropologist Michael Taussig and heritage scholar Denis Byrne, official heritage constructs have perpetuated the "thingification" of heritage.[40] During the Globalization Period, although national heritage institutions began researching and promoting intangible forms of heritage, Belizean state heritage practices and policies continue to have heavy object- and built environment-centered foci. Archaeology is often "thingified" and defined as an official heritage practice through tourism and museum contexts. Following American and European museological traditions, material culture is a primary focus in exhibits at museums and archaeological sites where quintessential Ancient Maya objects (for example, jade, obsidian and flint stone tools, pottery, grave goods) are displayed on platforms and behind glass with limited descriptions of daily use. When government officials

and other heritage experts employ the "thingified" approach in efforts to construct ideas about national identity or promote tourism, they reinforce the idea that cultural identities are "essentialized, fixed, and monologic,"[41] rather than complex, lived practices. And, as heritage scholar Uzi Baram suggests, state programs that emphasize touristic aspects of heritage resources reify "abstractions" like culture and the past as "commodities to be exploited in a rational manner, under the logic of advanced capitalism."[42]

As I discuss in the following section, a Maya-centric emphasis and thingification of archaeology has particularly powerful impacts on Belizean citizens. Teachers, community actors, and youth associate archaeology almost exclusively with the Ancient Maya. In their descriptions of Ancient Maya history and culture, they focus on material culture and the monumentality of Ancient Maya cities. And, many associate the value of archaeology, Ancient Maya cities, and local culture and history with their tourism potential.

Diversification of Heritage Representations and Management

During the Globalization Period, Belizean social science, humanities, and education scholars have also advocated for changes to the ways culture and history have long been defined and managed. The historic privileging of Ancient Maya culture and history among foreign archaeologists and under state policies and practices has been challenged, as Belizean media, state actors, and archaeologists bring attention to non-Maya sites and as scholars have begun to examine these sites archaeologically. In 2003, a Belize Times article acknowledged: "Learning about our Mayan ancestors is only one facet of Archaeology. Belize has old sugar mills, maroon colonies and colonial sites worth examining. There are stories from slavery days worth telling and worth learning from. These are stories that must be told and must be taught."[43]

Since the early twenty-first century, archaeologists have focused more extensively on historic archaeology in Belize, researching Maya, Anglo, and African-descendant history during the Colonial Period. Projects have included examinations at St. George's Caye,[44] early Kriol settlements,[45] and even intersections between Maya, British, Creole, and ex-Confederate populations.[46] This work contributes to a rich body of scholarship in African diaspora and colonial archaeologies that has been growing steadily since the 1970s, which I discuss at length in the conclusion of this chapter.[47]

Archaeological research about Ancient Maya history and culture has also diversified. Archaeological projects are increasingly shifting toward community-based research and heritage management across the globe.[48] Many archaeologists working in Belize now go beyond the permit-mandated responsibility to

publicly share their results and incorporate community residents, interests, and concerns into their projects. Archaeological projects at Chau Hiix, Lamanai, and El Pilar were some of the earliest to involve community-based initiatives.[49] Several heritage scholars working in Maya and Mestizo communities have developed collaborative initiatives to celebrate Maya culture, history, and archaeology through culturally relevant pedagogy, heritage tourism efforts, community mapping, cultural festivals and outreach days.[50] The shift toward community-based archaeology is also evidenced by the increase in projects that involve comanagement arrangements between Belizean and non-Belizean stakeholders (for example, community members, foreign landowners, resort owners, researchers, and government institutions).[51]

Some state-level archaeologists advocate for more reflexive and culturally relevant research and education in Belize. In conversations I had with Nelson Westby,[52] then director of scholarship at the IA, he suggested that educational materials with content about archaeology could address national social issues and cultural politics. Westby noted that archaeologists need to "write a story people can understand" and that Belizean youth need to learn about local ancient history so they can appreciate "how ancient cultures contribute to what we are today." When asked what the most important things for Belizean schoolchildren to learn about history are, Westby emphasized young people connecting personally with history and culture and learning that, "You [a young individual] are creating history and a part of history [. . .] you play a role [in history] [. . .] [you] determine history."[53]

Recent examples of efforts to promote Belizean heritage forms beyond archaeology and Ancient Maya history and culture include exhibits and programs at state-run and independent cultural centers and museums and the development of new cultural centers. The Gulisi Garifuna Museum, which celebrates Garifuna heritage, was opened in Dangriga in 2004. The Museum of Belize and The Government House/House of Culture in Belize City display Kriol cultural materials and often highlight aspects of Kriol history and culture in exhibits. With support from the ISCR, the Kriol village of Flowers Bank developed a community museum and festival to celebrate local Kriol culture and history and the role of Flowers Bank ancestors in Belizean history. Crooked Tree Village has also been the site of recent efforts to promote Kriol culture and history through community museum projects.[54] A project in the Garifuna community of Seine Bight has been working to develop a community heritage center.[55] And local cultural actors and non-state cultural organizations like the National Garifuna Council of Belize, the East Indian Council, Corozal Organization of East Indian Cultural Heritage, the Toledo Maya Cultural Council, and

the National Kriol Council of Belize emphasize the heritage of Belize's diverse ethnic groups through a variety of initiatives.

Similarly, national programs have diversified official heritage definitions and promotions in the Globalization Period. A UNESCO-sponsored Intangible Cultural Heritage project in Belize, first initiated in 2013, has run training workshops and documented, promoted and worked to safeguard diverse forms of intangible heritage. Though partly inspired by efforts to bring attention to Belize on an international stage, this project has included a range of ethnic groups in Belize, documented vernacular heritage practices, and involved extensive stakeholder input.

Engaging Official Archaeological Heritage in Kriol Villages

For more than a century, colonial and state institutions, government actors, international organizations, and scholars have established official archaeological heritage discourses and practices. In many ways, official archaeological heritage discourses have privileged monumental and Ancient Maya sites and objects, emphasized the research and social and economic development value of archaeology, and favored foreign scientific and tourist engagements with historic sites and objects over vernacular heritage practices.

To understand how Belizean citizens are affected by and negotiate official heritage discourses and the ideologies they embody and sustain, I have conducted extensive research on Crooked Tree and Biscayne residents' engagements with archaeology through their interactions with nearby Ancient Maya cities, tourism, and community-based research initiatives like the Chau Hiix Archaeological Project (CHAP). Through this research I learned that community members, especially young people, had been strongly influenced by official heritage constructs at active archaeological sites, museums, and other cultural centers; in school curricula on culture and history; and in the portrayals of archaeology in popular imagery. But the ways that local citizens manipulate official heritage discourses and practices reveals a great deal about power dynamics, colonial legacies, and vernacular heritage values, ideas, and practices.

The Heritage Landscape Surrounding the Chau Hiix Archaeological Project

Crooked Tree Village, Biscayne Village, and the Chau Hiix archaeological site are situated in a network of multilayered traveled, worked, historicized, humanized, transformed, and symbolic landscapes[56] that have meanings and implications for the ways people think about land management and archae-

ology specifically. Chau Hiix is an Ancient Maya center with approximately twenty-five large structures located on and around a central platform. The site is less than fifteen miles from the larger Ancient Maya settlements of Lamanai and Altun Ha, both popular tourist sites. Chau Hiix was occupied continuously from at least 1100 BCE–1500 CE. Kriol history in the region began in the early eighteenth century when British loggers settled in the area and forced enslaved African people to engage in timber extraction. A formal settlement developed in Crooked Tree, when the Baptist church established a local church and school in 1843.

Located close to the rich soil and farmland in the Blackburn region of Crooked Tree, Chau Hiix dominates the western side of the Western Lagoon, which connects to historically and culturally significant waterways; together, they make up part of a complex wetlands system. The waterways and surrounding ecosystem were integral to Ancient Maya cultural values and practices, supplying transportation and subsistence.[57] They were also central to the foundation of the early colonial settlements around Crooked Tree—eighteenth-century logging outposts established by British citizens, white Belizeans, and free black Belizeans. The early colonial settlements were located on and near local waterways because of the prevalence of logwood and the ease of transporting it. Crooked Tree residents continue to use the waterways for subsistence, transportation, and leisure and I discuss their persistent connections to the natural environment in the following chapter.

The Blackburn area is an important community resource. It has been farmed as "*plantayshan*"[58] by Crooked Tree residents, likely for over a century. In the mid-nineteenth century, the majority of land surrounding Crooked Tree was procured by the Belize Estate and Produce Company (BEC), forcing community residents to farm in the interior of the village, where there is limited open land and fertile soil.[59] As BEC control of Belizean land declined in the mid-twentieth century, Crooked Tree inhabitants began (re)claiming land plots in Blackburn and grazing cattle there.[60]

In the 1970s, conservation groups became interested in the wetlands surrounding Crooked Tree, and in 1984, the lagoon system was designated the Crooked Tree Wildlife Sanctuary. This designation means that the land is protected by national guidelines and regulations. The sanctuary, which is currently comanaged by the Belizean government and the Belize Audubon Society, encompasses the majority of land surrounding Crooked Tree Village, including Blackburn and Chau Hiix.[61] As an archaeological site, Chau Hiix itself is national property, and is also regulated by national cultural property laws.

Heritage scholars Shoshaunna Parks and Patricia McAnany define an "ar-

chaeoscape" as the "web of communities and temporalities surrounding an archaeological site" and "the physical and ideological intersection of the past and the present."[62] The Chau Hiix Maya Site, Crooked Tree Village, and CHAP are part of a rich archaeoscape in which diverse actors have long interacted with archaeology, negotiating ideas about its meanings, significance, and management. As the Chau Hiix site is one part of a complex surrounding landscape, residents' ideas about Chau Hiix intersect and at times conflict with their other connections—to local land, ecological and cultural resources, and racial history, as well as contemporary cultural politics, and the global heritage industry.

The CHAP was initiated in the late 1980s by Crooked Tree leaders, who asked archaeologists for support in caring for, learning about, and developing the local Maya site they had known about for generations. The CHAP formally began in 1989 under the direction of K. Anne Pyburn, a classically-trained Mayanist and pioneer of community-based archaeological research. The project ended in 2007. Throughout its existence, the CHAP employed Crooked Tree residents and CHAP members engaged local publics in project research and shared scholarship results through public presentations and educational outreach, both at the site and in the village.[63]

Biscayne Village, a nearby rural, Kriol community was formed in the 1970s, and does not have the same history of contact with archaeological resources and research. However, many of Biscayne's founding families were originally from Crooked Tree. And both Crooked Tree and Biscayne residents have developed extensive knowledge about Ancient Maya history and culture and archaeology through social studies education, direct contact with archaeologists and archaeological research (through the CHAP and other projects), and family outings to museums and archaeological sites. Adults and young people alike shared fond memories with me of taking picnics to Ancient Maya sites, and visiting sites with family from "the States" (the US). At these sites, people learn about archaeology and Ancient Maya history and culture from tour guides and site museums.

Through their contact with official archaeological heritage discourse, Crooked Tree and Biscayne residents have become savvy to the political and economic values of Ancient Maya history and archaeology and have developed tools for navigating official heritage practices and institutions. Similar to Noel Salazar's work on "tourism imaginaries," I consider how cultural intersections with archaeological heritage serve as circuits of culture which lead to coproduction of knowledge.[64] Below, I discuss what educators, those involved in tourism, and young people in Crooked Tree and Biscayne have learned from their contact with archaeology and how they have reconciled official archaeo-

logical heritage discourse and practices with vernacular heritage including local history and cultural realities.

My examples are based on ethnographic research with adults and youth. Adults included community elders, educators, cultural activists, environmental actors, and individuals involved in the tourism industry. Young people primarily included Standard IV and V students because much of the national curriculum focused on Belizean culture and history is integrated in these grades and much of the information about archaeology and Ancient Maya history and culture at sites and museums is aimed toward youth. I engaged in participant observation of Crooked Tree and Biscayne residents' interactions with archaeology and Ancient Maya history and culture in the Crooked Tree and Biscayne Government Schools, at museums, and at archaeological sites. Additionally, I conducted semi-structured interviews with adults focused on how archaeology is portrayed and promoted in different contexts (for example, school, ancient sites, museums, home) and with young people about their existing knowledge of archaeology and Ancient Maya history and culture and after field trips to museums and archaeological sites. I also collected information through youth-centered activities that I directed in classroom contexts. For example, I had students draw archaeological sites and archaeologists,[65] which gave me an idea of how youth visualize and conceptualize Ancient Maya history and culture and the work conducted by archaeologists.

Adults' Negotiations of Archaeology Heritage Discourse during the Globalization Period

Many adults I had contact with referenced and reinforced official heritage discourses and ideologies, including the physicality and centrality of Ancient Maya history and culture. They identified archaeologists as heritage experts and Ancient Maya sites and archaeology as tourism resources. However, they also manipulated official heritage discourses to advocate for their communities and revealed rich vernacular heritage constructs and practices.

"We Need Things, Stuff, to Display"

Belizean citizens are strongly affected by the "thingification" of heritage noted above. This was strikingly demonstrated in an interview with Leena Garbutt, a Kriol language and culture scholar and cultural activist. During our conversation about tourism, economic development, and cultural identity, Leena discussed her interest in tapping into Belize's tourist market. She emphasized heritage in the form of material culture, but said she had a hard time identifying Kriol souvenirs that could be produced and sold to tourists.

Leena has spent much of her adult life addressing the consequences of a Belizean colonial history that propagated ethnic stereotypes and racial inequalities, and marginalized Kriol culture and history. In her work with the National Kriol Council, Leena has raised awareness about the richness of Belizean Kriol vernacular heritage.[66] She obviously recognizes the complexities of Kriol culture, but had a hard time envisioning any Kriol material culture that would interest archaeologists. Leena associated archaeology with Ancient Maya sites, and was struck by my suggestion that the ancestors of contemporary Kriol peoples could be studied archaeologically. She said, "what I found was provocative from you was just thinking about what is there to dig up that's Kriol? [. . .] what are the artifacts of Kriol?" Leena referred back to the possibility of Kriol archaeology and what could be "dug up" several times. At one point, Leena laughed and said, "Yeah, dig up the roots of our language—at least from my perspective." Shaped by a "thingification" ideology, Leena recognized that to promote Kriol culture and history, especially on national and international levels, "We need things, stuff, to display. Somewhere that is critical in this cultural identity. We need stuff to show [. . .] We have the books [Kriol language texts] now. You need this stuff to show."[67]

Like Leena, the Crooked Tree and Biscayne teachers I worked with were influenced by "physical authenticity" arguments in official heritage discourse.[68] Teacher Ranicia brought attention to the tangible aspects of Ancient Maya history and culture that remain in Belize and implied that Kriol history is excluded from official discourse because they have not "left something" physical behind, "the Maya's left something for us. They wrote books about the Mayas and right now we have maps, [. . .] that we have to teach about the Mayans and Africans to the children and they don't say you have to teach about the Kriols."[69]

Such perceptions about the physical authenticity of material culture and the built environment, and the different nature of African-descendant material culture are not unique to Belizeans. Archaeologists studying Afro-Caribbean peoples have struggled in their efforts to identify and examine the material culture of Afro-Caribbean and enslaved peoples. In a discussion about an early archaeological project directed by Jerome Handler and Frederick Lange to locate and examine settlements that had been occupied by enslaved laborers in Barbados, archaeologists Douglas Armstrong and Mark Hauser note that Handler and Lange "were frustrated in their efforts to define material culture directly attributable to persons of African descent" and "had difficulty recognizing discrete ruins of slave settlements at plantations in Barbados."[70]

However, while Kriol people I spoke with struggled to conceptualize archae-

ologists studying anything but Ancient Maya history and culture, in other contexts where African-descendant history and culture was discriminated against and marginalized, people have long connected with the historical markers of their past in the physical landscape. Additionally some people have demonstrated an astute "archaeological consciousness" of the political and cultural power of archaeological research at times even requesting archaeological examinations of their heritage.[71] In a discussion of collaborative archaeology programming focused on an Afro-Ecuadorian cemetery, Daniela Catalina Balanzátegui Moreno argues that Afro-Ecuadorians "have developed their own strategies to protect their heritage, interpret their past, and study their material culture" and references the traditional knowledge about and interests in the cemetery among local residents.[72] And, in a discussion about an archaeological project at the Clifton Plantation on the island of New Providence, Bahamas, Caribbean archaeologist Laurie Wilkie notes that local African-descendant people felt connections to the plantation site because they considered it a place where enslaved peoples constructed a collective African Bahamian identity.[73] Wilkie demonstrated that "island preservationists, descendants, and other stakeholders employed [. . .] archaeological interpretations to rally support for preservation" of the site.[74] As I unpack in the following sections, Crooked Tree and Biscayne residents reveal a similar kind of "archaeological consciousness" with regards to Ancient Maya history and culture.

"You Got to Learn Your History if You Want to Be a Tour Guide"

In Belize, the official focus on Ancient Maya cities and archaeology as tourist attractions often values culture and history insofar as it can drive tourism, and privileges tourists as primary stakeholders. Several adult participants in my research suggested that education focused on culture, local history, and archaeology was important to prepare young people for contact with tourists.

Teacher Sandy: when somebody comes in and asks them [youth], "Did you know how Crooked Tree got its name, and do you understand why?" You know, for them to just look and say, "No, I have no idea," that would be an embarrassment to the child and to the entire community because they don't have that background knowledge of their own surroundings.[75]

Teacher Christina: it's [social studies and history] important in a lot of different ways. If [. . .] somebody come and visit—the tourist comes—then you can tell them about your culture, about what happens in this [community] [. . .] They [children] should learn that. At least enough information to pass on to somebody else.[76]

Teacher Ranicia suggested that Maya history is central to Belizean history and identity and highlighted the tourism significance of Maya sites,

> Maya history is important [to learn about] because the Mayas were the first people who settled in our country. [. . .] their sites still remain. And we use them, as tourist attractions—it is part of our history. Without the Mayas I will say we wouldn't have been here, or Belize wouldn't have been here.[77]

Other Crooked Tree residents had perspectives similar to those of the teachers. Edmund Banks has worked in environmental conservation and the local tourism industry for decades. When asked about the most important things for Belizean kids to learn about history, he framed his response in terms of the tourism significance of history: "Well, first thing they have to learn about their culture. Their ancestors. And where the language came from. [. . .] And learn the history of the area, because [. . .] You got to learn your history if you want to be a tour guide."[78]

Crooked Tree residents recognize the touristic value of Ancient Maya sites and history because of national archaeo-tourism discourse, but also because of the village's long history of tourism: since the 1970s, Crooked Tree has been a center of ecological tourism because of its wetland resources and diversity of fauna, especially birds.[79] In the late twentieth century and early twenty-first centuries, residents sought to diversify the community's tourist offerings. They saw that Ancient Maya heritage was becoming increasingly popular in tourism and supported by the government. It was at this time that village leaders approached Anne Pyburn to conduct research at Chau Hiix with explicit interests in tourism development.

For Crooked Tree community members, knowledge about and development of local cultural resources has economic and political benefits.[80] Not only can the village benefit directly financially from local tourism, it can also draw national attention to the area and attract resources from government agencies. However, local attitudes toward tourism did not develop in a vacuum; they are influenced by nationalist agendas that value citizens who contribute to the economy and serve as respectable ambassadors for the state to tourists.

"We Don't Know Nothing about What They Have in Those Hills"

Belizeans are well aware of academic archaeologists' expertise about culture and history, and they know that these scholars have government connections and permits to conduct their work. These facts frame archaeologists as legitimate heritage actors whose perspectives about research, management,

and engagement with archaeological resources should be listened to, but also frame archaeological sites and research as potential resources for local communities.

Many Belizeans I spoke with acknowledged national interests in archaeology, and implied or explicitly stated that they believed archaeological research increased the economic and cultural value of places, thus contributing to community development–hence Crooked Tree's efforts to attract archaeologists to work at Chau Hiix. My exchange below with Edmund Banks demonstrates that some community members believe archaeologists determine the value of sites like Chau Hiix.

Interviewer: Going back to when you were talking about farming plantation in Blackburn, did you know as a kid that there were ruins back there?

Edmund: I know a place called Injun Hill[81] [. . .] a lot of people used to be farming around there, and they used to have a camp right there in the area [. . .] But nobody ever tell us [the significance of] Maya ruins till you [archaeologists] comes around [. . .] When they [archaeologists] started to come here [. . .] and the Mayan raise sanctuaries here, they [archaeologists] understand we have a Maya ruin back there. It changed from Injun Hill to Maya ruins [. . .] And they will never tell us then about no Maya ruins being *valuable* and stuff like that. The *value, value* of them.

Interviewer: As a kid, what did you, since you didn't know it was Maya ruins, what did, where did you think that stuff came from?

Edmund: [. . .] we don't do nothing about it, we do none of the excavation. We don't know nothing about what they have in those hills. Cause we never know we can search in them. We just knows it's just a hill. Its name is Injun Hill. Yeah, we don't know what the *value* in them. But you people know the *value*. [. . .] Yeah, because you have the studies to know the stuff [. . .] when they started to excavate there, [. . .] That's the only time we care towards back there.[82]

In addition to showing that archaeology attaches value to existing sites, Edmund's commentary is interesting for other reasons: it simultaneously downplays local cultural connections with Chau Hiix *and* protects local cultural knowledge. Crooked Tree residents knew that an Ancient Maya community existed at Chau Hiix long before archaeologists came. They used this knowledge to attract archaeologists to the site. Edmund's implication that village residents knew nothing before archaeologists arrived actually obscures information about how people used and still use the land surrounding Chau

Hiix, which Crooked Tree people have cleared, farmed, and hunted in for centuries.

Edmund focused heavily on the concept of value, associating Chau Hiix's cultural significance with its potential economic, cultural, and political values. By implying that people were unaware of such value until archaeologists arrived, Edmund articulated the idea that archaeological sites and knowledge are especially valuable, and that archaeologists define such worth. Although he stated that when the archaeologists arrived, the site name "changed from Injun Hill to Maya ruins," the site name, Chau Hiix, was in fact chosen in consultation between community members and archaeologists. Crooked Tree residents felt strongly that the site should be given a Maya name instead of a Kriol name as this would add legitimacy to it, potentially attracting more tourists.[83] Edmund's statement does not account for the fact that locals wielded agency and defined a specific set of values for Chau Hiix by naming the site.

Edmund's comment that "we do none of the excavation. We don't know nothing about what they have in those hills. Cause we never know we can search in them" is also significant. It is difficult to fully understand Edmund's intent given the tense changes. I think he was both downplaying the role Crooked Tree people played in the CHAP-led archaeological investigations, implying that the "important work" was done by archaeologists *and* trying to draw attention away from the ways villagers have long engaged with Chau Hiix. Since its inception, CHAP had an agreement with the Crooked Tree Village Council that only local residents would conduct excavations at the site. It is untrue that Crooked Tree people "do none of the excavation." Most people in the village have either worked at Chau Hiix or have a relative who worked there.

In Edmund Bank's commentary, we can see official archaeological heritage discourse in conflict with community tactics of negotiation and resistance. Edmund was hesitant to appear too knowledgeable about local Ancient Maya heritage, although some of his affinal relatives live near the earliest Maya and historic settlements in Crooked Tree—his words are also an example of a common Kriol cultural guardedness about sharing information with outsiders.[84]

Advocacy and Autonomy through Archaeological Engagement

Through their contact with archaeology and archaeologists, Crooked Tree and Biscayne community members have developed many culturally-specific tools for navigating and challenging official heritage discourse and practice. These include: attempting to maintain local control over archaeological resources; engaging with archaeological resources on their own terms; devising

strategies for marketing Ancient Maya history and culture and Kriol heritage; and expressing frustration about heritage resource management and development.

Edmund Banks' story and ways of invoking agency are not unique. Crooked Tree community leaders have been negotiating official archaeological heritage discourse and practices since the beginning of CHAP. A Crooked Tree Village chairman, Mr. Leroy, extended the invitation to Pyburn to work at Chau Hiix after doing extensive research on Maya archaeology and Belizean cultural property laws and after carefully vetting both Pyburn and her husband, cultural anthropologist Richard Wilk, who had been researching local foodways. After Pyburn decided to work at Chau Hiix, the Crooked Tree Village Council established guidelines with the CHAP to ensure that there would be community benefits and village control over the project: CHAP would work with the Village Council during their field seasons; hire a local foreman to recruit and manage project employees; and only Crooked Tree community members would be hired to work at Chau Hiix. Throughout the tenure of the CHAP, Village Council members surveilled the project and vocalized opinions about the project to CHAP members, Crooked Tree residents, and regional and national government officials.

In 2013, I returned to Crooked Tree and Biscayne to share the results of my earlier research on Belizeans' perspectives about archaeology and education. I organized events where I observed villagers negotiating their relationships with external heritage actors to meet local needs and interests. For example, I held an open house that any interested community member could attend, though I particularly targeted people who had been involved with the CHAP or were interested in Ancient Maya culture, archaeology, and local history. Approximately fifty people attended, including tour guides, children, teachers, and former CHAP employees. I made a brief presentation about my research findings and we looked at hundreds of photographs projected on a screen. The photographs inspired storytelling about "*da rooinz*" and the CHAP. As part of the event, I had invited Teacher Albert to tell stories about village history, but he instead chose to make comments about the history of the CHAP, my involvement with the Crooked Tree Government School, and what village youth learned through their interactions with archaeology. When talking about my involvement with the school, Teacher Albert jokingly stated that at first, he thought it was a punishment on him when I was placed in his classroom, but that it ended up being a great partnership through which his students learned a lot. His sincere comments demonstrate local agency in controlling what is said at public meetings and events,

but also showed Crooked Tree residents' suspicion about outsiders and the guardedness with which they approach collaborations.

At the open house, I showed CHAP photographs from before I worked with the project. Attendees were enthralled with the old images, which catalyzed reminiscences about recent community history, people who had passed away, village involvement with the CHAP, and changes in the village over the previous couple of decades. Community members tacitly took control of the event, sharing local stories and socializing. I learned more about how the CHAP had become part of community history and identity through informal stories—stories I would likely have never heard if I had asked people to share CHAP memories in formal individual interviews, or in focus groups. Interacting with Crooked Tree residents on their terms and in contexts that fit Kriol cultural norms also opened new possibilities for future engagements. For the first time during my work, villagers made suggestions for projects they thought would be well received and address community needs, such as creating a social studies and language arts reader about local history.

"It Can Be a Tourist Destination"

As a principal economic resource in Belize, tourism shapes community development efforts. As noted, official archaeological heritage discourse privileges tangible manifestations of Ancient Maya history and culture and emphasizes archaeological resources as tourism commodities. Most Crooked Tree residents identify as ethnically Kriol, though many have mixed ethnic backgrounds and some reference Maya ancestry. It is unlikely that there are many direct descendants of the original Ancient Maya inhabitants of the Chau Hiix site living in Crooked Tree, and when asked, most villagers do not acknowledge an ethnic connection to the site. But many community members feel a strong sense of ownership over Chau Hiix and consider it a community asset. Because Ancient Maya archaeological sites dominate the tourism industry and archaeological scholarship in Belize, villagers believe it can be leveraged to attract researchers, tourists, and government support.

When the CHAP began in the 1980s, community members felt that having an archaeological expert at Chau Hiix, especially one associated with a foreign university, would eventually lead to tourism development.[85] Crooked Tree residents continue to identify Chau Hiix as a touristic resource, and frequently mention tourism development possibilities for the site. Though Edmund Banks concealed some information about ways Crooked Tree villagers interacted with Chau Hiix, he also drew my attention to the site's tourism potential,

I think it [tourism] would, would get more people coming, and it would be part of the package [. . .] And go there [to Chau Hiix] [. . .] because guys, most of the people they love Mayan sites [. . .] they go to Lamanai, they go to Altun Ha [. . .] people like Mayan stuff. I think if we were [to] sell it as a Maya person site, I think it would get even more people coming to Crooked Tree. Sell the area.[86]

Teachers also expressed interest in Chau Hiix being developed as a tourist site:

Interviewer: [. . .] what are your feelings about the project that was run back there at Chau Hiix?

Teacher Albert: I really wish that the government would pick up on that and try to allocate the funding to bring that back, bring the ruin back to what it was before, bring temples back to what they were, and—[. . .] reconstruct it [. . .] so that it can be a tourist destination. [. . .] it would create [. . .] more income for the village, there would be more influx of tourism, and therefore, definitely the village would be blooming with people. More people [would] have jobs and stuff like that.[87]

Crooked Tree residents see tourism work as a form of upward mobility for youth, a view that is also reinforced by national education materials. Teachers and parents often encourage school children to connect with heritage scholars when they are in the village, and many teachers have asked me to organize lectures and workshops to help young people learn about the Ancient Maya to prepare them for work in the tourism industry. Lloyd, a charismatic 11-year old Crooked Tree student, was urged by Teacher Albert to attend to a group of annual visitors to the village, birders who had grown fond of Lloyd, in order to fulfill his role as a young tour guide and ambassador for Crooked Tree.

Crooked Tree residents' interest in developing Chau Hiix for tourism shows their engagements with official heritage discourses. When discussing tourism, village residents often emphasize Ancient Maya history and culture and ecological resources (like the diversity of bird species) over vernacular Kriol heritage. Similarly, Laurie Medina documented how Mestizo residents in western Belize recognized that tourists valued "things Maya" over "things Mestizo;" even producing products inspired by Ancient Maya heritage.[88] Cultural anthropologist Pierre Van Den Berge describes a similar situation in Chiapas, Mexico, where Ladino (Mestizo) people altered their "attitudes and behavior toward Indians," embracing a fluid cultural identity and promoting it in tourism programming.[89] These examples have similar themes: demonstrating how

people can connect with culture with which they may not immediately ethnically identify to benefit from tourism development.

In this way, Crooked Tree residents are in clear agreement with Belizean state heritage priorities. But they are also unsatisfied with these priorities, both with Chau Hiix's lack of development and with the fact that Kriol culture and history are underrepresented. In response, through their interactions with tourists, Crooked Tree residents have learned how to package aspects of vernacular heritage in ways that fit current global tourism discourse. For example, Crooked Tree residents have developed "tourism imaginaries" about what they think tourists expect and have worked to match vernacular heritage practices with these expectations.[90] Residents have emphasized their village's "traditional" Kriol identity, organized festivals to promote Kriol food practices and marketed local ecological resources and Kriol culture and history to tourists. Belizeans have learned to package and promote specific forms of culture and history for consumption, identifying certain marketable practices, traditions, and forms of material culture as essential heritage traditions.

In tour guides' stories about local history, Crooked Tree is characterized as a particularly old Kriol village. In the Crooked Tree Wildlife Sanctuary Visitor's Center, which was located at the entrance of the village and was often tourists' introduction to the village,[91] displays promoted a "traditional" Kriol kitchen reconstruction, with a fire hearth for cooking food over open flames. Food plays an important role in identity, and the ways that Crooked Tree people talk about food have changed since they became aware of tourists' interest in culinary matters (for example, recent slow food and local food movements).[92] Many adults told me food tasted better when it was cooked on a fire hearth, which is considered a potent symbol of "traditional" Kriol food practices. By promoting aspects of culture and history that could appeal to tourist audiences and packaging them in ways that fit common and government supported heritage tropes, people in Crooked Tree draw attention to their culture and community. I expand on vernacular Kriol heritage practices related to ecological resources and foodways in the following chapter.

Negotiating Expectations, Tensions, and Resistance

Crooked Tree residents' expectations for tourism development in their village have largely not been met. They have attempted to negotiate with archaeologists, government officials, and other heritage actors for autonomy over and development of local resources like Chau Hiix, but have often been frustrated with the results or lack thereof. This has occasionally produced direct resistance to externally directed heritage efforts.

From the inception of the CHAP, Anne Pyburn recognized the potential benefits of tourism in Crooked Tree. She organized meetings to discuss the logistics of tourism development efforts, such as creating informational signage at Chau Hiix. The national government expressed early interest in developing Chau Hiix, but site development is expensive, and Crooked Tree is remote and surrounded by seasonal lagoons, making the site difficult to access.[93] Many government heritage actors also felt that Crooked Tree Village did not have the infrastructure required to support a large-scale tourism project. Ultimately, these factors (and the untimely death of a DoA advocate for Chau Hiix development) meant that the government did not fulfill promises to develop the site.[94]

Many community members maintain unrealistic expectations about how much control individual villagers or archaeologists have over archaeological work and development as compared to the national government. And many villagers are unaware of the logistics involved in developing a site. One major area of confusion among Crooked Tree villagers is about what cultural property laws mean for the ownership, management, and export of Ancient Maya objects for research. These laws play integral roles in the protection of archaeological resources, but their details are complicated and not overly transparent. Although archaeological sites are legally designated as national property, many sites are on or near private land. However, Belizean citizens cannot "own" archaeological objects, and penalties for collecting objects, even on private property, can be severe. When misunderstandings about cultural property laws are combined with simmering frustrations about development, resistance sometimes arises. For example, Anne Pyburn told me a story about an archaeologist's interests in exploring Maya sites on Albion Island in northern Belize. According to Pyburn, one day the archaeologist told a local quarry owner that he was interested in conducting an archaeological survey to identify Maya sites surrounding a cenote[95] that the landowner was quarrying. By the end of the day, the landowner had bulldozed several sites because he was concerned about potential threats to his land rights due to the existence of archaeological resources, and perhaps because he did not think of archaeology as a resource that would directly benefit him.[96] This demonstrates that Belizean citizens have engaged in such resistance efforts for over a century–recall the Santa Rita plaster murals, which were removed by local people almost immediately after Thomas Gann "discovered" them.[97]

Crooked Tree residents frequently expressed anger about limitations to community control over Chau Hiix. Residents have spoken negatively about the CHAP at community meetings, spread false rumors about the project, called the IA to demand more information about the CHAP, and even caused damage to structures built by archaeologists at the site. For example, some Crooked

Tree residents have "misremembered" details of the community's involvement in research at Chau Hiix in ways that challenged CHAP efforts. Edmund Banks' commentaries above are one example. Similarly, at a Village Council meeting in 2007 when CHAP members were presenting research finds, Mr. Patrick, who had never participated in the CHAP, asked what happens to the Ancient Maya objects once they are excavated. Mr. Patrick said he had heard that the best quality objects were taken by the archaeologists back to the United States and that when special artifacts were found at Chau Hiix, Crooked Tree workers were asked to leave the area, allowing the foreign archaeologists to finish the excavations in secret.[98] Mr. Patrick said he heard this story from Mr. Oswin, who had excavated at Chau Hiix for several seasons. But in truth, Oswin had been present when the most elaborate burials in Structure 1 at Chau Hiix were excavated. He assisted with this work and had the opportunity to hold several of the burial objects. I believe Oswin told this story to manipulate the CHAP for additional resources, but also perhaps out of frustration that the objects are not housed somewhere in the village.[99]

Some acts of resistance have been material. In 2013, several years after the CHAP ceased working at the site, the equipment and artifact storehouses at Chau Hiix sustained significant damage.[100] Locals knew that the CHAP kept equipment in the storehouse, and although the perpetrators were never identified, many local people were suspicious that community members were involved. When the damage was discovered, the Village chairman contacted the IA, Anne Pyburn, and national media outlets. Although the IA and Pyburn made statements to the press expressing dismay about the destruction, the IA did not visit Crooked Tree or Chau Hiix, and no resolution was reached. Crooked Tree residents likely knew who damaged the storehouse and overlooked it because of their collective frustration at the national government's lack of support for development and because they were angry that the CHAP had ended. In the years following the 2013 damage at Chau Hiix, prominent Crooked Tree residents, including former Village chairmen, have repeatedly asked me why archaeologists stopped work at the site, expressed anger with the IA for not contributing to site and community development, and criticized the CHAP, even blaming it for the 2013 damage.

In addition to various forms of active resistance, Crooked Tree residents have engaged in passive resistance to heritage initiatives organized by outsiders through nonparticipation and feigned ignorance or forgetting. For example, when the CHAP tried to develop a craft guild in Crooked Tree, bringing ceramic artists from the United States to train villagers to make and sell ceramic crafts such as reproductions of Maya pots, the project did

not endure because locals did not continue the ceramic work after the CHAP left. Tourism brochures, written by Chau Hiix staff and distributed to tour guides, were rarely used. Similarly, despite decades of development and education projects often focused on culture and history occurring in the village (for example, Peace Corps efforts), people rarely discuss these projects and there is little evidence of them in the village. For such projects to succeed in a sustainable way, they require time, energy, and resources from local people, and the lack of participation and seeming lack of institutional memory are defense mechanisms that protect Crooked Tree community members from being taken advantage of.

Despite their active attempts to gain autonomy and control over archaeological heritage, Crooked Tree residents have limited power in archaeological research and tourism due to the way these structures are organized in Belize. Thus, the resistance practices described above are tools for local cultural actors to use in negotiating official heritage discourse and ideologies.

Young Peoples' Negotiations of Archaeology Heritage Discourse during the Globalization Period

As I have previously discussed, young Belizeans encounter official archaeological heritage discourse through school curricula and tourism materials. Additionally, over half of the Belizean students I interviewed had visited an archaeological site, the Museum of Belize, or both. Biscayne and Crooked Tree students recalled visiting an impressive number of Ancient Maya sites, including Altun Ha, Che Chem Ha, Chau Hiix, Cerros, Lamanai, Xunantunich, and Cahal Pech. About a quarter of the students I interviewed had been to Altun Ha, the Belizean site most visited by tourists, and more than a third of the Crooked Tree students who had visited an archaeological site had visited Chau Hiix. The students who visited Chau Hiix recalled school trips and site open houses and referenced family members who worked at "*da rooinz*" (the ruins). Sonia said, "I went *da* (to the) place where they, they got big big hole, to see where the Maya [. . .] was livin first [. . .] My auntie was working there and, we went there [. . .] They got lot of, old stuff."[101]

Below, I discuss how young people in Crooked Tree and Biscayne interpret, replicate, and negotiate their encounters with archaeological sites, objects, and research, using evidence from participant observation, student interviews, and student drawings. Though they were struck by the monumentality and material aspects of Ancient Maya history and culture and perceived Maya people as different from themselves, youth also made their own connections with Ancient Maya people.

"Ruins Look Like Big High Things!"

Many young Belizeans I spoke with mentioned the size and scope of Ancient Maya sites—an attitude that mirrors the way that monumentality has been valorized through official archaeological heritage practices since the Colonial Period. When asked to draw archaeologists, students who drew them in a setting most frequently drew them alongside pyramids (as demonstrated in figure 3). When asked to describe ruins (the culturally appropriate term for archaeological sites), 74 percent of the terms and phrases students used referred to the monumentality of Ancient Maya heritage–they used adjectives like big, tall, and high, mentioned steps and climbing, and referenced mountains. During field trips I organized to Ancient Maya sites, the first thing most students wanted to do was climb to the

Figure 3. Student drawings of archaeologists with pyramids. Drawings done by Yvette (*A*), Jamal (*B*).

A

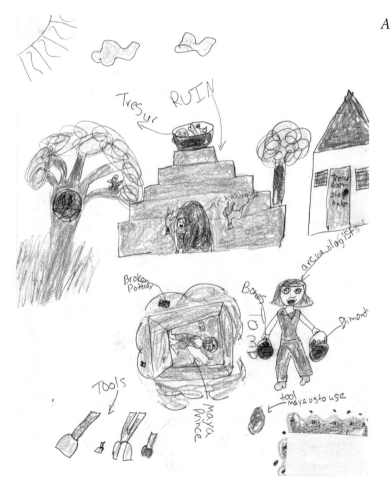

top of the tallest buildings. Ethan said, "The ruins look like, some, some **big *ting*** (thing) [. . .] Yeah. **Huge. Huge** [. . .] **Huge** thing."[102] Alda also emphasized height: "The ruin looked, big like . . . the school walked *pan* (on) the steps way way up high."[103] Maria described climbing a building at a specific site: "*Di* (the) Caracol one, *dat* (that) was big [. . .] When we climbed that was big [. . .] *Ah mi was tired* (I was tired). *Ah mi goh* (I went) by step by step [. . .] Because *Ah mi feel* (I felt) afraid because *di* (that) man tell us if you are afraid to go up, don't go up and I say no and *Ah gaan* (I went)."[104]

Crooked Tree and Biscayne youth I worked with often referred to the structural mounds at Ancient Maya cities as hills or mountains, and in their drawings, they represented structures as hills with trees. Many of the structures at

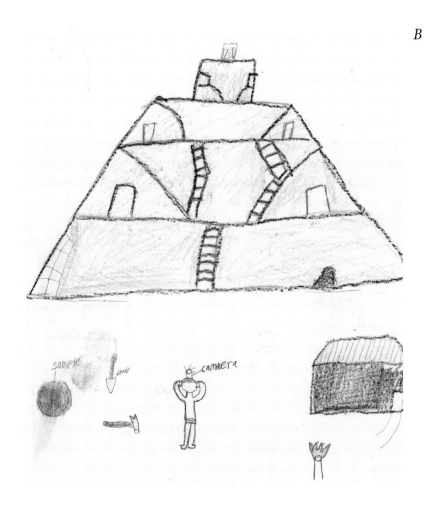

B

Ancient Maya cities are unexcavated; others have received structural consolidation and reconstruction treatments. Structures that have not been excavated or reconstructed often look like mounds of dirt, stones, and plants.

One student, Marion described an archaeological site and her experiences there: "Some big mountains that you have to walk—I climb mountains {that are} so hard sometime when I reach I feel {like I will} fall."[105] In an interview with Kenneth, he described having seen "high high mountains" at Chau Hiix. When I asked him what he thought the high mountains were, he responded, "I think they were, mounds to—mountains to see, to see how far, how far you were and to see how high. I think they, I think the mountains made themselves."[106] Some youth did not necessarily think of the mounds as cultural spaces (as ruins) until they were reconstructed. The perception of unreconstructed cities as mounds of dirt reflects the effects of the focus on architectural monumentality in official archaeological heritage discourse; the conservation practice of reconstruction reinforces the belief that *valuable* archaeological heritage is *monumental* reconstructed sites, like a tourist would visit.

"Old Bones" and "Old Stuffs"

Crooked Tree and Biscayne youth repeatedly defined and described archaeology in terms of things that are dead or old. When asked "What is archaeology?" or "What do archaeologists do?" 40 percent of all of the students interviewed gave a response with the word "old" in it. When describing archaeologists' work, students suggested they study old *tingz* (things), or work with *oal taims tingz* (old time things). When asked to describe an archaeologist, Kadijah said, "Person that, studies old things about *laang laang* (long long) ago"[107]; Camille said "People *wah dig fi* (who dig for) old stuff"[108]; and Linda said, "someone who, who study about, things from way back."[109] When asked, "What do archaeologists find?" students also referenced old things. Judith said, "old, stuff *weh di Mayas di dead* (that the Mayas who died) left [. . .] Like old pots or junk *dat weh mek outta* (that they made out of) clay."[110] These responses suggest that youth conceptualize archaeological heritage as old, distant, and remote.

Students also conceptualized Ancient Maya sites as being full of "old stuff." For example, when I asked students, "If you could go back in time and you could visit a Maya ruin when people were still living there, what kinds of things would you see?" Eric said, "A lotta old thing."[111] Sherika said she would see "Old bones. Old stuffs. Old shoes. Old glasses. Old clothes. Old shoes."[112] Tameka said, "Old, old bones. Old stuff *eena di* (in the) ground."[113] Similarly, when I separately asked students to imagine Maya cultural objects, they mentioned old things. Sherika answered, "Like, old, old stuff [. . .] Like old bones [. . .]

Old hammers and, old, peoples' body."[114] Delroy said, "Old bone, teeth [. . .] Old pots of clay."[115] When I asked how they imagined the Mayas' contemporary world, the students still thought of age: for example, Evelyn said, "Lone, old things."[116] These responses suggest the students identified a distance between themselves and archaeology as well as Ancient and Modern Maya people.

Perhaps because of the association with age, most young people saw limited connections between Ancient Maya history and culture, archaeological work, and contemporary people[117] (although, as a later section will examine, a few did make such connections). Several students suggested that the majority of Maya people are dead. Maria told me that, "*di* (the) real Mayas is done dead. Just um, few left."[118] When asked whether there were still Maya people alive today, Matthew said, "No [. . .] I think they died out."[119] Kevin described the Mayas as people "who live at the ruins [. . .] they live long long long at the ruins [. . .] they died out and people go and found, their bones they dig up their bones."[120] The students did not seem to consider living Maya people to be the descendants of Ancient Maya people.

I also identified an association between archaeology and things that are old and dead in students' comments about bones, *skelintans* (skeletons), or bodies, which often came up when they described archaeological work. When Brianna was asked, "What do archaeologists do?" she responded: "They dig up bodies off the graveyards and things like that."[121] When describing the tools archaeologists use, Kendail brought up skeletons, saying they would use "brushes to, brush off the dead people [. . .] *di* (the) bones [. . .] *skelintan* (skeleton) bones and [. . .] gloves."[122] When Kenneth, Mavis, and Kenisha were asked "What do archaeologists find?," they all mentioned bones: Kenneth said, "Like dead bodies. Bones. Old stuffs."[123] Mavis said, "Like, pots and so, and bones_find bones like_last time when I been back there I saw they find bones and all kind of things."[124] And Kenisha said, "Maybe *di, di* (the, the) bone *ting* (thing) that *dehn* (they) [. . .] Pots. Animal *tingz* (things). Animal skulls. Maybe even human bones."[125] Crooked Tree youth's connection of bones with archaeology thus reflects their belief that Ancient Maya people are dead and gone, unconnected to living people.

Interestingly, the association of bones with archaeology was much more prominent in Crooked Tree students' interviews and drawings than in those of Biscayne students. In interviews, 37 Crooked Tree students (88 percent) mentioned bones while only four Biscayne students (18 percent) did. A similar difference holds in drawings of archaeological sites; 93 percent of Crooked Tree students drew bones of some kind. And while some students drew animal bones, 30 students included obviously human bones, like skulls and fully articulated skeletons (see figure 4). The prevalence of bones in Crooked Tree

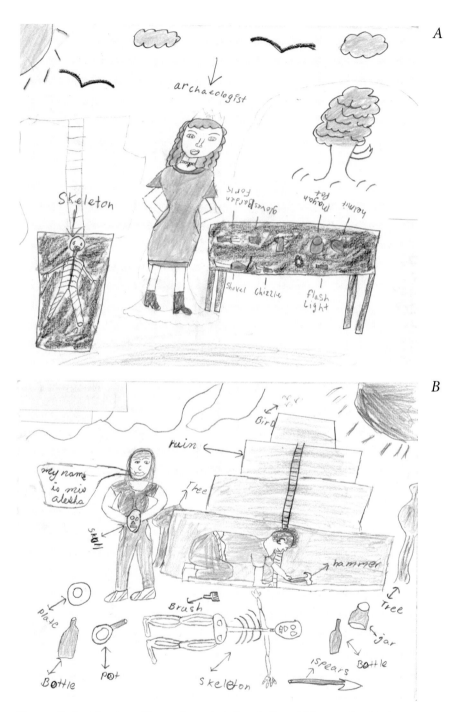

Figure 4. Student drawings of human bones including skulls and fully articulated skeletons. Drawings done by: Tanisha (*A*), Clarence (*B*).

drawings and interviews likely stems from their extensive contact with the CHAP.[126] There is also a local fascination with human remains and ghosts in Crooked Tree. Some community members tell stories of excavating human remains at Chau Hiix and others have stories about nearby hauntings including at Chau Hiix during their hunting and camping practices[127]–young people have certainly heard these stories or had such experiences.

"Oanli (Only) Maya Ruins"

The young Belizeans I worked with conceived of archaeological sites almost exclusively as Maya. When I asked Crooked Tree and Biscayne students if there are archaeological ruins other than Maya ones in Belize, or specifically if there are Kriol ruins, 63 percent of the 57 students who responded said "no" or that they were "unsure." The students who responded "yes" seemed to be thinking about different kinds of Ancient Maya ruins rather than archaeological heritage associated with other ethnic groups. Students answered the prompt, "Are there other ruins in Belize or just Maya ruins?" in various ways. Joseph said, "Huh uh. I only know about Maya ruins."[128] Jamal said, "I don't know. *Oanli* (only) Maya ruin I think *dehn* (they) got *da* (at) Belize."[129] Brianna said, "I'm not sure {but} as far as I am concerned, it's only Maya ruins."[130] Elwood responded, "*Oanli* (only) Maya ruins. *Oanli* (only) the Maya used to make ruins."[131]

Yvette answered the original question by saying, "I think you have different ruins," but when I followed up, asking "Are there Kriol ruins or Garifuna ruins?" she responded, "No ma'am. I think there lone just em, Mayan ruins."[132] Similarly, the following exchange with a student interviewee demonstrates the prevalence of students' limited constructs of archaeological sites:

Interviewer: Are there only Maya ruins in Belize or are there other kinds of ruins too?
Donald: There are {different} kinds of Mayan ruins too.
Interviewer: But are there, Garifuna ruins?
Donald: No sir.
Interviewer: Are there Kriol ruins?
Donald: No sir.
Interviewer: Are there Mestizo ruins?
Donald: No sir.[133]

Ruins is a potentially loaded term, but it is still apparent that students did not consider Kriol vernacular heritage practices as the purview of archaeology because of established definitions of what counts as archaeologically significant.

Dehn Maiyaz Difrant fram Wi (The Maya Were Different from Us)

In young peoples' discussions about Ancient Maya cultural practices, several youths talked about Ancient Maya people in a way that implied a separation between Ancient Maya people and themselves, in particular with regards to cooking practices. Students indicated that Ancient Maya people cooked on hearths and said things like "in those days they *noh* (didn't) have stove" or "they *noh* (don't) cook like we." However, most Crooked Tree residents still have a fire hearth at home and cook on it at least occasionally. In fact, as I mentioned previously, many villagers believe foods taste better when made over a fire hearth.

Comments about changes in cooking practices were particularly common when Biscayne and Crooked Tree students talked about whether it was harder or easier to live in the past. To the students, it seemed good to have the option and convenience of a stove, which represented modern technology. For example, when asked whether it was harder to live in the past than today, Elwood responded, "Yes ma'am. Cause they never have stove. They *hav fi* (had to) use fire hearth. Like how *wi* (we) have stove *betta fi wi dan, dehn* (better for us than them) cause they have [. . .] wood and all *dat* (that) [. . .] lotta work." I followed up, asking, "You don't have fire hearth at home?" And Elwood replied, "Yes maam. *Wi* (we) have . . . At home you learn how *fi* (to) use the fire hearth. You put the wood under *di* (the) fire. They use kerosene [. . .] just light it and you put a pot on top of it. And when you *noh* (don't) have gas *fi di* (for the) stove you could use *di* (the) fire hearth."[134]

Elwood's comments demonstrate how the practice of fire hearth cooking takes on different meanings in different contexts. When older people talk about using a fire hearth, it is seen as a cherished traditional Kriol cooking method that people worry will die out. Perhaps this concern is justified, for students see it as a difficult practice that was used in the past by people who did not have modern conveniences. Similar mixed messages about cultural practices are found in tourism, public discourse, museum exhibits, and informal and formal educational contexts, which associate cooking on a fire hearth only with Ancient Maya people or the past. Such discourses and practices reinforce distance between cultural groups such as the Kriol and the Ancient Maya, even when they share similar cultural practices. It also frames contemporary Maya groups as groups that belong to the past, implying, incorrectly, that their cultural practices are survivals of an earlier time.[135]

"Carry Them to Museum"

In interviews it was apparent that Biscayne and Crooked Tree youths' perspectives about official archaeological heritage were shaped by their contact

with archaeological research through site visits, outreach at school, and trips to museums. When discussing Ancient Maya culture and history, students frequently brought up archaeologists and tourists in ways that privileged them as stakeholders. Several students talked about tourists visiting Maya sites. One student, Maria, even suggested that Ancient Maya sites existed for the sake of tourists. She said that when she asked a tour guide what would happen if the Mayas had never built the ruins, the guide said, "if *dehn neva* (they never) build *dis dehn neva mi a hav no rooin* (they never would have had ruins) [for the] tourists to *kom* (come) see." When I asked Maria if she agreed with the guide, she said, "They build *mek* (made) [them so that] everybody could see it and learn about how *dehn* (they) used to learn."[136]

Methods of learning discussed by students also demonstrated distancing from ancient objects. The average Belizean youth does not handle Ancient Maya objects or see how they are studied. When they visit museums and archaeological sites, they usually observe Ancient Maya objects on platforms and behind glass (as demonstrated at the Museum of Belize in figure 5). Heritage

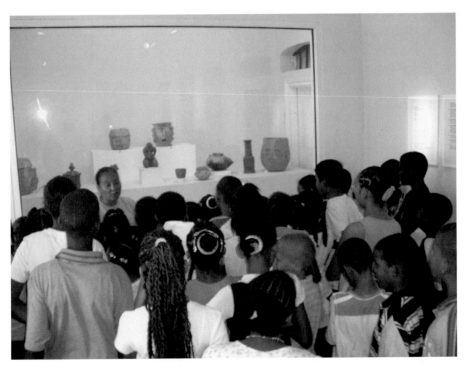

Figure 5. Ancient Maya objects on display on platforms and behind glass at the Museum of Belize. Photo by author.

scholar, Chiara De Cesari suggests typical museum and conservation practices "disembed [. . .] heritage objects from the everyday," isolating them "under the glass case," directing the viewer's focus to the thingified objects themselves rather than their uses and cultural significance.[137]

When Crooked Tree and Biscayne students were asked, "What do archaeologists do with stuff when they find it?" they provided responses that expressed a disconnection and distance they felt from Ancient Maya objects, which become objects of scientific study and display through archaeology and museological practice. Students suggested that archaeological artifacts are "put up"—the phrase used when Belizean parents remove objects from children's reach. Evelyn said, "They *moasli* (mostly), put they up";[138] Matthew said, "I think you just, put it up. Put it up."[139] Two students directly connected the distance between themselves and ancient objects with tourism: Ethan said, "They usually put them up for so the tourists could see them,"[140] and Jacob said they "Carry them to museum [. . .] So other people could see it. [. . .] Like tourists."[141] These responses suggest that young people think archaeological objects are not intended to be engaged with by Belizean citizens—they are "put up" out of reach of themselves and others; they are not authorized to examine them.

Although official archaeological heritage discourses and practices distance youth from Ancient Maya history and culture and archaeology, I found that youth also try to make connections between the past and their everyday lives, understand what archaeologists do, or redefine official archaeological heritage in familiar terms.

"I Think They Just Did the Main Things We Do Now"

In interviews, I determined that young people often make connections between their own lives and experiences and the past even though official archaeological heritage discourses do not necessarily foster this practice. When asked what Ancient Maya people did on a daily basis, some students discussed daily chores, including chores that they themselves and their family members do, such as: cooking, cleaning house, chopping bush, minding children, and backing (carrying) water. Brianna explicitly made a connection between Maya activities and contemporary ones: "I think, they just did the main things we do now, do their wash, grow their food, work in the farm. Things like, what, farmers do [. . .]"[142] Linda imagined a scene that was like a normal day in Crooked Tree, "They are cooking and planting [. . .] *di mens* (the men) go to *di* (the) farm and plant and *di* (the), ladies stay and cook *di* (the) food,[143] as did Jamal: "People workin. *Dehn di wash* (they washed),

clothes [. . .] People *di cook* (cooked) [. . .] *eena* (on) fire hearth [. . .] And people [. . .] *di fishin* (were fishing)."[144] When asked what kinds of things Maya people wrote about Brianna envisioned her own school life: "they just probably write letters and messages and, like we do now, schoolwork."[145] When asked what she would see at a site if she could fly overhead and watch what the Ancient Maya were doing, Mahalia said , "They would be working and playing. The children will be playing and the people will be working. And you will see some people cooking and some raking and some chopping bush."[146] Jacob also specifically mentioned children at Ancient Maya sites, saying he would see "Hardworkin men and women working. And, maybe sometime children will be working. You could see children, playing having fun."[147] And just as students imagined their own lives and experiences to be shared by the Ancient Maya, some seemed to project their own fears and concerns back into Maya culture. Several students expressed worry about Ancient Maya people having to protect their children and find enough to feed the children. Alda said, "Because back then they were poor and [. . .] their children, no have thing for *fi* (to) eat."[148]

Although most Belizean young people I interacted with clearly saw Ancient Maya history as something completely distinct from modern Belizean history, their use of the same colloquial phrases (for example, "*laang* (long) ago," "*laang* (long) time ago," or "*oal taims* (old times)") to refer to archaeology, Ancient Maya history and culture, and their vernacular heritage practices also indicates some noted connections.

Some young people saw parents and grandparents as connecting them to the past, as a mediating generation between themselves and history. In a discussion about what life was like when his mother was growing up, Dean said, "when my Mom was younger they used to use *oal taim* (old time) things and, *tingz dat,* (things that) Kriol people does used to use." He referred to "*oal taims* (old times) things" several times in the interview and also talked about how the "Mayas live a *laang laang* (long long) time ago."[149] For some students, it seemed that cultural aspects of the past and localized forms of history (for example, subsistence practices and traditions) were part of the "*Oal Taims* (Old Times) Days" for both Ancient Maya and Kriol people. In these ways, I think students unconsciously created their own implicit connections with Ancient Maya history and culture. Similarly, when asked how one might learn more about the past, most students suggested they would ask teachers, grandparents, and very old people in their village.

Historically, archaeological scholarship has overlooked children's lives and practices[150] As Kathryn Kamp suggests, "archaeologists have paid little atten-

tion to the lives of children who inhabited the prehistoric landscape [. . .] children have been relegated to the home, their work devalued, their actions seen as passive and lacking in agency, and their import scant."[151] However, it seemed easy for Crooked Tree and Biscayne youth to visualize and connect with other children in the past. Understanding how young people think about children in the past is useful for archaeological outreach, public history projects, and museum interpretation.[152] For example, though archaeologists have overlooked children's social and economic contributions in the past, Belizean children easily identified ways Ancient Maya children might have contributed to society, particularly through daily chores.[153]

Conclusion: Addressing Archaeological Heritage Discourse and Ideologies

Although culture and history can be economic and social resources for Belizeans, archaeology, and tourism, there are also serious disconnects between official archaeological heritage discourses and practices and the vernacular heritage of descendant and local communities. Residents in rural Kriol villages like Crooked Tree and Biscayne have rich constructs of community, culture, and history, but limited state recognition of Kriol culture and history shapes how people self-identify and how they position themselves in local, national, and global contexts.

Without pyramids, monumental sites, or major Kriol-based tourist attractions or programs, many Belizeans I worked with were confused about what would constitute Kriol material culture and archaeological heritage. Crooked Tree and Biscayne young people recognized the value of archaeology to their country and communities, but as I demonstrated, they could not conceive of Kriol archaeological sites. As cultural theorist Stuart Hall has put it, "Heritage is a powerful mirror. Those who do not see themselves in it are therefore excluded."[154]

As a historian and anthropologist, I am excited that young people are fascinated by the size and spectacle of archaeological sites in Belize. Because Ancient Maya history and culture is an important component of national history, Ancient Maya sites should continue to be visited during school field trips and incorporated into educational programming and content. Familiarity with archaeology is also important, because young people should understand the importance of preservation and how artifacts are studied and interpreted by archaeologists. But Belizeans should not be limited to thinking about heritage as solely archaeological, focused only on Ancient Maya history and culture,

object-oriented, or intended for people other than themselves. Archaeology can coexist with diverse forms of heritage.

As I have demonstrated, global institutions like tourism strongly influence how culture and history are represented to citizens and foreign visitors. As states and communities compete to claim space in tourist markets, cultural practices and identities are often compartmentalized, commodified, and packaged, reifying heritage as a thing and essentializing culture. These processes are particularly problematic for cultural groups like Belizean Kriols, who do not have the same monumental markers on the landscape that are promoted by the national government and the tourism industry. Tourism positions local publics and outsiders as consumers of the past. In many ways, the national focus on tourism in Belize perpetuates the idea that culture and history are not for the average citizen. For example, when Teacher Sandy noted that a child's ignorance about local history could cause "embarrassment to the child and to the entire community," she demonstrated a belief that heritage values are determined and reinforced by outsiders.[155]

As heritage professionals increasingly interact with Indigenous groups, local communities, and descendant populations throughout the world, it is important for such professionals to consider how fields like archaeology have historically constructed and supported official heritage discourses and practices and reinforced social and political inequalities in the past and continue to do so in the present. It is also important to understand how archaeological practices and knowledge are interpreted, internalized, and transformed by stakeholders like educators and young people.

Although an archaeological focus on Kriol history and culture in Belize is relatively recent, over the last several decades there has been significant archaeological research conducted on African-descendant communities throughout the Atlantic World.[156] Archaeologists and heritage scholars working in Belize and other Afro-Caribbean contexts can draw important lessons from this scholarship. These lessons include: being creative about interpreting the material culture of Afro-Caribbean peoples, conducting research beyond the agro-industrial context of plantation spaces and societies, offering more nuanced examinations of the experiences of Afro-Caribbean peoples and specifically enslaved peoples to understand the construction of Creole identities and Afro-Caribbean agency, and the importance of community engagements for archaeological research focused on Afro-Caribbean history and culture.

As noted, archaeologists have historically struggled to uncover and interpret the material culture signatures of Afro-Caribbean peoples, in part because

these populations did not leave monumental architectural markers in the built environment and used a significant amount of perishable materials in their daily lives.[157] However, it is also the case that for decades archaeologists misinterpreted or had incorrect expectations of the material culture signatures of Afro-Caribbean peoples, not expecting the amount of cultural mixing that took place between African-descendant and European peoples or the fact that many African-descendants would have had access to European wares.[158] These factors in scholarship on Afro-Caribbean peoples means that archaeologists need to be creative in the ways they seek and interpret their material culture. Examples include examinations of the significant modifications African-descendant populations have made on natural and cultural landscapes.[159] In a historic project in Cuba, archaeologist Teresa Singleton focused on a barrier wall between the planter's estate and living quarters of enslaved peoples at the Santa Ana de Biajacas coffee plantation (Cafetal Biajacas) to understand Afro-Caribbean agency and the limitations of colonial structures on enslaved peoples' lives. In this work, Singleton interpreted the barrier wall through the lens of Afro-Caribbean negotiations of space and power dynamics.[160] Such nuanced studies of Afro-Caribbean peoples would help combat perspectives like the "what would they dig up?" response to the possibility of Kriol archaeology in Belize.

Archaeologists examining Afro-Caribbean cultures and histories in the late twentieth and early twenty-first centuries have also engaged in "ground up" research to better understand the agency and complicated identities and ethnogenesis of Afro-Caribbean and enslaved peoples. This movement has included studies on the cultural production and consumption practices of Afro-Caribbean peoples,[161] investigations of the ways people constructed emergent communities and "New World Creole" identities,[162] and foci on creolization processes, hybridity, and racial fluidity in Afro-Caribbean contexts.[163] Scholars have also advocated for archaeological studies in the Caribbean beyond plantations sites and societies, for example of maroon societies,[164] free urban Black populations, mixed race communities, non-elite Europeans, and civilians surrounding military complexes to "understand the strategies of people who sought to maintain their own spaces inside or outside the fixed borders of the plantation."[165]

Important lessons can also be learned from community-based heritage research in Afro-Caribbean contexts. Engagements with African-descendant communities are necessary for archaeologists and other heritage scholars to understand persistent forms of vernacular heritage, find meaningful ways to make information accessible and inclusive, and identify the needs and

interests people have in archaeological research. Indeed, archaeologist Paul Farnsworth advocates forging "relationships and alliances with Caribbean people and their governments," and suggests that "by studying sites and subjects [. . .] that are of relevance to local stakeholders, and involving them in the research process [. . .] archaeologists can build local coalitions to support research and heritage preservation."[166] In an article about ethnographic, historic, and archaeological investigations of maroon communities in Florida and The Bahamas, Rosalyn Howard demonstrates that interdisciplinary community-based heritage research can reveal the ways the lives of Africans, African-descendants, Native peoples, and Europeans are complexly intertwined in the past and present.[167] In Antoinette Jackson's work on the interpretations of the history and culture of enslaved Africans and their descendants in the United States South, Jackson demonstrates that engagements with descendants and oral history research can reveal ways African-descendants constructed and maintained vernacular heritage practices and can help to develop more engaging and inclusive heritage tourism, national programming, and interpretations of American history.[168]

In Belize, archaeological practices are beginning to change on institutional and local levels in many of the ways noted in other Afro-Caribbean communities. The IA is working to change public perceptions of archaeology and to make research and interpretations more accessible through public education and efforts to train Belizean archaeologists. Additionally, historic archaeology has grown more common in Belize and some archaeological projects have explored Kriol culture and history. These efforts will ideally raise awareness about what archaeologists do in Belize, while diversifying Belizeans' images of archaeologists, and reflecting the material culture and history of groups other than the Ancient Maya.

Since the end of the twentieth century, archaeologists and other heritage scholars in Belize have also increasingly developed community-based initiatives that incorporate the needs and interests of living people.[169] Many heritage projects have incorporated educational outreach and curricular components.[170] Successful educational outreach requires a firm understanding of what people already know, as well as their interests. As my discussions of Crooked Tree and Biscayne have shown, teachers and other community leaders have strong ideas about education related to history and culture and archaeology's impacts on their communities. Unpacking localized connections with archaeology, as well as the historical roots of agency in the face of official heritage discourses and practices reveals exciting paths forward for archaeologists, historians, cultural anthropologists, and other heritage schol-

ars interested in community-based heritage work and collaboration. Such collaborations will enable heritage scholars to expand the reach of disciplines that study the past, challenge social, racial, and economic inequalities, and make space for multiple voices. Indeed, as Baram suggests, "When communities are taken into consideration, it becomes possible to evaluate whether archaeology is maintaining the status quo or empowering silenced groups."[171]

6

Conclusion

Kriol Cultural Resilience and Community Engagement

I first arrived in Belize in 2005 as a participant with the long-term community-based Chau Hiix Archaeological Project (CHAP). I was aware of the extensive collaborations between Crooked Tree Village and the CHAP, and CHAP goals to make archaeology accessible and engaging through educational outreach. As an early career heritage scholar, I set out to understand how and why Kriol villagers connected with Maya archaeology, how young people learned about Belizean and Kriol history and culture, and to understand Crooked Tree residents' ideas about the meanings, values, and uses of heritage. For me, it was clear that archaeology and education were intertwined through discourse and practice in the minds and actions of archaeologists, educators, state actors, and local community members. Thus, I set out to examine both institutions.

I interviewed state heritage actors who told me: "in Belize, archaeology is about national identity. It's about [. . .] symbols of a nationhood [. . .]"[1] I learned about state education goals to decolonize the Belizean curriculum, integrate content about Maya and African civilizations, enhance young peoples' pride in their cultural heritage,[2] and cultivate a citizenry with "a strong sense of Belizean identity and history."[3] State heritage actors implied that Belizeans should "do something" with their culture and history to better the nation. A message of social uplift through culture and history even pervaded music I heard on the radio, such as the lyrics of a twenty-first century pop song, "We want you [Belizean musicians] to come join hands with your fellow man, make music, flood up di market, and *big-op* (big up)[4] yourself [. . .] Sweet Belizean music, take over wi country [. . .] Come Belizean rock rock, rock di boat till it turn all over."[5]

Given the 15-plus year history of the CHAP, the rich Kriol history and culture in Belize, and state initiatives to promote Belizean heritage, I expected Crooked Tree residents and those in the nearby Kriol community of Biscayne to readily connect with archaeology, and to share with me vernacular forms of heritage. However, throughout my early research, I felt a disconnect between

my expectations about Belizeans' heritage constructs and the heritage constructs of the students and adults with whom I interacted. Despite the CHAP's history of community outreach and education, employing Crooked Tree residents, and the fact that many Crooked Tree residents had farmed near Chau Hiix for decades, Chau Hiix was not commonly mentioned in community history narratives. And when asked about young people learning about archaeology and local history, Crooked Tree adults repeated clichés about the importance of learning about the past so mistakes of the past were not repeated. Kriol culture and history were rarely discussed in classrooms I observed. Teachers told me that Kriol people have lost "their sense of identity" and that young Kriol people are "fastly forgetting their culture."[6] Many students I spoke with expressed limited knowledge about national and local history and were confused about the history and culture of different Belizean ethnic groups.

I naively pondered whether the public archaeology efforts of the CHAP had "failed" for these reasons. My misunderstandings about the ways people connected with archaeological resources and the impacts of the CHAP are linked to broader issues within community-based archaeological work. Many archaeologists now acknowledge the value of engaging with local communities and many projects include collaborative components to understand peoples' needs and interests in archaeological research, to learn about the existing knowledge local and descendant communities have about the past, and to share the information gathered through archaeological research. But there are still assumptions about who the "community/ies" is/are that heritage professionals should engage with, as well as what forms of history communities will connect with.[7] Community-based archaeological projects in Afro-Caribbean communities provide useful comparisons. In an article about archaeological investigations and public archaeology at sugar plantation ruins and a residential village for enslaved African laborers in St. Maarten, Jay Haviser was surprised that in spite of the fact that the plantation and village locations were eventually identified as a local monument and could reveal important information about African legacies in the nearby community, there seemed to be little public interest in the archaeological project and its findings.[8] Through further community engagement, Haviser and colleagues learned that it was not that local people were disinterested in history, but that the work of the archaeologists needed to be more relevant to living Afro-Caribbean peoples.[9] Haviser suggests that archaeologists should consider more recent histories and experiences; develop ways for Caribbean youth to engage with heritage careers; address sensitive issues like slavery, race relations, and inequality, as well as "positive aspects of the African diaspora life experiences;" and connect archaeology more with

contemporary intangible heritage like dance and music in the communities in which they work.[10] Archaeologist Edward González-Tennant notes similar ways in which his own assumptions about what kinds of archaeological sites Afro-Caribbean peoples would connect with affected his community-based heritage research.[11] Working at a colonial fortification (Saddle Hill) on the island of Nevis, González-Tennant and colleagues initially limited their engagements with local Afro-Caribbean residents because of the colonial history of the site. When he and his colleagues recognized that locals of African descent had stories about Saddle Hill and considered it an "integral part of Nevisian heritage," González-Tennant began to document these local engagements. González-Tennant suggests heritage professionals need to go beyond descendant/racial connections with archaeological sites and "decolonize" their views about "what counts as African diaspora heritage in the Caribbean."[12]

Recognizing that the CHAP had different impacts on local communities than I assumed, and hearing Kriol people lament "cultural loss," and discuss the cultural preservation successes of other communities, I sought to examine the history of official and vernacular heritage discourses and practices in Belize to provide needed context to my observations. My research thus needed to expand beyond a focus on the CHAP to include the history of the formal heritage institutions of education and archaeology as well as vernacular heritage and historical knowledge in rural Kriol communities.

While researching the institutions of education and archaeology historically and ethnographically in Belize, I learned how they have worked together since the Colonial Period to establish specific constructions of culture, history, and identity that laid the foundation for official heritage discourse through which Kriol people in the twenty-first century think about the past, who they are, and how they are situated in Belizean history. This is not to say that Kriol culture is what it is because of outsider influence—rather, the specific views that Crooked Tree and Biscayne residents have about the past, themselves, and their country, are influenced by intersections of the histories of education and archaeology and their ancestors' cultural responses, negotiations, and resistance.

As I demonstrated throughout this book, though official heritage discourse, practice, and ideologies in Belize have historically been hegemonic and exclusionary particularly with regards to Kriol culture and history, Belizeans have resisted and negotiated such discourses and practices since the Colonial Period. As early as the 1920s, there is documented evidence of Kriol children in Crooked Tree and surrounding villages missing school to participate in bush practices and learn about Kriol identity. And Crooked Tree villagers emphasized their community uniqueness in petitions to the colonial government

while at the same time advocating for external resources. Today, Kriol community leaders continue to advocate for their villages by negotiating with NGOs, foreign researchers, and government representatives for tourism development and recognition of local heritage. Teachers resist education resources and programs that do not fit everyday realities. And young people construct unique identities and make connections with Ancient Maya people through assumptions about shared experiences.

These conclusions provide several lessons of import to public historians, public archaeologists, and heritage scholars working in the regions of Central America and the Caribbean, but also globally. This chapter serves as a kind of cautionary tale about community-based heritage and public history scholarship and engagement. Through 15 years of engaging in daily activities and conversations with people in Crooked Tree and Biscayne, I have learned to pay better attention to the stories people tell and their cultural practices. I have learned about heritage resiliency among elders and youth, the ways people adapt to contemporary cultural politics and shifting demographics to ensure cultural sustainability, the centrality of youth to cultural identity, and particularly successful approaches in heritage outreach.[13]

The specific lessons I unpack below are as follows:

Although colonial constructions of race, culture, and history marginalized vernacular Kriol heritage practices in Belize, Kriol peoples in communities like Crooked Tree and Biscayne carve out space for themselves, develop ways to adapt to colonial legacies and contemporary identity politics, and maintain rich constructs of Kriol history and culture through practices like storytelling and their engagements with ecological resources.

Youth are central to Kriol identity, culture, and sustainability and I provide examples of how historical and cultural knowledge persist across generations. In Crooked Tree and Biscayne, the successes of young people are embraced and equated with community success. And although community members are concerned about the loss of Kriol culture, young people connect with and perpetuate Kriol culture and history in many ways.

Finally, I highlight the facts that hands-on interactions with tangible forms of history and cultural exchanges can be particularly engaging and effective forms of heritage outreach.

Enduring Kriol Heritage Practices

Many forms of Belizean Kriol culture and history are not represented at museums, in curricula, tourism materials, or at archaeological sites. This is because

of the long history of marginalization discussed in this book, but also because some forms of vernacular Kriol heritage are intangible or do not fit with the official heritage discourse. Rural Kriol identity and culture are deeply tied to the environmental landscape. These ties shape the ways Belizeans situate themselves in society. Kriol heritage practices tied to environmental landscapes persist in stories about community elders, transportation, and contemporary food industries.

Storytelling is an enduring Kriol heritage practice. I rarely witnessed Crooked Tree or Biscayne teachers giving formal lectures about local history to their students, but often observed teachers and other adults recounting narratives about village life, their childhoods, and notable community figures. These stories serve as historical narratives and lessons for youth, particularly with regards to community identity, overcoming adversity, and Kriol ties to ecological resources and environmental landscapes.

Young people told me that if they wanted to know more about "the Olden Days" (the past) they could ask their grandparents or other "Old Heads." Particular community members are considered iconic representatives of "the Olden Days" due to their age, and are often identified by name, for example, "Go talk to Braa Owen to learn more about village history." And when these elders pass away, villagers emphasize the tremendous loss of historical knowledge.

Crooked Tree historical narratives often feature details about travel before modern roads existed. Crooked Tree residents (ages 40 and older) have enthusiastically shared stories with me of traveling to and from "the city" (Belize City) by boat. These trips took an entire day or longer and sometimes involved several stops at other Kriol riverine villages along the way. The focal point of such stories is never what people did in the city, but the journey there and back. People talk about who drove the boats, the rapids they encountered, the food people prepared for the trip, and the fact that children sat together on one boat and adults rode in another boat. As Crooked Tree is an island surrounded by seasonal lagoons, stories about its remote location and the surrounding waterways are integral to community identity and history. These heritage-stories continue to be discussed, particularly during flood times when people again become dependent on waterways for transportation. The narratives certainly have significant historicity; as I demonstrated in chapter two, water transportation figured prominently in Crooked Tree villagers' negotiations with the colonial government from at least as early as the 1920s.

A few stories are commonly told about the earliest non-Maya inhabitants to settle around Crooked Tree and the founding and naming of the village. These include a narrative about loggers settling in the area due to the abundance

of logwood trees and naming the village after a particularly "crooked tree" they saw. Another story refers to a group of bandits or the "Crooked Three" settling in the region. Early historic documents reference a settlement called Tilletton[14] and some villagers also note that the village was first called Tilletton. Stories about the village's history are referenced in resources meant for community consumption (the Crooked Tree Village Reunion website) as well as in resources primarily marketed to non-residents (the Crooked Tree Village cookbook and Visit Crooked Tree website).[15]

In April 2009, I witnessed Teacher Albert recount details about Crooked Tree history and culture to a group of Belize City students (many of whom were likely ethnically Kriol) who were visiting Crooked Tree Government School (CTGS) to learn about "village life" and "the Olden Days." Teacher Albert started by explaining that Crooked Tree is a village and Belize City is a city and stressed that Crooked Tree is an island.[16] He then began talking about three logwood cutting brothers (Crawford, Tillett, Gillett)[17] who he said were the original inhabitants of Crooked Tree and the ancestors of today's villagers. According to Teacher Albert's story there were no logwood trees left in Belize except in Crooked Tree. Thus, they were worth lots of money, and the three brothers made this secret place with good trees their hideaway and named it Crooked Tree. In his story, Teacher Albert also talked about village assets that attract visitors, including the jabiru stork and cashews.[18] He explained that cashews grow naturally and abundantly in the village and talked about the annual Cashew Fest, which celebrates cashew production every May.

Teacher Albert finished his story with details about Crooked Tree involvement in contemporary sports. He highlighted that the CTGS girls' softball team won the National Championship in 2009 and the Crooked Tree men's cricket team (*Brilliance*) had won the National Championship three years in a row. Teacher Albert's discussion about tourism and sports emphasized Crooked Tree's relationship with the outside world in areas of both local and global significance. By demonstrating success in sports on a national level, Teacher Albert legitimized Crooked Tree's Belizean identity while also highlighting cultural practices that are a source of great pride and tied to local identity.

At the end of his story, Teacher Albert invited the Belize City students to ask questions. It was clear from their questions that the students felt distanced from the residents of this rural Kriol village. One child asked, "How did you get meat?" Teacher Albert responded with a quip about cavemen and spears and then told the students that actually current villagers hunt deer with guns and have done so for several generations. Interestingly, although some Crooked Tree residents still hunt, the majority of the meat consumed comes from the

store, which Teacher Albert did not mention. Instead he talked about a sense of community and reciprocity in Crooked Tree and said that people used to share deer meat because in the past there was no way to refrigerate it. One student asked, "How did you make fire?" Teacher Albert laughed and said the girl was thinking about history "way back" and said today people just use matches. At the end of the question and answer session, Teacher Albert invited the Belize City students to collect mangoes—ending the visitors' time by connecting with local ecology.

Teacher Albert embraced his role as storyteller and recited the history of Crooked Tree with energy, excitement, and pride. His narrative was different from compartmentalized and simplified forms of ethnic heritage that youth learn in the national social studies curriculum. It was also different from the dominant Maya-centric and monumental heritage forms presented to Belizeans and tourists at archaeological sites and museums. Teacher Albert's story highlighted aspects of Crooked Tree history and culture that are central to its identity in a form easily consumable by outside visitors, in this case an audience of Belize City children. Teacher Albert's narrative was also a safe story to tell. He did not mention the complex racial or colonial history of Crooked Tree, nor did he discuss slavery or other aspects of British colonialism.

Teacher Albert's interactions with the Belize City students portrayed pride about Crooked Tree cultural practices and familiarity with how outsiders perceive the village. His discussion of logwood history, cashew production, the abundance of mangoes, and success of local sports teams brought attention to things that make Crooked Tree special and draw outsiders. And his stories about hunting and doing schoolwork by gas lamp highlighted characteristics Teacher Albert considered integral to Crooked Tree identity and admirable aspects of local heritage (for example, self-sufficiency and overcoming adversity). But Teacher Albert also recognized the negative stereotypes of Crooked Tree, and the kind of double-standard experienced by rural Kriol villages and other communities in Belize (for example, between cultural authenticity and backwardness). After the city students left, Teacher Albert told Teacher Christina about the visit and mentioned some of the questions the students asked. They both laughed and Teacher Christina said, "We aren't Stone Age you know Teacher Albert."

Cashew production is an especially important component of vernacular Crooked Tree heritage. Crooked Tree is known as the "Village of the Cashew" and people throughout Belize are aware of the prevalence of cashews there. Cashews were noted in British colonial expeditions to Belize, and grow easily and abundantly in the sandy soils of Crooked Tree and other communities in north

central Belize.[19] The most lucrative cashew product is the nut (referred to in Belize as the "seed") and many Crooked Tree residents rely on the production of cashew seeds as a primary income source. However, cashew is a seasonal crop and the harvest fluctuates based on climatic conditions. The process of producing cashew seeds from harvesting to final packaging is also incredibly labor intensive and time consuming.

It was not until the late 1980s and early 1990s that Crooked Tree residents began publicly claiming cashew production as local heritage. At this time, Crooked Tree villagers established the annual Cashew Festival. Cashew Fest is promoted as a form of tourism to domestic and international travelers, but also to villagers who have emigrated as a kind of homecoming. The festival includes the sale of a variety of cashew products (for example, cashew seeds, wine made from the fruit, jams, cakes and other sweets), a dance, carnival games and rides, and educational booths.

I learned about Crooked Tree's cashew heritage in a variety of ways. Cashew Harvest events are held at local churches to celebrate and give thanks for the crop's annual harvest. During these events, churches are decorated with parts of the cashew tree, pastors give thanks for the year's bounty, young people perform poems, and people bring cashew products to sell. Villagers also talked with me about the local significance of cashew heritage and emphasized Crooked Tree cashew production as particularly authentic. People from other parts of Belize have also told me cashew seeds taste better from Crooked Tree and acknowledge Crooked Treeans are the experts in all things cashew.

In the summer of 2016, I directed an international public history field experience for university students in Crooked Tree and Biscayne. The field experience involved experiential education, interdisciplinary research, and collaboration between American and Belizean university students, public history, cultural anthropology, and archaeology scholars, United States and Belizean institutions, and community residents.[20] Resulting products included an exhibit on local culture and history and educational materials. Our team consulted with Crooked Tree and Biscayne residents about what they wanted highlighted in the exhibit and many people talked about cashew production. North Carolina State University (NC State) Public History PhD student, Lisa R. Withers developed the majority of the exhibit panels and included an entire section documenting cashew seed production in images and text. One villager heard about the work we were doing and invited us to tour his farm to see the variety of ecological resources harvested by Crooked Tree villagers, and to learn about the process of making cashew wine. In order for the students to understand the full cashew seed production process, I orga-

nized demonstrations with villagers and the students learned how to process cashew seed by hand (as demonstrated in figure 6). At the exhibit opening, we showed video footage of the cashew processing demonstrations. People from outside the village as well as Crooked Tree residents were enthralled by the video footage and people featured in the videos and photos were proud to be highlighted in the exhibit and were excited to identify friends and family members in the materials.

When I recently discussed potential future research projects with Crooked Tree residents, many of them expressed interest in me continuing to research and create visual displays focused on the uniqueness of cashew production in Crooked Tree. One village elder said, "you already have this information," referencing my previous interviews with and observations of herself and other villagers engaging in various steps in cashew seed production.[21]

It should be noted that the ways vernacular heritage among African-descendant communities is integrally tied to the environment has been explored by

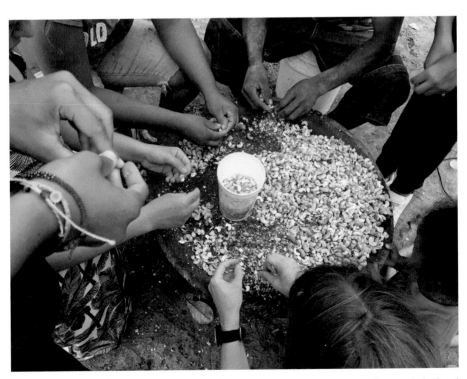

Figure 6. Belizean and American university students learning how to process cashew seeds by hand with Crooked Tree villagers. Photo by Lisa R. Withers.

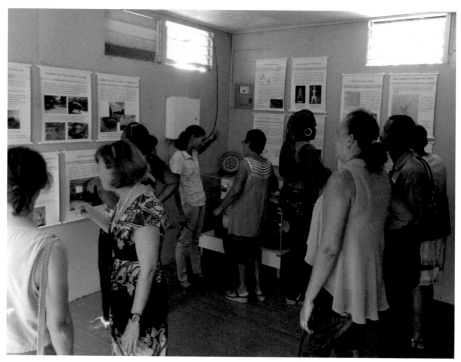

Figure 7. Crooked Tree villagers and other Belizean stakeholders observing exhibit on local history and culture developed as part of an international public history field experience in 2016. Photo by Dru McGill.

several scholars. Anthropologist Melissa Johnson has documented extensive "socionatural" heritage among Belizean Kriol populations in Crooked Tree and other rural Belize River valley communities.[22] In a provocative article titled, "Black Landscapes Matter," scholar of landscape architecture, Kofi Boone too notes the numerous ways African-descendant peoples have adapted to diverse environments and modified environments for subsistence practices and industry. He also explores how the social experiences of African-descendant peoples have left indelible markers in built environments. Boone argues that these landscapes have too long been relegated to societal, political, and scholarly margins, and need to be studied, preserved, and recognized.[23] And, environmental historian, Dianne Glave argues that although African American's connections to and engagements with nature have long been denied and misunderstood, African-descendants have utilized rich knowledge and skills to interact with, modify, resist, and negotiate the natural environment throughout history.[24]

Adaptations to Cultural Politics

Many Crooked Tree residents have figured out ways to adapt vernacular heritage practices and identity markers to fit global dynamics related to the tourism industry and shifting national demographics. Much tourism in Crooked Tree takes the form of ecotourism through which villagers bring attention to local natural resources and curated forms of bush knowledge.[25] Locally-owned lodges serve Westernized versions of traditional Kriol dishes that utilize local resources. Additionally, many lodges employ local tour guides renowned for their knowledge of flora and fauna.

Although there is extensive interest in ecotourism in Belize, it is a small country and has a limited capacity for cultural tourism, especially in rural communities. Citizens in villages like Crooked Tree often have to compete for business and figure out ways to appear distinct. Crooked Tree residents have found ways to adapt to a fluctuating heritage industry and developed ways to promote and package culture in different ways.

In 2013, I met a young entrepreneur who had recently decided to take over the family tourism business, Tillett's Village Lodge. The young gentleman developed a website for the lodge that highlighted local culture, food, and nature tours like other hotels in the village. But he also added opportunities that cater to the interests of ecotravelers and the global slow-food movement. These include a "jungle survival experience" that promotes bush knowledge, and "real and true contact with the jungle [. . .] guided by a native villager" who is identified as a "'bushman' and certified jungle expert." Also offered are "village life experiences" including a traditional cooking demonstration with an elder who is described as "progressive without losing traditional stability, outspoken, dependable, and generous." In these ways, Tillett's Lodge turns potential limitations like its small size into a strength promoting an "authentic" village experience.[26]

The majority of Crooked Tree villagers have at least one family member who lives in the United States. Some community members raise their children in the States, some live in the States for a period of time while their children remain in Belize, sending remittances back to Crooked Tree. Still others spend their middle aged and elderly years in the States and build a vacation or retirement home in Crooked Tree. These migration dynamics affect community make-up and can threaten cultural sustainability. But they can also reinforce village and ethnic identity, pride, and resilience. Similar to Johnson's work on the maintenance of socionatural heritage in rural Kriol communities, I observed ways many emigrants maintain close cultural and familial ties with Crooked Tree

and sustain aspects of their Kriol identity.[27] Every summer many Crooked Tree emigrants either visit Crooked Tree with their children or send their children to the village for the summer to spend time with family members and "learn their roots." When emigrants return to the States after Crooked Tree visits, they bring back local foods including cashew products, palm oils, and even fish. Those unable to visit Crooked Tree request family members who visit them in the States come with extensive amounts of local products.

Crooked Tree community members also use social media as a cultural preservation tool to promote Crooked Tree cultural knowledge and history, establish transnational community networks, and maintain cultural and familial ties across physical boundaries. Several social media efforts are managed by middle aged women who grew up in Crooked Tree.

The Village View Post is a personal blog created by Linda Crawford, who no longer lives in Crooked Tree. Linda no longer posts on the site, but during its period of activity (2008–2014) she posted news stories and Crooked Tree village updates about deaths, festivals, local and national politics, the accomplishments of village sports teams, CTGS successes, and community needs. Also, on the blog were postings about Kriol cultural practices and knowledge, stories about village history, and recipes for traditional dishes made with Belizean fruits and vegetables. The blog was a way for people to connect but also demonstrates Linda Crawford's recognition of the richness of Kriol culture and her concerns about Crooked Tree's future and cultural preservation.[28] The Crooked Tree Village Reunion was initiated as an event in 2008 to encourage community members to return to the village to reconnect with family and friends and celebrate Crooked Tree culture and identity. The Reunion's website site is no longer active, but retains extensive information about Crooked Tree people, events, accomplishments, and history. The site hosts a sizable collection of historic and recent photographs.[29] The Crooked Tree Village Reunion Facebook page (created in 2010)[30] continues to be active and has obituaries and eulogies, posts about current events, local politics, civic volunteer opportunities, and fundraisers for families in need. The Facebook page seems to be a particularly successful tool for maintaining connections within the now highly dispersed Crooked Tree community as it is "followed," "liked," and utilized by over 1,200 people across generations.

Youth and Crooked Tree Identity

Young people play roles as cultural agents, constructing ideas about culture, history, and community for future generations. It is important to consider

the significance young people play in their communities in relation to transmitting culture and negotiating heritage. The centrality of youth to Kriol culture has historic roots as well. As I have noted, education documents, colonial minute papers, community petitions, political rhetoric, and the ways Crooked Tree and Biscayne residents talk about the importance of young people learning about local history all reveal the fact that young people are central to governmental, but also community agendas for social and economic development.

In Crooked Tree, the successes of young people are markers of pride and recognized as community successes. Softball has become popular in Crooked Tree over the last fifteen years. Though softball is particularly important for the cultural identity and experiences for CTGS and adolescent girls in Crooked Tree, it is also an integral aspect of community identity, especially during successful seasons. In 2009 and 2010, the Crooked Tree girls' team won the National Softball Championship. I was in Crooked Tree during the 2009 competition and attended several of the games throughout Belize. CTGS classes were canceled for the upper level grades on game days. Many adult residents also chose to attend the games and the local bus company donated use of one of its buses for villagers to travel to the games. After each win, the bus returned to Crooked Tree full of cheering students and adults. On the day the team won the championship, the riders on the bus were particularly rowdy. The bus drove through the entire village honking the horn while everyone sang and cheered. Many villagers have fond memories of this accomplishment and the sports talents of Crooked Tree youth continue to be a source of community pride.[31]

School is promoted as an important tool for upward mobility by Belizean political leaders and the general public. Many Kriol youth and adults I spoke with acknowledged that a formal education would influence their future job opportunities. The primary school examination (PSE) often determines the high school options available to Belizean students. Thus, it is a high stakes exam and there is much discussion throughout the village at PSE time. Every year, the top PSE scores from the village are celebrated on various blogs and Facebook pages. In 2014, a Crooked Tree student, Ashton Tillett received the top PSE score in the entire country. This made national news and was a point of great pride in Crooked Tree.[32] CTGS planned a parade throughout the village and the Minister of Education visited the village to congratulate Ashton and then spoke at the CTGS primary school graduation. The ways people spoke about Ashton's success were notable as they emphasized village pride and the importance of maintaining community identity. For several years, Ashton had

been financially supported by a family from the States who met him when they were ecotourists in the village. This family saw promise in Ashton because he is an intelligent, warm person, and has always acted as an ambassador for his village. Though the American family had provided Ashton financial support, several villagers mentioned to me that it was important for Ashton to stay in Crooked Tree and be a part of his village, rather than the American family taking him to study in the States. These villagers emphasized the importance of Ashton maintaining his culture and identity as a Crooked Tree community member.

My interactions with Kriol youth in Crooked Tree and Biscayne have revealed ways they conceptualize cultural knowledge and community identity, as well as aspects of local culture that are particularly significant to them. When I conducted research in CTGS and Biscayne Government School (BGS), I often developed activities that were not explicitly part of my research project. For example, my relatives in the States were curious about daily practices at Belizean schools and my sister-in-law suggested I organize a pen pal exchange between the Belizean students and my niece's class (as the Belizean and American students were close in age). Although the Belizean teachers provided their students with some suggestions on what to highlight in their letters (for example, aspects of their community that might be unfamiliar or interesting to their American pen pals), they encouraged students to write about anything they wanted. Many Belizean students wrote about their siblings and their favorite television shows and musicians and asked the American students about the same things. The responses from the States came in a package that included gifts from the American students and a school newsletter. The newsletter prompted the CTGS and BGS classes to create newsletters about their schools. Again, the teachers made some suggestions about what to include and Teacher Albert told the students to write a section about Cashew Fest. Other topics students chose to write about included Standard VI graduation and the high school opportunities of their classmates, local sports, the wetlands environment surrounding Crooked Tree and Biscayne, cashew production, and foods they enjoy eating.

The results of the 2016 public history field experience also revealed a great deal about rural Kriol youth's vernacular heritage practices. NC State Public History MA student, Hannah Scruggs, directed educational outreach with adolescents at CTGS and BGS. Hannah talked with Belizean students about their lives in informal interviews. The students drew pictures of things meaningful to them and CTGS students wrote responses for a "Why I Love Crooked Tree" essay contest. Students shared information with Hannah about their interests

in popular culture (for example, musicians and sports), cultural practices, their favorite pastimes, and traditional folktales.

The range in styles and types of narratives students told about their communities brought attention to the diverse and creative ways young Kriol people process and construct knowledge about culture and history. In their responses for the CTGS essay contest young people talked about their connections to local ecological resources. Arnold said, "I also love living in Crooked Tree because of my farm. I love my farm because the wild life you can see there are beautiful. The best reason why I love farming is because I love to ride the horses and feed the cows with cashew and milkweed. I also love it because you can see the beautiful deer feeding and foxes." And Georgiana said, "I like Crooked Tree because we have traditional stories. My grandmother loves to tell us Anansi stories and while she tell [sic] us she does the action and it is very funny to see those action [sic]. You would laugh. Ha! Ha!"

Several youths told detailed, original, and personal stories about hunting and fishing traditions and narratives about trips to the bush with family members. Others recounted their own lengthy and entertaining versions of folktales. In years of research, I had never heard accounts of folktales from Belizean youth. Hannah noted in her field-notebook:

> I got incredibly excited when I learned that stories about Anansi the spider were popular and well known throughout the Kriol families. It's amazing to me that those stories traveled from West Africa and continue to be passed down via oral tradition in families in Crooked Tree, and with other Kriol communities in Belize. The kids are not taught much about their enslaved African ancestors within the school curriculum, so the fact that those stories live on is incredible.[33]

The diverse ways young Kriol people talked about local culture and history to me and my students are another example of the continuum of Kriol vernacular heritage and demonstrate that even young people are savvy in the ways they negotiate and perform heritage. Though youth struggled at times in formal contexts like interviews with me (a white woman) and at school (a historically white space) to describe Kriol culture and history, they did so with ease in other contexts in which it seemed more appropriate and comfortable. In their conversations with Hannah (a young African American woman), students shared their own interests, expressed pride in their communities, and told folktales in ways that combined a mixture of many cultural influences that rural Kriol peoples have come into contact with over centuries. These young people revealed they are not "losing their culture," but constructing and enacting it every day.

Lessons for Community Engagement

Decades of public archaeology and public history literature has explored effective approaches and pedagogies for teaching people about the past, and addressing diverse groups' needs and interests in the past.[34] As I have been conducting community-based heritage work in Belize for 15 years, I frequently reflect on "what works" in community engagement. While recognizing I do not have all the answers, I conclude with examples of community engagement that I have found particularly successful, including engagements that involve material culture, cultural exchanges, and highlighting connections with ecological heritage.

Children and adults alike enjoy connecting with cultural objects and their interactions with material culture are often quite memorable.[35] Just as was the case with Belizeans who engaged with Ancient Maya objects through some of the earliest archaeological investigations in the country, I found with the Belizeans I worked with that interactions with material culture influenced their knowledge about archaeological practices, and often inspired them to share personal historical narratives.

Although young people may feel disconnected from cultural objects behind glass in museums and cultural centers, when they have opportunities to engage with objects through hands-on activities, they can become better connected to archaeological heritage practices. During the 2008–2009 school year when I asked Belizean youth what kinds of things archaeologists find, CTGS students more frequently mentioned archaeologists finding evidence of daily life practices (for example, pottery) while BGS students often mentioned "treasure" or elite goods (for example, gold, silver, jewelry, and jade). Only 7 percent of the objects mentioned by CTGS students fell into this "treasure" category. The most popular objects mentioned by CTGS students were bones and *skelintans* (skeletons) (88 percent of the students gave this response), and pottery (74 percent). When asked what archaeologists find, CTGS student Dean demonstrated the diverse and numerous objects CTGS students associated with archaeological excavation. He responded, "Weapons, sharp stones, cups, pots, pans, out of clay that, they used to make . . . bones, skulls."[36] Conversely, in interviews with BGS students, in addition to treasure few included traditional archaeology data categories like pottery (27 percent) and bones (18 percent). When asked the same question as Dean, BGS student Beto said, "When *di* (the) Mayas dead. They left *latta* (a lot of) gold."[37]

The higher rate of pottery mentioned by CTGS students in interviews is likely the result of CHAP educational outreach. During several field seasons CTGS students had the opportunity to screen soil for artifacts, CHAP mem-

bers visited CTGS with artifacts, and CTGS students visited the Chau Hiix archaeology lab. CHAP outreach brought CTGS students into direct contact with broken pottery, stone tools, and other material culture evidence of the everyday lives of Ancient Maya people. Certainly, these experiences were memorable for young people and helped them develop broader and more accurate understandings of archaeology.

I have also witnessed adults connecting with cultural objects in various heritage contexts. Cultural objects often inspired adults to share heritage knowledge with young people. Historic household objects that Belizeans frequently used prior to the late twentieth century are often exhibited at the Museum of Belize. When I visited this museum with CTGS and BGS students, teachers and parent chaperones identified objects they were familiar with (for example, mahogany bowls and steam irons) in displays and used them to tell personal stories about their childhood experiences—one teacher fondly shared memories of being bathed in a large mahogany bowl. Historic objects are memory points that help adults make connections between the past and present for young people. Such objects also inspire lessons about change over time, the hardships adults experienced, and how far society has come. Mahogany bowls are a particularly cherished heritage object for many Kriol people I know. Bowls for bathing, doing laundry, and for kneading dough have been passed down through many generations. Indeed, I learned how to make Kriol bread from the daughter of a Crooked Tree elder on the family's large mahogany bowl.

As I demonstrated in this book, Belizean education practices have reinforced disconnects between formal education and peoples' lived realities. And, official archaeological heritage practices have long "thingified" culture and history and emphasized monumentality and elite lives over everyday experiences of the past. It is unsurprising then when people can actually touch objects and connect their own histories and vernacular heritage practices with these objects that they might resonate more with them.

Through my research in Belize, I have also learned about the power of cultural exchanges. In July 2014, Kristina Baines (City University of New York, Guttman Community College) and I organized a cultural exchange in Crooked Tree between its Kriol villagers and Mopan Maya villagers from Santa Cruz in southern Belize. Kriol and Maya peoples have both been politically, socially, and economically disenfranchised throughout Belizean history. Crooked Tree and Santa Cruz both have histories of engagement with archaeological research and Ancient Maya sites, as well as involvement in community-based heritage management initiatives. Participants in the Crooked Tree/Santa Cruz exchange shared cultural expertise and strategies about developing commu-

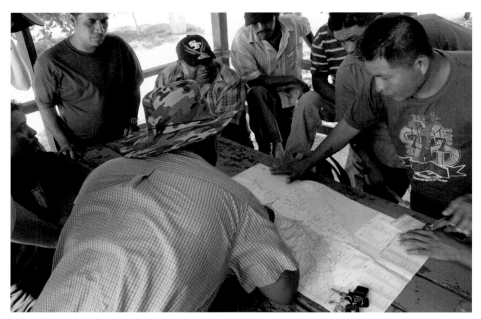

Figure 8. Village leadership meeting during Crooked Tree/Santa Cruz cultural exchange in 2014. Participants are discussing issues related to land management and cultural heritage while looking at maps. Photo by GJ Pinelo, Institute for Social and Cultural Research-National Institute of Culture and History.

nity-run initiatives, managing ecological and archaeological resources, and navigating heritage management power dynamics.[38]

One component of the cultural exchange was a meeting between Santa Cruz and Crooked Tree leadership, which included members of village political administration as well as the Uxb'enka K'in Ajaw Association (UKAA), a community heritage organization in Santa Cruz (see figure 8). During the meeting, Crooked Tree Chairman Donald Flowers expressed frustration about limited government support for tourism development at Chau Hiix. He suggested that because Chau Hiix was never developed as a tourism site, Crooked Tree was missing out on potential economic gains.[39] In response, UKAA members emphasized the need for community involvement in addition to government support for sustainable heritage management. Crooked Tree Village Council Secretary Godwin Crawford brought up land management concerns. Using maps of Crooked Tree as a reference, he talked about the difficulties young people face accessing good land, and expressed frustration about Crooked Tree farmers and ranchers who do not respect Chau Hiix site boundaries in their land-clearing and cattle grazing practices.[40] The UKAA Chair proffered that

they protect Uxbenká with a Memorandum of Understanding (MOU) with villagers and local and national government representatives that established site boundaries and outlines how close to the site people can farm. This meeting provided Crooked Tree community leaders with ideas for ways to engage community support for preserving and promoting local heritage while also attempting to hold national government representatives accountable.

Sharing ecological cultural knowledge was another powerful way Santa Cruz and Crooked Tree residents connected. The Santa Cruz visitors were invited to two Crooked Tree community members' yards to collect mangoes and everyone excitedly discussed the bounty and variety of mangoes. One of the yards belongs to a Crooked Tree church elder who has a vast garden and extensive ecological knowledge. She and the Santa Cruz visitors conversed about plant types, uses, and cultivation. Particularly intrigued by an ackee tree (*Blighia sapida*), the visitors asked questions about its origins and uses, and one Santa Cruz individual collected an ackee seed to carry home and plant (figure 9 shows the Crooked Tree elder revealing the ackee seed).

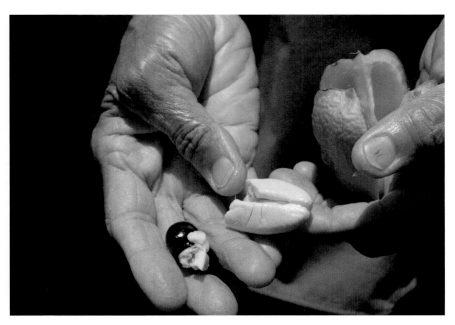

Figure 9. Crooked Tree elder showing Santa Cruz villagers the various parts of the ackee tree fruit during Crooked Tree/Santa Cruz cultural exchange in 2014. Photo by GJ Pinelo, Institute for Social and Cultural Research-National Institute of Culture and History.

The Santa Cruz/Crooked Tree cultural exchange enabled dialogue among groups who often do not have the opportunity to interact. It privileged the voices of marginalized peoples and allowed them "to be heard in spaces [in] which they would not normally extend."[41] The exchange was worthwhile for the community participants as it provided them with examples of ways people with similar concerns address heritage issues and contributed to the construction of heritage networks beyond village boundaries. It also allowed people a space to express knowledge and community identity and pride through ecological knowledge.[42] But the exchange was also productive for Kristina and me as heritage professionals because it helped us better understand community heritage needs and interests, provided us with ideas for future community-based heritage engagements, and emphasized the methodological value of cultural exchanges in heritage work.

Conclusion

Polarizing heritage stories offer particularly important lessons for public history and heritage professionals. At the beginning of this book, I discussed the 2013 damage to the temple at Nohmul because it demonstrates ways values and perspectives about archaeology and development manifest, intersect, and conflict in the twentieth-first century. The Nohmul story also reveals societal expectations for heritage professionals to speak with authority in debates about culture and history, and reveals the ongoing pressures heritage professionals face trying to help people understand and resolve such conflicts.

Less than two months after the Nohmul incident, I visited Belize to share the results of my research on the CHAP at CTGS and BGS, the Belize Archaeology/Anthropology Symposium, and Belizean higher education institutions.[43] I gave presentations at the University of Belize and Galen University to engage with the future generation of Belizean heritage practitioners and teachers. I hoped to gather feedback from them about my findings, and learn about students' heritage interests, needs, and possibilities for future collaborations with the universities. Several students asked me questions about my positionality and experiences as a foreign researcher and the reasons why I was interested in Belizean history and culture. We also discussed contemporary heritage issues including the damage at Nohmul. An aspiring business major asked me about the fate of archaeological sites in Belize and whether I thought all archaeological resources should be preserved. This student especially wanted to discuss whether economic development and community needs ever outweigh the significance of archaeological sites. Such student interests in Nohmul drew atten-

tion to the ways heritage themes are part of the daily reality of Belizean citizens. The university students' questions reiterated what I came to know after over a decade of historical and ethnographic research in Belize—young people have strong opinions about heritage issues, and are eager for more intellectual discussions about them; and, that educational contexts are an important space through which people learn about culture and history.

Debates about how best to study, protect, and manage the past while being accountable to the present will continue to be an issue central not solely to Belize, but to local communities and states across the globe. And heritage professionals will continue to be implicated in these debates. Though these facts may appear obvious to any scholar of history or anthropology, the social, political, and economic dynamics that frame the ways heritage plays out in society are complex and can best be understood through historical and anthropological examinations, which provide a diachronic view and emic and etic perspectives of how people have constructed, reinforced, and negotiated official heritage and vernacular heritage discourse and practices over time.

Notes

Chapter 1. Negotiating Heritage: Education and Archaeology in Belize

1. For consistency, I refer to the country and colony as Belize throughout the book. The settlement officially became a crown colony, named British Honduras in 1862. In 1973, the colony's name was changed to Belize.

2. Johnson, "Nature and Progress," 29, 35, 103.

3. For a range of descriptions regarding the destruction of Nohmul see, AmbergrisCaye.com, "No More Noh Mul?"; Channel Five News, "Thousands of Mayan Artifacts"; Channel Seven News, "No More Noh Mul?"; Daily Beast, "Ancient Maya Pyramid"; Snodgrass, "Ancient Maya Pyramid Destroyed"; Reeser and Novotny, "Destroying Nohmul."

4. Smith, *Uses of Heritage,* 1, emphasis added.

5. I define culture as the shared and learned ideas, traditions, beliefs, and practices of a group of people and history as the events of the past and the ways they are described by historical experts.

6. Smith, *Uses of Heritage.*

7. Harrison, *Heritage Critical Approaches,* 14–15; Harrison, "What is Heritage?" 8–9.

8. Harrison's definition of "official heritage" also includes "the series of mechanisms by which objects, buildings and landscapes are set apart from the 'everyday' and conserved for their aesthetic, historic, scientific, social or recreational values."

9. For example, when using the phrase "Belizean heritage," I am referring to a collective of the history, culture, and historic objects and places of Belize as well as the practices (often official) of people to make meaning in and of the past—i.e., the forms and practices utilized by colonial, government, and academic actors to determine that which is national and shared "Belizean heritage." Similarly, when using "archaeological heritage" or "official archaeological heritage," I include both historic sites and objects and interpretations typically associated with archaeology (for example, in the context of Belize, Ancient Maya sites and objects) as well as the practices of archaeologists. And with "Kriol heritage" or "vernacular Kriol heritage," I include Kriol cultural practices (for example, language, foodways, historical narratives) as well as Kriol agency in asserting identity and negotiating power structures and cultural politics.

10. Belizean Kriol is an ethnicity comprised of the descendants of freed and enslaved African peoples and European colonists (primarily British). "Creole" is the spelling first used by the British for this cultural group. I use "Kriol" because this spelling is used by the National Kriol Council of Belize whose mission is to increase knowledge and appreciation of Kriol language, culture, and history. I only use "Creole" when quoting from and describing text

from historic and contemporary documents that use that spelling or when describing shared cultural practices across Afro-Caribbean and other African-descendant groups.

11. For more discussion of early history in the region around Crooked Tree Village, see Crowe, *Gospel in Central America.*

12. Johnson, "Nature and Progress," 48–50. It is important to note that the development of Kriol cultural practices including language occurred as the result of colonial encounters, often violent between people of European, African, and Indigenous American descent and resulted in a continuum of identities and practices that have changed over centuries of interactions and exchanges. See Johnson, *Becoming Creole,* 20, 31, 196; Mintz and Price, *Birth of African-American Culture.*

13. Parks, "Collision of Heritage," 434–48.

14. Adair, Filene, and Koloski, *Letting Go?;* Smardz and Smith, *Archaeology Education Handbook.*

15. Lowenthal, *Possessed by the Past.*

16. Harvey, "Heritage Pasts," 319–38.

17. Nora, "Between Memory and History," 7–24.

18. Savage, *Monument Wars;* Gordon, *Spirit of 1976.*

19. Hancock, *Politics of Heritage;* See also Handler and Gable, *New History;* Stanton, *Lowell Experiment.*

20. Waterton and Watson, "Framing Theory," 552.

21. Mortensen and Hollowell, *Ethnographies and Archaeologies.* See also Castañeda and Matthews, *Ethnographic Archaeologies;* Edgeworth, *Ethnographies;* Hamilakis and Anagnostopoulos, *Archaeological Ethnographies.*

22. For discussion of the intersections between colonialism, imperialism, post-colonialism, and archaeology, see Jacobs, *Edge of Empire;* Lydon and Rizvi, *Handbook;* Meskell, "Practice and Politics," 149–150.

23. Atalay, "'Diba Jimooyung,'" 61–72; See also Gnecco and Ayala, *Indigenous Peoples.*

24. Hansen, *Sociocultural Perspectives;* Bourdieu and Passeron, *Reproduction in Education.*

25. Althusser, "Ideology."

26. Spring, *Educational Ideologies,* 3.

27. Coe, *Dilemmas of Culture.*

28. Levinson, Foley, and Holland, *Cultural Production.*

29. Amit-Talai and Wulff, *Youth Cultures;* Corsaro, "Interpretative Reproduction," 160–177; Graue and Walsh, *Studying Children;* Tobin and Henward, "Ethnographic Studies."

30. Coe, *Dilemmas of Culture,* 5, 8. See also Gustafson, *New Languages;* Levinson, *We Are All Equal.*

31. Bolland, *Colonialism and Resistance;* Ashcraft and Grant, "Development and Organization," 171–79; Grant, *Making of Modern Belize.*

32. Cedric Grant uses the term forestocracy to reference the fact that the early Belizean economy was dominated by the extraction of forest products. This term also characterizes the early settlers and colonists who controlled the forest industry in Belize and the "imbalance in the ratio of ownership to the size of holdings and the system of land tenure." Grant, *Making of Modern Belize,* 36.

33. Moberg, *Citrus Strategy;* Barbara Bulmer-Thomas and Victor Bulmer-Thomas, *Economic History of Belize.*

34. Laura Rival discusses intersections between state education programs, social and economic development, and modernization goals. Rival, "Formal Schooling," 153; See also Anderson and Bowman, *Education and Economic Development;* Illich, *Deschooling Society.*

35. Meskell, *Nature of Heritage.*

36. Simmons, *Reconstructing Racial Identity;* Thomas, *Modern Blackness;* Williams, *Stains on My Name.*

37. Wilson, "The Logwood Trade, 1–15.

38. Bolland, *Colonialism and Resistance;* Cunin and Hoffmann, "From Colonial Domination," 35.

39. Bolland, *Colonialism and Resistance,* 24, 80.

40. Medina, "Defining Difference," 764' See also Judd, "Cultural Synthesis."

41. Bristowe and Wright, *Handbook of British Honduras,* 202.

42. Cunin and Hoffmann, "From Colonial Domination," 43.

43. Bolland, *Colonialism and Resistance,* 200–03.

44. Smith, *Pluralism.*

45. Johnson uses the term race/color/class matrix to discuss cultural dynamics in Belize. I added ethnicity to this concept. Johnson, "Nature and Progress," 55–56.

46. Racial science largely influenced these ideas. I define racial science as scientific practices and theories carried out by biological and social scientists predicated on the belief that humans can be divided into distinct, fundamentally different racial categories and hierarchies defined by perceived inheritable social, mental, psychological, physical, and biological traits. For examples of racial science that likely influenced British colonial education, see Morton, *Crania Americana;* Nott and Gliddon, *Types of Mankind;* Nott and Gliddon, *Indigenous Races.*

47. Sir Richard Roy Maconachie (1885–1962) studied at Tonbridge School in Kent, England and University College, Oxford before joining the Indian Civil Service and he was British Minister in Kabul, Afghanistan from 1929 to 1935.

48. Maconachie, "Education of Native Races," 211–13, 216–18.

49. See Bude, "Adaptation Concept," 341–55.

50. Macpherson, *From Colony to Nation;* Medina, *Negotiating Economic Development;* Wainwright, *Decolonizing Development.*

51. De Cesari, "World Heritage," 309.

52. Anderson, *Imagined Communities.*

53. Handler, "On Having a Culture," 210.

54. Díaz-Andreu and Champion, *Nationalism and Archaeology;* Hamilakis, *The Nation;* Kohl and Fawcett, *Nationalism;* Barkan and Bush, *Claiming the Stones.*

55. Askew, "The Magic List," 19–44; Labadi, "Representations," 147–70.

56. For discussions of these issues in Jamaica, see Thomas, *Modern Blackness,* 48–51.

57. Wilk, "Learning to Be Local," 110–33; Wilk, "Connections and Contradictions," 217–32.

58. Trouillot, *Silencing the Past,* 26.

59. Simmons, *Reconstructing Racial Identity.*

60. Thomas, *Modern Blackness.*

61. Thomas, *Modern Blackness,* 85; Ministry of Education, Youth and Culture, *Consultative Guidelines,* 1.

62. Thomas, *Modern Blackness,* 159–63.

63. Abrahams, *The Man-of-Words;* Salmon and Gómez Menjívar, "Language Variation," 316–60.

64. Johnson, *Becoming Creole.*

65. Glave, *Rooted in the Earth.*

66. Agbe-Davies, "Concepts of Community," 373–89; Moreno, "Collaborative Archaeology," 44.

67. Wilkie, "Communicative Bridges," 225–43.

68. Schadla-Hall, "Public Archaeology," 75–82.

Chapter 2. Education as Heritage Practice in Belize's Colonial and Independence Periods

1. Ashcraft and Grant, "Development and Organization," 172.

2. Ibid.; See also Hitchen. "State and Church," 198–201.

3. A church-state education system persisted throughout the Colonial Period in Belize and church involvement in education continues today.

4. Ashcraft and Grant, "Education in British Honduras"; Hitchen, "British Honduran Education."

5. *The Angelus,* Editorial. *The Angelus* was the Roman Catholic newspaper for British Honduras.

6. Bolland, *Colonialism and Resistance,* 53–55.

7. Education Act of 1850, British Honduras Colonial Government, 1850.

8. For discussion of the British colonial and overseas services, see Kirk-Greene, *On Crown Service.*

9. Dillon, *Report on Elementary Education Year 1899.*

10. Dillon, *Report on Schools.*

11. *The Times,* Editorial 1873.

12. Chailley-Bert and Stevenson Meyer, *Administrative Problems.*

13. McKinney, *Annual Report,* 11.

14. Ormsby-Gore, "Memorandum," 7.

15. Board of Education, *Special Reports.*

16. Carman, *British Honduras Education Report for the Year 1938.*

17. Reverend Robert Cleghorn to A. Barrow Dillon, June 21, 1920, Minute Paper Collection MP 2295/1920, Belize Archives and Records Service (hereafter cited BA).

18. Social control through school attendance monitoring is similar to the surveillance tactics in police programs and penal systems described by Foucault in *Security, Territory, Population.*

19. Mayhew, *Education in the Colonial Empire.*

20. Information in this and the following paragraphs was gathered from: Board of Education, "System of Education in British Honduras"; Education Act of 1850; and Wilson, "Education and Educational Planning."

21. Thomas, *Modern Blackness,* 4.

22. Bude, "Adaptation Concept," 352.

23. Censuses also functioned as bureaucratic political tools that constructed and reinforced cultural categories to manage citizens. See Cunin and Hoffmann, "From Colonial Domination," 31–60.

24. Bristowe and Wright, *Handbook of British Honduras,* 201–03; See also Cunin and Hoffmann, "Making of the Nation," 42.

25. Carman, *British Honduras Education Report for the Year 1938.*

26. Hess and Shipman, "Early Experience," 869.

27. Song and Pyon, "Cultural Deficit Model," 216–17.

28. For more about cultural deficit models in education see also, Bereiter and Engelmann, *Teaching Disadvantaged Children.*

29. Reverend Robert Cleghorn to A. Barrow Dillon, June 21, 1920, Minute Paper Collection MP 2295/1920, BA.

30. Bush is the Kriol word used to refer to the forest or the jungle.

31. Johnson, *Becoming Creole.*

32. Reddock, *Women, Labour and Politics;* Smith, "Introduction" i–xliv.; Smith, *The Matrifocal Family.*

33. Thomas, *Modern Blackness,* 49.

34. Hammond, "Education in the West Indies," 429.

35. Ibid., 438–39.

36. Thomas, *Modern Blackness,* 49.

37. As African and Afro-Caribbean populations were similarly racialized and perceived to be culturally similar, British colonial education officials often shifted between posts in colonies throughout Africa and the West Indies. Prior to his Belizean post, Jack W. Forrest served as an education officer in St. Vincent 1943–1947. He went on to become Director of Education for Belize 1947–1950, and later served as an education officer and eventually Director of Education in The Gambia in 1952. After resigning from his post in The Gambia, Forrest worked in teacher training in the UK and for fourteen years was a part-time adviser with the Ministry of Overseas Development.

38. Forrest, *Education Department Report 1947.*

39. Macpherson, *From Colony to Nation,* 189.

40. Primary Medical Officer to colonial secretary, July 16 (or maybe February 17), 1933, Minute Paper Collection MP 415/1933, BA.

41. Board of Education, "Education in Jamaica," 466.

42. Forrest, *Education Department Report 1947.*

43. London, "Ideology and Politics," 287–320; Pennycook, *Discourses of Colonialism;* Phillipson, *Linguistic Imperialism;* Ricento, *Ideology, Politics.*

44. Bacchus, *Utilization,* 51.

45. Board of Education, "System of Education in British Honduras, Appendix B," 165.

46. London, "Ideology and Politics," 309, 313.

47. Board of Education, "System of Education in British Honduras," 141.

48. Dillon, *Report on Elementary Education 1912.*

49. As a British colonial civil servant, B. H. Easter wrote several texts about education infrastructure reform in the West Indies. One of his most well-known posts was as the last colonial Director of Education for Jamaica.

50. Easter, *Report of an Enquiry,* 23, 32.

51. Carman, *British Honduras Education Report for the Year 1938;* Forrest, *Education Department Report 1949.*

52. Forrest, *Education Department Report 1948.*

53. Allsopp, "British Honduras," 55.

54. Easter, *Report of an Enquiry.*

55. Known today as Roatán.

56. Carman, *British Honduras Education Report for the Year 1938.*

57. Judd, "Cultural Synthesis," 112; Medina, "Defining Difference," 764.

58. Shoman, *Thirteen Chapters.*

59. Burdon, *A Brief Sketch;* Burdon, *The Archives;* Macpherson, "Imagining the Colonial Nation," 108–31; Macpherson, *Colony to Nation,* 82–87; Medina, *Negotiating Economic Development,* 33.

60. Macpherson, *Colony to Nation,* 83. See within a citation of an article in the *Clarion,* October 20 and November 3, 1921.

61. Macpherson, 83.

62. Burdon, *Brief Sketch;* Burdon, *Archives,* 34; Metzgen and Cain, *The Handbook.*

63. Cited in Macpherson, *Colony to Nation,* 85.

64. Macpherson, 82–87.

65. As noted in the introductory chapter, in the Dominican Republic, especially under the Trujillo dictatorship, officials similarly obscured African history, culture, and identity, including the history of slavery and relegated African history and enslavement to Haitian history. See Simmons, *Reconstructing Racial Identity,* 15–33, 38.

66. Carman, *British Honduras Education Report for the Year 1938.*

67. In an interesting comparison, Deborah Thomas describes the ways Creole nationalists in Jamaica constructed a Creole identity in the mid-twentieth century in ways that did not deny African heritage, but also distinguished "modern" Jamaicans from the "'backwardness' of Africa" and the rural and urban lower-class Jamaicans who were seen as perpetuating cultural practices associated with enslaved peoples. Thomas, *Modern Blackness,* 55–56.

68. Macpherson, *Colony to Nation,* 82.

69. Board of Education, "System of Education in Barbados," 43.

70. Board of Education, "System of Education in Bermuda."

71. Board of Education, "System of Education in British Honduras."

72. Whitehead, "Education in British Colonial Dependencies," 72.

73. Seghers, "Phelps-Stokes in Congo," 455–477; See also, Bude, "Adaptation Concept."

74. Ormsby-Gore, "Memorandum," 4, emphasis added.

75. Ormsby-Gore, 6, 8.

76. Arthur Mayhew, educated at Oxford University joined the Indian Education Service in Madras and was eventually Director of Public Instruction in the Central Provinces. Mayhew held positions as the editor of the journal *Oversea Education* (1929–46) and as the Joint Secretary of the ACNE. For more on Mayhew's career in colonial education, see Whitehead, "The Nester," 51–76.

77. Mayhew, *Education,* 254.

78. Ormsby-Gore, "Educational Problems," 165.

79. Bude, "Adaptation Concept," 353.

80. Seghers, "Phelps-Stokes in Congo," 464.

81. Ashcraft and Grant, "Development and Organization," 174.

82. Easter, *Report of an Enquiry,* 32. There is some irony in Easter advocating for a text

that teaches students about the environment as many Belizean subject-citizens, especially in rural communities, likely had sophisticated vernacular ecological knowledge and cultural practices linked to local environmental resources.

83. Forrest, *Education Department Report 1949.*

84. Easter, *Report of an Enquiry,* 32.

85. Thomas, *Modern Blackness,* 52.

86. Thomas, 61–65.

87. Forrest, *Education Department Report 1944.*

88. Forrest, *Education Department Report 1949.*

89. For an expanded discussion of modernizing reforms and colonial control over populations through welfare programs in Belize see Macpherson, *Colony to Nation,* 72–192.

90. Clatworthy, *Formulation,* 15.

91. Hammond, "Education in the West Indies," 437.

92. Hammond, 427–49.

93. Thomas, *Modern Blackness,* 52–53.

94. Jamaica Welfare was founded in 1937 by Norman Manley, politician and nationalist activist in Jamaica and the first premier of Jamaica. This organization "focused on land reform, the development of community-based small industries, and community uplift." Thomas, *Modern Blackness,* 52.

95. Marier, *Social Welfare,* 27.

96. Thomas, *Modern Blackness,* 53.

97. Macpherson, *Colony to Nation,* 115–94.

98. Thomas, *Modern Blackness,* 4. Thomas does note that this cultural programming was a double-edged sword that reinforced a kind of "creole hegemony." She argues that adaptive education and cultural programming in Jamaica generally did not connect with constructs of "contemporary 'Africanness'" but rather presented a "folk blackness." Also, in the mid-twentieth century this programming continued to be conducted through British institutions and socialization contexts and cultivated British and middle class values such as "discipline, temperance, collective work, thrift, industry, Christian living, community uplift, and respect for [. . .] leadership." Thomas, 65–66.

99. Macpherson, *Colony to Nation,* 192.

100. *Sensu* Bourdieu and Passeron, *Reproduction in Education.*

101. Markham, *Return Passage,* 50. Violet Rosa Markham (1872–1959) was a British social reformer committed to education and involved in public service throughout her life.

102. For discussion of resistance to colonial projects in other contexts, see Canagarajah, *Resisting Linguistic Imperialism;* Thomas, *Colonialism's Culture,* 11–32; Stoler and Cooper, "Between Metropole and Colony."

103. Macpherson, *Colony to Nation.*

104. Macpherson, 29.

105. Macpherson, 29–71.

106. I only include historical examples about Crooked Tree Village because Biscayne Village did not exist until the 1970s.

107. Letter from Robert Cleghorn, August 6, 1924, Minute Paper Collection 2235/1924, BA.

108. E. H. Bradley to Department of Public Works, May 15, 1925, Minute Paper Collection 2235/1924, BA.

109. Franco and Ellis, successors to Woods, Slack, and Franco, Solicitors and Notaries Public, to the colonial secretary, July 16, 1925, Minute Paper Collection 2235/1924, BA.

110. Randolph Gillett to Sir Ronald Garvey, colonial governor August 2, 1951, Minute Paper Collection 1016/1951, BA.

111. Gillett.

112. Letter from the pupils of the Crooked Tree Government School to Sir Ronald Garvey, colonial governor August 2, 1951, Minute Paper Collection 1016/1951, BA.

113. Letter from Randolph Gillett and Crooked Tree petitioners to the colonial secretary, May 3, 1954, emphasis added, Minute Paper Collection 1016/1951, BA.

114. See Johnson, *Becoming Creole.*

115. Johnson, *Becoming Creole,* 20, 112–113; Salmon and Gómez Menjívar, "Language Variation," 316–360.

116. Robert Cleghorn to A. Barrow Dillon, June 21, 1920, Minute Paper Collection MP 2295/1920, BA.

117. Carman, *British Honduras Education Report for the Year 1937.*

118. Forrest, *Education Department Report 1947;* Forrest. *Education Department Report 1949.*

119. Forrest, *Education Department Report 1949.*

120. *Sensu* Scott, *Weapons of the Weak.*

121. McGill, "Situating Public Archaeology," 127–38; Johnson, "Nature and Progress."

122. Johnson, "The Making of Race," 598–617; Johnson, *Becoming Creole,* 54–55; Wilk, "Colonialism and Wildlife," 4–12.

123. When talking about research participants or quoting them, I use pseudonyms throughout the book.

124. Forrest, *Education Department Report 1949.*

125. Manzanares, "All to the Sound."

126. Johnson, *Becoming Creole,* 20.

127. Johnson, "Nature and Progress," 48–50.

128. Salmon and Gómez Menjívar, "Language Variation."

129. Johnson, *Becoming Creole,* discusses similar perceptions in Crooked Tree and other rural Belize River valley villages.

130. Carman, *British Honduras Education Report for the Year 1937.*

131. Carman, *British Honduras Education Report for the Year 1938.*

132. Reverend O. T. Johnston to the colonial secretary, May 7, 1954, Minute Paper Collection 1016/1951, BA.

133. E. Brown to the colonial secretary, May 8, 1954, Minute Paper Collection 1016/1951, BA.

134. E. Brown to C. A. Engleton, March 17, 1954, Minute Paper Collection 1016/1951, BA.

135. Deborah Thomas discusses similar concerns about citizenship, social and economic development, and the transition to independence in Jamaica in *Modern Blackness.*

136. For more about the history of modern Belizean politics and the transition to independence see Bolland, *Colonialism and Resistance,* 172–223; Macpherson, *Colony to Nation;* Medina, "Defining Difference"; Shoman, *Thirteen Chapters.*

137. UBAD was formed by Lionel Clarke and Evan X Hyde in 1969 as a political party that supported the interests of Belize's African-descendant populations and promoted an Afrocentrist nationalist vision of the country. The party officially dissolved in 1974.

138. Said Musa and Assad Shoman are both Belizean public intellectuals, activists, and

politicians. Musa was minister of foreign affairs from 1989 to 1993 and eventually a central figure in the PUP, serving as prime minister of Belize from 1998 to 2008. Shoman was minister of foreign affairs in Belize from 2002 to 2003.

139. Documentary sources I examined did not reveal the same kinds of engagements with education from rural Belizean communities that I found in the Colonial Period, though such engagements undoubtedly existed. For more on community responses to colonial and state labor practices and social services during the Independence Period, see MacPherson, *From Colony to Nation.*

140. Read, *Education and Social Change,* 3.

141. William Ernest Frank (W.E.F.) Ward studied history at Oxford and Cambridge. Ward was a British colonial education officer, educator, and colonial adviser from the 1920s to the late 1900s and served as editor of the journal *Oversea Education* from 1946 to 1963. See Whitehead, "'The Admirable Ward,'" 138–60.

142. Ward, "Education in the Colonies."

143. Ward, 187.

144. Ward, 196.

145. For discussion of the roles of middle class Belizeans and welfare organizations supporting colonial education and development programs, see Macpherson, *Colony to Nation,* 159–94.

146. Macpherson, 82–87.

147. Forrest, *Education Department Report 1948.*

148. Anderson, "Economic Development;" Becker, *Human Capital;* Mincer, *Schooling, Experience, and Earnings.*

149. Germanacos, Gaskin, and Syrimis, *UNESCO Educational Planning Mission,* 19.

150. Germanacos, Gaskin, and Syrimis, 17, emphasis added.

151. Germanacos, Gaskin, and Syrimis, 7–8.

152. Germanacos, Gaskin, and Syrimis, Appendices, 60, emphasis added.

153. Lourié, *Belize: A View,* 9.

154. Lourié, Annex 2, 1–2., emphasis added.

155. Lourié, Annex 2, 5., emphasis added.

156. Lourié, iv.

157. Lourié, 27.

158. Germanacos, Gaskin, and Syrimis, *UNESCO Educational Planning Mission,* Appendices, 19.

159. Economic Commission for Latin America, *Removal of Language Barriers,* 1–16.

160. Economic Commission for Latin America, 12.

161. Economic Commission for Latin America, 14.

162. Sanchez, *The Easter and Dixon Reports,* 3.

163. For more on educational developments and curricular reforms in Belize from the 1950s–1980s, see Bennett, *Education in Belize,* 101–29; Bennett, "Aspects of Educational Development"; Thompson, "Education Reform."

164. *Sensu* Anderson, *Imagined Communities.*

165. At the same time that Belizeans were promoting nationalism and decolonization, transitioning and former colonies across the globe were focused on similar concerns, including education as an institution that could aid in decolonization despite its imperial founda-

tions. See, Amin, "What Education," 48–52; Basu, "Policy and Conflict"; Carnoy, *Education as Cultural Imperialism.*

166. Blackett et al., *Planning Committee on Education,* 1–2.

167. Blackett et al., 3.

168. Thompson, "Education Reform," 3.

169. Fonseca, *Report 1969–1970 and 1971–1972.*

170. Joseph Alexander Bennett received a BA from the University of the West Indies and an MA of Education from the Institute of Education at the University of London. Bennett taught on numerous levels in Belizean education, including as a lecturer at Belize Teachers College, University College of Belize, and the University of Belize. He taught an important tertiary-level course (perhaps the first of its kind) on "The History and Development of Education in Belize" at BELCAST when it was first opened. Bennett also served as curriculum development officer for the Belize Ministry of Education.

171. Bennett, "Goals, Priorities," 23.

172. Blackett et al., *Planning Committee on Education,* 7–8, 12–13.

173. Thompson, "Education Reform," 4; Massey, "Rural Education."

174. Thompson, "Education Reform," 7.

175. Shoman, *SPEAR 1990,* 2.

176. Deborah Thomas notes similar efforts by politicians and cultural actors in Jamaica in the 1970s to promote Jamaica's African heritage as a human resource and emphasize heritage's "potential to positively influence individual and national growth." Thomas, *Modern Blackness,* 77; see also 74–78.

177. Briceño, *Souvenir Brochure,* emphasis added.

178. Fonseca, *Report 1969–1970 and 1971–1972.*

179. Philip Manderson Sherlock spent twenty years teaching before working in human development sectors in Jamaica. He served as Education Officer with Jamaica Welfare Limited, contributed to higher education in Jamaica and Trinidad, and served as Vice-Chancellor for University of West Indies.

180. Fonseca, *Report 1969–1970 and 1971–1972.*

181. Allsopp, "British Honduras," 61.

182. Ashcraft, "Educational Planning," 31.

183. Ashcraft, 32.

184. Robert Leslie was born in Belize City in 1942 and was educated at Kalamazoo College in Michigan. He has held positions in journalism, public service, and diplomatic posts in Belize. In 2006, Prime Minister Musa honored Leslie with the "Order of Distinguished Service" award for his commitments to raising awareness about Belizean culture and history.

185. Robert Leslie, *A History of Belize,* 73.

Chapter 3. Globalization Period Education: A Culturally Educated Citizenry

1. Wilk, "Learning to Be Local"; Wilk, "Connections and Contradictions," 217–32.

2. Stone, "Cultural Policy, Local Creativity," 290.

3. Victor Espat quoted in *Belize Times,* 2005.

4. Shoman, "Why a National Education Symposium?" 44.

5. Ministry of Education, *The National Syllabus;* National Culture Policy Council, *What the People Said.*

6. Oestreich, "Social Studies Curriculum," 1–2, 43, 45.

7. Education Development Centre, *Textbook Standardization.*

8. And as noted in the introduction, the Jamaican government was taking efforts to develop cultural programming focused on national culture and history at the same time. See Thomas, *Modern Blackness,* 85–89, 159–163.

9. Rutheiser, "Culture, Schooling," 31.

10. Cal, *Maya Civilizations: Students' Handbook (Primary School—Upper Division),* back cover.

11. Interview, June 2006.

12. The most significant shift is that Mestizo, not Kriol, is now the largest ethnic group in Belize. See Straughan, "Emigration from Belize," 254–279; Woods, Perry, and Steagall, "The Composition," 63–88.

13. Medina, "Defining Difference."

14. Medina, 772.

15. Hall, "Old and New Identities," 166.

16. I used a standard set of symbols in the transcripts of interviews. A comma indicates short pauses, and dashes indicate longer pauses. An underscore _ indicates an interruption or change in the direction of a response. Curly brackets, also known as braces { }, with blanks are used when the audio was indecipherable. Curly brackets with text inside of them indicate what the transcriber thought the interviewee was saying. Text in bold shows emphasis in the response of the interviewee. Standard brackets [] are used for comments about something going on during the interview or to describe some aspect of the context of the interview (for example, background noise). Standard brackets are also used to indicate something implied or previously stated. Ellipses inside standard brackets denote that I left out text. Kriol text is written in italics. My English translations are written in parentheses following the Kriol text. For the majority of translations, I used Herrera et al. *Kriol-Inglish Dikshineri.*

17. Interview, June 2006.

18. Faber became UDP Leader in July 2020 and Leader of the Opposition in November 2020.

19. Patrick Faber, 6th Form graduation speech, Belize Adventist Junior College, Calcutta, Belize, May 2009.

20. This is similar to the nationalist goals Deborah Thomas discusses for cultural programming in Jamaica in the late twentieth century. Thomas says that consultation meetings about the development of a new cultural policy emphasized concerns about Jamaican youth and national identity and include recommendations such as "greater emphasis on Jamaican history in the schools; a more general overhaul of curricular content and pedagogical approaches; and a repositioning of culture as an industry" with the idea that these tasks "would stimulate the development of self-esteem [. . .] result in greater national pride [. . .] [and] serve as the foundation for a more productive economy." Thomas, *Modern Blackness,* 89; see also 159–63.

21. Belizean primary education starts with two years at the "Infant" level and then there are six years at the "Standard" level of primary education before high school begins.

22. Oestreich, "Curriculum Development," 248.

23. At the time of my research (the 2008–2009 school year), the teachers I observed in BGS and CTGS continued to primarily use the 2001 curriculum.

24. Baron Bliss was a wealthy British-born traveler and benefactor who visited the sea waters of Belize. On his death in 1926 Bliss willed approximately $2 million BZE to projects for the benefit of Belizean citizens.

25. In the region today, Indigenous Maya people live in Mexico, Guatemala, Belize, El Salvador, and Honduras. There are many Maya cultural groups and at least thirty different Maya languages still spoken. Today three distinct Maya groups live in Belize: Yucatec, Mopan, and Q'eqchi' (or Kekchi).

26. Anaya, "Reparations for Neglect"; Moore, "Human Rights in Belize"; Wainwright, *Decolonizing Development*.

27. Ministry of Education, *National Social Studies Curriculum,* 70.

28. Cal, *Maya Civilizations: Students' Handbook (Primary School—Upper Division)*; Cal, *Maya Civilizations: Primary School Teachers' Handbook (Lower Division)*; Cal, *Maya Civilizations: Primary School Teachers' Handbook (Middle Division)*; Iyo, *African Civilizations: Student's Handbook (Primary School—Upper Division)*; Iyo, *African Civilizations: Primary Schools Teachers' Handbook (Lower Division)*; Iyo, *African Civilizations: Primary Schools Teachers' Handbook (Middle Division)*.

29. Medina, "Defining Difference," 761–62.

30. Lewis, "Influences"; Lundgren, "Children, Race, and Inequality," 86–106.

31. Thomas, *Modern Blackness,* 85.

32. Thomas, 85.

33. Thomas, 85–89.; 159–163.

34. Thomas, 85–89.

35. Students I worked with ranged in age from eight to fifteen with most of them being ten to twelve years old. I chose to work primarily with Standard IV-VI students because they are the oldest primary school students, their curriculum includes information about Ancient Maya and African civilizations and Belizean history, and Standard IV-VI are the last few years students attend school in a village context and primarily with peers from their communities.

36. Ruin (Kriol: *rooin;* plural *rooinz*) is the term frequently used in Belize to refer to an archaeological site.

37. The interviews were semi-structured qualitative interviews with a series of about thirty questions total focused on archaeology, Ancient Maya history and culture, and students' backgrounds and experiences. My husband, Dru McGill who has an Anthropology PhD from Indiana University assisted with research activities such as taking photos and conducted some of the preliminary interviews with school children.

38. Williams, *Marxism and Literature,* 112.

39. Ground food is the Belizean term for root vegetables including cassava, potatoes, yams, and coco.

40. Interview, June 10, 2009.

41. *Bushi* is a socially complex Kriol adjective which implies that someone is "of the bush" (bush is the Kriol word for the forest or jungle). *Bushi* is most often applied to Kriol people, usually from rural areas and even specific communities. The term is racialized, and can describe landscapes as well as people perceived as "backwards," unsophisticated, and not modern. The term is often derogatory, but can also refer to toughness, independence, and

adaptability. For extensive discussion of the complex meanings and uses of "bush," "bushy," and "bushyness," see Johnson, *Becoming Creole,* especially 54–59, 61–62, 65–67.

42. Interview, June 10, 2009.

43. This is the Belizean term used to describe when people of multiple ethnicities have offspring. It is used in reference to hybridized cultural practices as well as perceptions of blended phenotypic characteristics especially in regards to skin color.

44. Interview, April 23, 2009.

45. Simmons, *Reconstructing Racial Identity.*

46. Johnson, "Nature and Progress," 102.

47. *Sensu* Wolf, *People without History.*

48. Interview, June 10, 2009.

49. Interview, April 29, 2009.

50. Interview, April 29, 2009.

51. Interview, July 7, 2009

52. Interview, April 23, 2009.

53. Interview April, 2005.

54. Silvaana Udz notes similar negotiations of seemingly conflicting ideas about Kriol language and identity among teachers. In a 2013 study about teachers' attitudes toward incorporating Belizean Kriol in primary education, teachers saw Kriol as both a hindrance and something of which to be proud. According to Udz, "47.3 percent believed that using Kriol keeps one back from learning English" despite the fact that "87.4 percent of them stated they enjoyed using Kriol." See Udz, "Improving Kriol Language Attitude," 20.

55. Salmon, "Language Ideology," 605–625; Salmon and Gómez Menjívar, "Language Variation," 316–360; Salmon and Gómez Menjívar, "Setting and Language Attitudes," 248–264.

56. As Johnson explains, "'Bocatora language' is what Creole people derogatorily but playfully call the version of Kriol that is farthest from standard English. The bocatora is the slowest and easiest to catch of the land turtles, reminding the speakers and the audience of the elite framing of Kriol as being backward and bushy." Johnson, *Becoming Creole,* 113.

57. Johnson, *Becoming Creole,* 4–6.

58. Johnson, 112–113.

59. Interview, June 2006.

60. Thomas, *Modern Blackness,* 158–191.

61. Interview, June 2006.

62. See Scott, *Weapons of the Weak;* Scott, *Seeing like a State;* Giddens' discussion of "strategic conduct" in Giddens, *The Constitution of Society,* 288.

63. Johnson, *Becoming Creole,* 20.

64. Roger Abrahams provides comparative examples from folkloristic and sociolinguistic scholarship he conducted in Afro-Caribbean communities in Nevis, St. Kitts, Tobago, and St. Vincent. Abrahams argues that the speech traditions that West Indian Afro-Caribbean people developed combined African linguistic attitudes and styles with European (specifically English) forms and norms. Abrahams demonstrates how Afro-Caribbean men negotiated politics of respectability and reputation, by shifting between being "good talkers" in standard English and "good arguers" in playful Creole. Through these practices, men reinforced social bonds and asserted identities. Abrahams, *The Man-of-Words.*

65. Salmon and Gómez Menjívar, "Language Variation," 347.

66. Interview, June 10, 2009.

67. For Belizean examples, see Haug, "'From Many Cultures'"; Haug, "Ethnicity and Ethnically 'Mixed,'" 44–67.

For other examples, see Pollock, *Colormute;* Rubin, "Youth Civic Identity"; Yon, *Elusive Culture.*

68. Interview, November 14, 2008.

69. It is a common pedagogical technique in Belize for students to take notes on topics teachers lecture about. This process is often quite formal, involving students writing a heading on the page with their name, the date, and subject and using rulers to ensure straight lines. Teachers then recite information from textbooks and their own notes and sometimes write information on the board. Students are expected to copy everything in their notebooks. Students often practice reciting from these notes and they are later asked to recount what they learned in assignments and tests.

70. Interview, December 1, 2008.

71. Miss Vanessa is an elder in one of the village churches (the one that Linda attends) and is well-respected in Crooked Tree because of her family lineage, wealth, high level of education, knowledge of local history, worldly experience, and commitments to community initiatives.

72. Interview, December 1, 2008.

73. Interview, November 25, 2008.

74. In my analysis, I created a category called "Garifuna food" that included fish, groundfood, plantains, coco, cassava, potatoes, yams, and traditional Garifuna dishes like hudut, fufu, matilda foot, and boil up.

75. Interview, November 14, 2008.

76. Belizeans I worked with often referred to Ancient Maya people as "the Mayas."

77. Interview, November 24, 2008.

78. Interview, November 25, 2008.

79. Interview, November 14, 2008.

80. Interview, November 27, 2008.

81. Interview, November 21, 2008.

82. Interview, December 1, 2008.

83. Interview, November 25, 2008.

84. Bezerra, "Make-Believe Rituals," 60–70.

85. Bezerra, 67

86. Interview, April 29, 2009.

87. My findings parallel Deborah Thomas' discussions about national cultural education and programming in Jamaica. Similar to the situation in Belize, Thomas argues that cultural programming in Jamaica essentializes the construct of culture, presents it as static, and emphasizes certain folk aspects of Jamaican African heritage. This state-sanctioned official heritage discourse does not incorporate dynamic forms of Jamaican popular culture similar to those I describe for Belizean youth. As such, cultural programming does not correspond with the lived reality for many Jamaicans and reinforces ideas among many citizens that Jamaicans are losing their culture. Thomas, *Modern Blackness,* 85–89, 158–191.

88. Haug, "'From Many Cultures'"; Haug, "Ethnicity."

89. Interview, November 25, 2008.

90. Interview, October 2008.

91. Interview, November 13, 2008

92. Interview, November 25, 2008.

93. Interview, 2008.

Chapter 4. Archaeology as an Official Heritage Practice and Community Negotiations since Colonialism

1. Official archaeological heritage established and reinforced by archaeologists and colonial and state actors includes: tangible historic sites and objects (primarily focused on Ancient Maya history and culture); archaeological research including excavation, analysis, and interpretation of historic sites and objects; policies and legislation that protect historic sites and objects; site conservation, management, and development efforts; and the practices of professional and government institutions that manage historic sites and objects.

2. Stephens, *Incidents of Travel in Central America;* Stephens, *Incidents of Travel in Yucatan.* For more history of early explorations of Ancient Maya sites, see Bernal, "Maya Antiquaries," 19–30.

3. Hammond, "The Development," 19.

4. Anderson, "Archaeology in British Honduras," 32; Pendergast, "The Center," 1–3; Rice, "Archaeology of British Honduras," 1.

5. Mitchell-Hedges, *Land of Wonder,* 8–9.

6. Fowler, *Narrative Journey,* 24–25.

7. For discussion of these dynamics in the United States, see Conn, *Museums 1876–1926.*

8. Thompson, "Antiquities Act," 225. See also, Colonial Reports-Miscellaneous, *Papers Relating to the Preservation of Historic Sites.*

9. Hammond, *Lubaantún,* 7.

10. Thompson, "Thomas Gann," 742.

11. Gann, *In an Unknown Land,* 179.

12. Gann, *Glories of the Maya,* 83–84.

13. Ibid.

14. Wallace, "Reconnecting Thomas Gann," 23–36.

15. Hammond, "Development of Belizean Archaeology," 19; McKillop and Awe, "History of Archaeological Research," 2; Pendergast "The Center and the Edge," 4; Thompson, *Maya Archaeologist,* 73.

16. Garvin, *The Crystal Skull.*

17. Walsh, "The Skull of Doom."

18. "Lady Richmond Brown"; Brown, *Unknown Tribes.*

19. Mitchell-Hedges, *Land of Wonder,* xvii.

20. Gann, *Discoveries and Adventures,* 31.

21. Mitchell-Hedges, *Land of Wonder,* xvi-xvii.

22. Said, *Orientalism.*

23. Wallace, "Reconnecting Thomas Gann," 28. Institutions supporting expeditions directed by American and British scholars included the British Museum, the Field Museum of Natural History in Chicago, the Carnegie Institute in Washington, Peabody Museum of Harvard, American Museum of Natural History, and the Royal Geographic Society.

24. *Illustrated London News,* "Maya Exploration"; Hammond also discusses the Belizean colonial secretary's and governor's concerns about German archaeological interests in Belize in 1903, Hammond, "The Development of Belizean Archaeology," 20.

25. A partage system that structured the division of antiquities between American and European archaeologists and colonial territories was common in imperial contexts in the early twentieth century. Cuno, *Who Owns Antiquity?*.

26. Julian Thomas examines antiquarianism as a technology of government and the ways states legitimized specific actors like archaeologists as heritage experts. Thomas, *Archaeology and Modernity,* 7; See also Rose and Miller, "Political Power," 173–205.

27. Gann, *Discoveries and Adventures,* 17.

28. *The Times,* "Maya Relics," 8.

29. Ibid, 35.

30. Mitchell-Hedges, *Land of Wonder,* 55.

31. Swayne, Colonial Reports-Miscellaneous, *Papers Relating to the Preservation of Historic Sites,* 34–35.

32. Gruning, *British Museum Expedition 1930.*

33. Gann, "Maya Jades," 282.

34. Thompson, *Ethnology of the Mayas,* 30.

35. Joyce, Gann, Gruning, and Long, *British Museum Expedition 1928,* 324, 347.

36. Mitchell-Hedges, *Land of Wonder,* 42–46, 68.

37. Gann, *Ancient Cities and Modern Tribes,* 52.

38. Gann, *Discoveries and Adventures,* 31.

39. Mason, "Early Maya Temples."

40. *The New York Times,* "Lindbergh Sights Unknown Maya City."

41. Gann, *Glories of the Maya,* 40.

42. Gann, *In an Unknown Land,* 86–87.

43. Cultural evolution was a teleological view of societies as progressing from savagery to barbarism to civilization. Archaeologists eventually rejected cultural evolution as inaccurate and problematic in favor of other ways to discuss social complexity. See Trigger, "Alternative Archaeologies," 355–370.

44. Gann, *In an Unknown Land,* 38.

45. Mitchell-Hedges, *Land of Wonder,* 72, 88.

46. Mitchell-Hedges, 12, 73.

47. Gann, *In an Unknown Land,* 14.

48. Gann, *Discoveries and Adventures,* 24.

49. Gann, *In an Unknown Land,* 21.

50. Ibid., 14–16.

51. Armstrong and Hauser, "A Sea of Diversity," 583; Keegan, "West Indian Archaeology," 255–284; Rouse, *The Tainos.*

52. Armstrong and Hauser, "A Sea of Diversity," 587.

53. Colonial Reports-Miscellaneous, *Papers Relating to the Preservation of Historic Sites.*

54. Armstrong and Hauser, 588. See also Pateman, "The Bahamas," 2–3.

55. Armstrong and Hauser, "A Sea of Diversity," 588.

56. Armstrong and Hauser, 593, 595. See also Singleton and Torres de Souza, "Archaeologies of the African Diaspora," 449–469. This chapter provides an extensive summary of

archaeological research on the African diaspora in Brazil, Cuba, and the United States from the 1970s to the early twenty-first century.

57. Mason, "Early Maya Temples."

58. Ibid.

59. Gann, *In an Unknown Land,* 38.; Gann, *Glories of the Maya,* 120, 134–136, 139, 141, 180, 219.; Mason, "Early Maya Temples"; Mitchell-Hedges, *Land of Wonder,* 74–75.

60. Gann, *Glories of the Maya,* 136.

61. Gann, *In an Unknown Land,* 38.

62. Many past and present archaeologists would likely not refer to the collecting, selling, and removal of ancient objects as stewardship. I use this term to make a point about the diverse ways that people can care for and control the usage of ancient objects and places.

63. Gann, "Some Superstitions," 169.

64. See Gann, "Mounds in Northern Honduras," 663; Gann, "Contents of Some Ancient Mounds," 313; Thompson, "Thomas Gann," 743.

65. Gann, *Glories of the Maya,* 157.

66. Ibid., 151.

67. Although certainly savvy about negotiating power dynamics with archaeologists, the people described in Gann's and others accounts could not have told stories about objects imbued with animate abilities if this did not make sense within their epistemologies and ontologies.

68. Mason, "Early Maya Temples."

69. Gann, *Discoveries and Adventures,* 164–167.

70. Joyce, Clark, and Thompson, *British Museum Expedition 1927,* 316–317.

71. Gann, *Glories of the Maya,* 134.

72. Ibid., 136.

73. Aspinall, Colonial Reports-Miscellaneous, *Papers Relating to the Preservation of Historic Sites,* 4.

74. Gann, *In an Unknown Land,* 169, emphasis added.

75. Thompson, *Maya Archaeologist,* 3, emphasis added.

76. Mitchell-Hedges, *Land of Wonder,* 74–75.

77. Armstrong and Hauser, "A Sea of Diversity," 592.

78. Richards and Henriques, "Jamaica," 27.

79. Pateman, "The Bahamas," 2–3.

80. Armstrong and Hauser, "A Sea of Diversity," 592.

81. Anderson, "Archaeology in British Honduras Today," 32.

82. Crown Site Reserves were the first historic sites officially designated as falling under the purview of the government to be managed and protected.

83. Hammond, "Development of Belizean Archaeology," 24.

84. Ibid., 22.

85. Iannone and Healy, "The Trent Connection," 34.

86. The first Belizean Archaeological Commissioner was anthropologist Joseph O. Palacio.

87. For discussions of the antiquities market, and related preservation efforts and educational programming in Belize see Gilgan, "Looting," 73–88; Gutchen, *Destruction of Archaeological Resources;* Matsuda, "Ethics of Archaeology," 89–98.

88. Anderson, *Brief Sketch,* 80–87.

89. Pendergast, "A. H. Anderson," 92.

90. Iannone and Healy, "The Trent Connection," 31–33.

91. Hammond, "Development of Belizean Archaeology"; Hammond, "Prehistory of Belize," 349–362; Pendergast, "The Center and the Edge."

92. Pendergast, "The Center and the Edge," 7.

93. Thompson, *Rise and Fall of Maya Civilization,* 11.

94. Thompson, *Maya Archaeologist,* 73–74.

95. Archaeologists and others have used the term "collapse" to describe a period of decline of Ancient Maya activities associated with the "Classic Maya" period (eighth to eleventh centuries CE), such as monumental architecture, representations of divine rulers, and the abandonment of some Maya city centers. The "collapse" was a common research focus for a long time in Maya archaeology. However, the "Maya Collapse" is now understood to be a period of political reorganization and cultural change by most archaeologists. See McAnany and Yoffee, "Why We Question Collapse"; McAnany and Negrón, "Bellicose Rulers"; Pyburn, "The Politics of Collapse," 3–7.

96. Coggins, "Maya Lords of the Jungle," 76–77.

97. Thompson, *Maya Archaeologist,* 168–69

98. Thompson, *Maya Archaeologist,* 162.

99. For discussion of the ways research interests with Ancient Maya history and culture have historically been privileged by archaeologists working throughout Central America with limited considerations of living peoples' cultural engagements see, Yaeger and Borgstede, "Professional Archaeology and the Modern Maya," 232–256.

100. Thompson, *Maya Archaeologist,* 91.

101. Ibid., 210

102. Ibid., 5.

103. Anderson, "Archaeology in British Honduras," 33–35.

104. Coggins, "Maya Lords of the Jungle," 77.

105. Pendergast and Graham, "Fighting a Looting Battle," 16.

106. Pendergast and Graham, 19.

107. I do not intend for my analysis to diminish or deny the negative impacts of looting at archaeological sites, rather I want to bring attention to the ways that particular stakeholders and forms of engagement with historic sites and objects become established as official discourse through the practices and rhetoric of archaeological actors.

108. *The Illustrated London News,* "Maya Exploration.

109. Leventhal, Ashmore, LeCount, and Yaeger, "The Xunantunich Archaeological Project," 4.

110. Hammond, "The Prehistory of Belize," 353.

111. Bullard, "Hunting Ruins."

112. Anderson, "Archaeology in British Honduras," 35.

113. Anderson, *Brief Sketch,* 85.

114. *Sensu* Anderson, *Imagined Communities;* Handler, "On Having a Culture," 210.

115. MacPherson, *From Colony to Nation,* 17.

116. Medina, *Negotiating Economic Development,* 41.

117. Cynthia Robin, personal communication, June 2006.

118. The development of community-based archaeological projects in Belize was part of a discipline-wide reflexive and political turn that acknowledged an ethical imperative for archaeologists to consider the social and political impacts of archaeology and the historic power dynamics in which archaeologists are embedded. See, Pyburn and Wilk, "Responsible Archaeology is Applied Anthropology," 78–83; Yaeger and Borgstede, "Professional Archaeology."

119. Wilk, *Agriculture, Ecology, and Domestic Organization;* Wilk and Rathje, "Household Archaeology," 617–39.

120. Pyburn, "Archaeology for a New Millennium."

Chapter 5. Official Archaeological Heritage Management and Community Negotiations in the Globalization Period

1. Hammond, "Prehistory of Belize," 361.

2. *Belize Times,* "Belizean Archaeology Emerges."

3. Hannerz, *Transnational Connections,* 53–54.

4. De Cesari, "World Heritage," 300. For more discussion of state manipulations of global heritage trends, see Askew, "The Magic List," 19–44; Labadi, "Representations," 147–70; Labadi, *UNESCO.*

5. Pateman, "The Bahamas," 4–5.

6. Reid and Lewis, "Trinidad and Tobago," 128.

7. Vicioso, "Dominican Republic," 37–38.

8. National Institute of Culture and History, "About NICH."

9. National Institute of Culture and History, "Houses of Culture," and "About MOB."

10. Topsey, "New Developments"; See also Hammond, "The Prehistory of Belize," 361.

11. Awe, "Coming of Age," 283–88.

12. For further discussion, see Rico, "Heritage at Risk," 147–62.

13. Parks, "Winning Title to Land," 126.

14. Garcia, "Ruins in the Landscape," 321.

15. Government of Belize, *National Institute of Culture and History Act,* 25.

16. For examples of Maya imagery on Belizean currency, see Central Bank, "$2 BZE Note." For similar imagery on beer, see Belikin Beer, "Our Story."

17. *Sensu* De Cesari, "World Heritage," 307.

18. Xavier Choc served as Director for the Belizean IA for over a decade in the late twentieth and early twenty-first centuries. He spent years working to legitimize archaeology as a career in Belize, cultivate heritage-based professional development opportunities for Belizeans, and enhance his own professional identity and prestige in the international scholarly archaeology community. Xavier Choc was also an adviser for the African and Maya History curricular project discussed in chapter three.

19. Interview, July 2006.

20. Herstad, "Collaborative Archaeology"; McAnany, *Maya Cultural Heritage;* Parks, "Winning Title to Land."

21. Belize Tourism Board, "Maya Heartland."

22. Anaya, "Reparations for Neglect," 567–604.

23. Parks, "Winning Title to Land."

24. Finneran and Welch, "Out of the Shadow," 229.

25. Finneran and Welch, 228. See also Jordan and Joliffe, "Heritage Tourism," 1–8; Innis and Joliffe, "Industrial Heritage of Sugar," 89–109.

26. Fortenberry, "Life Among Ruins," 601–613.

27. Colonial history is of increasing interest to the Belizean state and there is increasing recognition among Belizean politicians and cultural actors of the need to address Belize's African history and the history of enslavement. See, Belize Ministry of Tourism and Civil Aviation, "Belize City House of Culture."

28. Phulgence, "African Warriors," 214–26.

29. Phulgence, 215.

30. For discussion of similar heritage practices in Peru and other parts of Latin America, see Cánepa, "Nation Branding," 7–18; Garcia, "Ruins in the Landscape"; McAnany, "Transforming the Terms," 159–78.

31. Interview, July 2006.

32. Interview, July 2006.

33. Parks, "Winning Title to Land," 126.

34. Wallace, "Tourism, Tourists and Anthropologists," 5.

35. According to the World Travel and Tourism Council, the direct contribution of travel and tourism to Belize's GDP in 2017 was $277.7 million USD (15 percent of the total GDP), and tourism directly supported 21,000 jobs, or 13.4 percent of total employment. World Travel & Tourism Council, *Travel & Tourism Economic Impact 2018* Belize, 1. For more on the social and economic contributions of tourism in Belize, see Richardson, "Economic Development in Belize," 21–45.

36. *Sensu* Magnoni, Ardren, and Hutson, "Tourism in the Mundo Maya," 355.

37. The Belize Tourism Board is the statutory board tasked with developing, marketing, regulating, and implementing tourism programs and training and the Belize Tourism Industry Association is a private-sector tourism association which addresses Belize's tourism industry needs.

38. Leventhal et al., "Xunantunich Archaeological Project," 2.

39. Leventhal et al., 9–13.

40. Taussig, *The Nervous System;* Byrne, "Critique of Unfeeling Heritage," 229–52.

41. De Cesari, "World Heritage and Mosaic Universalism," 310; See also Fraser, "Rethinking Recognition," 108.

42. Baram, "Archaeology in the Public Interest," 114.

43. *Belize Times,* "Belizean Archaeology Emerges."

44. Garber, Awe, and Sullivan, "Birthplace of a Nation," 259–266.

45. Harrison-Buck et al., "From Ancient Maya to Kriol Culture," 353–61.

46. Harrison-Buck et al., "The Strange Bedfellows of Northern Belize," 172–203.

47. For example, see Handler, "An Archaeological Investigation," 64–72; Ogundiran and Falola, *Archaeology of Atlantic Africa;* Orser Jr., "Archaeology of the African Diaspora," 63–82; Singleton and de Souza Torres, "Archaeologies of the African Diaspora," 449–469.

48. Matsuda and Okamura, *New Perspectives in Global Public Archaeology;* McAnany, *Maya Cultural Heritage;* Phillips and Allen, *Bridging the Divide;* Thomas and Lea, *Public Participation in Archaeology.*

49. Ford, "Community Voice"; Pyburn, "Archaeology for a New Millennium," 167–184.

50. Batty, Friedel, and McCurdy, "To the Mountain"; Ishihara et al. "The MACHI Project," 307–13; Robin, Kosakowsky, Grauer, and Nissen, "Community Archaeology at Aventura," 319–328; Zarger and Baines, *TEACHA*.

51. Baines and Zarger, "Maya Cultural Heritage Exchange," 77–84.

52. Nelson Westby has worked at the IA for decades, since he was a young heritage professional in training. During the early twenty-first century, he served as Interim Director of the ISCR and he now serves as Director of the IA.

53. Interview, July 2006.

54. McGill, "Examining the Pedagogy," 55–84; See also the Crooked Tree Museum and Cultural Heritage Center, https://crookedtreemuseum.org/.

55. Koenig, Wells, and Garcia, "Reclaiming Development," 63–75.

56. Garcia, "Ruins in the Landscape," 324–25.

57. Pyburn, "Hydrology of Chau Hiix," 123–129.

58. *Plantayshan* (plantation) is the Kriol word for farm. It is used to describe a place larger than a kitchen garden where people grow crops. It is also often used to refer to family land plots.

59. Following the Honduras Land Act Titles of 1858 and 1861, large landholding companies like the Belize Estate and Produce Company (BEC) were able to purchase land "even if the title was insecure." By the late 1800s, the BEC owned the majority of private land in Belize. Johnson, *Becoming Creole,* 52, 61.

60. Johnson, *Becoming Creole,* 73.

61. For details about the history of wildlife conservation in Crooked Tree and conservation politics see Johnson, "Nature and Progress," 117–142.

62. McAnany and Parks, "Casualties of Heritage Distancing," 81; See also, Parks, "Collision of Heritage," 437; Parks, "Archaeological Ethics," 4–7.

63. Pyburn, "Archaeology for a New Millennium."

64. Salazar, "Tourism Imaginaries," 863–82; For further discussion of "circuits of culture" see also, Ateljevic, "Circuits of Tourism," 358–69; Bruner, *Culture on Tour.*

65. For examples of scholars using young peoples' drawings to gauge their perspectives, see Gobbi, "Desenho Infantil e Oralidade," 69–92. For work about young peoples' perspectives of archaeology and archaeologists, see Bezerra, "Make-Believe Rituals," 60–70; Bezerra, *The Hunchback Austhralopitecus.*

66. For information about the National Kriol Council and its projects, see National Kriol Council, "Welcome to the National Kriol Council: Welkom tu di Nashanal Kriol Kongsl," http://www.nationalkriolcouncil.org/.

67. Interview, July 7, 2009.

68. De Cesari, "World Heritage and Mosaic Universalism," 307.

69. Interview, April 23, 2009.

70. Armstrong and Hauser, "A Sea of Diversity," 595. See also Handler and Lange, *Plantation Slavery in Barbados;* Handler and Lange, "Plantation Slavery on Barbados," 45–52.

71. For examples, see Agbe-Davis, "Concepts of Community," 373–89; Haviser and MacDonald, *African Re-Genesis.*

72. Moreno, "Collaborative Archaeology," 44.

73. Wilkie, "Minding the Gaps," 343–44.

74. Wilkie, "Minding the Gaps," 343–44. See also Wilkie, "Communicative Bridges Linking Actors," 225–43.

75. Interview, April 29, 2009.

76. Interview, April 17, 2009.

77. Interview, April 23, 2009.

78. Interview, February 16, 2009.

79. Johnson, *Becoming Creole,* 134–42.

80. Public archaeologist Arwa Badran has documented how Jordanian teachers identify the economic value of archaeological resources, especially as tourism assets, in ways similar to Belizean teachers. Badran reports that one teacher told her, "Our archaeological heritage is more expensive than oil . . . It has to be preserved; it brings hard currency through tourism into the country." Badran, "Heritage Education in Jordanian Schools," 105.

81. Some Crooked Tree residents refer to Chau Hiix and other nearby locations of Ancient Maya occupation as Injun Hill, a common Kriol name given to Ancient Maya sites.

82. Interview, February 16, 2009, emphasis in italics added.

83. K. Anne Pyburn, personal communication.

84. Shoshaunna Parks discusses similar ways residents in the Maya community of Santa Cruz attempted to negotiate relationships with archaeologists and heritage institutions. Many community members claimed they did not know about the existence of Uxbenká (a local archaeological site) prior to archaeologists noting its existence in the mid-1980s, even though this is not true. See Parks, "Winning Title to Land"; Parks, "Archaeological Ethics."

85. Pyburn, "Preservation as 'Disaster Capitalism,'" 232; Pyburn, "Archaeology for a New Millennium."

86. Interview, February 16, 2009.

87. Interview, April 29, 2009.

88. Medina, "Commoditizing Culture," 353–68.

89. Van Den Berghe, "Tourism and Ethnic Division," 246, 234–249. See also Van Den Berghe, *The Quest for the Other.*

90. Salazar, "Tourism Imaginaries." See also Stronza, "Through a New Mirror."

91. This building was destroyed in a fire in May 2017.

92. Wilk, *Home Cooking.*

93. Quixotically, the fact that Chau Hiix is so inaccessible likely helps to protect the site from looters and other threats. This fact may also have been a deterrent to site development as the Belizean national government regarded it as relatively safe from disturbance. K. Anne Pyburn, personal communication.

94. Pyburn, "Preservation as 'Disaster Capitalism,'" 232.

95. A cenote is a natural pit or sinkhole in the ground that is the result of collapsed limestone bedrock. Cenotes contain groundwater and can range in size with many over 50 meters deep. Cenotes were important to Ancient Maya people and are common in Central America and particularly common in the Yucatán Peninsula.

96. K. Anne Pyburn, personal communication.

97. Gann, "Some Superstitions and Customs," 169; Gann, "On the Contents," 313; Thompson, "Thomas Gann," 743.

98. It is true that Chau Hiix Archaeological Project members carried out the majority of burial excavation at Chau Hiix. This was due to poor preservation conditions so the work was very delicate. However, local workers often witnessed these excavations and Crooked Tree people were not sent away during burial excavations so archaeologists could work in secret.

99. Many of the complete or rare artifacts (for example, jade objects, whole pots, jewelry) from the Structure 1 burials are stored in the Institute of Archaeology collections or curated at the Museum of Belize (MOB). Several of these objects have also been displayed at the MOB with labels indicating there were from Chau Hiix.

100. Channel Five, "Thousands of Mayan Artefacts."

101. Interview, December 1, 2008.

102. Interview, November 14, 2008.

103. Interview, November 14, 2008.

104. Interview, November 27, 2008.

105. Interview, November 13, 2008.

106. Interview, December 2, 2008.

107. Interview, November 25, 2008.

108. Interview, November 24, 2008.

109. Interview, November 2008.

110. Interview, November 13, 2008.

111. Interview, November 21, 2008.

112. Interview, November 24, 2008.

113. Interview, December 1, 2008.

114. Interview, November 24, 2008.

115. Interview, November 24, 2008.

116. Interview, November 25, 2008.

117. Similar findings were observed among Ch'orti' Maya children in Honduras. See McAnany and Parks, "Casualties of Heritage Distancing."

118. Interview, November 27, 2008.

119. Interview, December 1, 2008.

120. Interview, November 24, 2008.

121. Interview, November 13, 2008.

122. Interview, November 14, 2008.

123. Interview, December 2, 2008.

124. Interview, November 24, 2008.

125. Interview, November 25, 2008.

126. In Belize, displays about archaeology and Ancient Maya heritage often depict or mention human remains and burials. Old Belize (a cultural center in Belize City) has a room focused on Ancient Maya culture that has extensive skeletal imagery and a model of a burial. Archaeological site museums also often have burials and associated grave goods as focal points in their exhibits; the Cahal Pech and Xunantunich site museums have burial reconstructions, and the Museum of Belize has an Altun Ha burial reconstruction.

127. Similar connections with ancient sites exist in other cultural contexts as well. Marcia Bezerra describes Brazilian people telling stories about hauntings at an archaeological site on Marajó Island. Bezerra, "Signifying Heritage in Amazon," 533–542.

128. Interview, November 14, 2008.

129. Interview, November 14, 2008.

130. Interview, November 13, 2008.

131. Interview, November 13, 2008.

132. Interview, December 1, 2008.

133. Interview, November 24, 2008.

134. Interview, November 13, 2008.

135. Jackson discusses similar interpretations and representations of African American cultural practices in the past. Jackson, "Changing Ideas about Heritage," 86.

136. Interview, November 27, 2008.

137. De Cesari, "World Heritage and Mosaic Universalism," 307; See also, Garcia, "Ruins in the Landscape," 329.

138. Interview, November 25, 2008.

139. Interview, December 1, 2008.

140. Interview, November 14, 2008.

141. Interview, November 25, 2008.

142. Interview, November 13, 2008.

143. Interview, November 2008.

144. Interview, November 14, 2008.

145. Interview, November 13, 2008.

146. Interview, November 24, 2008.

147. Interview, November 25, 2008.

148. Interview, November 14, 2008.

149. Interview, November 25, 2008.

150. Archaeological examinations of children and childhood have grown significantly since the 1980s. Baxter, "Archaeology of Childhood," 159–75; Baxter, "Children in Action"; Clark and Wilkie, "Prism of Self"; Lillehammer, "A Child Is Born," 89–105; Schwartzman, *Children and Anthropology.*

151. Kamp, "Where Have All the Children Gone?" 24.

152. Brookshaw, "The Archaeology of Childhood," 215–32.

153. Visualizing children in the past is not universal among young people. Marcia Bezerra notes that when she asked Brazilian children to describe past people and practices, they rarely mentioned children. Bezerra, "Make-Believe Rituals."

154. Hall, "Whose Heritage?" 223.

155. Interview, April 29, 2009.

156. For summaries of this scholarship, see Bates, Chenoweth, and Delle, *Archaeologies of Slavery and Freedom;* Lee and Scott, "New Directions in African Diaspora Archaeology," 85–90; Ogundiran and Falola, *Archaeology of Atlantic Africa;* Singleton and de Souza Torres, "Archaeologies of the African Diaspora."

157. Singleton, *Slavery Behind the Wall,* 12.

158. Armstrong and Hauser, "A Sea of Diversity," 595.

159. Boone, *"Black Landscapes Matter,"* 8–23; Jackson, *Speaking for the Enslaved.*

160. Singleton, *Slavery Behind the Wall.*

161. See Hauser, *The Archaeology of Black Markets.*

162. Wilkie and Farnsworth, "Trade and the Construction of Bahamian Identity," 283–320; Wilkie and Farnsworth, *Sampling Many Pots.*

163. Ahlman and Schroedl, "Contextualizing Caribbean Historical Sites," 1–8.

164. Agorsah, *Maroon Heritage.*

165. Chenoweth, Delle, and Bates, "Caribbean Spaces in Between," 4, 1–27; See also Farnsworth, "Current and Future Directions," 189–207.

166. Farnsworth, "Current and Future Directions," 207.

167. Howard, "'Looking for Angola,'" 32–68.

168. Antoinette Jackson, *Speaking for the Enslaved.*

169. For examples, see Ford, "Community Voice"; McAnany, "Transforming the Terms of Engagement"; Pyburn, "Archaeology for a New Millennium"; Robin et al., "Community Archaeology at Aventura."

170. Batty, Friedel, and McCurdy, "To the Mountain"; Baines and Zarger, "Circles of Value," 65–86.

171. Baram, "Archaeology in the Public Interest," 124.

Chapter 6. Conclusion: Kriol Cultural Resilience and Community Engagement

1. Xavier Choc Interview, July 2006.

2. Manuel Jimenez Interview, July 2006.

3. Christina Pop Interview, July 2006.

4. This Kriol word means to glorify, praise, or recognize.

5. Rocking the boat here is a metaphor for overcoming societal issues and likely also connects with challenging and overcoming legacies of colonialism, outsider influence, and structural institutions.

6. Teacher Albert Interview, April 29, 2009.

7. Pyburn, "Engaged Archaeology," 29–41.

8. Haviser, "Truth and Reconciliation," 247.

9. Haviser, 243–259.

10. Haviser, 257.

11. González-Tennant, "The 'Color' of Heritage," 26–50.

12. González-Tennant, 45.

13. Antoinette Jackson's work on heritage tourism and interpretations of the history and culture of enslaved Africans and their descendants in the United States South inspired me to think more about nuanced and agency-driven historical narratives and constructs of heritage in other African-descendant communities. See, Jackson, *Speaking for the Enslaved.*

14. Johnson, *Becoming Creole;* Crowe, *Gospel in Central America,* 426, 460.

15. Crooked Tree Village Reunion website, "History"; Visit Crooked Tree, "History & Culture."

16. This is often emphasized in stories about the village as a geographic feature, but also to highlight insider/outsider dynamics. Many villagers fondly refer to Crooked Tree as the "Inland Island."

17. These are three of the most common surnames in the village.

18. The jabiru, which seasonally nests in Crooked Tree, is the tallest flying bird found in Central and South America.

19. Johnson, *Becoming Creole,* 102.

20. McGill, "Examining the Pedagogy," 55–84.

21. For further discussion of the process of cashew production and the cultural significance of cashews, see Johnson, *Becoming Creole:* 58–59, 102–03.

22. Johnson, *Becoming Creole;* Johnson, "Nature and Progress."

23. Boone, "Black Landscapes Matter," 8–23.

24. Glave, *Rooted in the Earth.*

25. Johnson, *Becoming Creole,* 134–137, 141. Throughout *Becoming Creole* Johnson discusses how Kriol people represent their relationship with "the bush" to others. She demonstrates that people in rural Kriol communities recognize the kinds of sanitized aspects of nature the majority of tourists are interested in and shows how residents in Crooked Tree and other villages have developed ways to market "safe" aspects of the bush while maintaining ties to the bush as integral aspects of their identity.

26. For details about the cultural experiences Tillett's offers, see Tillett's Village Lodge, "Activity: Discovering Belize" http://www.tillettvillage.com/EN/Activities/activities.html.

27. Johnson discusses the ways that Kriol people maintain and reinforce transnational familial and other social ties, Belizean and rural Kriol identity, and socionatural heritage across national borders. She especially highlights the exchange and sharing of food products, return visits to Belize, and discussions about food through social media. *Becoming Creole,* 143–169.

28. Crawford, Village View Post.

29. Crooked Tree Village Reunion, "Photo Album."

30. Crooked Tree Village Reunion, Facebook.

31. Village View Post, "Crooked Tree Village School."

32. Channel 5 News, "Crooked Tree Student."

33. Hannah Scruggs, field notes, June 3, 2016.

34. For discussions about how people learn about the past and effective ways of teaching about the past, see Bender and Messenger, *Pedagogy and Practice;* Davis, *How Students Understand the Past;* Rabinowitz, *Curating America;* Smardz and Smith, *Archaeology Education Handbook.* For discussions of community engagement and addressing diverse needs in heritage work, see Adair, Koloski, and Filene, *Letting Go?;* Moshenska, *Key Concepts in Public Archaeology;* Skeates, McDavid, and Carman, *Oxford Handbook of Public Archaeology.*

35. Education, history, and archaeology professionals have written much on how children and adults connect with history and learn about the past through hands-on activities and interactions with material objects. See Cerón and Mz-Recaman, "The Museum Comes to School," 148–58; Hurley, *Beyond Preservation,* 84–94.

36. Interview, November 25, 2008.

37. Interview, November 14, 2008.

38. McGill, "Learning from Cultural Engagements," 1068–1083.

39. Village leadership meeting, June 20, 2014.

40. Village leadership meeting, June 20, 2014.

41. Baines and Zarger, "Maya Cultural Heritage Exchange," 83.

42. For more on ties between ecological heritage and cultural and community identity, see Baines, *Embodying Ecological Heritage.*

43. This trip was funded by a Wenner-Gren Foundation Engaged Anthropology Grant (Project Number: EAG-27).

Bibliography

Abrahams, Roger D. *The Man-of-Words in the West Indies: Performance and Emergence of Creole Culture.* Baltimore: The Johns Hopkins University Press, 1983.

Adair, Bill, Benjamin Filene, and Laura Koloski, eds. *Letting Go?: Sharing Historical Authority in a User-Generated World.* Philadelphia: The Pew Center for Arts and Heritage, 2011.

Agbe-Davies, Anna S. "Concepts of Community in the Pursuit of an Inclusive Archaeology." *International Journal of Heritage Studies* 16, no. 6 (2010): 373–89.

Agorsah, E. Kofi. *Maroon Heritage: Archaeological, Ethnographic and Historical Perspectives.* Kingston: University of the West Indies, 2000.

Ahlman, Todd M., and Gerald F. Schroedl. "Introduction: Contextualizing Caribbean Historical Sites through Colonialism, Capitalism, and Globalization." In *Historical Archaeologies of the Caribbean: Contextualizing Sites through Colonialism, Capitalism, and Globalism,* edited by Todd M. Ahlman, Gerald F. Schroedl, Douglas V. Armstrong, Samantha Rebovich Bardoe, and Paul Farnsworth, 1–8. Tuscaloosa: University of Alabama Press, 2019.

Allsopp, Stanley Reginald Richard. "British Honduras—The Linguistic Dilemma." *Caribbean Quarterly* 11, no. 3, September & December (1965): 54–61.

Althusser, Louis. "Ideology and the Ideological State Apparatuses." In *Lenin and Philosophy, and Other Essays,* edited by Louis Althusser, 85–125. New York: Monthly Review Press, 1971.

AmbergrisCaye.com. "No More Noh Mul? Contractor Bulldozes Mayan Temple." May 11, 2013. https://ambergriscaye.com/forum/ubbthreads.php/topics/465838.html.

Amin, Samir. "What Education for What Development?" *Prospects* 5, no. 1 (1975): 48–52.

Amit-Talai, Vered, and Helena Wulff, eds. *Youth Cultures: A Cross-Cultural Perspective.* London: Routledge, 1995.

Anaya, James. "Reparations for Neglect of Indigenous Land Rights at the Intersection of Domestic and International Law—The Maya Cases in the Supreme Court of Belize." In *Reparations for Indigenous Peoples: International and Comparative Perspectives,* edited by Federico Lenzerini, 567–604. Oxford: Oxford University Press, 2008.

Anderson, A. H. "Archaeology in British Honduras Today." In *Proceedings of the Thirtieth International Congress of Americanists* (1952): 32. London: The Royal Anthropological Institute.

———. *Brief Sketch of British Honduras.* British Honduras: Printing Department, 1958.

Anderson, Benedict. *Imagined Communities: Reflections on the Origin and Spread of Nationalism.* New York: Verso, 1991.

Anderson, C. A. "Economic Development and Post-Primary Education." In *Post Primary Education and Political and Economic Development,* edited by D.C. Piper and T. Cole, 3–26. Durham, NC: Duke University Press, 1964.

Anderson, Charles, and M. J. Bowman. *Education and Economic Development.* London: Frank Cass, 1965.

The Angelus, "Editorial." August 1, 1885.

Armstrong, Douglas V., and Mark W. Hauser. "A Sea of Diversity: Historical Archaeology in the Caribbean." In *International Handbook of Historical Archaeology,* edited by Teresita Majewski and David Gaimster, 583–612. New York: Springer, 2009.

Ashcraft, Norman. "Educational Planning in a Developing Society: The Case of British Honduras." *Caribbean Quarterly* 17, no. 1 (March 1971): 23–33.

Ashcraft, Norman, and Cedric Grant. "The Development and Organization of Education in British Honduras." *Comparative Education Review* 12, no. 2 (1968): 171–79.

Askew, Marc. "The Magic List of Global Status: UNESCO, World Heritage, and the Agendas of States." In *Heritage and Globalization,* edited by Sophia Labadi and Colin Long, 19–44. New York: Routledge, 2010.

Aspinall, Algernon E. "Extract from the West India Committee Circular, dated October 27th, 1908." In Colonial Reports-Miscellaneous, No. 84 *Papers Relating to the Preservation of Historic Sites and Ancient Monuments and Buildings in the West Indian Colonies,* London: His Majesty's Stationary Office, (1912): 4–5.

Atalay, Sonya. "'Diba Jimooyung'—Telling Our Story: Colonization and Decolonization of Archaeological Practice from and Anishinabe Perspective." In *Handbook of Postcolonial Archaeology,* edited by Jane Lydon and Uzma Z. Rizvi, 61–72. New York: Taylor & Francis, 2010.

Ateljevic, Irena. "Circuits of Tourism: Stepping Beyond the 'Production/Consumption' Dichotomy." *Tourism Geographies* 2, no. 4 (2000): 358–69.

Awe, Jaime. "Coming of Age: Reflecting on the Past 25 Years at Archaeology." In *Taking Stock: Belize at 25 Years of Independence,* edited by Barbara S. Balboni and Joseph O. Palacio, 283–88. Benque Viejo del Carmen, Belize: Cubola Productions, 2007.

Bacchus, Mohammed Kazim. *Utilization, Misuse and Development of Human Resources in the Early West Indian Colonies.* Waterloo, ON: Wilfred Laurier University Press, 1990.

Badran, Arwa. "Heritage Education in Jordanian Schools: For Knowledge or Profit." In *Public Participation in Archaeology,* edited by Suzie Thomas and Joanne Lea, 105–118. Woodbridge, UK: Boydell Press, 2014.

Baines, Kristina. *Embodying Ecological Heritage in a Maya Community: Health, Happiness, and Identity.* Lanham, MD: Lexington Books, 2015.

Baines, Kristina, and Rebecca Zarger. "Circles of Value: Integrating Maya Environmental Knowledge into Belizean Schools." In *The Anthropology of Environmental Education,* edited by Helen Kopnina, 65–86. New York: Nova Science Publishers, 2012.

———. "Maya Cultural Heritage Exchange in Southern Belize: A Dialogue among Communities, Archaeologists and Sociocultural Anthropologists." In *Research Reports in Belizean History and Anthropology: Papers of the 2015 Belize Archaeology and Anthropology Symposium,* edited by Nigel Encalada, Rolando Cocom, Selene Solis, and Giovanni Pinelo, 77–84. Belmopan, Belize: Institute for Social and Cultural Research, 2016.

Baram, Uzi. "Archaeology in the Public Interest: Tourist Effects and Other Paradoxes that Come with Heritage Tourism." In *Ideologies in Archaeology,* edited by Reinhard Bernbeck and Randall McGuire, 123–150. Tucson: University of Arizona Press, 2011.

Barkan, Elazar, and Ronald Bush, eds. *Claiming the Stones, Naming the Bones: Cultural Prop-*

erty and the Negotiation of National and Ethnic Identity. Los Angeles: Getty Research Institute, 2003.

Basu, Aparna. "Policy and Conflict in India: The Reality and Perception of Education." In *Education and Colonialism,* edited by Philip G. Altbach and Gail P. Kelly. New York: Longman, 1978.

Bates, Lynsey A., John M. Chenoweth, and James A. Delle, eds. *Archaeologies of Slavery and Freedom in the Caribbean: Exploring the Spaces in Between.* Gainesville, FL: University Press of Florida, 2016.

Batty, Sylvia, Rebecca Friedel, and Leah McCurdy. "To the Mountain: Heritage Preservation through Archaeological Literacy in San Jose Succotz, Belize." Poster presented at the 82nd Annual Meeting of the Society for American Archaeology, Vancouver, British Columbia, 2017.

Baxter, Jane Eva, "The Archaeology of Childhood." *Annual Review of Anthropology* 37, no. 1 (2008): 159–75.

Baxter, Jane Eva, ed. *Children in Action: Perspectives on the Archaeology of Childhood.* Archeological Papers of the American Anthropological Association 15, no. 1, 2006.

Becker, Gary. *Human Capital: A Theoretical and Empirical Analysis, with Special Reference to Education.* Chicago: University of Chicago Press, 1964.

Belikin Beer. "Our Story." Accessed September 12, 2020. https://www.belikin.com/our-story. html.

Belize Ministry of Tourism and Civil Aviation. "Belize City House of Culture and Downtown Rejuvenation Project." Accessed September 3, 2020. https://tourism.gov.bz/hoc-project/

Belize Times. "Belizean Archaeology Emerges." http://www.belizetimes.bz/news/story/2176. shtml (site discontinued).

Belize Tourism Board. "Maya Heartland." Accessed September 3, 2020. https://www.travel-belize.org/do-and-see/maya-heartland.

Bender, Susan J., and Phyllis Mauch Messenger, eds. *Pedagogy and Practice in Heritage Studies.* Gainesville: University Press of Florida, 2019.

Bennett, Joseph Alexander. "Aspects of Educational Development in Belize Part II." *Journal of Belizean Affairs* 2, no. 1 (December 1973): 66–88.

———. *Education in Belize: A Historical Perspective.* Belize City: The Angelus Press Ltd., 2008.

———. "Goals, Priorities and the Decolonization of Education in Belize." *Belizean Studies,* 7, no. 5 (1979): 18–23.

Bereiter, Carl, and Siegfried Engelmann. *Teaching Disadvantaged Children in the Preschool.* Englewood Cliffs, NJ: Prentice-Hall, 1966.

Bernal, Ignacio. "Maya Antiquaries." In *Social Process in Maya Prehistory: Studies in Honor of Sir Eric Thompson,* edited by Norman Hammond, 19–30. Cambridge, MA: Academic Press, 1977.

Bezerra, Marcia. *The Hunchback Austhralopitecus: Children and Archaeology in a Public Archaeology Project in School.* PhD diss., Universidade de São Paulo, São Paulo, Brazil, 2003.

———. "Make-Believe Rituals: Reflections on the Relationship between Archaeology and Education through the Perspective of a Group of Children in Rio de Janeiro, Brazil." *Archaeologies* 1, no. 2 (2005): 60–70.

———. "Signifying Heritage in Amazon: A Public Archaeology Project at Vila de Joanes, Marajó Island, Brazil." *Chungara, Revista de Antropología Chilena* 44, no. 3 (2012): 533–42.

Blackett, J. L., C. P. Cacho, Reverend C. W. Cousins, S. E. Daley, A. S. Frankson, W. F. Fonseca, Reverend E. L. Sylvestre, Reverend L. Weber, and E. P. Yorke. *Report of the Planning Committee on Education: 1963–1970,* Manuscript on file at the Belize Archives and Records Service, Belmopan, Belize, 1963.

Board of Education. "Education in Jamaica and its Relation to Skilled Handicraft and Agricultural Work." In *Special Reports on Educational Subjects, Volume 12,* 465–474. London: Wyman & Sons, Limited, 1905.

Board of Education. *Special Reports on Educational Subjects: Volume 12: Educational Systems of the Chief Crown Colonies and Possessions of the British Empire, Including Reports on the Training of Native Races.* London: Wyman & Sons, Limited, 1905.

Board of Education. "The System of Education in Barbados." In *Special Reports on Educational Subjects, Volume 12,* 44–98. London: Wyman & Sons, Limited, 1905.

Board of Education. "The System of Education in Bermuda." In *Special Reports on Educational Subjects, Volume 12,* 99–134. London: Wyman & Sons, Limited, 1905.

Board of Education. "The System of Education in British Honduras." In *Special Reports on Educational Subjects, Volume 12,* 135–174. London: Wyman & Sons, Limited, 1905.

Bolland, Nigel O. *Colonialism and Resistance in Belize: Essays in Historical Sociology.* Benque Viejo del Carmen, Belize: Cubola Productions, 2003.

Boone, Kofi. "Black Landscapes Matter." *Ground Up: Journal of Landscape Architecture and Environmental Planning,* Issue 06: Of Process, no. 1 (2017): 8–23.

Bourdieu, Pierre, and Jean-Claude Passeron. *Reproduction in Education, Society, and Culture.* Beverly Hills, CA: Sage Publications, 1977.

Briceño, Elizio J. *Souvenir Brochure, Belize Teacher's College.* Belize City: Belize Teacher's College, 1979.

Bristowe, Lindsay, and Philip Wright. *The Handbook of British Honduras, 1888–1889.* Edinburgh and London: Blackwood, 1889.

British Honduras, *Annual Report of the Prison Department,* 1947.

British Honduras Colonial Government, Education Act of 1850, 1850.

Brookshaw, Sharon. "The Archaeology of Childhood: A Museum Perspective." *Complutum* 21, no. 2 (2010): 215–32.

Brown, Lady Richmond. *Unknown Tribes: Uncharted Seas.* London: Duckworth & Co., 1924.

Bruner, Edward M. *Culture on Tour: Ethnographies of Travel.* Chicago: University of Chicago Press, 2005.

Bude, Udo. "The Adaptation Concept in British Colonial Education." *Comparative Education* 19, no. 3 (1983): 341–55.

Bullard, Helen. "Hunting Ruins in the Other (British) Honduras." *New York Times,* May 5, 1968.

Bulmer-Thomas, Barbara, and Victor Bulmer-Thomas. *The Economic History of Belize: From the 17th Century to Post-Independence.* Benque Viejo del Carmen, Belize: Cubola Productions, 2012.

Burdon, John A. *The Archives of British Honduras.* London: Sifton Praed and Co., 1934.

———. *A Brief Sketch of British Honduras Past, Present, and Future.* London: West India Committee, 1927.

Byrne, Denis. "A Critique of Unfeeling Heritage." In *Intangible Heritage,"* edited by Laurajane Smith and Natsuko Akagawa, 229–252. London: Routledge, 2009.

Cal, Angel. *Belize: Maya Civilizations: Primary School Teachers' Handbook (Lower Division).* Belmopan: Ministry of Education, Culture and Sports. University of Belize, 2005.

———. *Belize: Maya Civilizations: Primary School Teachers' Handbook (Middle Division)*. Belmopan: Ministry of Education, Culture and Sports, 2005.

———. *Belize: Maya Civilizations: Students' Handbook (Primary School—Upper Division)*. Belmopan: Center for Multi-cultural Studies and University of Belize Press, 2004.

Canagarajah, A. Suresh. *Resisting Linguistic Imperialism in English Teaching*. London: Oxford University Press, 1999.

Cánepa, Gisela. "Nation Branding: The Re-foundation of Community, Citizenship and the State in the Context of Neo-Liberalism in Perú." *Medien Journal* 3, no. 1 (2013): 7–18.

Carman, B. E. *British Honduras Education Report for the Year 1937*. Belize: Government Printer, 1938.

———. *British Honduras Education Report for the Year 1938*. Belize: Government Printer, 1939.

Carnoy, Martin. *Education as Cultural Imperialism*. New York: Longman, 1974.

Castañeda, Quetzil, and Christopher N. Matthews, eds. *Ethnographic Archaeologies: Reflections on Stakeholders and Archaeological Practices*. Lanham, MD: AltaMira Press, 2008.

Central Bank of Belize. "$2 BZE Note." 2003 Issue. Accessed September 12, 2020. https://www.centralbank.org.bz/currency/currency-notes/2003-issue.

Cerón, I. Delgado, and C. I. Mz-Recaman. "The Museum Comes to School in Colombia: Teaching Packages as a Method of Learning." In *The Presented Past: Heritage Museums, and Education*, edited by Peter Stone and Brian Molyneaux, 148–58. London: Routledge, 1994.

Chailley-Bert, Joseph, and Sir William Stevenson Meyer. *Administrative Problems of British India*. London: Macmillan, 1910.

Channel Five News. "Crooked Tree student, Ashton Tillett, tops the 2014 P.S.E." June 12, 2014. https://edition.channel5belize.com/archives/100114.

Channel Five News. "Thousands of Mayan Artifacts Deserted at Chaw Hiix." May 21, 2013. http://edition.channel5belize.com/archives/85755.

Channel Seven News. "No More Noh Mul? Contractor Bulldozes Mayan Temple." May 10, 2013. http://www.7newsbelize.com/sstory.php?nid=25471.

Chenoweth, John M., James A. Delle, and Lynsey A. Bates. "Introduction: The Caribbean Spaces in Between." In *Archaeologies of Slavery and Freedom in the Caribbean: Exploring the Spaces in Between*, edited by Lynsey A. Bates, John M. Chenoweth, and James A. Delle, 1–27. Gainesville, FL: University Press of Florida, 2016.

Clark, Bonnie, and Laurie A. Wilkie. "Prism of Self: Gender and Personhood." In *Identity and Subsistence: Gender Strategies for Archaeology*, edited by Sarah Nelson, 1–32. Walnut Creek, CA: Altamira Press, 2007.

Clatworthy, James F. *The Formulation of British Colonial Education Policy, 1929–1961*. Washington, DC: Office of Education, 1969.

Coe, Cati. *Dilemmas of Culture in African Schools: Youth, Nationalism, and the Transformation of Knowledge*. Chicago: University of Chicago Press, 2005.

Coggins, Clemency. "Maya Lords of the Jungle." *Archaeology* 34, no. 6 (1981): 76–77.

Colonial Reports-Miscellaneous, No. 84 *Papers Relating to the Preservation of Historic Sites and Ancient Monuments and Buildings in the West Indian Colonies*, London: His Majesty's Stationary Office, (1912): 1–80.

Conn, Steven. *Museums and American Intellectual Life, 1876–1926*. Chicago: University of Chicago Press, 2000.

Corsaro, William. "Interpretative Reproduction in Children's Peer Cultures." *Social Psychology* 55, no. 2 (1992): 160–77.

Crawford, Linda. "NEWS and COMMENTARY ABOUT BELIZE, CROOKED TREE VIL-LAGE, AND ABROAD!" Village View Post. Accessed September 3, 2020. http://www.villageviewpost.com/.

Crooked Tree Museum and Cultural Heritage Center. "Home." July 20, 2018. https://crookedtreemuseum.org/.

Crooked Tree Village Reunion. "History." Accessed May 3, 2013. http://www.crookedtreevillagereunion.com/3/miscellaneous2.htm;

Crooked Tree Village Reunion. "Photo Albums." Accessed May 3, 2013. http://www.crookedtreevillagereunion.com/3/gallery.htm.

Crooked Tree Village Reunion. Facebook Main Page. Accessed September 3, 2020. https://www.facebook.com/Crooked-Tree-Village-Reunion-247602114806/.

Crowe, Frederick. *The Gospel in Central America: Containing a Sketch of the Country, Physical and Geographical, Historical and Political, Moral and Religious: A History of the Baptist Mission in British Honduras, and of the Introduction of the Bible into the Spanish American Republic of Guatemala.* London: Charles Gilpin, 1850.

Cunin, Elisabeth, and Odile Hoffmann. "From Colonial Domination to the Making of the Nation: Ethno-Racial Categories in Censuses and Reports and Their Political Uses in Belize, 19th-20th Centuries." *Caribbean Studies* 41, no. 2 (July–December 2013): 31–60.

Cuno, James. *Who Owns Antiquity? Museums and the Battle over Our Ancient Heritage.* Princeton, NJ: Princeton University Press, 2010.

Daily Beast. "This Ancient Maya Pyramid Was Destroyed To Build a Road." June 10, 2017. https://www.thedailybeast.com/this-ancient-maya-pyramid-was-destroyed-to-build-a-road.

Davis, Elaine. *How Students Understand the Past: From Theory to Practice.* Walnut Creek, CA: Altamira Press, 2005.

De Cesari, Chiara. "World Heritage and Mosaic Universalism: A View from Palestine." *Journal of Social Archaeology* 10, no. 3 (2010): 299–324.

Diaz-Andreu, Margarita, and Timothy Champion, eds. *Nationalism and Archaeology in Europe.* London: University College London Press, 1996.

Dillon, A. Barrow. *Report on Elementary Education Year 1899.* Belize City: Government Printer, 1900.

———. *Report on Elementary Education Year 1912.* Belize City: Government Printer, 1913.

———. *Report on Schools from Boom Wesleyan School, Grace Wesleyan School, Crooked Tree Baptist School.* Belize City: Government Printer, 1916

Easter, B. H. *Report of an Enquiry into the Educational System of British Honduras 1933–1934.* Belize: Government Printing Office, 1935.

Economic Commission for Latin America. *Report on Meeting on Removal of Language Barriers.* Office of the Caribbean, Caribbean Development and Co-operation Committee, 1978.

Edgeworth, Matt, ed. *Ethnographies of Archaeological Practice: Cultural Encounters, Material Transformations.* Lanham, MD: AltaMira Press, 2006.

Education Development Centre. *Textbook Standardization Committee Report.* Ministry of Education, Belize, 1999.

Farnsworth, Paul. "Current and Future Directions in the Historical Archaeology of the Eastern Caribbean." In *Historical Archaeologies of the Caribbean: Contextualizing Sites through Colonialism, Capitalism, and Globalism,* edited by Gerald F. Schroedl, Douglas V. Armstrong, Samantha Rebovich Bardoe, and Paul Farnsworth, 189–207. Tuscaloosa: University of Alabama Press, 2019.

Finneran, Niall, and Christina Welch. "Out of the Shadow of Balliceaux: From Garifuna Place of Memory to Garifuna Sense of Place in Saint Vincent and the Grenadines, Eastern Caribbean." *Journal of African Diaspora Archaeology and Heritage* 8, no. 3 (2015): 226–51.

Fonseca, William F. *Report of the Education Department for the Years 1969–1970 and 1971–1972.* Belmopan, Belize: Ministry of Education, 1972.

Ford, Annabel. "Community Voice." BRASS/El Pilar Program, ISBER/MesoAmerican Research Center University of California. Accessed September 3, 2020. http://www.marc.ucsb.edu/research/community-voice

Forrest, Jack W. *Education Department Report for the Year 1944.* Belize City: Government Printer, 1945.

——. *Education Department Report for the Year 1947.* Belize City: Government Printer, 1948.

——. *Education Department Report for the Year 1948.* Belize City: Government Printer, 1949.

——. *Education Department Report for the Year 1949.* Belize City: Government Printer, 1950.

Fortenberry, Brent. "Life Among Ruins, Bermuda and Britain's Colonial Heritage." *International Journal of Historic Archaeology* 20, no. 1 (2016): 601–613.

Foucault, Michel. *Security, Territory, Population: Lectures at the Collège de France 1977–1978.* Edited by Michel Senellart. New York: Palgrave Macmillan, 2007.

Fowler, Henry. *A Narrative Journey across the Unexplored Portion of British Honduras: With a Short Sketch of the History and Resources of the Colony.* Belize: Government Press, 1879.

Fraser, Nancy. "Rethinking Recognition." *New Left Review* 3, no. 1 (2000): 108.

Gann, Thomas. *Ancient Cities and Modern Tribes: Exploration and Adventure in Maya Lands.* London: Duckworth, 1926.

——. *Discoveries and Adventures in Central America.* London: Duckworth, 1928.

——. *Glories of the Maya.* New York: Charles Scribner's Sons, 1939.

——. *In an Unknown Land.* Freeport, NY: Books for Libraries Press, 1924.

——. "Maya Jades." In *Congrès International des Américanistes. Compte-rendu de la XXIe Session, Deuxième Partie à Göteborg en 1924.* Gothenburg: Göteborg Museum, 274–82, 1925.

——. "Mounds in Northern Honduras." *Nineteenth Annual Report of the Bureau of American Ethnology to the Secretary of the Smithsonian Institution, 1897–1898* Part 2. Washington, DC: Government Printing Office, 1900.

——. "On the Contents of Some Ancient Mounds in Central America." *Proceedings of the Society of Antiquaries of London.* Second series, 16, (1897): 313.

——. "Some Superstitions and Customs of the Maya Indians." *Chamber's Journal* February 10, 1900: 169.

Garber, James F., Jaime J. Awe, and Lauren A. Sullivan. "Birthplace of a Nation: The Archaeology of St. George's Caye, Belize." In *Research Reports in Belizean Archaeology, Volume 7,* edited by John Morris, Sherilyne Jones, Jaime Awe, George Thompson, and Melissa Badillo, 259–266. Belmopan, Belize: Institute of Archaeology, 2010.

Garcia, Pablo. "Ruins in the Landscape: Tourism and the Archaeological Heritage of Chinchero." *Journal of Material Culture* 22, no. 3 (2017): 317–33.

Garvin, Richard. *The Crystal Skull: The Story of the Mystery, Myth and Magic of the Mitchell-Hedges Crystal Skull Discovered in a Lost Mayan City during a Search for Atlantis.* Garden City, NY: Doubleday & Company Inc., 1973.

Germanacos, C. L., M. Gaskin, and S. Syrimis. *Report of the UNESCO Educational Planning Mission to British Honduras.* Paris: UNESCO, 1964.

Giddens, Anthony. *The Constitution of Society.* Berkeley: University of California Press, 1984.

Gilgan, Elizabeth. "Looting and the Market for Maya Objects: A Belizean Perspective." In *Trade in Illicit Antiquities: The Destruction of the World's Archaeological Heritage*, edited by Neil Brodie, Jennifer Doole, and Colin Renfrew, 73–88. Cambridge, UK: McDonald Institute for Archaeological Research, 2001.

Glave, Dianne D. *Rooted in the Earth: Reclaiming the African American Environmental Heritage*. Chicago: Lawrence Hill Books, 2010.

Gnecco, Cristóbal, and Patricia Ayala, eds. *Indigenous Peoples and Archaeology in Latin America*. Walnut Creek, CA: Left Coast Press, 2011.

Gobbi, Márcia. "Desenho Infantil e Oralidade: Instrumentos para Pesquisas com Crianças Pequenas." In *Por uma Cultura da Infância: Metodologias de Pesquisa com Criança*, edited by Ana Lúcia Goulart de Faria, Zeila de Brito Fabri Demartini, and Patrícia Dias Prado, 69–92. Campinas, São Paulo, Brazil: Autores Associados, 2000.

González-Tennant, Edward. "The 'Color' of Heritage: Decolonizing Collaborative Archaeology in the Caribbean." *Journal of African Diaspora Archaeology and Heritage* 3, no. 1 (2014): 26–50.

Gordon, Tammy S. *The Spirit of 1976: Commerce, Community and the Politics of Commemoration*. Amherst: University of Massachusetts Press, 2013.

Government of Belize. *National Institute of Culture and History Act Chapter 331, Revised edition 2000*. Belmopan, Belize: Government Printer, 2000.

Grant, Cedric H. *The Making of Modern Belize: Politics, Society & British Colonialism in Central America*. Cambridge, UK: Cambridge University Press, 1976.

Graue, Elizabeth, and Daniel Walsh. *Studying Children in Context: Theories, Methods, and Ethics*. Thousand Oaks, CA: Sage, 1998.

Gruning, Captain E. L. *Report on the British Museum Expedition to British Honduras, 1930*. London: Royal Anthropological Institute of Great Britain and Ireland, 1930.

Gustafson, Bret. *New Languages of the State: Indigenous Resurgence and the Politics of Knowledge in Bolivia*. Durham, NC: Duke University Press, 2009.

Gutchen, Mark A. *The Destruction of Archaeological Resources in Belize, Central America. Report Presented to the Subcommittee on International Trade of the Committee of Finance, United States*. Tucson: University of Arizona Press, 1982.

Hall, Stuart. "Old and New Identities, Old and New Ethnicities." In *Culture, Globalization, and the World System: Contemporary Conditions for the Representation of Identity*, edited by Anthony D. King, 41–68. Binghamton: State University of New York Press, 1991.

———. "Whose Heritage? Un-Settling 'The Heritage,' Re-Imagining the Post-Nation." In *The Heritage Reader*, edited by Graham Fairclough, Rodney Harrison, John H. Jameson, and John Schofield, 219–28. London: Routledge, 2008.

Hamilakis, Yannis. *The Nation and its Ruins: Antiquity, Archaeology, and National Imagination in Greece*. Oxford: Oxford University Press, 2007.

Hamilakis, Yannis, and Aris Anagnostopoulos, eds. *Archaeological Ethnographies—Special issue of Public Archaeology*, Vol 8. London: Maney, 2009.

Hammond, Norman. "The Development of Belizean Archaeology." *Antiquity*, LVII, (1983): 19–28.

———. *Lubaantún 1926–70*. London: British Museum, 1972.

———. "The Prehistory of Belize." *Journal of Field Archaeology* 9, no. 1 (1982): 349–62.

Hammond, S. A. "Education in the West Indies." *Journal of Negro Education* 15, no. 3 (Summer 1946): 427–49.

Hancock, Mary E. *The Politics of Heritage from Madras to Chennai.* Bloomington: Indiana University Press, 2008.

Handler, Jerome S. "An Archaeological Investigation of the Domestic Life of Plantation Slaves in Barbados." *The Journal of the Barbados Museum and Historical Society* 34, no. 2 (1972): 64–72.

Handler, Jerome, and Frederick Lange. *Plantation Slavery in Barbados: An Archaeological and Historical Investigation.* Cambridge, MA: Harvard University Press, 1978.

———. "Plantation Slavery on Barbados." *West Indies Archaeology* 32, no. 4 (1979): 45–52.

Handler, Richard. "On Having a Culture: Nationalism and the Preservation of Quebec's Patrimony." In *Objects and Others: Essays on Museums and Material Culture,* edited by George Stocking, 192–217. Madison: University of Wisconsin Press, 1985.

Handler, Richard, and Eric Gable. *The New History in an Old Museum: Creating the Past at Colonial Williamsburg.* Durham, NC: Duke University Press, 1997.

Hannerz, Ulf. *Transnational Connections: Culture, People, Places.* London: Routledge, 1996.

Hansen, Judith Friedman. *Sociocultural Perspectives on Human Learning: Foundations of Educational Anthropology.* Long Grove, IL: Waveland Press, 1979.

Harrison, Rodney. *Heritage: Critical Approaches.* New York: Routledge, 2013.

———. "What is Heritage?" In *Understanding the Politics of Heritage,* edited by Rodney Harrison, 5–42. Manchester, UK: Manchester University Press, 2010.

Harrison-Buck, Eleanor, Jessica Craig, Satoru Murata, and Adam Kaeding. "From Ancient Maya to Kriol Culture: Investigating the Deep History of the Eastern Belize Watershed." In *Research Reports in Belizean Archaeology: Papers of the 2016 Belize Archaeology Symposium,* edited by John Morris, Melissa Badillo, Sylvia Batty, and George Thompson, 353–361. Belmopan, Belize: Institute of Archaeology, 2017.

Harrison-Buck, Eleanor, Brett A. Houk, Adam R. Kaeding, and Brooke Bonorden. "The Strange Bedfellows of Northern Belize: British Colonialists, Confederate Dreamers, Creole Loggers, and the Caste War Maya of the Late Nineteenth Century." *International Journal of Historical Archaeology* 23, no. 1 (2019): 172–203.

Harvey, David C. "Heritage Pasts and Heritage Presents: Temporality, Meaning and the Scope of Heritage Studies." *International Journal of Heritage Studies* 7, no. 4 (2001): 319–38.

Haug, Sarah Woodbury. "Ethnicity and Ethnically 'Mixed' Identity in Belize: A Study of Primary School-Aged Children." *Anthropology and Education Quarterly* 29, no. 1 (1998): 44–67.

———. "'From Many Cultures, One Nation': Ethnic and Nationalist Identity in Belizean Children." PhD diss., University of Washington, 1995.

Hauser, Mark W. *The Archaeology of Black Markets: Local Ceramics and Economies in Eighteenth Century Jamaica.* Gainesville: University Press of Florida, 2008.

Haviser, Jay B. "Truth and Reconciliation: Transforming Public Archaeology with African Descendant Voices in the Dutch Caribbean." *Journal of African Diaspora Archaeology and Heritage* 4, no. 3 (2015): 243–59.

Haviser, Jay B., and Kevin C. MacDonald, eds. *African Re-Genesis: Confronting Social Issues in the Diaspora.* Walnut Creek, CA: Left Coast Press, 2006.

Herrera, Yvette, Myrna Manzanares, Silvana Woods, Cynthia Crosbie, and Ken Decker, eds. *Kriol-Inglish Dikshineri—English-Kriol Dictionary.* Belize City: Belize Kriol Project, 2007.

Herstad, Kaeleigh. "Collaborative Archaeology on a Global Scale: Challenges and Possibilities." Paper presented at the 77th Annual Meeting of the Society for American Archaeology, Memphis, Tennessee, 2012.

Hess, Robert D., and Virginia C. Shipman. "Early Experience and the Socialization of Cognitive Modes in Children." *Child Development* 36, no. 4 (1965): 869–886.

Hitchen, Peter. "State and Church in British Honduran Education, 1931–1939: A British Colonial Perspective." *History of Education* 29, no. 3 (2000): 198–201.

Howard, Rosalyn. "'Looking for Angola': An Archaeological and Ethnological Search for a Nineteenth Century Florida Maroon Community and its Caribbean Connections." *The Florida Historical Quarterly* 92, no. 1 (2013): 32–68.

Hurley, Andrew. *Beyond Preservation: Using Public History to Revitalize Cities.* Philadelphia: Temple University Press, 2010.

Iannone, Gyles, and Paul F. Healy. "The Trent Connection: A Cornerstone of Maya Archaeology in Belize." *Canadian Journal of Archaeology* 36, no. 1 (2012): 29–50.

Illich, Ivan. *Deschooling Society.* Harmondsworth, UK: Penguin, 1973.

Illustrated London News. "Maya Exploration in British Honduras: A Great National Archaeological Enterprise." 1928.

Innis, Tara A., and Lee Joliffe. "The Industrial Heritage of Sugar at World Heritage Sites in the Caribbean." In *Sugar, Heritage and Tourism in Transition,* edited by Lee Joliffe, 89–109. Bristol, UK: Channel View Publications, 2013.

Intriguing People. "Lady Richmond Brown: Adventurer, Archaeologist and Angler." January 25, 2016. http://intriguing-people.com/lady-richmond-brown/.

Ishihara, Reiko, Morvin Coc, Shoshaunna Parks, and Patricia A. McAnany. "The MACHI Project in Belize: Bridging the Past and the Present through a Public Education Program in the Toledo District, Belize." In *Research Reports in Belizean Archaeology: Papers of the 2007 Belize Archaeology Symposium,* edited by John Morris, Sherilyne Jones, Jaime Awe, and Christophe Helmke, 307–13. Belmopan, Belize: Institute of Archaeology, 2008.

Iyo, Aondofe. *African Civilizations: Primary Schools Teachers' Handbook (Lower Division).* Belmopan, Belize: Ministry of Education, Culture and Sports, 2005.

———. *African Civilizations: Primary Schools Teachers' Handbook (Middle Division).* Belmopan, Belize: Ministry of Education, Culture, and Sports, 2005.

———. *African Civilizations: Student's Handbook (Primary School—Upper Division).* Belmopan: Center for Multi-Cultural Studies and University of Belize Press, 2004.

Jackson, Antoinette. "Changing Ideas about Heritage and Heritage Resource Management in Historically Segregated Cities." *Transforming Anthropology* 18, no. 1 (2010): 80–92.

———. *Speaking for the Enslaved: Heritage Interpretation at Antebellum Plantation Sites.* Walnut Creek, CA: Left Coast Press, 2012.

Jacobs, Jane M. *Edge of Empire: Postcolonialism and the City.* London: Routledge, 1996.

Johnson, Melissa. *Becoming Creole: Nature and Race in Belize.* New Brunswick, NJ: Rutgers University Press, 2019.

———. "The Making of Race and Place in Nineteenth-Century British Honduras." *Environmental History* 8, no. 4 (2003): 598–617.

———. "Nature and Progress in Rural Creole Belize: Rethinking Sustainable Development." PhD diss., University of Michigan, 1998.

Jordan, Leslie-Ann, and Lee Joliffe. "Heritage Tourism in the Caribbean: Current Themes and Challenges." *Journal of Heritage Tourism* 8, no. 1 (2013): 1–8.

Joyce, T. A., J. Cooper Clark, and J. E. Thompson. *Report on the British Museum Expedition to British Honduras, 1927.* London: Royal Anthropological Institute of Great Britain and Ireland, 1927.

Joyce, Thomas A., Thomas Gann, Edward L. Gruning, and Richard C. E. Long. *Report on the British Museum Expedition to British Honduras, 1928.* London: Royal Anthropological Institute of Great Britain and Ireland, 1928.

Judd, Karen. "Cultural Synthesis or Ethnic Struggle? Creolization in Belize." *Cimarron* 2, no. 1 (1989): 103–18.

Kamp, Kathryn. "Where Have All the Children Gone? The Archaeology of Childhood." *Journal of Archaeological Method and Theory* 8, no. 1 (2001): 1–34.

Keegan, William F. "West Indian Archaeology. 1. Overview and Foragers." *Journal of Archaeological Research* 2, no. 1 (1994): 255–84.

Kirk-Greene, Anthony. *On Crown Service: A History of HM Colonial and Overseas Civil Services 1837–1997.* London: I. B. Tauris Publishers, 1999.

Koenig, Eric, E. Christian Wells, and Sarita L. Garcia. "Reclaiming Development: Community-Based Heritage Conservation and University-Engaged Research." In *Research Reports in Belizean History and Anthropology: Papers of the 2015 Belize Archaeology and Anthropology Symposium,* edited by Nigel Encalada, Rolando Cocom, Selene Solis, and Giovanni Pinelo, 63–75. Belmopan, Belize: Institute for Social and Cultural Research, 2016.

Kohl, Phillip, and Clare Fawcett, eds. *Nationalism, Politics, and the Practice of Archaeology.* Cambridge, UK: Cambridge University Press, 1995.

Labadi, Sophia. "Representations of the Nation and Cultural Diversity in Discourses on World Heritage." *Journal of Social Archaeology* 7, no. 2 (2007): 147–70.

———. *UNESCO, Cultural Heritage, and Outstanding Universal Value: Value-based analysis of the World Heritage and Intangible Cultural Heritage Conventions.* Lanham, MD: AltaMira Press, 2013.

Lee, Nedra K., and Jannie Nicole Scott. "Introduction: New Directions in African Diaspora Archaeology." *Transforming Anthropology* 27, no 2 (2019): 85–90.

Leslie, Robert. *A History of Belize: Nation in the Making.* Benque Viejo del Carmen, Belize: Cubola Productions, 1983.

Leventhal, Richard M., Wendy Ashmore, Lisa J. LeCount, and Jason Yaeger. "The Xunantunich Archaeological Project, 1991–1997." In *Classical Provincial Politics: Xunantunich and Its Hinterlands,* edited by Lisa J. LeCount and Jason Yaeger, 1–19. Tucson: The University of Arizona Press, 2010.

Levinson, Bradley. *We Are All Equal: Student Culture and Identity at a Mexican Secondary School, 1988–1998.* Durham, NC: Duke University Press, 2001.

Levinson, Bradley, Douglas Foley, and Dorothy Holland, eds. *The Cultural Production of the Educated Person.* Albany: State University of New York Press, 1996.

Lewis, Karla. "Influences on Garifuna Youth's Education." Paper presented at the Annual Meeting of the American Education Research Association, Montreal, Quebec, 1999.

Lillehammer, Grete. "A Child Is Born: The Child's World in an Archaeological Perspective." *Norwegian Archaeological Review* 22, no. 2 (1989): 89–105.

London, Norrel A. "Ideology and Politics in English-Language Education in Trinidad and Tobago: The Colonial Experience and a Postcolonial Critique." *Comparative Education Review* 47, no. 3 (2003): 287–320.

Lourie, Sylvain. *Belize: A View of Educational Growth and Change.* Paris: UNESCO, 1975.

Lundgren, Nancy. "Children, Race, and Inequality. The Colonial Legacy in Belize." *Journal of Black Studies* 23, no. 1 (1992): 86–106.

Lowenthal, David. *Possessed by the Past: The Heritage Crusade and the Spoils of History.* New York: Free Press, 1996.

Lydon, Jane, and Uzma Z. Rizvi, eds. *Handbook of Postcolonial Archaeology.* New York: Taylor & Francis, 2010.

Maconachie, R. "On the Education of Native Races." In *Special Reports on Educational Subjects, Volume 14.* London: Wyman & Sons, Limited, 1905.

Macpherson, Anne. *From Colony to Nation: Women Activists and the Gendering of Politics in Belize, 1912–1982.* Lincoln: University of Nebraska Press, 2007.

———. "Imagining the Colonial Nation: Race, Gender, and Middle-Class Politics in Belize 1888–1898." In *Race and Nation in Modern Latin America,* edited by Nancy P. Appelbaum, Anne. S. Macpherson, and Karin Alejandra Rosemblatt, 108–31. Chapel Hill: University of North Carolina Press, 2003.

Magnoni, Aline, Traci Ardren, and Scott Hutson. "Tourism in the Mundo Maya: Inventions and (Mis)Representations of Maya Identities and Heritage." *Archaeologies* 3, no. 3 (2007): 353–83.

Manzanares, Myrna. "All to the Sound of the Brokdong." Belizean Journeys. Accessed September 4, 2020. http://www.belizeanjourneys.com/features/brokdong/newsletter.html

Marier, Roger. *Social Welfare Work in Jamaica: A Study of the Jamaica Social Welfare Commission.* Paris: UNESCO, 1953.

Markham, Violet Rosa. *Return Passage: The Autobiography of Violet R. Markham.* London: Oxford University Press, 1953.

Mason, Gregory. "Early Maya Temples Still in Use Today: Mason-Spinden Expedition Finds More Evidence Suggesting that a Living Link Connects Present Natives of Yucatan with Ancient American Race." *New York Times,* May 30, 1926.

Massey, Romeo M. "The Rural Education and Agriculture Program (REAP): Belize's New Approach to Rural Primary Education." Paper presented at the Annual Meeting of the American Educational Research Association, New York, NY, March 1982.

Matsuda, Akira, and Katsuyuki Okamura, eds. *New Perspectives in Global Public Archaeology.* New York: Springer, 2011.

Matsuda, David J. "The Ethics of Archaeology, Subsistence Digging, and Artifact Looting in Latin America: Point, Muted Counterpoint." *International Journal of Cultural Property* 7, no. 1 (1998): 89–98.

Mayhew, Arthur. *Education in the Colonial Empire.* London: Longmans, Green, 1938.

McAnany, Patricia. *Maya Cultural Heritage: How Archaeologists and Indigenous Communities Engage the Past.* Lanham, MD: Rowman & Littlefield, 2016.

———. "Transforming the Terms of Engagement between Archaeologists and Communities: A View from the Maya Region." In *Transforming Archaeology: Activist Practices and Prospects,* edited by Sonya Atalay, Lee Rains Clauss, Randall H. McGuire, and John R. Welch, 159–78. Walnut Creek, CA: Left Coast Press, 2014.

McAnany, Patricia A., and Norman Yoffee. "Why We Question Collapse and Study Human Resilience, Ecological Vulnerability, and the Aftermath of Empire." In *Questioning Collapse: Human Resilience, Ecological Vulnerability, and the Aftermath of Empire,* edited by Patricia A. McAnany and Norman Yoffee, 1–17. New York: Cambridge University Press, 2009

McAnany, Patricia A., and Shoshaunna Parks. "Casualties of Heritage Distancing Children, Ch'orti' Indigeneity, and the Copán Archaeoscape," *Current Anthropology* 53, No. 1 (2012): 80–107.

McAnany, Patricia A., and Tomás Gallareta Negrón. "Bellicose Rulers and Climatological Peril? Retrofitting Twenty-first Century Woes on Eighth Century Maya Society." In *Questioning Collapse: Human Resilience, Ecological Vulnerability and the Aftermath of Empire,* edited by Patricia A. McAnany and Norman Yoffee, 142–75. New York: Cambridge University Press, 2009.

McGill, Alicia Ebbitt. "Examining the Pedagogy of Community-Based Heritage Work through an International Public History Field Experience." *The Public Historian* 40, no. 1 (2018): 55–84.

———. "Learning from Cultural Engagements in Community-based Heritage Scholarship." *International Journal of Heritage Studies* 24, no. 10 (2018): 1068–1083.

———. "Situating Public Archaeology in Crooked Tree, Belize." In *Public Participation in Archaeology,* edited by Joanne Lea and Suzie Thomas, 127–38. Suffolk, UK: Boydell Press, 2014.

McKillop, Heather, and Jaime Awe. "The History of Archaeological Research in Belize." *Belizean Studies* 11, no. 2 (1983): 1–9.

McKinney, W. J. *Annual Report on Primary Education in British Honduras for the Year 1892: Annexure 4.* Belize City: Government Printer, 1893.

Medina, Laurie Kroshus. "Commoditizing Culture: Tourism and Maya Identity." *Annals of Tourism Research* 30, no. 2 (2003): 353–68.

———. "Defining Difference, Forging Unity: The Co-Construction of Race, Ethnicity and Nation in Belize." *Ethnic and Racial Studies* 20, no. 4 (1997): 757–80.

———. *Negotiating Economic Development: Identity Formation and Collective Action in Belize.* Tucson: The University of Arizona Press, 2004.

Meskell, Lynn. *The Nature of Heritage: The New South Africa.* London: Wiley-Blackwell, 2012.

———. "The Practice and Politics of Archaeology in Egypt." *Annals of the New York Academy of Sciences* 925, no. 1 (2000): 149–50.

Metzgen, Monrad, and H. E. C. Cain. *The Handbook of British Honduras.* London: West India Committee, 1925.

Mincer, Jacob. *Schooling, Experience, and Earnings.* New York: Columbia University Press, 1974.

Ministry of Education. *National Social Studies Curriculum.* Belize: Ministry of Education, 2004.

Ministry of Education. *The National Syllabus.* Belize: Ministry of Education, 1999.

Ministry of Education, Youth and Culture. *Consultative Guidelines for Use in Defining a National Cultural Policy.* Kingston, Jamaica: 1997.

Mintz, Sidney, and Richard Price. *The Birth of African-American Culture: An Anthropological Approach.* Boston: Beacon Press, 1992.

Minute Paper Collections. Belize Archives and Records Service, Belmopan, Belize.

Mitchell-Hedges, F. A. *Land of Wonder and Fear.* New York: The Century Company, 1931.

Moberg, Mark. *Citrus Strategy and Class: The Politics of Development in Southern Belize.* Iowa City: University of Iowa Press, 1992.

Moore, Antoinette. "Twenty-Five years of Human Rights in Belize: From Theory to Practice, a Work in Progress." In *Taking Stock: Belize at 25 Years of Independence,* edited by Barbara S. Balboni and Joseph O. Palacio, 221–23. Benque Viejo del Carmen, Belize: Cubola Productions, 2007.

Moreno, Daniela Catalina Balanzátegui. "Collaborative Archaeology to Revitalize an Afro-Ecuadorian Cemetery." *Journal of African Diaspora Archaeology and Heritage* 7, no. 1, (2018): 42–69.

Mortensen, Lena, and Julie Hollowell, eds. *Ethnographies and Archaeologies: Iterations of the Past.* Gainesville: University of Florida Press, 2009.

Morton, Samuel George. *Crania Americana, Or Comparative View of the Skulls of Various Aboriginal Nations of North and South America.* Philadelphia: J. Dobson, 1839.

Moshenska, Gabriel, ed. *Key Concepts in Public Archaeology.* London: University College London Press, 2017.

National Culture Policy Council. *What the People Said.* Belize City: Government of Belize and National Culture Policy Council, 1993.

National Institute of Culture and History. "About NICH." Accessed September 4, 2020. https://nichbelize.org/about-nich/.

New York Times. "Lindbergh Sights Unknown Maya City." October 7, 1929.

Nora, Pierre. "Between Memory and History: Les Lieux de Mémoire." *Representations* 26, no. 1 (1989): 7–24.

Nott, Josiah Clark, and George R. Gliddon, eds. *Indigenous Races of the Earth.* Philadelphia: J. B. Lippincott, 1857.

———. *Types of Mankind.* Philadelphia: Lippincott, Grambo & Co., 1854.

Oestreich, Jo Beth Babcock. "Social Studies Curriculum Development in Belize: 1950–2001." PhD diss., University of Texas at Austin, 2002.

Ogundiran, Akinwumi, and Toyin Falola, eds. *Archaeology of Atlantic Africa and the African Diaspora.* Bloomington: Indiana University Press, 2010.

Ormsby-Gore, William. "Educational Problems of the Colonial Empire." *Journal of the Royal African Society* 36, no. 143 (1937): 165.

———. "Memorandum submitted to the Secretary of State for the Colonies by the Advisory Committee on Native Education in the British Tropical African Dependencies." London: His Majesty's Stationary Office, 1925.

Orser Jr., Charles E. "The Archaeology of the African Diaspora." *Annual Reviews in Anthropology* 27, no. 1 (1998): 63–82.

Parks, Shoshaunna. "Archaeological Ethics and the Struggle for Community Legitimacy in the Maya Archaeoscape." PhD diss., Boston University, 2009.

———. "The Collision of Heritage and Economy at Uxbenká, Belize." *International Journal of Heritage Studies* 16, no. 6 (2010): 434–48.

———. "Winning Title to Land but Not to Its Past: The Toledo Maya and Sites of pre-Hispanic Heritage." *International Journal of Cultural Property* 18, no. 1 (2011): 111–29.

Pateman, Michael P. "The Bahamas." In *Protecting Heritage in the Caribbean,* edited by Peter E. Siegel and Elizabeth Righter, 4–5. Tuscaloosa: The University of Alabama Press, 2011.

Pendergast, David. "A. H. Anderson, 1901–1967." *American Antiquity* 33, no. 1 (1968): 92.

———. "The Center and the Edge: Archaeology in Belize, 1809–1992." *Journal of World Prehistory* 7, no. 1 (1993): 1–3.

Pendergast, David, and Elizabeth Graham. "Fighting a Looting Battle: Xunantunich, Belize." *Archaeology* 34, no. 4 July/August (1981): 16.

Pennycook, Alastair. *English and the Discourses of Colonialism.* London: Routledge, 1998.

Phillips, Caroline, and Harry Allen, eds. *Bridging the Divide: Indigenous Communities and Archaeology into the 21st Century.* Walnut Creek, CA: Left Coast Press, 2010.

Phillipson, Robert. *Linguistic Imperialism.* Oxford: Oxford University Press, 1992.

Phulgence, Winston F. "African Warriors, Insurgent Fighters, and the Memory of Slavery in

the Anglophone Caribbean." *Journal of African Diaspora Archaeology and Heritage* 4, no. 3, (2015): 214–26.

Pollock, Mica. *Colormute: Race Talk Dilemmas in an American School.* Princeton, NJ: Princeton University Press, 2005.

Pyburn, K. Anne. "Archaeology for a New Millennium: The Rules of Engagement." In *Archaeologists and Local Communities: Partners in Exploring the Past,* edited by Linda Derry and Maureen Malloy, 167–84. Washington, D.C.: Society for American Archaeology, 2003.

———. "Engaged Archaeology: Whose Community? Which Public?" In *New Perspectives in Global Public Archaeology,* edited by Akira Matsuda and Katsuyuki Okamura, 29–41. New York: Springer, 2011.

———. "The Hydrology of Chau Hiix." *Ancient Mesoamerica* 14, no. 1, (2003): 123–29.

———. "The Politics of Collapse." *Archaeologies* 2, no. 1 (2006): 3–7.

———. "Preservation as 'Disaster Capitalism': The Downside of Site Rescue and the Complexity of Community Engagement." *Public Archaeology* 13, no. 1–3 (2014): 232.

Pyburn, K. Anne, and Richard R. Wilk. "Responsible Archaeology is Applied Anthropology." In *Ethics in American Archaeology,* edited by Mark Lynott and Alison Wylie, 78–83. Washington, DC: Society for American Archaeology, 2000.

Rabinowitz, Richard. *Curating America: Journeys through Storyscapes of the American Past.* Chapel Hill: University of North Carolina Press, 2016.

Read, Margaret. *Education and Social Change in Tropical Areas.* London: Thomas Nelson and Sons Ltd., 1955.

Reddock, Rhoda. *Women, Labour and Politics in Trinidad and Tobago: A History.* London: Zed Books, 1994.

Reid, Basil A., and Vel Lewis. "Trinidad and Tobago." In *Protecting Heritage in the Caribbean,* edited by Peter E. Siegel and Elizabeth Righter, 125–33 Tuscaloosa: The University of Alabama Press, 2011.

Resser, Douglas, and Claire Novotny. "Destroying Nohmul: Heritage Distancing and an Ancient Mayan Site in Belize, Notes from the Field." *Anthropology News* 54, no. 5 (2013)

Rice, Don Stephen. "The Archaeology of British Honduras: A Review and Synthesis." *Occasional Publications in Anthropology, Archaeology Series, No. 6.* Greeley, CO: Museum of Anthropology, University of Northern Colorado, 1974.

Ricento, Thomas, ed. *Ideology, Politics and Language Policies.* Amsterdam: John Benjamins, 2000.

Richards, Andrea, and Ainsley Henriques. "Jamaica." In *Protecting Heritage in the Caribbean,* edited by Peter E. Siegel and Elizabeth Righter, 26–34. Tuscaloosa: The University of Alabama Press, 2011.

Richardson, Robert. "Economic Development in Belize: Two Steps Forward, Two Steps Back." In *Taking Stock: Belize at 25 Years of Independence,* edited by Barbara S. Balboni and Joseph O. Palacio, 21–45. Benque Viejo del Carmen, Belize: Cubola Productions, 2007.

Rico, Trinidad. "Heritage at Risk: The Authority and Autonomy of a Dominant Preservation Framework." In *Heritage Keywords: Rhetoric and Redescription in Cultural Heritage,* edited by Kathryn Lafrenz Samuels and Trinidad Rico, 147–62. Boulder: University Press of Colorado, 2015.

Rival, Laura. "Formal Schooling and the Production of Modern Citizens in the Ecuadorian Amazon." In *The Cultural Production of the Educated Person,* edited by Bradley Levinson,

Douglas Foley, and Dorothy Holland, 153–68. Albany: State University of New York Press, 1996.

Robin, Cynthia, Laura Kosakowsky, Kacey Grauer, and Zachary Nissen. "Community Archaeology at Aventura: Archaeology about Communities and Archaeology for Communities, Results of the 2016 Field Season." In *Research Reports in Belizean Archaeology, Volume 15,* edited by John Morris, Melissa Badillo, and George Thompson, 319–28. Belmopan, Belize: Institute of Archaeology, 2018.

Rose, Nikolas, and Peter Miller. "Political Power Beyond the State: Problematics of Government." The British Journal of Sociology 43, no. 1 (1992): 173–205.

Rouse, Irving. *The Tainos: Rise and Decline of the People Who Greeted Columbus.* New Haven, CT: Yale University Press, 1992.

Rubin, Beth. "'There's Still Not Justice': Youth Civic Identity Development Amid Distinct School and Community Contexts." *Teachers College Record* 109, no. 2 (2007): 449–81.

Rutheiser, Charles. "Culture, Schooling, and Neocolonialism in Belize." PhD diss., Johns Hopkins University, 1990.

Said, Edward. *Orientalism.* New York: Vintage Books, 1979.

Salazar, Noel B. "Tourism Imaginaries: A Conceptual Approach." *Annals of Tourism Research* 39, no. 2 (2012): 863–82.

Salmon, William. "Language Ideology, Gender, and Varieties of Belizean Kriol." *Journal of Black Studies* 46, no. 6, (2015): 605–25.

Salmon, William, and Jennifer Gómez Menjívar. "Language Variation and Dimensions of Prestige in Belizean Kriol." *Journal of Pidgin and Creole Languages* 31, no. 2 (2016), 316–60.

———. "Setting and Language Attitudes in a Creole Context." *Applied Linguistics* 40, no. 2 (2019): 248–64.

Sanchez, Inez E. *The Easter and Dixon Reports: An Analysis and Discussion of Their Impact on Our Educational Development.* Belize Institute for Social Research and Action, Occasional Publications, no. 7, 1977.

Savage, Kirk. *Monument Wars: Washington, D.C., the National Mall, and the Transformation of the Memorial Landscape.* Berkeley: University of California Press, 2009.

Schadla-Hall, Tim. "Public Archaeology in the Twenty-First Century." In *A Future for Archaeology: The Past in the Present,* edited by Robert Layton, Stephen Shennan, and Peter Stone, 75–82. Walnut Creek, CA: Left Coast Press, 2006.

Schwartzman, Helen B., ed. *Children and Anthropology: Perspectives for the 21st Century.* Westport, CT: Bergin and Garvey, 2001.

Scott, James C. *Seeing like a State: How Certain Schemes to Improve the Human Condition Have Failed.* New Haven, CT: Yale University Press, 1999.

———. *Weapons of the Weak: Everyday Forms of Peasant Resistance.* New Haven, CT: Yale University Press, 1987.

Seghers, Maud. "Phelps-Stokes in Congo: Transferring Educational Policy Discourse to Govern Metropole and Colony." *International Journal of the History of Education* 40, no. 4 (2004): 455–77.

Shoman, Assad. *SPEAR 1990 Annual Report.* Belize: SPEAR Press, 1990.

———. *Thirteen Chapters of a History of Belize.* Belize City: Angelus Press Limited, 1994.

———. "Why a National Education Symposium?" In *Backtalking Belize: Selected Writings,* edited by Anne S. Macpherson, 35–46. Belize City: Angelus Press Limited, 1995.

Simmons, Kimberly Eison. *Reconstructing Racial Identity and the African Past in the Dominican Republic.* Gainesville: University Press of Florida, 2009.

Singleton, Teresa. *Slavery Behind the Wall: An Archaeology of a Cuban Coffee Plantation.* Gainesville: University Press of Florida, 2015.

Singleton, Teresa, and Marcos André de Souza Torres. "Archaeologies of the African Diaspora: Brazil, Cuba, United States." In *International Handbook for Historical Archaeology,* edited by Teresita Majewski and David Gaimster, 449–69. New York: Springer, 2009.

Skeates, Robin, Carol McDavid, and John Carman, eds. *The Oxford Handbook of Public Archaeology.* Oxford: The Oxford University Press, 2012.

Smardz, Karolyn E., and Shelley J. Smith, eds. *The Archaeology Education Handbook: Sharing the Past with Kids.* Walnut Creek: Altamira Press, 2000.

Smith, Laurajane. *Uses of Heritage.* London: Routledge, 2006.

Smith, Michael Garfield. "Introduction." In *My Mother Who Fathered Me: A Study of the Family in Three Selected Communities in Jamaica,* edited by Edith Clarke, i-xliv. London: George Allen and Unwin, 1966.

———. *Pluralism, Politics and Ideology in the Creole Caribbean.* New York: Research Institute for the Study of Man, 1991.

Smith, R. T. *The Matrifocal Family: Power, Pluralism, and Politics.* New York: Routledge, 1996.

Snodgrass, Elizabeth. "Ancient Maya Pyramid Destroyed in Belize." May 16, 2013. https://news.nationalgeographic.com/news/2013/13/130515-belize-pyramid-destroyed-archeology-maya-nohmul-world-road/.

Song, S. Y., and S. M. Pyon. "Cultural Deficit Model." In *Encyclopedia of Educational Psychology,* edited by Neil J. Salkind, 216–17. Thousand Oaks, CA: SAGE Publications, Inc., 2008.

Spring, Joel. *How Educational Ideologies Are Shaping Global Society: Intergovernmental Organizations, NGOs, and the Decline of the Nation-State.* Mahwah, NJ: Lawrence Erlbaum, 2004.

Stanton, Cathy. *The Lowell Experiment: Public History in a Post-industrial City.* Amherst: University of Massachusetts Press, 2006.

Stephens, John Lloyd. *Incidents of Travel in Central America, Chiapas and Yucatán.* Volumes I and II. London: John Murray, 1841.

———. *Incidents of Travel in Yucatan,* Volumes I and II. New York: Harper and Brothers, 1843.

Stoler, Ann Laura, and Frederick Cooper. "Between Metropole and Colony: Rethinking a Research Agenda." In *Tensions of Empire,* edited by Frederick Cooper and Ann Laura Stoler, 1–56. Berkeley: University of California Press, 1997.

Stone, Michael. "Cultural Policy, Local Creativity and the Globalization of Belize." In *Taking Stock: Belize at 25 Years of Independence,* edited by Barbara S. Balboni and Joseph O. Palacio, 290. Benque Viejo del Carmen, Belize: Cubola Productions, 2007.

Straughan, Jerome. "Emigration from Belize since 1981." In *Taking Stock: Belize at 25 Years after Independence,* edited by Barbara S. Balboni and Joseph O. Palacio, 254–279. Benque Viejo del Carmen, Belize: Cubola Productions, 2007.

Stronza, Amanda. "Through a New Mirror: Tourism and Identity in the Amazon." In *Tourists and Tourism: A Reader,* edited by Sharon Bohn Gmelch, 279–304. Long Grove, IL: Waveland Press. 2010.

Swayne, Eric John Eagles. Letter from "The Governor to the Secretary of State, 29th March 1910." In Colonial Reports-Miscellaneous, No. 84 *Papers Relating to the Preservation of*

Historic Sites and Ancient Monuments and Buildings in the West Indian Colonies, London: His Majesty's Stationary Office, (1912): 34–35.

Taussig, Michael. *The Nervous System.* New York: Routledge, 1992.

Thomas, Deborah A. *Modern Blackness: Nationalism, Globalization, and the Politics of Culture in Jamaica.* Durham, NC: Duke University Press, 2004.

Thomas, Julian. *Archaeology and Modernity.* London: Routledge, 2004.

Thomas, Nicholas. *Colonialism's Culture: Anthropology, Travel and Government.* Princeton, NJ: Princeton University Press, 1994.

Thomas, Suzie, and Joanne Lea, eds. *Public Participation in Archaeology.* Suffolk, UK: Boydell & Brewer, Ltd, 2014.

Thompson, Cynthia. "Education Reform in Post-War Post-Independence Belize." In *Education Reform in the Commonwealth Caribbean,* edited by E. Miller, 47–70. Washington, D.C.: Organization of American States, 1999.

Thompson, J. Eric S. *Ethnology of the Mayas of Southern and Central British Honduras.* Anthropological Series XVII, no. 2. Chicago: Field Museum of Natural History, 1930.

———. *Maya Archaeologist.* Norman: University of Oklahoma Press, 1963.

———. *The Rise and Fall of Maya Civilization.* Norman: University of Oklahoma Press, 1954.

———. "Thomas Gann in the Maya Ruins." *The British Medical Journal* 2, no. 4 (1975): 741–43.

Thompson, Raymond Harris. "The Antiquities Act of 1906 by Ronald Freeman Lee." *Journal of the Southwest* 42, no. 2, summer (2000): 197–269.

The Times. "Editorial," unknown date, 1873.

The Times. "Maya Relics For The British Museum." May 25, 1931.

Tobin, Joseph, and Allison Henward. "Ethnographic Studies of Children and Youth and the Media." In *A Companion to Anthropology of Education,* edited by Bradley Levinson and Mica Pollock, 212–31. Malden, MA: Wiley-Blackwell, 2011.

Topsey, Harriet W. "New Developments in the Cultural Resource Management of Belize." Paper presented at the IV Mesa Redonda de Palenque, June 1980.

Trigger, Bruce G. "Alternative Archaeologies: Nationalist, Colonialist, Imperialist." *Man* 19, no. 3 (1984): 355–70.

Trouillot, Michel-Rolph. *Silencing the Past: Power and the Production of History.* Boston: Beacon Press, 1995.

Udz, Silvaana. "Improving Kriol Language Attitude and English Accuracy: An Exploratory Study." Paper presented at the Belize International Symposium on Education, Belize, January 2, 2013.

Van Den Berghe, Pierre L. *The Quest for the Other: Ethnic Tourism in San Cristobal, Mexico.* Seattle: University of Washington Press, 1994.

———. "Tourism and the Ethnic Division of Labor." *Annals of Tourism Research* 19, no. 2 (1992): 234–49.

Vicioso, Esteban Prieto. "Dominican Republic." In *Protecting Heritage in the Caribbean,* edited by Peter E. Siegel and Elizabeth Righter, 37–38. Tuscaloosa: The University of Alabama Press, 2011.

Village View Post. "CROOKED TREE VILLAGE SCHOOL GIRLS WIN NATIONAL SOFTBALL CHAMPIONSHIP." April 6, 2009. http://www.villageviewpost.com/2009/04/crooked-tree-village-school-girls-wins.html.

Visit Crooked Tree. "History & Culture." Accessed September 4, 2020. http://visitcrookedtree.com/know-learn/history-culture/.

Wainwright, Joel. *Decolonizing Development: Colonial Power and the Maya.* Malden, MA: Blackwell Publishing, 2008.

Wallace, Colin. "Reconnecting Thomas Gann with British Interest in the Archaeology of Mesoamerica: An Aspect of the Development of Archaeology as a University Subject." *Bulletin of the History of Archaeology* 21, no. 1 (2011): 23–36.

Wallace, Tim. "Tourism, Tourists and Anthropologists at Work." *NAPA Bulletin* 23, no. 1 (2005): 5.

Walsh, Jane MacLaren, "The Skull of Doom." *Archaeology.* May 27, 2010. https://archive.archaeology.org/online/features/mitchell_hedges/acquisition_history.html.

Ward, W. E. F. "Education in the Colonies." In *New Fabian Colonial Essays,* edited by Arthur Creech Jones, 185–205. New York: Praeger, 1959.

Waterton, Emma, and Steve Watson. "Framing Theory: Towards a Critical Imagination in Heritage Studies." *International Journal of Heritage Studies* 19, no. 6 (2013): 552.

Whitehead, Clive. "'The Admirable Ward'; A Portrait of W.E.F. (Frank) Ward CMG, Colonial Educator, Administrator, Diplomat, and Scholar." *Journal of Educational Administration and History* 25, no. 2 (1993): 138–60.

———. "Education in British Colonial Dependencies, 1919–39: A Re-Appraisal." *Comparative Education* 17, no. 1 (March 1981): 71–80.

———. "The Nester of British Colonial Education: A Portrait of Arthur Mayhew CIE, CMG (1878–1948)." *Journal of Educational Administration and History* 29, no. 1 (1997): 51–76.

Wilk, Richard. *Agriculture, Ecology, and Domestic Organization Among the Kekchi Maya.* PhD diss., University of Arizona, 1981.

———. "Colonialism and Wildlife in Belize." *Belizean Studies* 27, no. 2 (2005): 4–12.

———. "Connections and Contradictions: From the Crooked Tree Cashew Queen to Miss World Belize." In *Beauty Queens on the Global Stage: Gender, Contests, and Power,* edited by Colleen Ballerino Cohen, Richard Wilk, and Beverly Stoeltje, 217–32. New York: Routledge, 1996.

———. *Home Cooking in the Global Village: Caribbean Food from Buccaneers to Ecotourists.* Oxford: Berg Publishers, 2006.

———. "Learning to Be Local in Belize: Global Systems of Common Difference." In *Worlds Apart: Modernity through the Prism of the Local,* edited by Daniel Miller, 110–33. London: Routledge, 1995.

Wilk, Richard, and William Rathje. "Household Archaeology." *The American Behavioral Scientist* 25, no. 6 (1982): 617–639.

Wilkie, Laurie A. "Communicative Bridges Linking Actors through Time: Archaeology and the Construction of Emancipatory Narratives at a Bahamian Plantation." *Journal of Social Archaeology* 1, no. 2 (2001): 225–43.

———. "Conclusion: Minding the Gaps in the Diasporic Web." In *Archaeologies of Slavery and Freedom in the Caribbean: Exploring the Spaces in Between,* edited by Lynsey A. Bates, John M. Chenoweth, and James A. Delle, 343–344. Gainesville: University Press of Florida, 2016.

Wilkie, Laurie A., and Paul Farnsworth. *Sampling Many Pots: An Archaeology of Memory and Tradition at a Bahamian Plantation.* Gainesville: University Press of Florida, 2005.

————. "Trade and the Construction of Bahamian Identity: A Multiscalar Exploration." *International Journal of Historical Archaeology* 3, no. 1 (1999): 283–320.

Williams, Brackette F. *Stains on My Name, War in My Veins: Guyana and the Politics of Cultural Struggle.* Durham, NC: Duke University Press, 1991.

Williams, Raymond. *Marxism and Literature.* Oxford: Oxford University Press, 1977.

Wilson, Arthur. "The Logwood Trade in the Seventeenth and Eighteenth Centuries." In *Essays in the History of Modern Europe,* edited by Donald C. McKay, 1–15. New York: Harper and Row, 1936.

Wilson, Josephine. "Education and Educational Planning in Belize." MA thesis, University of Manitoba, 1980.

Wolf, Eric. *Europe and the People without History.* Berkeley: University of California Press, 1982.

Woods, Louis A., Joseph M. Perry, and Jeffrey W. Steagall. "The Composition and Distribution of Ethnic Groups in Belize: Immigration and Emigration Patterns, 1980–1991." *Latin American Research Review* 32, no. 3 (1997): 63–88.

World Travel & Tourism Council. *Travel & Tourism Economic Impact 2018 Belize.* March 2018. https://wttc.org/Research/Economic-Impact.

Yaegar, Jason, and Greg Borgstede. "Professional Archaeology and the Modern Maya: A Historical Sketch." In *Continuities and Changes in Maya Archaeology: Perspectives at the Millennium,* edited by Charles W. Golden and Greg Borgstede, 232–56. London: Routledge, 2004.

Yon, Daniel. *Elusive Culture: Schooling, Race, and Identity in Global Times.* Albany: University of New York Press, 2000.

Zarger, Rebecca, and Kristina Baines. *TEACHA—Toledo Environmental and Cultural Heritage Alliance: An Environmental and Cultural Heritage Workbook for Students and Teachers.* Toledo Environmental and Cultural Heritage Alliance, Belize, 2014. http://teacha.org/media/teacha-workbook-version-1.pdf.

Index

Page numbers in *italics* indicate illustrations.

with, 140–41; looting of antiquities in, 137–38, 226n107; Maya-centric practices, 140, 142; national heritage management and, 131, 133–34; national identity and, 132, 138–40, 142; object-driven focus of, 135; partage system in, 132–33; partnerships with foreign institutions, 133–34; preservation efforts in, 133, 137–38; privileging of archaeological science in, 137–38, 226n107; tourism development and, 138–39, 142

Archives of British Honduras, The (Burdon), 40

Armstrong, Douglas, 126–27, 131, 160

Ashcraft, Norman, 69

Authorized heritage discourse, 2, 114. *See also* Official heritage

Bacchus, Mohammed Kazim, 36

Badran, Arwa, 230n80

Bahamas, 132, 144, 161, 185

Baines, Kristina, 203

Banks, Edmund, 162–66, 170

Baram, Uzi, 154, 186

Barbados, 41, 160

Baron Bliss Institute, 139

Battle of St. George's Caye, 39–41, 61, 106, 126

Baymen, 12, 38, 40, 60, 106

Belize: African history in, 12–13, 39, 106, 125–26; Ancient Maya in, 12–13, 17; antiquities laws in, 121, 131–32, 147; archaeological expeditions to, 19, 114–21; archaeologically-themed tourism in, 138–39; Archaeological Reserves in, 148; colonial economy and, 10–11, 210n32; community-based archaeological initiatives, 141, 155, 185, 227n118; cultural heritage education and, 75, 155–56; cultural pluralism in, 13, 15, 76, 81, 84; demographics of, 12, 219n12; development aid agencies and, 57, 61–63; economic development in, 11; ecotourism and, 197; ethnic diversity in, 77–82; foreign dependency, 11, 157–58; globalization and, 109; history of colonialism in, 228n27; history of enslavement in, 40, 228n27; independence of, 19, 56–58, 132; Kriol language and, 95; language diversity in, 32, 37, 95; Mestizo people in, 12, 219n12; national identity and, 17, 187; nationalism and, 50, 57–58; political movements in, 57–58, 60; racial and ethnic dynamics, 12–15, 23; racialization and, 30–32; resistance to external heritage efforts, 128, 168–70; state management of archaeology, 143–49, 152–53; tourism and, 6, 152–53, 166,

183, 228n35, 228n37; universal adult suffrage in, 57. *See also* British colonialism

Belize (Sherlock), 68

Belizean Forestry Department, 4

Belizean heritage: Ancient Maya heritage and, 132, 142, 148–49; British-centric narratives, 61; cultural programming and, 72, 84, 142, 155, 187; defining, 209n9; development aid agencies and, 62; globalization period education and, 20, 41; independence period education and, 69; Kriol identity and, 12; marginalization of history of enslavement in, 11; marginalization of Kriol history in, 11, 41; marginalization of non-Ancient Maya heritage, 11; official, 3–4, 209n9; professional training and, 134, 143, 206; vernacular, 3–4, 209n9. *See also* Heritage; Official heritage; Vernacular heritage

Belize Archaeology Symposium, 146

Belize Audubon Society, 4, 157

Belize City, 4, 13, 26, 49, 115, 191

Belize Estate and Produce Company (BEC), 54, 157

Belize Film Commission, 145

Belize Ministry of Tourism and Civil Aviation, 145

Belize Tourism Board, 152, 228n37

Belize Tourism Development Project, 153

Belize Tourism Industry Association, 152, 228n37

Belize Town, 13, 26–27, 48–49, 55, 115

Belmopan, 57, 139–40

Bennett, Joseph Alexander, 67, 217n170

Bermuda, 41, 150

"Between Memory and History" (Nora), 7

Bezerra, Marcia, 108, 231n127, 232n153

Biscayne Government School (BGS), 81, 86, 89, 200

Biscayne Village: Ancient Maya knowledge in, 158; archaeological consciousness and, 161, 164–65; geographic setting of, 4; Kriol culture and, 189; official heritage discourse and, 156, 158–59; public history field project in, 194; vernacular heritage and, 182; youth as cultural agents in, 199; youth encounters with archaeology, 171, 174, 177–82

Blackburn, 33, 53–54, 157

Black Cross Nurses, 60

Bliss, Baron, 79, 220n24

Bocatora language, 95, 221n56

Bolland, Nigel, 13

Boone, Kofi, 196

Bradley, E. H., 50

Briceño, Elizio, 68

Brief Sketch of British Honduras (Anderson), 133, 139

Brief Sketch of British Honduras Past, Present, and Future, A (Burdon), 40

Bristowe, Lindsay, 31

British colonialism: agricultural education and, 36; archaeological oversight and, 121; archaeology as surveillance in, 117–18; censuses in, 212n23; colonial race concept and, 14, 124–25; community development requests, 49–53; concern about family practices under, 34–35; control of historical narratives, 14, 126; cultural identity and, 94; cultural inequalities and, 25; development aid agencies and, 62; education and, 6, 11, 14, 30, 34, 213n37; enslaved Africans and, 4, 12; forestocracy and, 10, 54, 210n32; heritage discourse and, 10, 107, 150; political control and, 16; popular resistance to, 47–49; racial ideologies and, 12–15, 25, 28, 30–34; sustainability concerns for, 59; timber extraction under, 4, 12, 107, 157; tourism and, 150; tourism marketing and, 150; underdevelopment and, 10–11. *See also* Archaeology (Colonial Period); Decolonization; Education (Colonial Period)

British Honduras, 1, 13, 26–27, 209n1. *See also* Belize

British Honduras Social Services Council, 60

British Honduras Taxpayers Association (BHTA), 39–40, 61

British Museum, 118, 120–22, 133

Brown, E., 56

Brown, Mabel Richmond, 118–19, 121

Bude, Udo, 30, 43

Burdon, John A., 40

Bureau of American Ethnology (Smithsonian Institution), 118

Bushi (bushy), 88, 95, 220n41, 221n56

Byrne, Denis, 153

Cain, H. E. C., 40

Caribbean: African-descendant heritage in, 37, 127, 150, 188–89; agricultural education in, 36; archaeological heritage and material culture in the, 160; archaeology and, 126–27, 131–32, 184–85, 188–89; church-state education system, 26; colonial education in, 16, 29–30; colonial history and, 126; colonial

race concept and, 12, 30; economic development and, 11; educational programming in, 45–46; multilingualism and, 64–65; national independence in, 131; official heritage and, 30; school attendance in, 29; shared history and culture, 64–65; speech traditions and, 64–65, 221n64; state management of archaeology, 144; tourism and, 150, 152. *See also* Jamaica

Caribbean Development and Co-operation Committee, 64

Caribs, 31–32, 38–39

Carman, B. E., 31, 38–39, 55

Carnegie Institution of Washington, 120

Cashew heritage, 193–95, *195,* 200

Catherwood, Frederick, 115–16

Central America: archaeologically-themed tourism in, 138–39; archaeologist racial constructs and, 125; archaeology in, 114–20; economic development and, 11; Kriol interactions in, 91; looting of antiquities in, 137; marginalization of African history in, 126–27; Mestizo people in, 12; tourism and, 152

Chailley-Bert, Joseph, 28

Chau Hiix Archaeological Project (CHAP): as an archaeoscape, 158; Blackburn and, 54; community-based initiatives, 141, 155; Crooked Tree residents and, 4–5, 8–9, 141, 158, 163–71, 187–88, 230n81; damage to, 170; educational outreach by, 202–3; inaccessibility of, 169, 230n93; landscape surrounding, 156–58; local autonomy over, 164–65, 168–70; local engagement with, 162–64, 230n98; Mayan occupation of, 157; official heritage and, 19, 86, 156; public archaeology and, 68, 141, 188; stories of hauntings at, 177; tourism development and, 162–64, 166–69, 204

Choc, Xavier, 148–49, 151, 153, 227n18

Clarke, Lionel, 216n137

Cleghorn, Robert, 29, 33, 49, 53–54

Coe, Cati, 9–10

Coggins, Clemency, 135, 137

Colonial race concept: adaptive education and, 43; archaeological adventure narratives and, 119; British colonialism and, 12, 14; colonial period archaeology and, 124–25; education and, 14–15, 30–31, 36

Committee on National Symbols and National Observances, 18. *See also* Racial science

Community petitions: Belizean nationalism and, 50; Crooked Tree residents and, 49–52, 189;

language usage in, 52–53; school resource requests, 51–52; vernacular heritage and, 52; waterway dredging and, 49–50

Corozal Organization of East Indian Cultural Heritage, 155

Courtenay, W. H., 58

Crawford, Godwin, 204

Crawford, Linda, 198

Creole, 31–32, 38, 80, 91, 183, 209n10. *See also* Kriol peoples

Creole language, 19, 32, 37–38, 53, 69, 221n64. *See also* Kriol peoples

Crooked Tree Government School (CTGS), 51, 81, 86, 165, 192, 199–200

Crooked Tree Village: Ancient Maya knowledge in, 158, 161–62; archaeological engagement and, 23, 159, 162–68; as an archaeoscape, 158; Blackburn, 54, 157; cashew production in, 193–95, *195,* 200; CHAP project and, 4–5, 8–9, 141, 156, 158, 163–71, 187–88, 202–3; colonial period education in, 27, 29; colonial settlement of, 157; community agency and, 55–56; community development requests, 49–53, 189; cultural exchanges and, 203–4, *204,* 205, *205,* 206; ecotourism and, 162, 197; emigrant ties with, 197–98; enslaved Africans and, 4, 12; fire hearth cooking, 168, 178; geographic setting of, 4, 157, 192, 233n16; Kriol culture and, 189, 191–93; Kriol language and, 54–55; local cultural resources and, 162–64, 167–68; official heritage discourse and, 156, 158–66, 168; promotion of Kriol culture, 155, 190; public history field project in, 194–95, *195,* 196, *196;* resistance to external heritage efforts, 169–71; school attendance in, 29, 33, 53; social media use, 198; socionatural heritage in, 196; sports and, 192, 199; storytelling and folk stories in, 55, 191–93; tourism and, 162, 167–69; use of school buildings for organizing, 56; vernacular heritage and, 52, 159, 163, 168, 182, 190–94, 197; youth as cultural agents in, 198–99; youth encounters with archaeology, 171–72, 174–75, 177–82. *See also* Kriol heritage

Crooked Tree Village Council, 165, 170, 204

Crooked Tree Village Reunion, 198

Crooked Tree Wildlife Sanctuary (CTWS), 4, 54, 157, 168

Crown Site Reserves, 132, 225n82

Cultural deficit rhetoric: African cultural practices and, 30; colonial period education and, 33–38; on family structures, 34–35; juvenile delinquency and, 35; on Kriol peoples, 33; music traditions and, 38; oral traditions and, 37–38; racial and ethnic stereotyping, 35–36

Cultural exchange, 203–4, *204,* 205–6

Cultural knowledge: archaeological interpretations and, 141; colonial education and, 33; ecological, 205, *205;* Kriol heritage and, 33, 54; Kriol youth and, 198–200; persistence of, 190; protection of, 4, 19, 72, 94, 117, 130, 163; social media use and, 198

Culture: defining, 209n5; essentialization of, 17, 21, 73, 79, 84–85, 88–89, 92; globalization of, 16; marginalization of African heritage, 150; national policy and, 18, 73–74, 145, 219n20

Cunin, Elisabeth, 13

Decolonization: African diaspora heritage and, 189; education and, 20–21, 65–67, 69–70, 187, 217n165; official heritage practices and, 16–17

Department of Archaeology (DoA), 131, 133, 138, 142–43, 152. *See also* Institute of Archaeology (IA)

Dillon, A. Barrow, 27, 29, 37, 53

Dominican Republic, 18, 90, 144, 214n65

Easter, B. H., 37–38, 44–45

East Indian Council, 155

Ecological heritage: Crooked Tree residents and, 205–6; cultural identity and, 234n42; Kriol peoples and, 54, 168, 190, 202; official heritage and, 167; storytelling and, 191; youth and, 201. *See also* Environmental heritage

Economic Commission for Latin America, 64

Education: adaptive, 41–43, 46; archaeology and, 5–6, 11, 24, 155, 167, 171, 185–86; Belizean levels of, 78, 219n21; church-state system, 26, 66; colonial, 6, 11, 14–16, 25, 29; colonial race concept and, 14–15, 30–31, 36; control of historical narratives and, 14; cultural deficit rhetoric, 33–34; decolonization of, 20–21, 65–67, 187, 217n165; as heritage practice, 10, 23, 25; national culture and, 9, 17, 21; official heritage and, 5–6, 9–10, 85–86; surveillance and discipline in, 29; upward mobility and, 199–200; vernacular heritage and, 5, 9; vernacular language and, 43, 45. *See also* Adaptive education; Education (Colonial Period); Education (Globalization Period); Education (Independence Period)

Education (Colonial Period): adaptive education and, 41–44, 46–47; agricultural education, 36; Battle of St. George's Caye myth and, 41; Belizean citizen response to, 48–49; British models for, 29–30; church-state system, 26–28, 212n3; civilizing mission and, 28; colonial race concept and, 30–31, 36; community support in, 55–56; concern about family practices and, 34–35; cultural deficit rhetoric and, 33–38; cultural differences and, 20, 25, 31; cultural heritage ideologies and, 30; discouragement of Kriol language, 13, 37–38; enforcement of colonial rule and, 20, 27–29; English language instruction and, 30, 36–37; exclusion of history of slavery in, 40–41; as heritage process, 25, 28; historical narratives in, 25, 28; marginalization of Kriol history in, 38–40; mass education and, 46–47; official heritage and, 37–40; poor school conditions in, 27; racial ideologies and, 28, 30–36, 38, 43–44; resistance to, 53–54; school attendance in, 33, 53; social control and, 29, 212n18; surveillance and discipline in, 29, 48; use of school buildings for organizing, 56; vernacular heritage and, 37–38, 53–54; vernacular language and, 37–38, 43, 45, 54

Education (Globalization Period): AMH materials, 82–83, *83,* 84, 95–97; Ancient Maya curriculum, 79, 153; Belizean ethnicity and, 78–84, 87–91; Belizean heritage and, 20–21, 78–79; colonial cultural values in, 73–76; cultural programming in, 72–73, 83–85, 87–94, 97–100, 110–11; ethnic stereotypes in, 73, 88–90, 101, 107–9; heritage discourse and, 73, 75–78, 87–103, 107–9, 112–13; Kriol language and, 95, 97–99, 221n54; lack of government support for, 97; language policies and, 75; marginalization of Kriol history in, 81–84, 92–94, 99–100, 106; national curricula and, 78–80, 100–101; national education in, 73–78; National Syllabus of Belize, 74; official heritage and, 85–87, 161–62; racial ideologies and, 73, 90; rote learning in, 74–75, 101, 103, 106, 222n69; syncretic nationalism and, 76–77, 81, 84; textbooks for, 78; tourism curricula and, 81–82; Western-based knowledge in, 75; youth interpretations and, 100–103, *104,* 105, *105,* 106–12

Education (Independence Period): adaptive

education and, 59–60; archaeological training and, 64; Belizean decolonization of, 56, 65–70; Belizean teacher training and, 68, 70; Belize-specific, 20–21; colonial heritage and, 25; community support in, 217n139; cultural activities and, 63; cultural differences and, 25–26; culturally relevant, 63–65, 68–70; curricular reform and, 63–64; imperialist approaches in, 56, 58–61; internationalist approaches in, 58–59, 61–65; mass education and, 59; nationalist approaches in, 58–59, 65–70; native languages and, 64–65; official heritage and, 71; for social and economic development, 67

Education and Social Change in Tropical Areas (Read), 59

"Education in the British West Indies" (Hammond), 34

Education Ordinance (1962), 66

Engleton, C. A., 56

Enslavement: archaeology and, 127; Belizean state and, 228n27; colonial education reports and, 38–40; colonial structures and, 184; community-based heritage, 185; Crooked Tree residents and, 99–100; economic development and, 34; educational curricula and, 25, 71, 78–79, 81–82, 96, 99–100, 112; identity and, 184; material culture and, 160–61, 183; official heritage mythology and, 39–41, 79, 106, 126, 150; rebellion narratives and, 126, 150; silencing of violence in, 150; timber extraction and, 4, 12, 157

Environmental heritage, 19, 184, 191, 196, 234n27. *See also* Ecological heritage

Ethnographies and Archaeologies (Mortensen and Hollowell), 8

Faber, Patrick, 77

Farnsworth, Paul, 185

Field Museum, 121

Finneran, Niall, 150

Flowers, Donald, 204

Flowers Bank, 155

Folklore, 61, 64–65, 68–69, 201

Fonseca, William, 67–68

Forestocracy, 10, 54, 210n32

Forrest, Jack, 34–36, 38, 44, 53, 213n37

Fortenberry, Brent, 150

Fowler, Henry, 115

Fuller, Herbert, 58

imaginaries and, 168; importance to Belize economy, 152, 166, 183, 228n35; Kriol material culture and, 159–60, 182–83; local cultural resources and, 167–68; official heritage and, 150, 152–53, 156, 167, 183; upward mobility and, 167

Trinidad and Tobago, 144

Trouillot, Michel-Rolph, 17

Trujillo administration, 17–18, 214n65

Tumul K'in Center of Learning, 75

Udz, Silvaana, 221n54

UNESCO, 16, 57, 59, 62–64, 156

UNESCO Intangible Cultural Heritage, 11, 72

UNESCO World Heritage, 11

United Black Association for Development (UBAD), 58, 216n137

United Democratic Party (UDP), 58

United Nations, Educational, Scientific and Cultural Organization (UNESCO). *See* UNESCO

United Nations Children's Fund (UNICEF), 57

United States Agency for International Development, 152

United States Antiquities Act, 116

Unknown Tribes (Brown), 119

Unofficial heritage, 3. *See also* Vernacular heritage

Uxbenká, 205

Uxb'enka K'in Ajaw Association (UKAA), 204

Van Den Berghe, Pierre L., 167

Vernacular heritage: African-descendant communities and, 184–85, 195–96, 201; British colonial delegitimization of, 37–38; cashew production as, 193–95; colonial archaeology and, 121; colonial education and, 53–54; defining, 209n8; folklore and, 61, 64–65, 68–69, 201; formal education and, 5; group identity and, 3; Kriol language and, 97–98; Kriol peoples, 18–19, 160, 189, 197; Kriol youth and, 200–201; language education, 45; local engagement with, 141; material culture and, 129; natural environment and, 19; official heritage and, 3, 159, 182; promotion of, 155–56; storytelling and, 3, 165, 190–91. *See also* Ecological heritage; Environmental heritage; Kriol heritage; Storytelling

Village View Post, 198

Ward, W.E.F., 60–61, 217n141

Waterton, Emma, 8

Watson, Steve, 8

Welch, Christina, 150

Westby, Nelson, 155, 229n52

West Indies. *See* Caribbean

Whitehead, Clive, 42

Wilk, Richard, 17, 72, 141, 165

Wilkie, Laurie, 161

Withers, Lisa R., 194

World Bank, 57

World Heritage Committee, 16

Wright, Philip, 31

Xunantunich, 137–38, 152–53

Yarborough Cemetery, 148

Young, Keesha, 95

Youth: on Ancient Maya skills, 107–9; archaeology heritage discourse and, 171–72; association of archaeology with bones, 175, *176*, 177, 231n126; association of archaeology with Maya, 177–82; connections with past children, 182, 232n153; connections with past practices, 180–81, 232n153; Crooked Tree identity and, 198–99; on cultural differences, 103, *104*, 105, *105*, 106, 109; cultural identity and, 100–103, 105–6, 109–11, 188–91; on cultural loss, 102, 110; on dress and ethnicity, 101–2; ecological resources and, 201; educational achievement and, 199–200; encounters with archaeology, 171–72, *172*, 173, *173*, 174–75, *176*, 177–82; globalization and, 109; heritage and, 206–7; interactions with material culture, 202–3, 234n35; Kriol heritage and, 105–6, 111–12, 199–200; national curricula and, 100–101; on national holidays, 102; vernacular heritage and, 200–201

ALICIA EBBITT MCGILL is assistant professor of history at North Carolina State University. She is the author of "Learning from Cultural Engagements in Community-based Heritage Scholarship," *International Journal of Heritage Studies* 24, no. 10 (2018): 1068–1083 and "Examining the Pedagogy of Community-Based Heritage Work through an International Public History Field Experience," *The Public Historian* 40, no. 1 (2018): 55–84.

Cultural Heritage Studies

EDITED BY PAUL A. SHACKEL, UNIVERSITY OF MARYLAND

Heritage of Value, Archaeology of Renown: Reshaping Archaeological Assessment and Significance, edited by Clay Mathers, Timothy Darvill, and Barbara J. Little (2005)

Archaeology, Cultural Heritage, and the Antiquities Trade, edited by Neil Brodie, Morag M. Kersel, Christina Luke, and Kathryn Walker Tubb (2006)

Archaeological Site Museums in Latin America, edited by Helaine Silverman (2006)

Crossroads and Cosmologies: Diasporas and Ethnogenesis in the New World, by Christopher C. Fennell (2007)

Ethnographies and Archaeologies: Iterations of the Past, edited by Lena Mortensen and Julie Hollowell (2009)

Cultural Heritage Management: A Global Perspective, edited by Phyllis Mauch Messenger and George S. Smith (2010; first paperback edition, 2014)

God's Fields: Landscape, Religion, and Race in Moravian Wachovia, by Leland Ferguson (2011; first paperback edition, 2013)

Ancestors of Worthy Life: Plantation Slavery and Black Heritage at Mount Clare, by Teresa S. Moyer (2015)

Slavery behind the Wall: An Archaeology of a Cuban Coffee Plantation, by Theresa A. Singleton (2015; first paperback edition, 2016)

Excavating Memory: Sites of Remembering and Forgetting, edited by Maria Theresia Starzmann and John R. Roby (2016)

Mythic Frontiers: Remembering, Forgetting, and Profiting with Cultural Heritage Tourism, by Daniel R. Maher (2016; first paperback edition, 2019)

Critical Theory and the Anthropology of Heritage Landscapes, by Melissa F. Baird (2017)

Heritage at the Interface: Interpretation and Identity, edited by Glenn Hooper (2018)

Cuban Cultural Heritage: A Rebel Past for a Revolutionary Nation, by Pablo Alonso González (2018)

The Rosewood Massacre: An Archaeology and History of Intersectional Violence, by Edward González-Tennant (2018; first paperback edition, 2019)

Race, Place, and Memory: Deep Currents in Wilmington, North Carolina, by Margaret M. Mulrooney (2018)

An Archaeology of Structural Violence: Life in a Twentieth-Century Coal Town, by Michael P. Roller (2018)

Colonialism, Community, and Heritage in Native New England, by Siobhan M. Hart (2019)

Pedagogy and Practice in Heritage Studies, edited by Susan J. Bender and Phyllis Mauch Messenger (2019)

History and Approaches to Heritage Studies, edited by Phyllis Mauch Messenger and Susan J. Bender (2019)

A Struggle for Heritage: Archaeology and Civil Rights in a Long Island Community, by Christopher N. Matthews (2020)

Earth Politics and Intangible Heritage: Three Case Studies in the Americas, by Jessica Joyce Christie (2021)

Negotiating Heritage through Education and Archaeology: Colonialism, National Identity, and Resistance in Belize, by Alicia Ebbitt McGill (2021)